'Driving to work for a shift at Nevill Hall during Covid, my stomach would be doing somersaults with dread, hoping that I didn't catch this dreadful virus, or worse, take it home to my wife and young daughter. But then, when I got to work, that would disappear and all I wanted to do was help the people I transferred if I could. I knew as long as I wore the correct PPE myself, my family and the patient I was transferring would be ok. It was a scary time at work but one I'm proud of myself for working through and helping in any way I could.'

Mike Gwillym-Pitt, Porter

The Second Wave Begins

Summer came and went and as the leaves started to fall from the trees, the numbers of people contracting COVID began to creep up again. We were keenly aware that any community transmission would eventually seep its way into the hospitals, but we didn't really have a reference point for how many that might be; in the first wave the only people who got swabbed were those who were sick enough to require hospitalisation or healthcare staff and their families who were symptomatic and unsure if they should come to work. The vast majority of people who contracted COVID in the first wave and didn't require hospital care never got a swab.

Testing resources and organisation had now moved on significantly so anyone with symptoms was able to get swabbed quite efficiently. We watched the numbers in the media creep up day by day and slowly COVID patients began to drip back into the hospital. We dusted off our plans, made sure the lessons we'd learned from the first wave were fully remembered and planned where we would surge our extra ITU beds into.

We'd also learned more about the virus and how to treat it. We had contributed to a national research project to try to find effective COVID treatments, so we knew that for patients who were sick enough to be in hospital on oxygen a dose of steroids would reduce their risk of dying and there were other potential treatments in the pipeline. We weren't going into this wave totally blind as we had in the first wave but although we had a couple of treatments up our sleeve we also knew too well how merciless and indiscriminate the disease could be. We had stopped trying to predict who would probably live and who would probably die, something we usually got right in ITU for non-COVID patients, which allowed us to prepare the relatives accordingly. We just had to do whatever we could for the patients, knowing that, ultimately, however skilled and committed our care was for them, if the severity of their disease was overwhelming then nothing we could do would save them. We'd also learned more about how the virus itself was spread and it seemed that it was a predominantly airborne virus, so sitting in crowded areas with poor ventilation was a sure-fire way to help it spread. With a standard wet Welsh autumn and winter on the cards, meeting people in well-ventilated outdoor spaces was going to get tougher.

We dusted off our plans, made sure the lessons we'd learned from the first wave were fully remembered and planned where we would surge our extra ITU beds into.

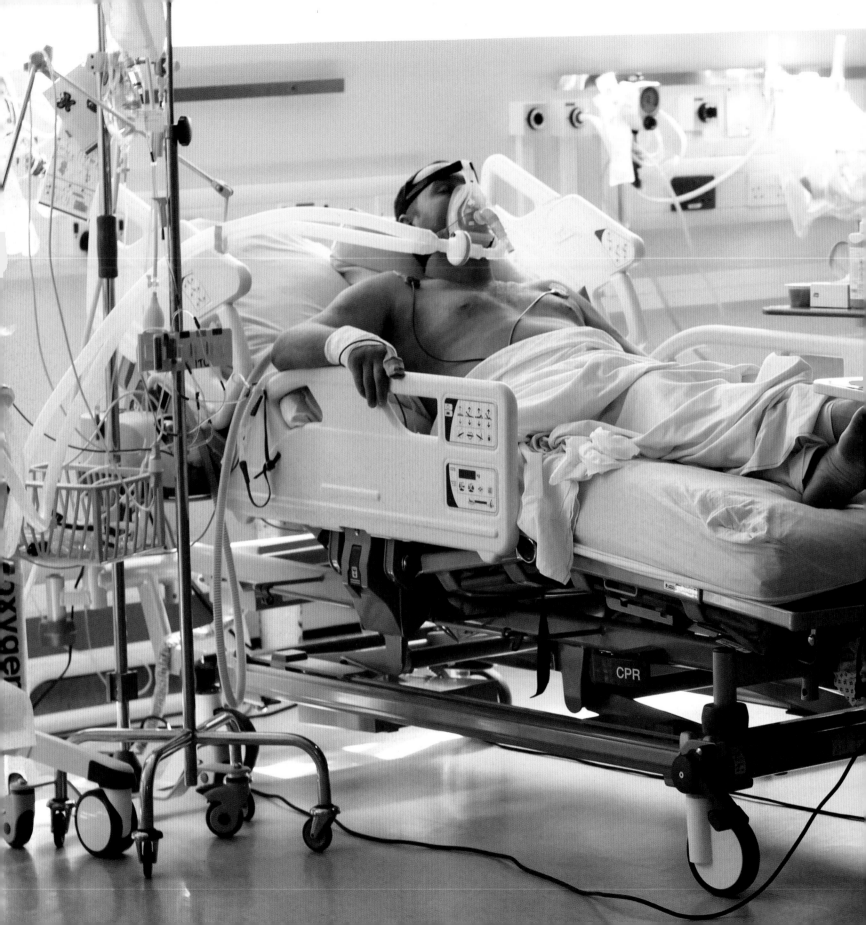

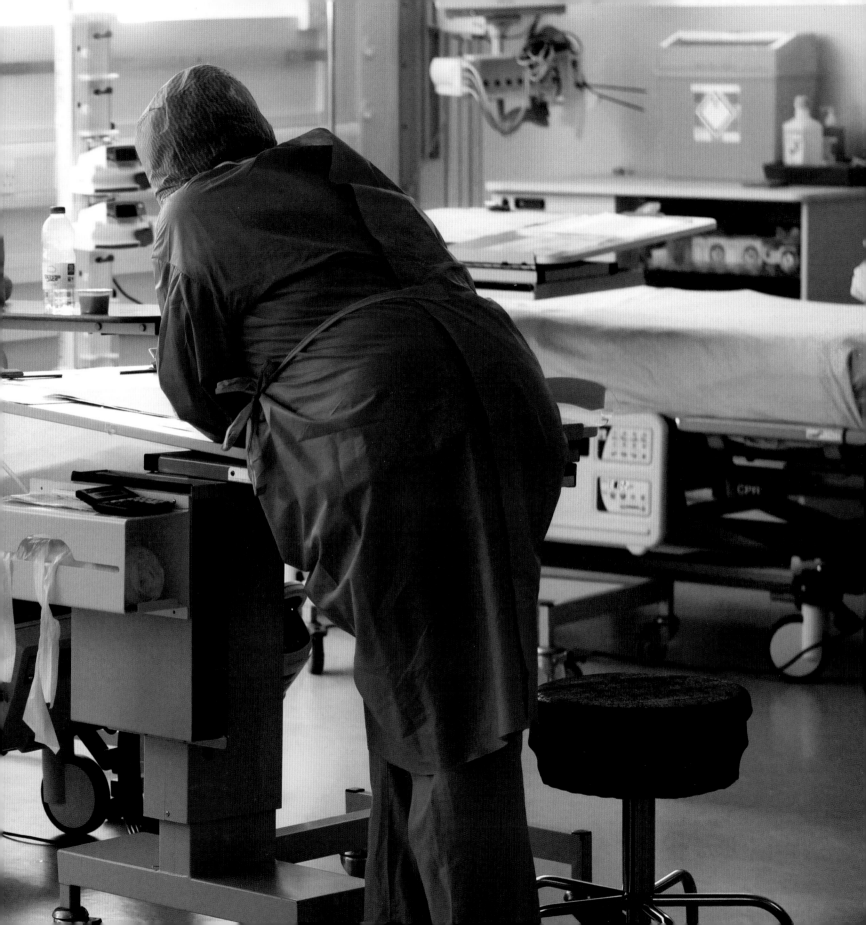

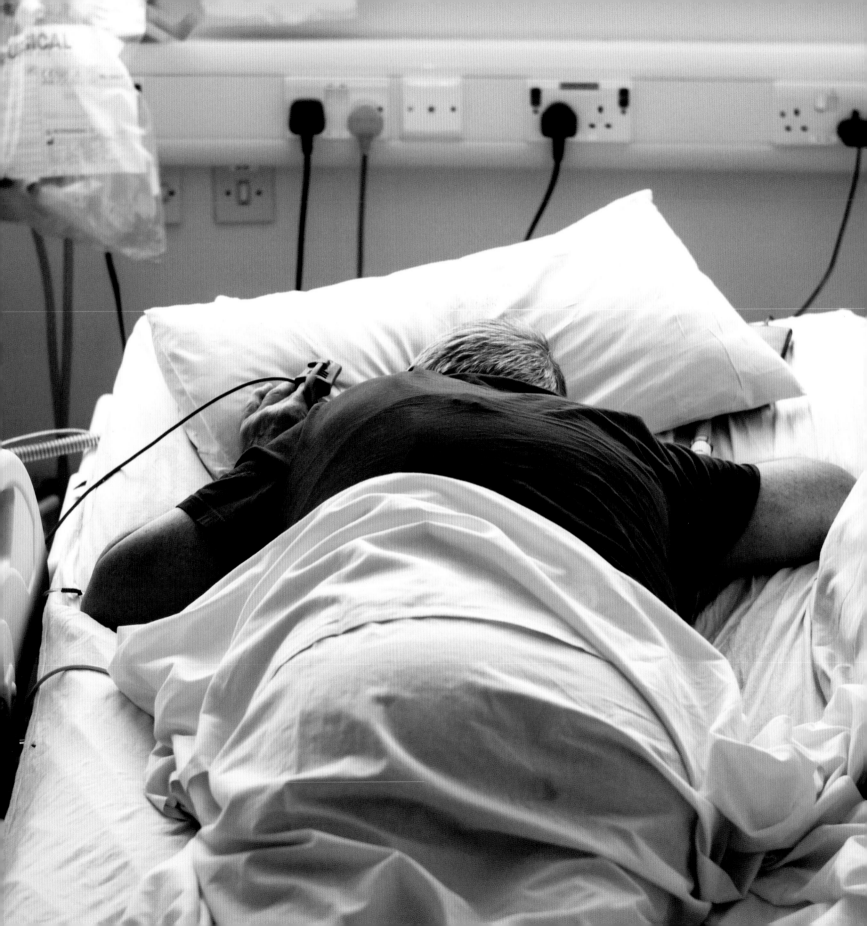

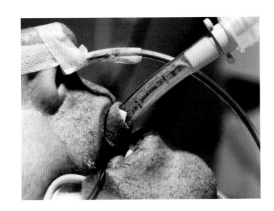

The media jumped on the uplift in hospitalisations and many of us intensive care doctors were thrust into the limelight to speak about the numbers of patients we were treating, our fears and predictions and our opinions about what action the politicians were taking. We were worried; not only were the COVID numbers climbing but we were heading towards winter, which was always a tough time for the NHS. A double whammy of the usual winter pressures plus a second significant wave of COVID was the stuff of nightmares and would be far more serious than the first wave, so we tried to get that message across to the public in any way that we could, including opportunities to speak to mainstream media.

People needed to stay out of poorly ventilated indoor areas, i.e. each other's houses, wear masks, socially distance from each other and continue strict hand hygiene, but this was easier said than done. The general public were fatigued; sick of lockdowns, sick of ever-changing rules, and some were sceptical about how risky COVID even really was. It's understandable that if you don't perceive yourself as someone who is at risk of dying from COVID, if it hasn't seriously affected any of your family or friends and if you've been adversely affected by the restrictions which had been put in place due to COVID then you might choose to ignore or disbelieve the threat which the virus posed. A COVID denial movement began to emerge and many spoke of the 'Great Barrington Declaration', which had begun over in America and called for individuals at the lowest risk of dying from COVID, as well as those at higher risk who wished to, to be allowed to resume a completely normal life as herd immunity caused by their infections would eventually protect everyone. Numerous academic, scientific and public health bodies throughout the world stated that this strategy was dangerous and unachievable, but it certainly muddied the waters of who to believe in some people's minds.

The general public were fatigued; sick of lockdowns, sick of ever-changing rules, and some were sceptical about how risky COVID even really was.

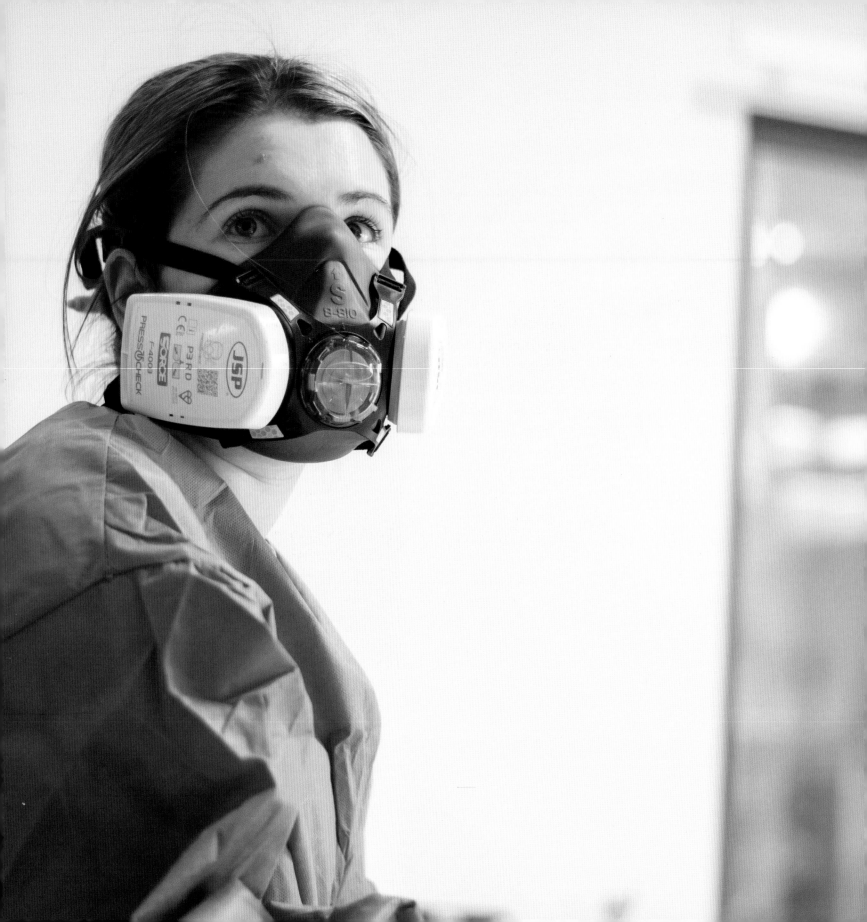

The hospital would not get turned over to be a purely COVID hospital again, it couldn't.

And what of the NHS staff who faced this second wave? We'd had a far from restful summer with the restoration of elective operations and procedures and the re-spinning of the hospital real estate into a structure that would account for the many different patient streams we needed to accommodate. Add to that the exhaustion caused by the first wave, both mental and physical, and you had a very tired and partially broken workforce who were now being asked to summon up the energy and determination to face this virus in a significant way once again. The virus hadn't changed, but this time winter was coming and the NHS departments that would likely bear the brunt of this new wave were unlikely to receive the public solidarity and mutual support we had in the first wave. The hospital would not get turned over to be a purely COVID hospital again, it couldn't. So many people had non-COVID-related illnesses that we needed to deal with, but this massively reduced our pool of willing and trained staff who we could call upon to bolster our numbers as we had in the first wave.

We felt quite alone.

Although by now we had purchased far more equipment to allow us to deal with a surge in patients on ITU and we'd upgraded our oxygen pipes so we shouldn't run out of that as we almost did in the first wave, it became clearer that we wouldn't have enough of the most valuable resource that a sick patient needs the most, highly trained ITU staff, especially ITU nurses, and we had no quick fix to remedy this.

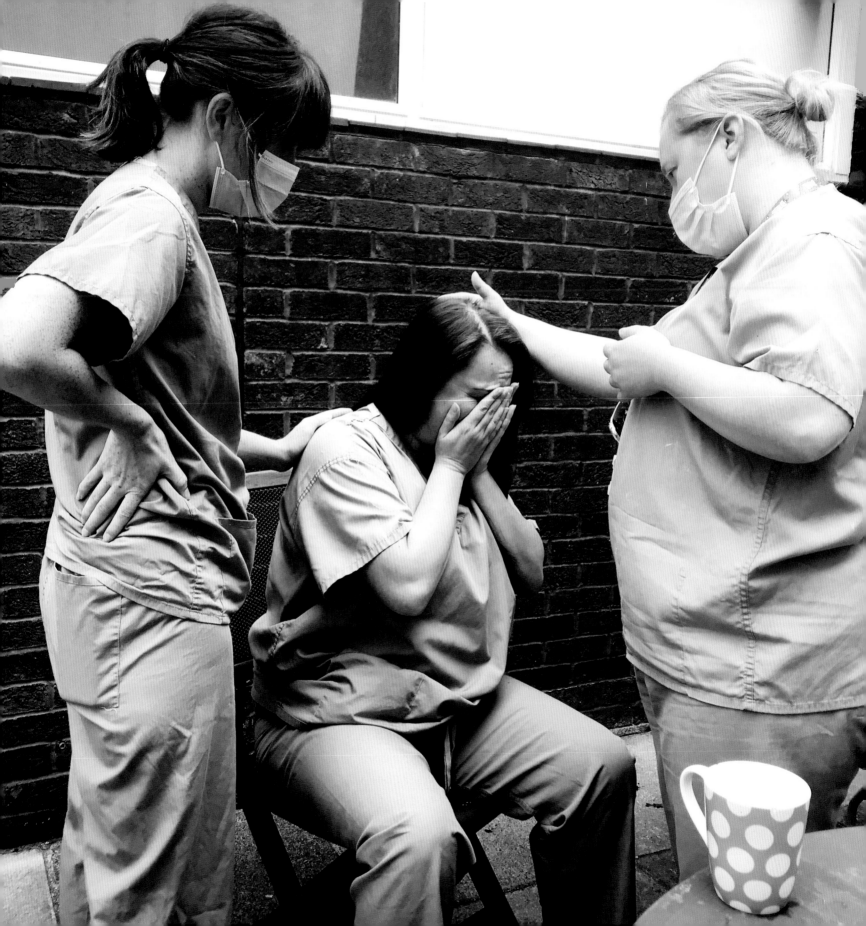

Moving Hospitals in the Middle of a Pandemic? You Must be Mad

As numbers of COVID patients started to trickle into the hospital and local lockdowns were triggered throughout the UK, the staff in Aneurin Bevan Health Board (ABUHB) had a unique dilemma to face.

During the first wave, every health board made plans to expand their bed capacity massively, as we thought we'd need many more beds than we currently had. So-called 'field hospitals' were planned and erected around all major cities in the UK. We were in an odd position in ABUHB as we'd spent the previous decade securing funding and then planning for a new hospital which would sit geographically between the two main acute hospitals in the health board, Nevill Hall Hospital and the Royal Gwent Hospital, and would cater for the sickest patients throughout the health board, a 'specialised critical care centre'.

This new hospital build was well underway when the first wave happened, so we decided to use any field hospital resource to build this new hospital quicker and that is where any additional patients would go should our established hospitals become saturated. It was actually a master stroke by the health board as by the end of April over half of the building was in a fully habitable state and our surge plans fully included its utilisation should the worst happen.

We didn't know then, as we do now, that the worst would never happen in the first wave and the field hospitals were totally underutilised. ABUHB never had to send a patient to the new hospital and even the biggest field hospital in Wales, 'The Dragon's Heart', which had capacity to take up to 1500 patients, only had 40-odd patients even at its busiest.

Momentum had been maintained by our builders and we were told that we could move into the new hospital in November 2020, rather than as we had planned to in April 2021, if we wanted to. From a perspective of what advantage it would give us, it allowed us to combine a number of critical departments from two sites to one; the emergency department, the critical care unit and the obstetric and paediatric departments, to name but a few. Rather than staffing and equipping two emergency departments, we could now staff and equip one giant one, rather than running two intensive care units we could run giant one, and so on.

It was actually a master stroke by the health board as by the end of April over half of the building was in a fully habitable state and our surge plans fully included its utilisation should the worst happen.

There was also an abundance of single patient cubicles within the new hospital, which when you're in the middle of an infectious disease pandemic is a very handy resource to have when isolating patients from one another is so critical. For example, if you combined the current ITUs in Nevill Hall and the Royal Gwent, we had just five cubicles in total, so we were having to turn entire 12-bedded open units 'red', as we didn't have enough cubicles to place COVID positive patients into to keep them separate from other patients. In the new hospital each of the 30 beds in the new ITU was an individual patient cubicle, and the good news didn't end there, as the rooms were so big and had such good medical gas and electricity supply that should we need more than those 30 beds then we could easily look after two COVID patients in each cubicle, giving us the option to surge to 60 beds without even leaving the footprint of the unit. This was a highly attractive surge plan compared to what we had to do in the first wave by sprawling all over the hospital, taking over operating theatres, day case suites and medical wards.

Seemed like a no-brainer, right?

But the second wave was beginning to build and our medical wards and ITUs began to steadily fill with COVID patients. We had to face the reality that moving two hospitals and most of their patients into a new one if both hospitals were fit to burst might not be the brightest idea. We the clinicians, the hospital execs and the managers had many meetings to try to figure out what was best to do and did detailed analysis of the pros and cons of each option. Ultimately, COVID was going to get the last word, as it had done for the last eight months, and if the numbers in the hospitals were too high we simply wouldn't be able to make the move. No matter how advantageous being in the new hospital would be, if the numbers got too high many of the patients would have to be moved with us and it was simply not safe to move hundreds of sick patients, especially if they were needing ITU level care.

We watched the hospital numbers closely as the potential move date edged closer and closer, but we watched the daily community transmission numbers even more closely. We had got used to seeing the trends in community transmission reflected in hospital admissions and then ITU admissions, and this was really the only way we could predict what might happen. We were surrounded by local lockdowns, with all but a few communities already under restrictions, but it didn't seem to be reducing the numbers. The overwhelming majority of the public were sticking to the rules but we saw what an impact a small number of rule breakers could cause; we heard tales of people holding birthday parties with hundreds of people attending and then saw COVID numbers spike in those communities, and hospital admissions spike shortly after.

We had got used to seeing the trends in community transmission reflected in hospital admissions and then ITU admissions and this was really the only way we could predict what might happen.

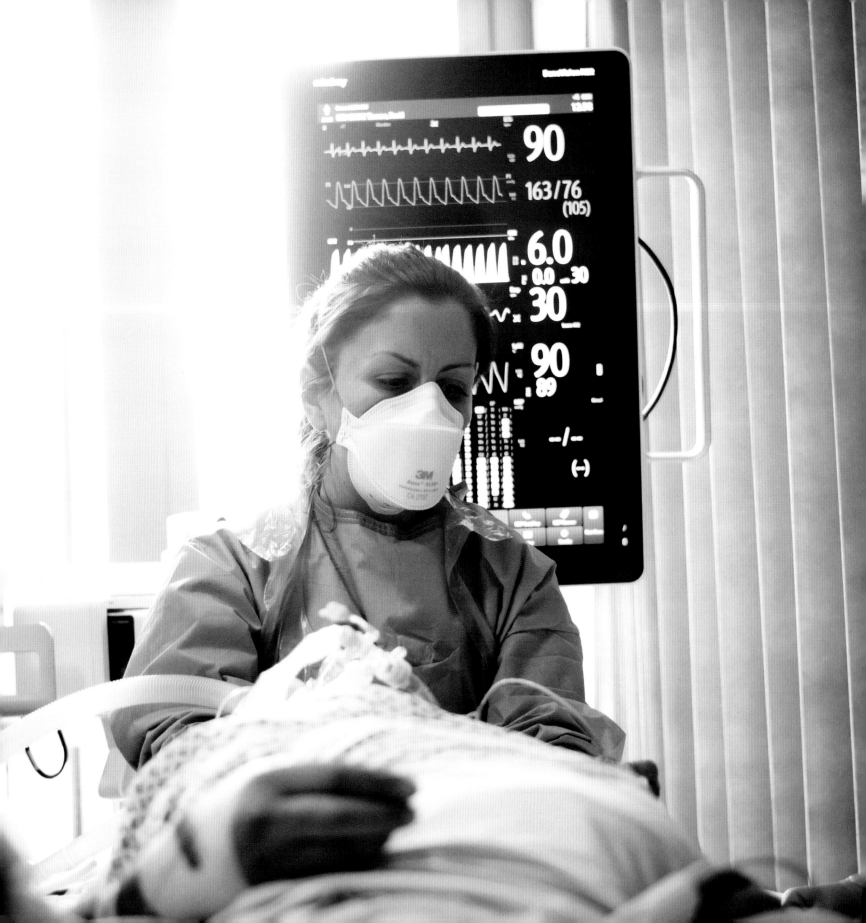

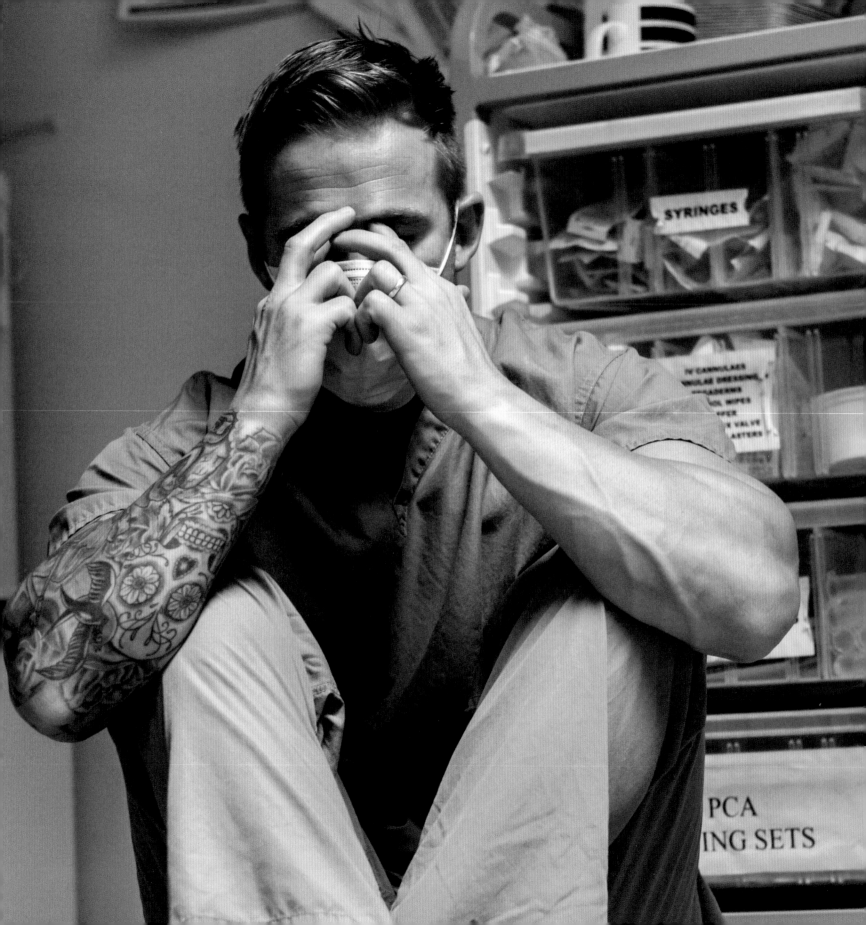

Most people knew of someone in their community who had sadly died.

It started to become more apparent to communities that COVID was a very real threat to them during this second wave. In the first wave, many people didn't know anyone who'd had COVID, let alone died from it. This was in small part due to a lack of swabbing capability for patients not requiring hospital in the first wave, but also that there were simply fewer patients who contracted COVID and therefore fewer patients overall got sick from it. This time, whole families and entire communities were decimated by COVID infections and soon enough almost everyone knew someone who'd contracted COVID and most people knew of someone in their community who had sadly died.

The First Minister of Wales, worried by the increase in community transmission and encouraged and applauded by all of us in the Welsh NHS, announced an approximately three-week firebreak, or miniature lockdown, which would start on 23 October. We hoped that this might dampen down the numbers and more importantly be a harsh reminder to people that the summer was over and that COVID was back with a vengeance and had to be taken seriously. In Aneurin Bevan we also needed a break in the amount of COVID patients streaming into hospitals to keep us below a level that would mean we could make the move to the new hospital. We knew that we would be unlikely to hold the wave back for the whole of the winter period, but we felt that we could cope with it much more effectively in the new hospital.

It went right to the wire, but thankfully the hospital numbers were such that we were able to complete the move with the first official in-patients being transferred to into the Grange University Hospital on November 15th and the hospital officially opening on 17 November 2020.

We had approximately 20 patients in critical care across the two sites on the planned ITU move day. They were moved seamlessly and safely to their new hospital and as the other departments moved across and the last piece in the puzzle was clicked into position, with the Emergency Department opening in the Grange and closing in Nevill Hall and the Royal Gwent, we all breathed a sigh of relief that we had made it in relatively unscathed. Many of us who were deeply involved in the planning and preparation had barely slept in the weeks leading up to the move, so finally opening the doors was a mixture of exhaustion and tempered exhilaration as we knew that any feelings of jubilance would be short lived; COVID numbers began to skyrocket following the end of the firebreak and it was a race against time to settle into the new hospital and prepare it to receive the onslaught of patients that public health specialists predicted would need us.

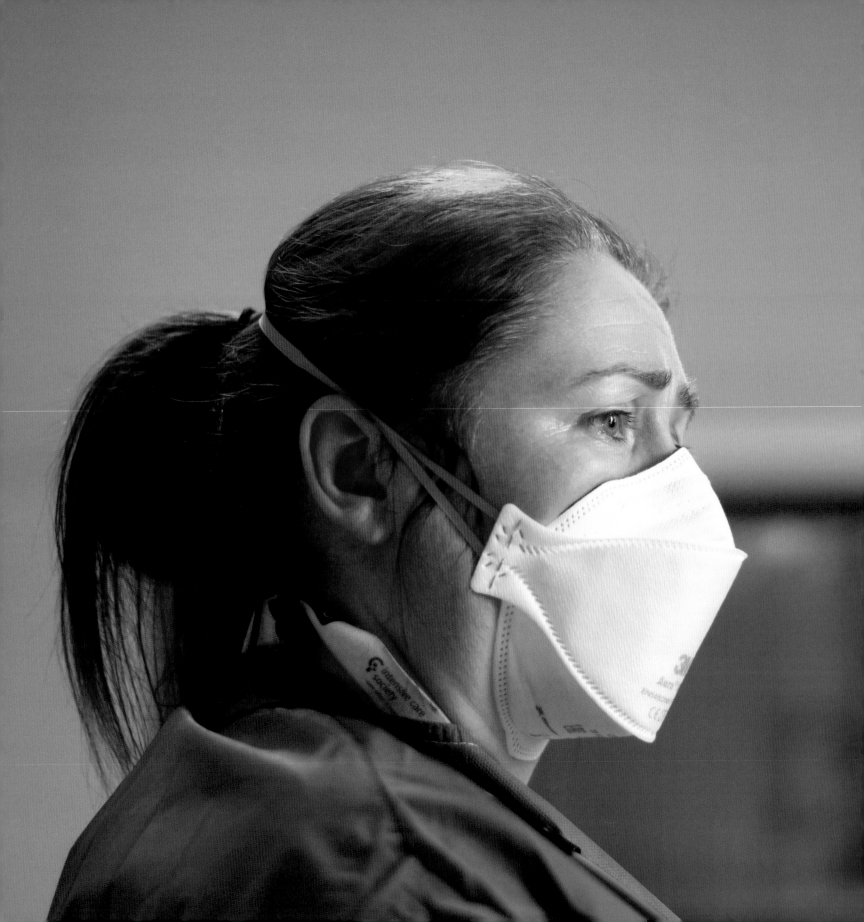

Goodbye, Old Friend

Nevill Hall was and is still a special place where colleagues are friends and often more like family.

In all the whirlwind of planning the move, worrying about if the move would happen and also dealing with the first COVID patients of the second wave, it had almost passed us by that we would soon be leaving some of our work family and the place that many of us had called home when the new hospital opened. Nevill Hall was and is still a special place where colleagues are friends and often more like family. It is difficult to describe in words the sense of community fostered within the walls of Nevill Hall; people genuinely cared about one another and all pulled together to do their very best for the patients we treated. It didn't matter what your job in the hospital was, everybody was important and everyone made time for each other. When the new hospital opened, approximately half of the staff would be leaving Nevill Hall to work there, leaving behind years of memories; difficult cases where we lost patients despite all efforts and seemingly miracle wins when we saved them against the odds. We had laughed and cried together and the first wave of COVID had given us some of our darkest times in our entire professional lifetimes, but had also galvanised us and bonded us even more deeply than before. It was with a heavy heart that we left the family we loved, and although many of us were excited about the move, others were apprehensive to leave the place they had worked for the previous 30 years and we all felt quite cheated that we couldn't say goodbye properly to each other and to this amazing community.

When the day of the move came around we stabilised and packaged our ITU patients and as the final one left in an ambulance we set about cleaning and packing up the last few pieces of equipment left behind. The ITU was going to be required to hold patients in as they waited for their ambulances when the wards began moving their patients over the next couple of days and after that was going to be renovated and transformed into a new area for the hospital to utilise. The place looked so strange being completely empty, bigger than it ever seemed when it was crammed full of patients as it had been over the previous six months.

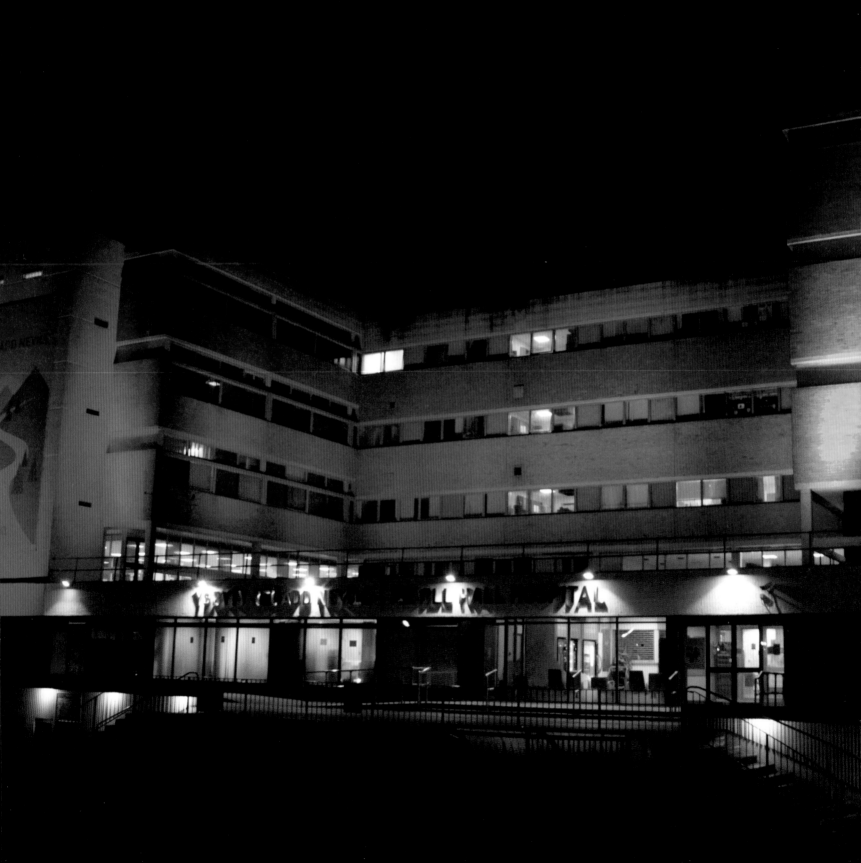

Every bed space could tell hundreds of stories of the patients who'd been cared for in it, if it could speak; some were tragedies, some were miracles, but all were the stories of our local people and their families and, sadly, even the stories of our own colleagues too, who we had tragically had to care for as patients. Many of us had cut our medical or nursing teeth in these bed spaces too; our experiences and training in this amazing unit when we were far more junior and inexperienced had made us the doctors and nurses we are today. As we left the unit behind, it almost felt as if we were also leaving those memories behind, as our heads were now full of COVID and the harsh memories of the last eight months and fear about what lay in front of us.

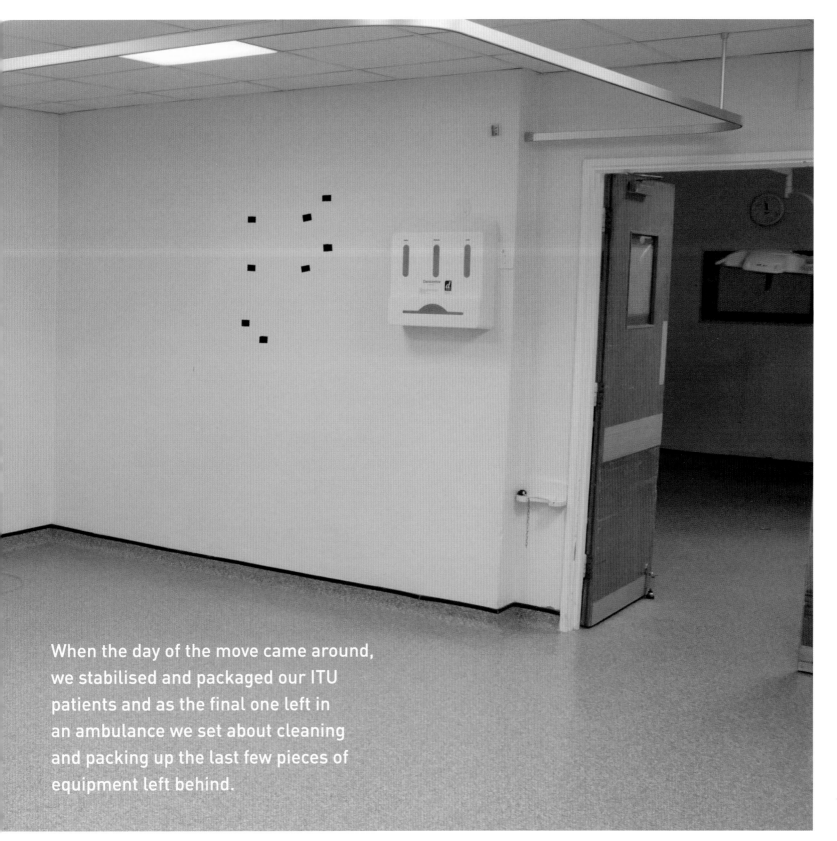

When the day of the move came around, we stabilised and packaged our ITU patients and as the final one left in an ambulance we set about cleaning and packing up the last few pieces of equipment left behind.

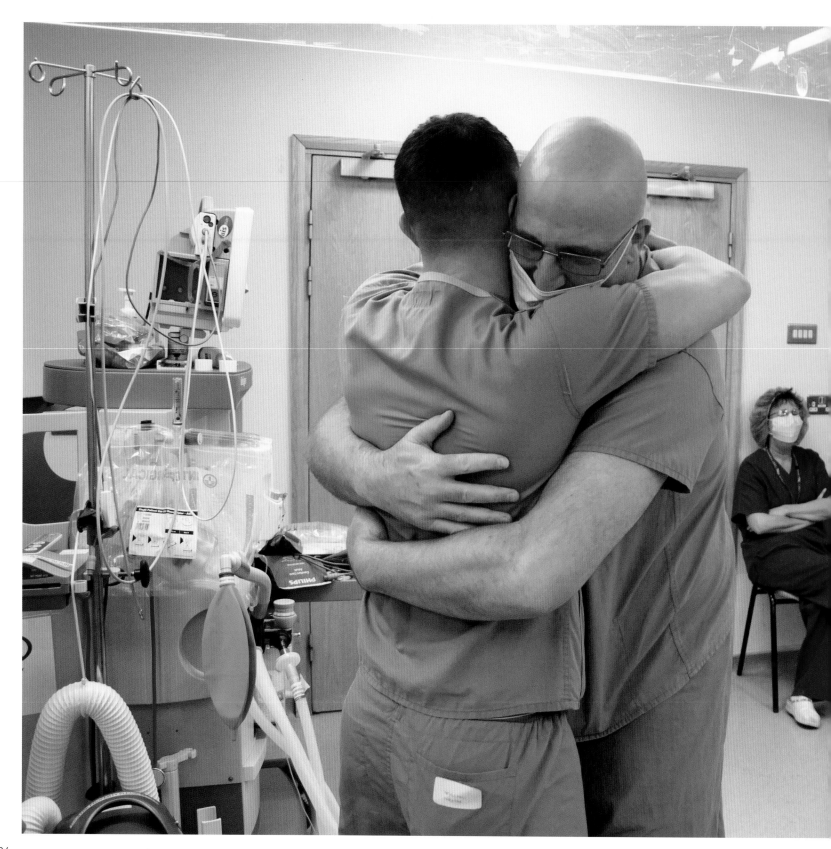

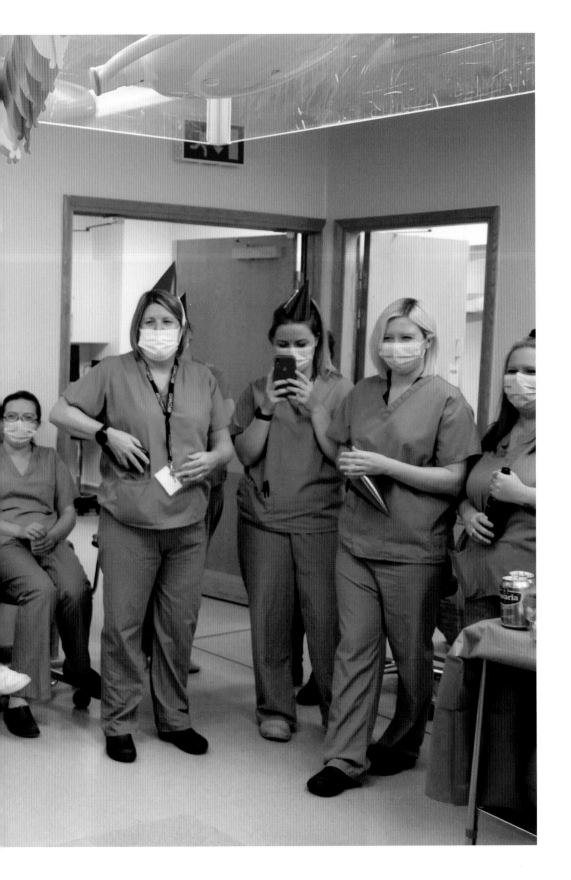

We are cream crackered and all packed up ready to go!

See you all at GUH

♡

IT'S BEEN GREAT WORKING, LAUGHING AND CRYING WITH SO MANY AMAZING PEOPLE. THOSE STAYING GOOD LUCK, THOSE MOVING ON GOOD LUCK AND THOSE GOING TO THE GRANGE GOOD LUCK. REMEMBER — YOU'LL TAKE THE STAFF OUT OF NEVILL HALL, BUT NEVER, NEVILL HALL OUT OF THE STAFF. WHAT A PLACE WHAT A FAMILY. ENJOY THE FUTURE WHEREVER YOU END UP

love you lots
Steve Bakes
last shift
04 11 20 xxx

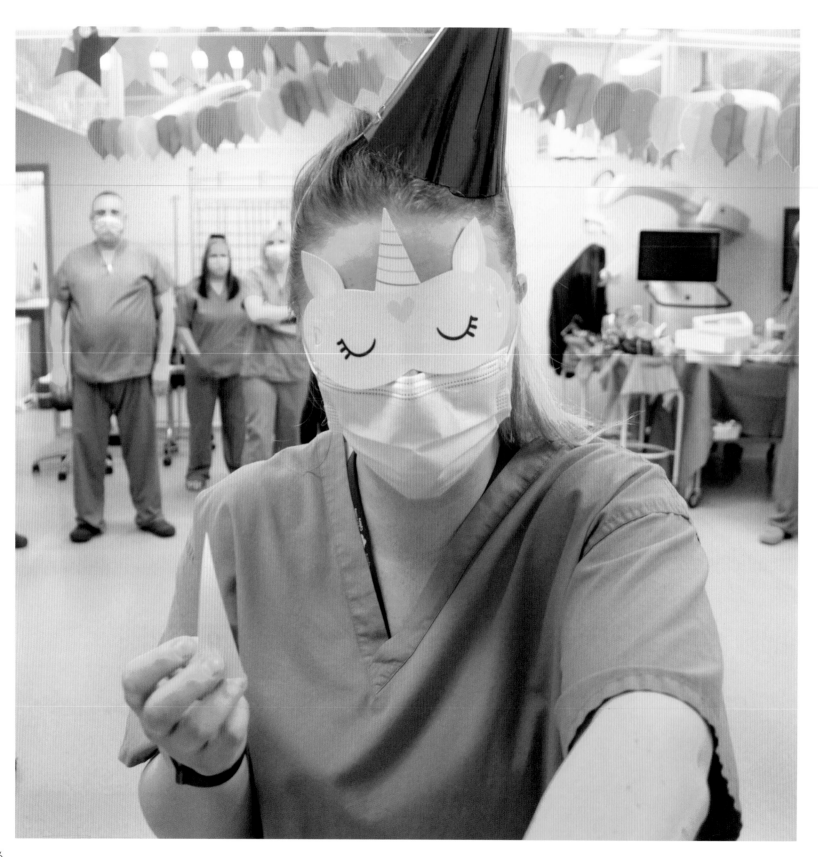

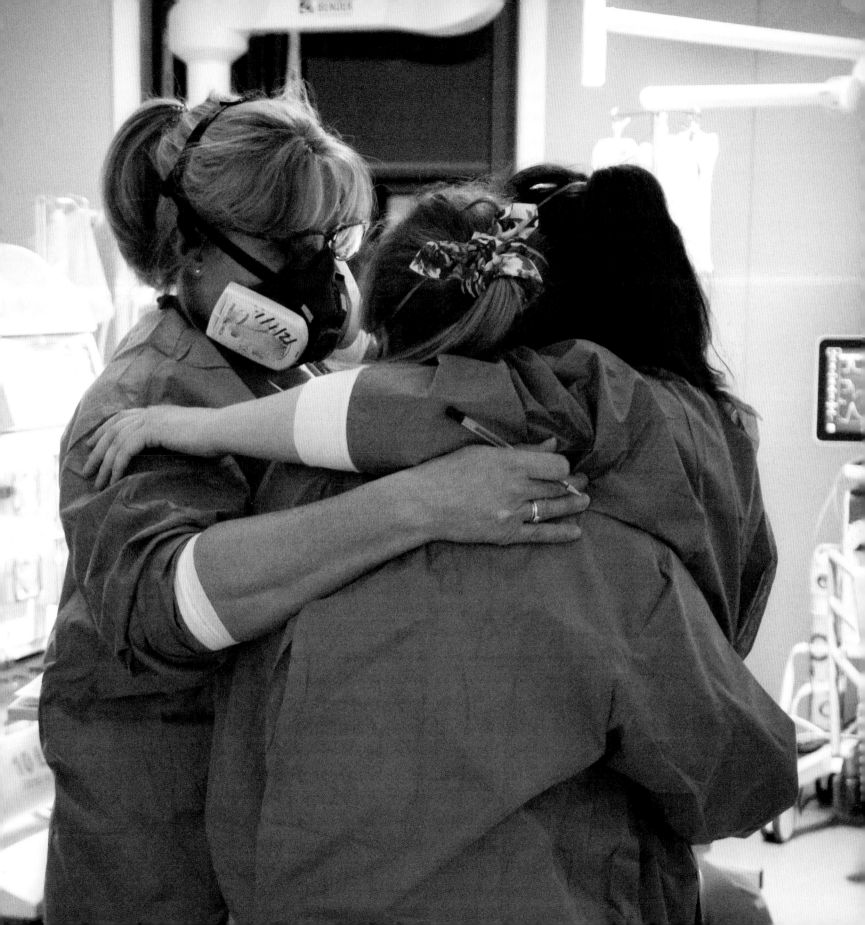

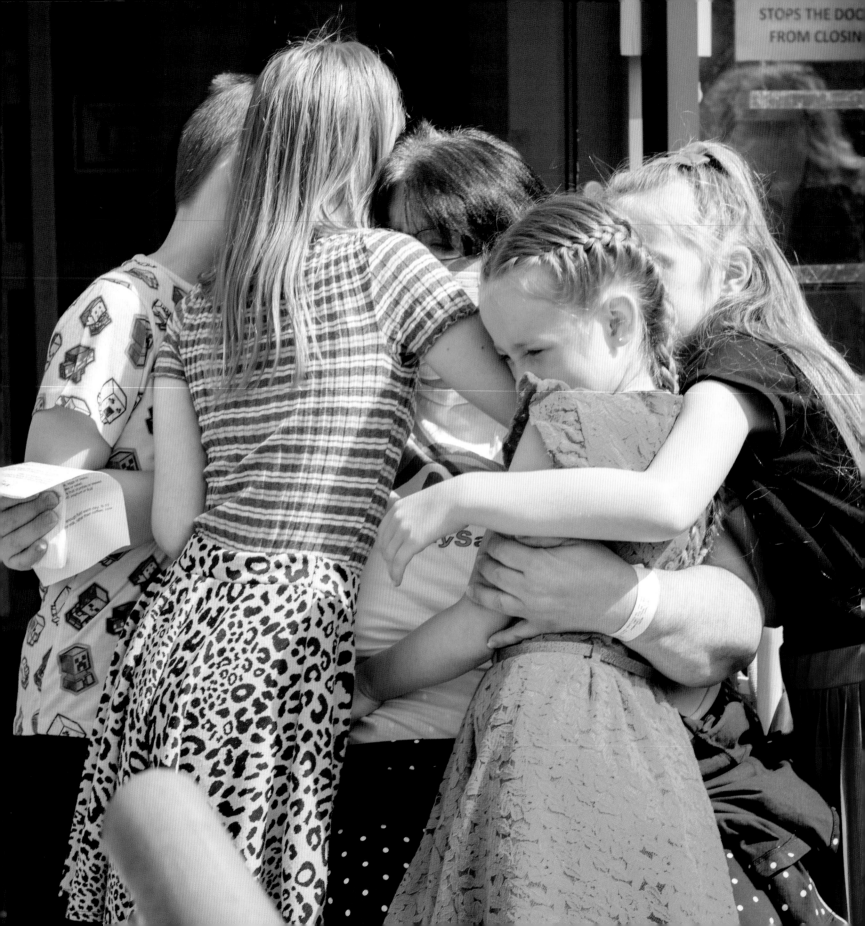

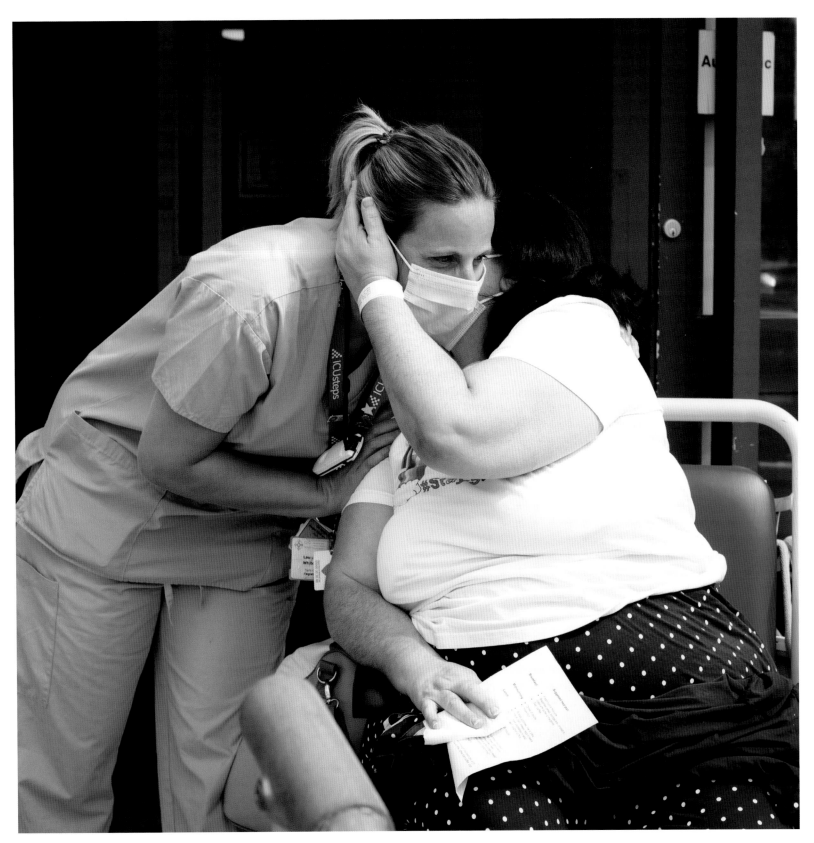

Was COVID Different This Time?

Our health board finally had to concede and cancel elective surgery on 14 December, as there was now insufficient space within the hospitals to keep elective or 'green' patients safe within the hospital footprint and insufficient staff to look after the numbers of patients who were now requiring hospital care.

There were further problems afoot in terms of staffing, however; now community testing was quite rightly far more available and widespread, more people were getting tested and testing positive for COVID. Community transmissions were rampant and obviously many of the people infected were either our staff or staff family members, so many hours of staffing were lost to quarantine and sickness. In addition, there were also staff off sick for a variety of other reasons; the impact of the first wave on people's mental wellness who were now suffering from longer term ill health issues and the need for vulnerable staff to shield at home or not be in contact with potential COVID patients meant that our pool of staff was significantly diminished. Thankfully, both ITUs having been moved into one site meant that staffing was generally more robust, which lessened this blow a little, but things were still very tight and we started to feel again like we were going to be put into a position where we were not able to give patients the level of care we wanted to, which was a high source of moral distress for staff.

Although things felt tough for us, neighbouring health boards who had multiple smaller ITUs, just as we had in the first wave, were having an even tougher time. One of them had the highest community transmission rates in the whole of the UK and the highest mortality rates, and although we felt as though we were fit to burst and ready to drop, they were in a worse position than us. It seemed like a ridiculous position to be in, but essentially, we had to look across Wales and see who was the least broken; whose patient numbers and staffing conditions were the least bad, so that unit who maybe only had a nurse per two patients could take patients from a unit who had a nurse per four patients. It was a tough call, but we began to transfer in ITU patients from other health boards as well as looking after our own. Our tired nurses looked on almost in disbelief as patients were wheeled in by transfer teams into rooms which had only just become vacant, their previous occupant having in all likelihood been transferred to the mortuary.

Although things felt tough for us, neighbouring health boards who had multiple smaller ITUs, just as we had in the first wave, were having an even tougher time.

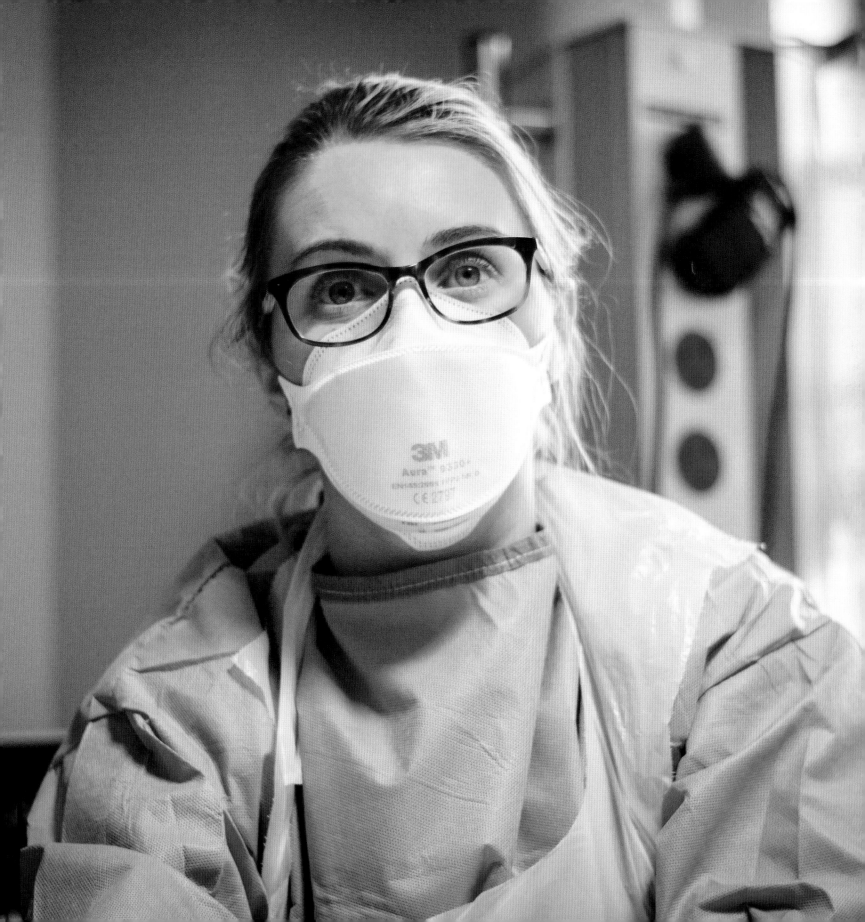

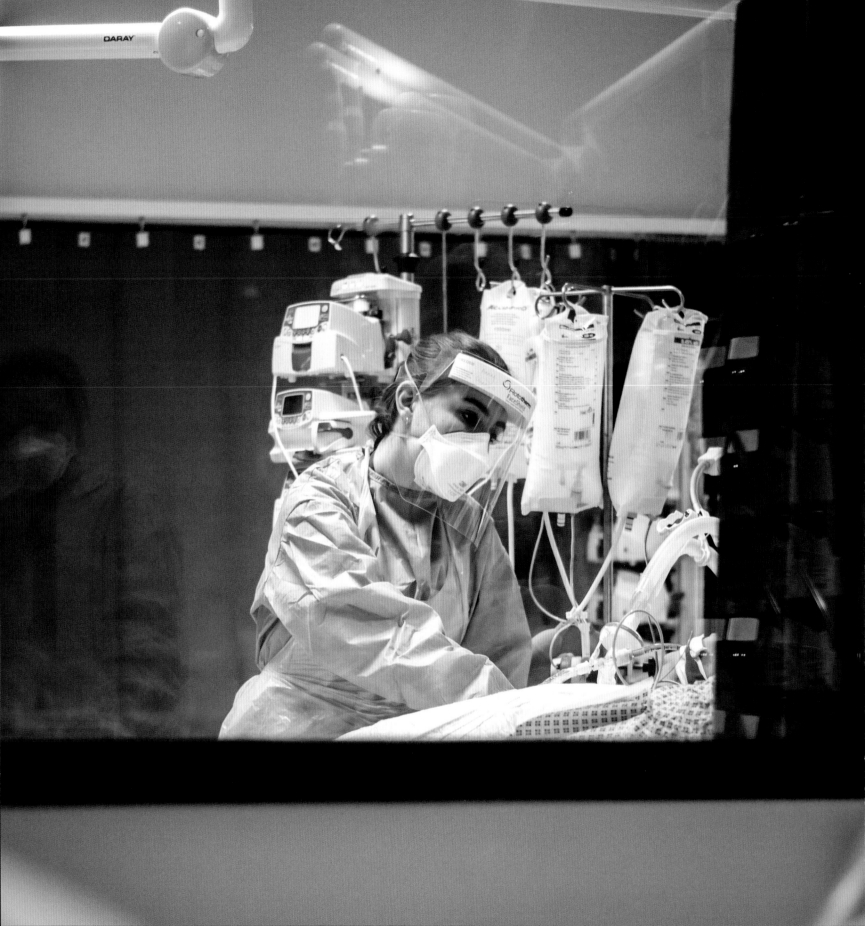

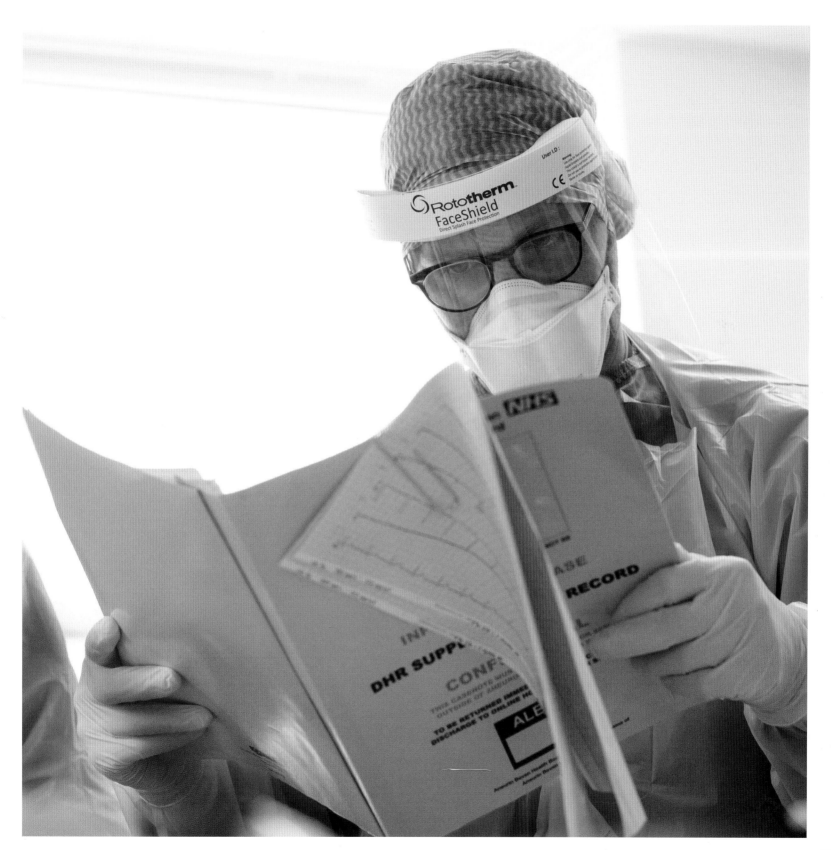

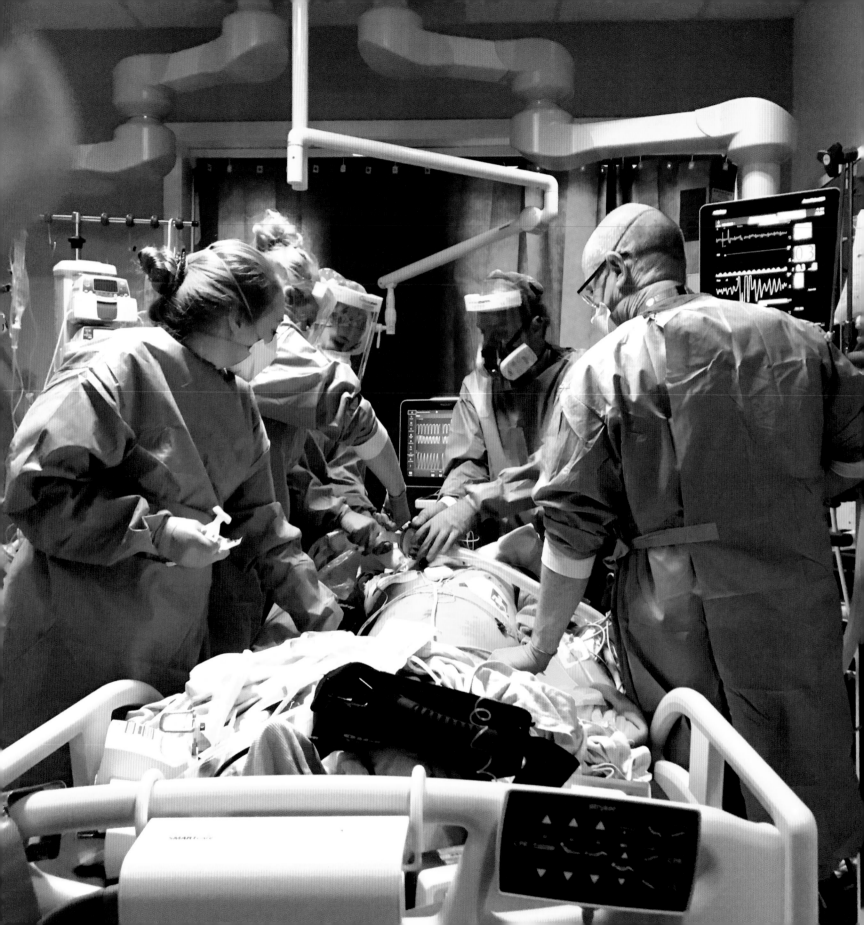

We Told Their Families to Expect the Worst but Hope for the Best

What of the patients during this second wave? Was COVID different this time? It was the same ravaging, merciless disease, and we certainly knew more about how to look after COVID patients this time, about what to say to the relatives from what we had experienced in the first wave. But for any expertise we thought we had developed, for the trump card of steroid treatment that we thought we held this time around, ultimately, COVID held all of the cards. We honestly could not tell when we admitted them who would live and who would die. We admitted fit young patients to ITU, gave them time to speak to their families and told them we would give them the very best care that we could as we put them onto ventilators with tears in their, and our, eyes. We told their families to expect the worst but hope for the best. We certainly hoped for the best, as on paper they were fit and well, they had years of good health in front of them, or they did have until they contracted COVID. On paper there was no way they should die, but now all bets were off.

We found in this second wave that even though the disease had not changed, because of advances in drug treatments that the patients could receive on the wards, namely dexamethasone, a very cheap and readily available steroid drug, many patients who might have needed ITU in the first wave were instead responding well to the steroids and getting better after a couple of days and so never needed us. Had it not been for this drug there is no doubt that ITU would have been overrun. The wards were very busy, far busier than the first wave, but many of the patients who may have needed us never did. We never even heard about them, they just got better and went home to their families and we never got to share in the happy stories of success. The physicians, those doctors who ran the medical wards, really bore the brunt of this second wave and very much kept the wolves from our doors so that we weren't completely overwhelmed and didn't need to use the 90 ITU beds we had been asked to plan for.

On the medical wards, if the steroids didn't work and some of the advanced oxygen treatments and proning (lying on tummy) treatments that the respiratory specialists used didn't work and we felt that the patient stood a chance of getting through the marathon that ITU care posed to them, then we took them to ITU for more complex treatments.

It was the same ravaging, merciless disease, and we certainly knew more about how to look after COVID patients this time, about what to say to the relatives from what we had experienced in the first wave.

They really were the sickest of the sick; the fact that they had not responded to steroids or advanced oxygen treatment meant their lung injury was very severe and even if we pulled all of our ITU tricks in terms of invasive ventilation with a breathing tube down their windpipe, blood pressure support with powerful drugs and kidney machines might not get them out of hospital and back to their family. In fact, because the wards were doing so well at getting patients better with steroids and the patients we were taking in ITU were so much sicker, it seemed like we were getting very few patients out to the wards alive and many more patients were leaving us to go to the mortuary. The numbers of patients dying from COVID was in the news daily, but to us they were far more than numbers; they were a person, we knew their names and had cared for them throughout their illness throughout the many days they spent with us. We'd spoken to their families daily, and then we'd finally met these families in person as they'd come in to spend the last moments with their loved ones when they finally died. They weren't just a number to us, they were a person. The constant bad news breaking, bereaved family visits and discharges to the mortuary took its toll on our staff. We were getting very few victories, very few patients getting out to the wards and back to their families.

We also found we had to fight hard to make those patients not seem like a bed number to us; when you're suffering with COVID, lying prone (on your tummy), unconscious, with a breathing tube in, wearing a hospital gown, and the patient next to you and across the way from you, in fact, all along the corridor from you are in the same state and are a similar age (typically 40s to 60s) with similar past medical history (very little wrong with you!), it can be very hard to remember or even to recognise which patient is which. We'd try to glean information to help us to differentiate between the patients as handover times between day and night teams were especially tough, much of the information we'd hand over being the same: 'Bed 71A is Bob, a 49-year-old with hypertension who's day 4 on ITU. He's intubated, ventilated and proned due to covid pneumonitis. Bed 71B is Frank, a 53-year-old hypertensive who's day 6 ITU. He's intubated, ventilated and proned due to covid pneumonitis'. This would potentially be a very similar story for huge numbers of patients and it was key to differentiate between them, partly so we handed important information over properly, but also so that the

The numbers of patients dying from COVID was in the news daily, but to us they were far more than numbers; they were a person, we knew their names and had cared for them throughout their illness throughout the many days they spent with us.

Nurse Cath.S (E) + Theresa
Nat.A ⊙
Consultant
Size 8.5 ETT 24cm @ teeth
Please play on youtube. . .
Bollywood music
Buddhist Mantra - Green Tara
 · medicine Buddha
 · Guru rinpoche

patients remained as people to us, people with families and jobs and hobbies and not just bodies attached to machines who we would periodically turn onto their backs and then back onto their tummies and occasionally insert a new tube into a vein of or write a new prescription chart for. The 'bodies attached to machines' description might sound harsh, depersonalised, but we'd been treating these kinds of patients for almost a year now with little respite and many of us were starting to feel quite burnt out by it all; it's hard to keep your compassion levels as high as you'd like when you're worn down daily with sadness and death, so depersonalising patients was a coping mechanism to try to protect ourselves a little from the pure wretchedness of the situation we faced daily. Trying to re-personalise whenever we could was important: 'Bed 71A is Bob, a 49-year-old with hypertension who usually works as a lorry driver for a brewery and supports Manchester United. He's day 4 on ITU and is intubated, ventilated and proned due to covid pneumonitis. Bed 71B is Frank, a 53-year-old hypertensive who is a science teacher at a local school and owns a whippet called Sparky. He's day 6 ITU. He's intubated, ventilated and proned due to covid pneumonitis'. It might not sound like much, but by trying to learn a little bit about them from their family, it helped us remember who they were and that they were people just like us with families who desperately wanted them home.

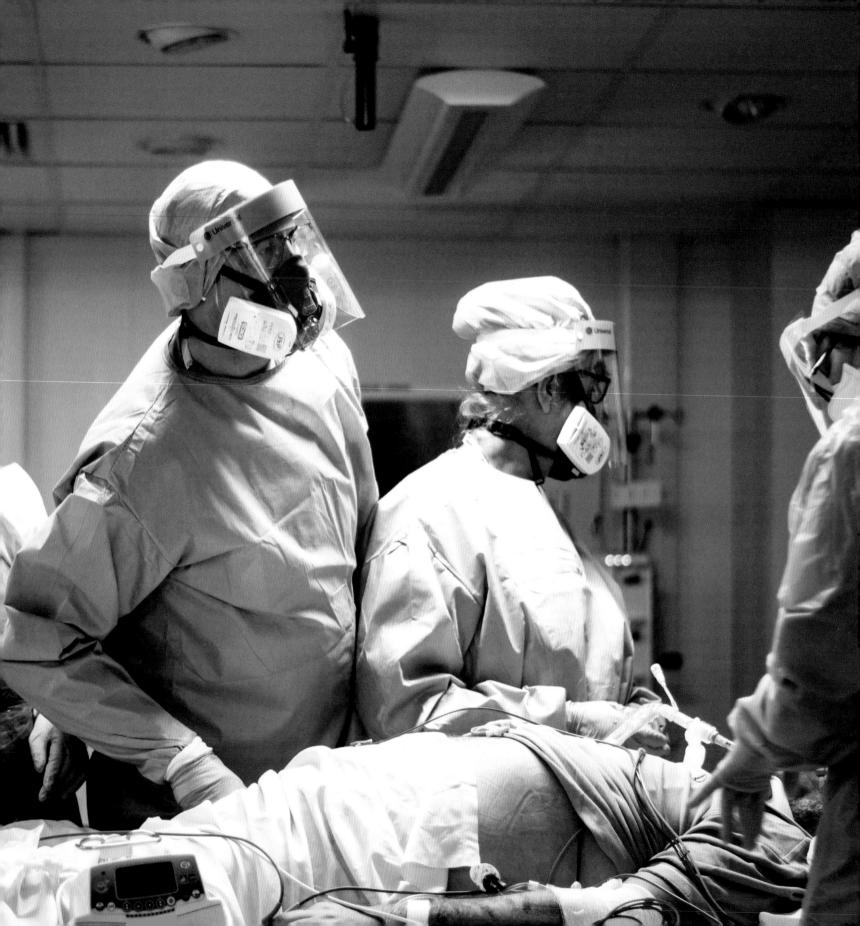

Save Christmas or Save the NHS

At the eleventh hour, on the 19 December, the First Minister made an announcement that Wales was going into immediate lockdown and that Christmas day would be constrained to a two-household bubble who would only be allowed contact for a single day.

Numbers of COVID patients continued to stream through the doors and as we implored the politicians to impose further lockdowns we faced the wrath of our public, labelled as 'Grinches who were trying to ruin Christmas'. Had the public seen what we had seen, we felt sure they would understand but the hospital was still out of bounds and it was hard for the public to understand our position. As the four nations gave a cohesive direction about how Christmas would work with potentially four households being allowed to mix, the discussions in the media seemed to hinge upon 'save Christmas or save the NHS'. We knew how much people were looking forward to spending the end of an awful year with their loved ones, but we feared that the mixing of households, especially with potentially vulnerable elderly relatives being exposed to their younger family members when community levels of infections being as high as they were and hospitals being as full as they were, was a recipe for disaster. At the eleventh hour, on the 19 December, the First Minister made an announcement that Wales was going into immediate lockdown and that Christmas day would be constrained to a two-household bubble who would only be allowed contact for a single day.

The relief was palpable throughout the hospital; we were more than happy to forgo Christmas celebrations if it meant that we might avoid a whole extra swell of patients ending up in hospital, ITU, or worse, in the mortuary. We crossed our fingers again that this new lockdown would help to reduce numbers and that people would resist the temptation to bend or break the rules to enjoy the Christmas that they had originally planned. Christmas wasn't going to be a happy affair in the hospital regardless, as the ITU and wards were full of patients, many of them COVID, who were going to keep staff busy and there would still be a number of new patients who would hit the hospital regardless of lockdown – despite any changes, numbers were already 'baked in' i.e. people had already become infected just prior to lockdown who would subsequently need hospital care. If we weren't going to have a merry Christmas then we at least hoped that the lockdown would bring us a happy New Year, as we didn't have much more hospital space or staff energy left to take much more.

Vaccination – Light at the End of the Tunnel

At the same time that we were watching the numbers of infections escalate throughout December, we were also given some good news; a chink of light in the long and dark tunnel that we'd been trudging for the last ten months. A vaccination had been approved and it was going to start being given to the most vulnerable people in the community and to healthcare staff first, and soon. There was much media coverage and a moderate amount of noise about the safety profile of this vaccine and others that had subsequently been approved, as they had been developed at a far more advanced pace compared to other vaccines. We were happy to be 'guinea pigs', as although some members of the public were concerned about safety, the overwhelming majority of healthcare professionals could not wait for the vaccine to arrive and trusted the science. The science behind the vaccines was completely sound; no short cuts had been performed and every precaution and appropriate study had been undertaken to ensure that they were safe and effective. Time had been saved by huge amounts of funding and copious numbers of volunteers who'd signed up to take part in the clinical trials; these were really the guinea pigs, not those of us who were lucky enough to receive the first official doses. We all gratefully rolled up our sleeves, feeling relieved that maybe the end really was in sight and in some way guilty that we were getting our jabs first when most of us would probably rather our middle-aged parents and friends receive them, as they were at higher risk of getting sick if they were to contract COVID, even if we were at higher risk of catching it in the first place due to our jobs.

The vaccine rollout has been one of the high points of the pandemic, not just because it's hopefully a beacon of light that will guide us out of the darkest year in most of our lives to date, but also because the NHS delivered it and delivered it effectively, efficiently and professionally. Much has been said in the media about how many billions of pounds has been spent on various government schemes within the pandemic and how poorly some of those had delivered what they had promised to, but the vaccine rollout has been money well spent and an unmitigated success.

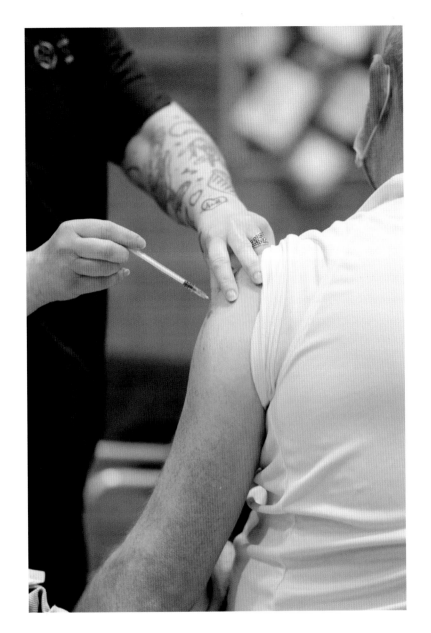

Time will tell how this pans out, but it's currently our best chance to make our way out of the darkness and get life back to something resembling normality.

If uptake is good enough we should be in a position to reap the rewards of this success and hopefully avoid the third wave that many countries in Europe and the wider world are now facing, but it relies on the majority of the population to get vaccinated and protect those who are unable to be vaccinated or in who the vaccine as not as effective. Time will tell how this pans out, but it's currently our best chance to make our way out of the darkness and get life back to something resembling normality.

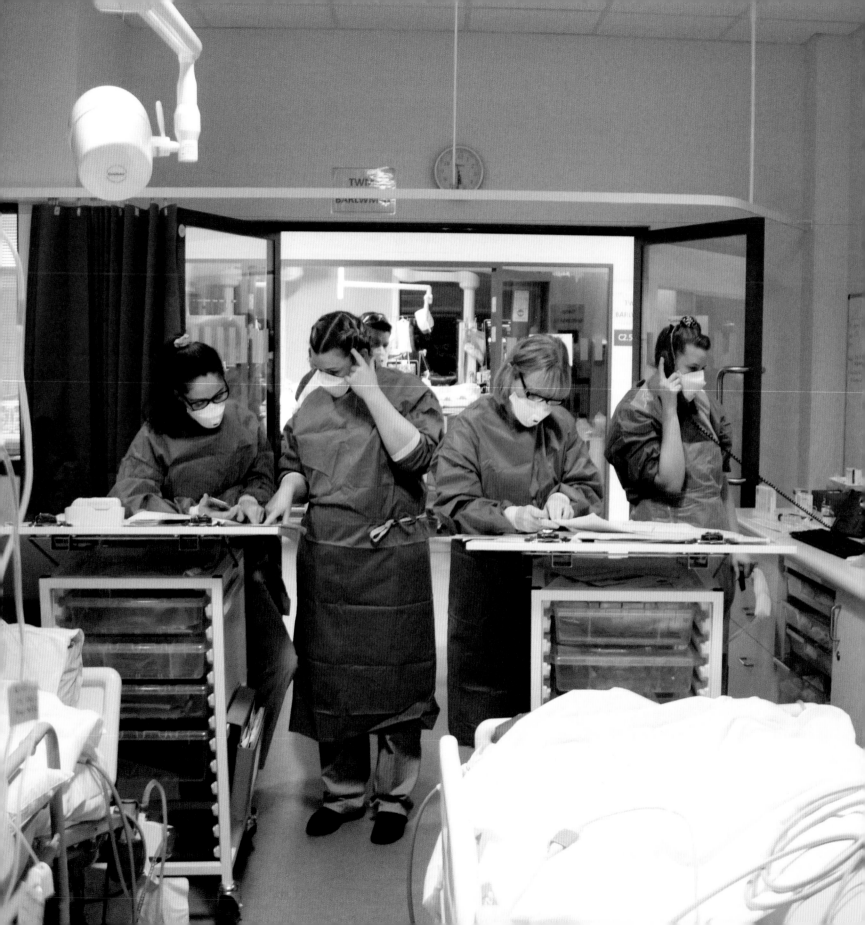

Covid Has Left the Building?

Lockdown seemed to be once again effective and as we write these words in late April 2021, community transmission rates are at their lowest since summer and death rates are down to single figures. The vaccination programme is ploughing its way through the different prioritisation categories of the population and the hope is that within the next month everyone over the age of 50 or with health problems which make them vulnerable to becoming very unwell with COVID will be vaccinated, or at least will have been offered a vaccine. This doesn't mean that numbers of COVID infections will disappear to zero, as clearly there is a large proportion of the population who still haven't been vaccinated, but it means that most of the people who were at risk of requiring hospitalisation or of dying will have been vaccinated and the different vaccines available in the UK have excellent data to prove a significant reduction in severity of disease. It's too soon to breathe a sigh of relief and get life straight back to normal; social distancing and facemasks will remain a part of life for a while yet, but we're taking the first small steps towards a more normal life with the rightly slow lifting of the various restrictions that have been in place since before Christmas.

So what legacies will COVID leave behind in its wake, if it ever really goes away?

From a healthcare planning perspective, it's very easy to look back and think 'if only' and pick holes in what we did to prepare, but we made the best plan we could, based on the information we had at the time. Michael J. Ryan, Chief Executive Director of the World Health Organisation Health Emergency Programme, summed this up best when we said:

'Perfection is the enemy of good when it comes to emergency management. Speed trumps perfection. Be fast, have no regrets. The problem in society we have at the moment is that everyone is afraid of making a mistake. Everyone is afraid of the consequence of error, but the greatest error is not to move. The greatest error is to be paralysed by the fear of failure.'

When we look at the position India is currently in, for example, with the gross and horrifically overwhelming position of its health service and the huge swathes of death that are reported daily, had we underestimated COVID then we could easily have been in that position too.

This doesn't mean that numbers of COVID will disappear to zero, as clearly there is a large proportion of the population who still haven't been vaccinated.

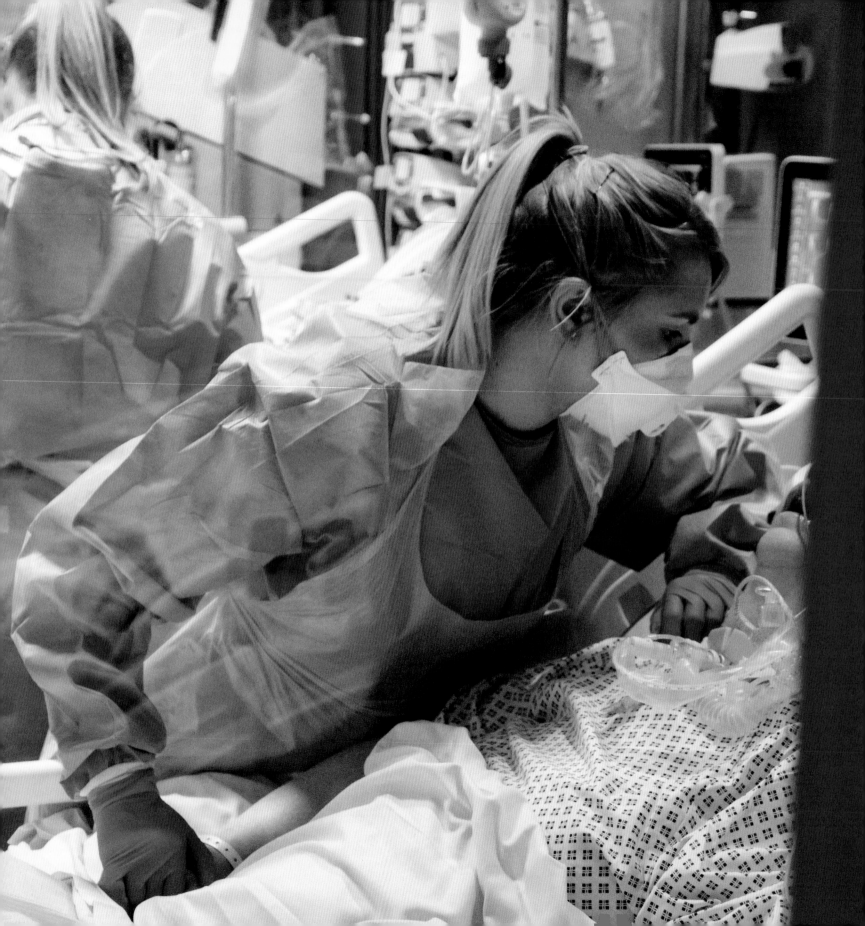

Had we not acted to bolster our health service to be ready then we could've ended up with hundreds of thousands more deaths due to lack of healthcare capacity. The UK has suffered over 150,000 deaths related to COVID, but these were not due to running out of oxygen or no hospital beds being available as we are currently seeing in India. It's very easy in hindsight to pick holes in what the NHS did or didn't do, but the retrospectoscope is a cruel instrument that healthcare professionals always beat themselves up with; we always think 'what if'. The decisions that governments made around border controls, lockdown timings and lockdown rules will be debated for years to come, but please know that the NHS and its hundreds of thousands of dedicated workers did the best that it could with the information and resource that it had at the time.

Regardless of whether COVID comes back for a third wave, which it is sadly likely to, we now have a very long tail of healthcare challenges to meet with insufficient staff to meet them. We were already understaffed prior to COVID and it will likely take us many years to catch up on all of the operations that were cancelled and clinic appointments that were delayed, and we are asking staff who've worked tirelessly through the toughest period in their professional career to put to one side their fatigue and get the NHS back up to full speed again. There's another nastier sting in the tail, too, as a proportion of staff just simply won't be able to face the next request to 'go again'. How many have already left the NHS, and how many will leave in the coming months as what they've seen and what they've experienced has changed them as people, broken them as healthcare professionals and made them question whether they can keep doing the job they once loved? The mental health burden of COVID is likely to be widespread and long-lasting and will affect those who were socially isolated whilst shielding at home and the chronically lonely in very different ways to those broken healthcare workers, many of whom have symptoms more akin to the post-traumatic stress disorder (PTSD) that we are more used to hearing about in soldiers who've returned from war. Many healthcare workers have witnessed and experienced so many distressing things that they are suffering significant mental health issues as a direct result, yet we are expecting them to keep on turning up to work every day, as the NHS and the people of the UK need them. We can only hope that the support and treatment is there to help them to live a fulfilling life again, even if that life might mean not working in the NHS.

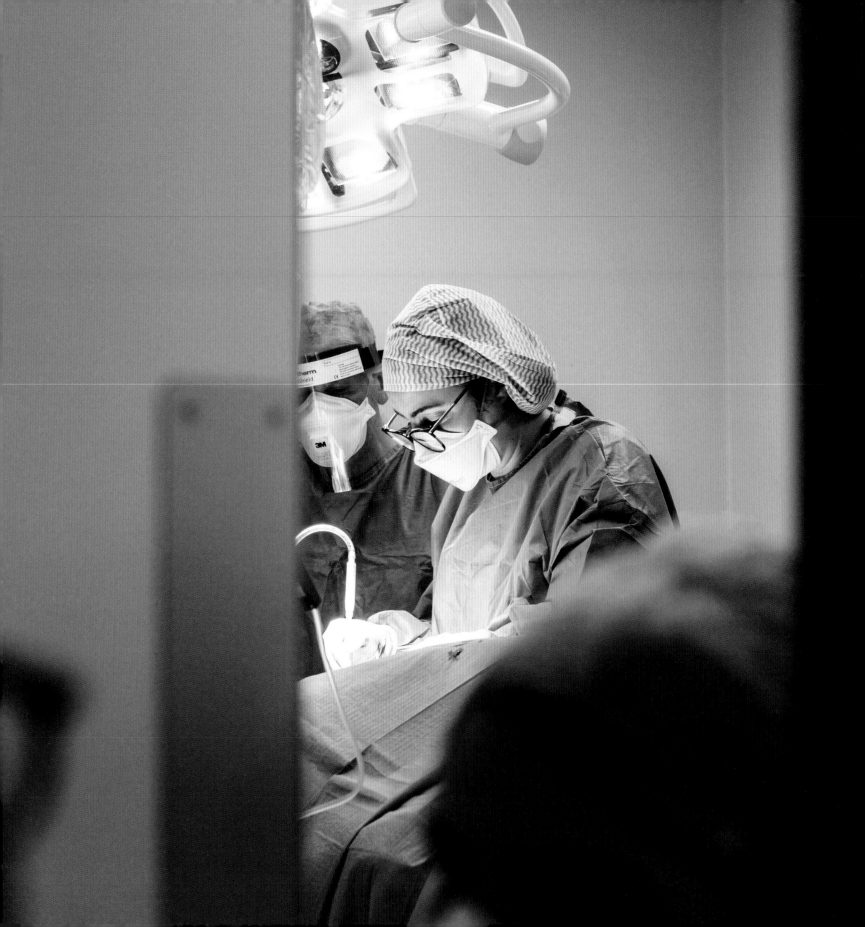

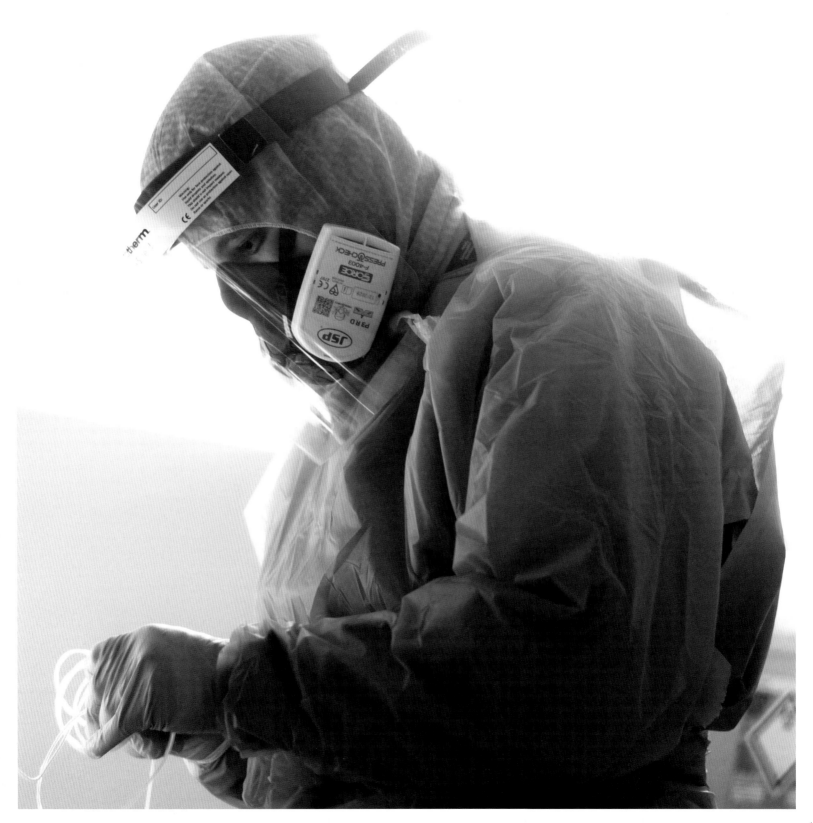

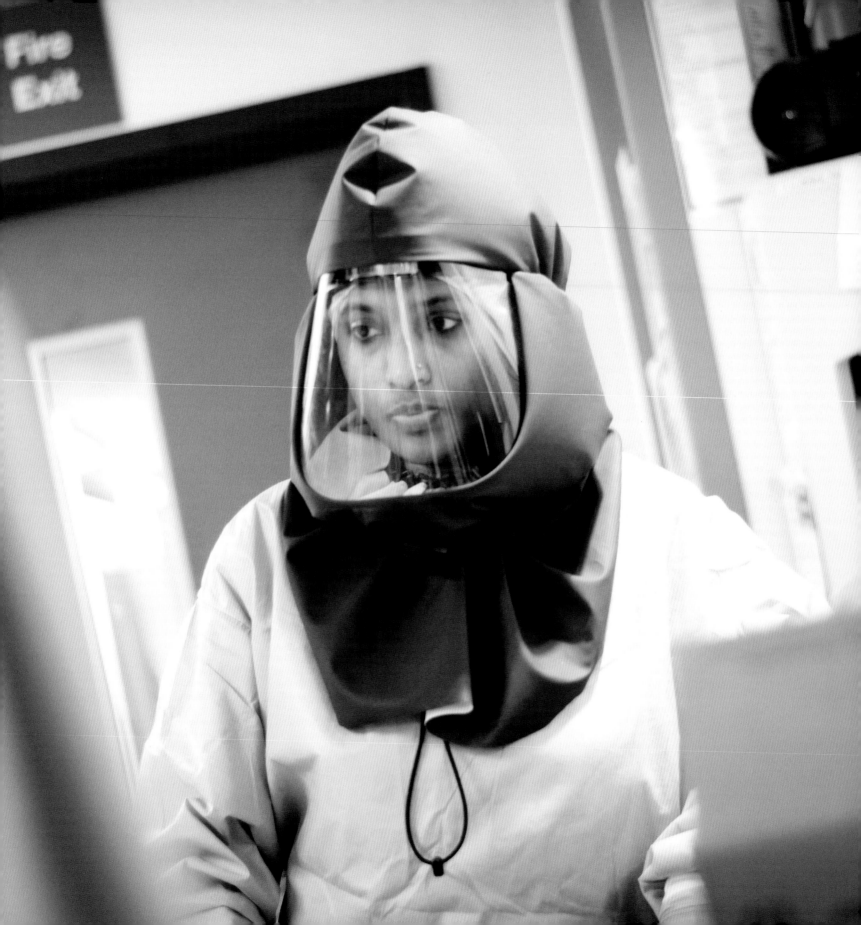

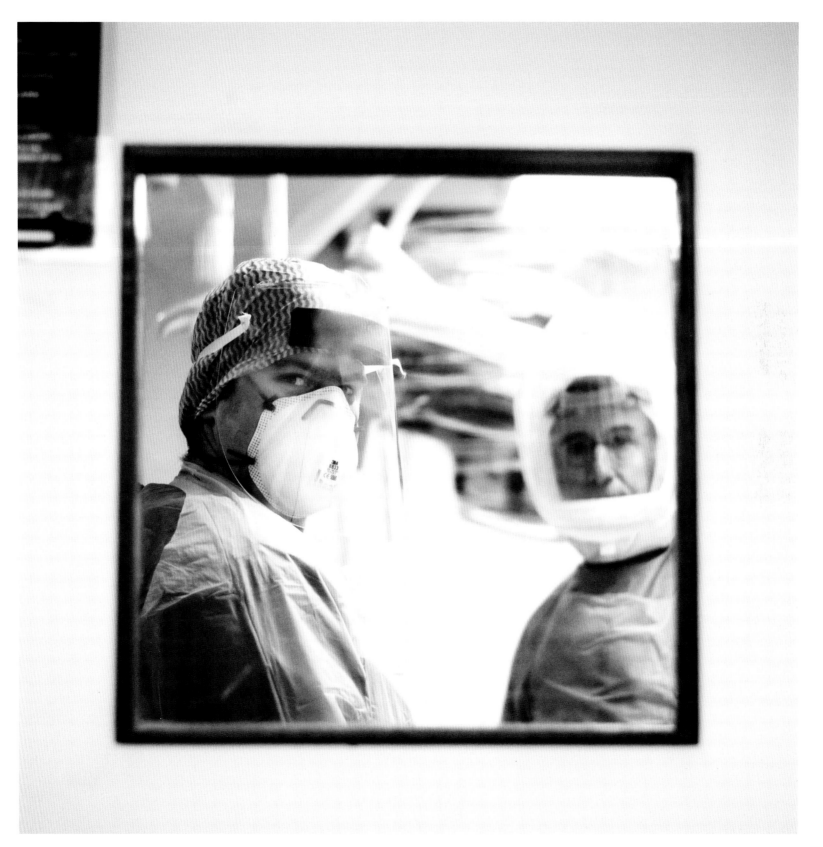

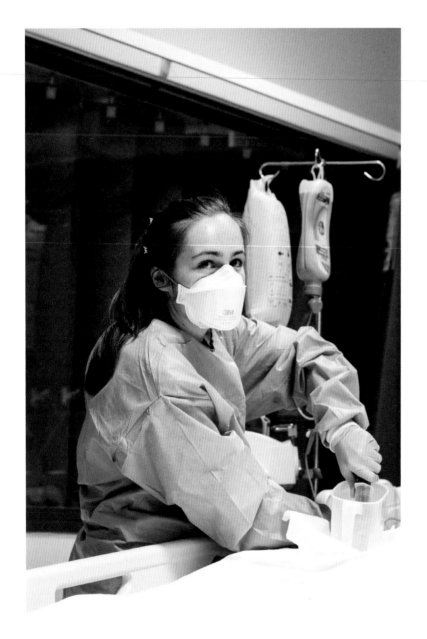

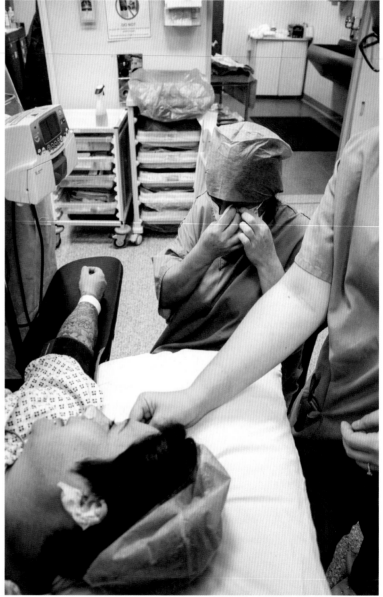

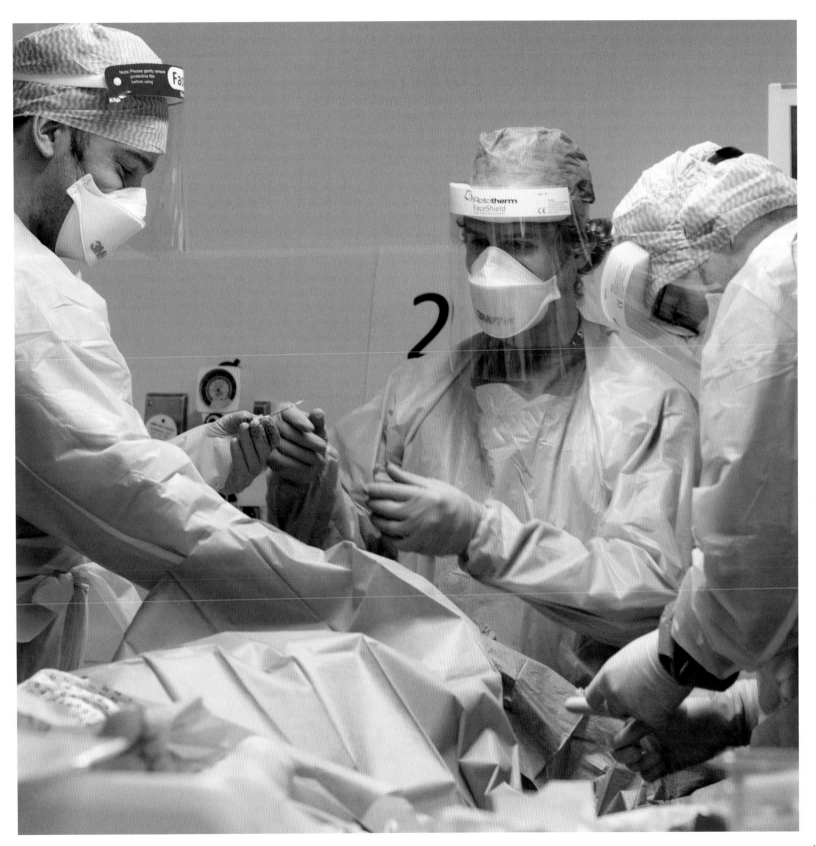

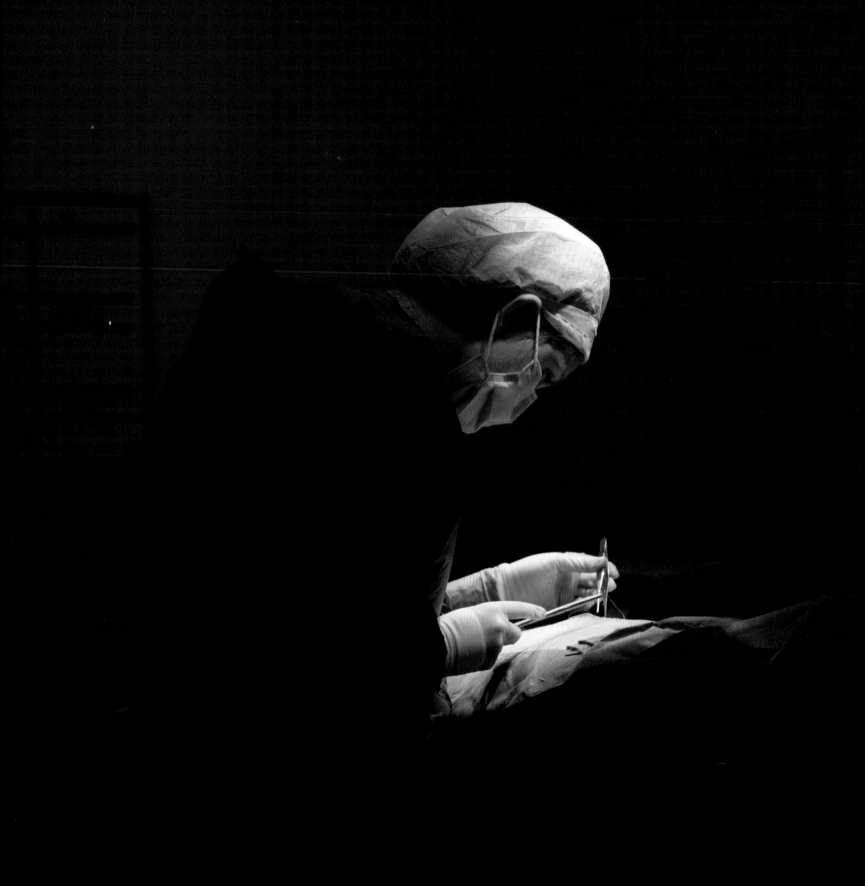

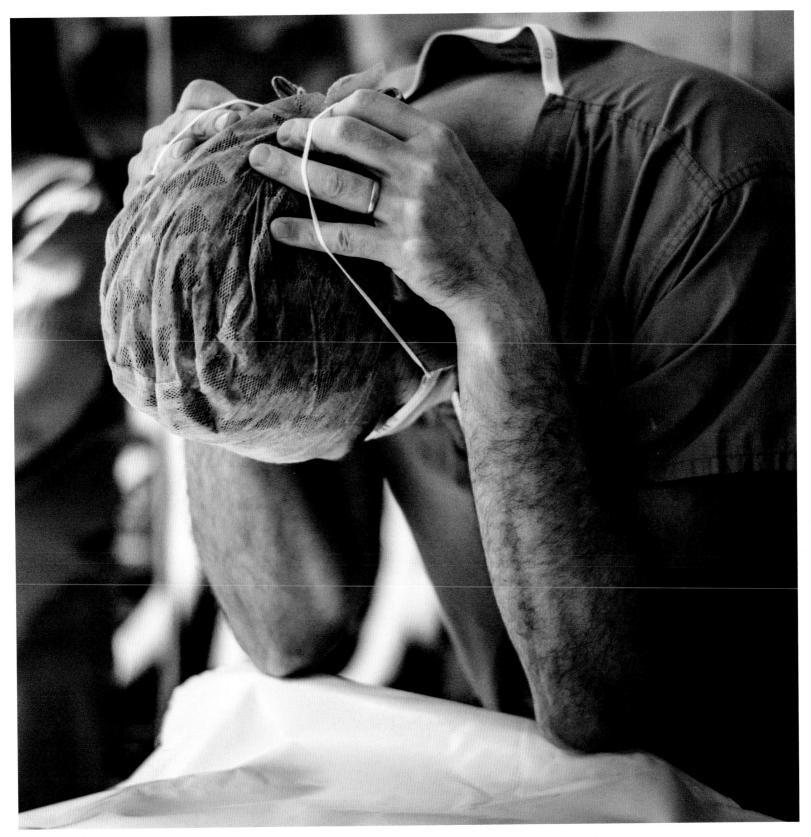

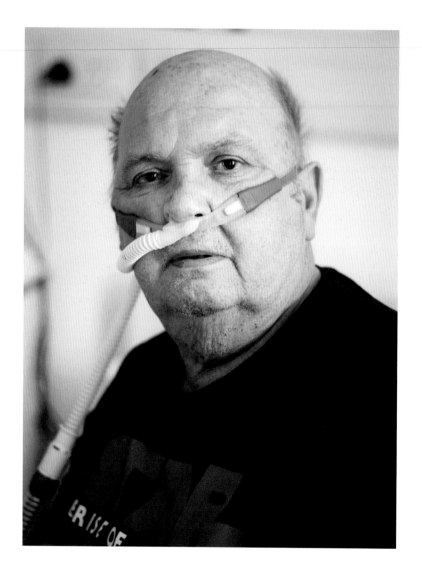

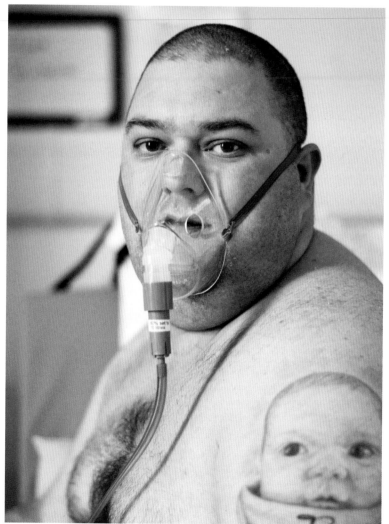

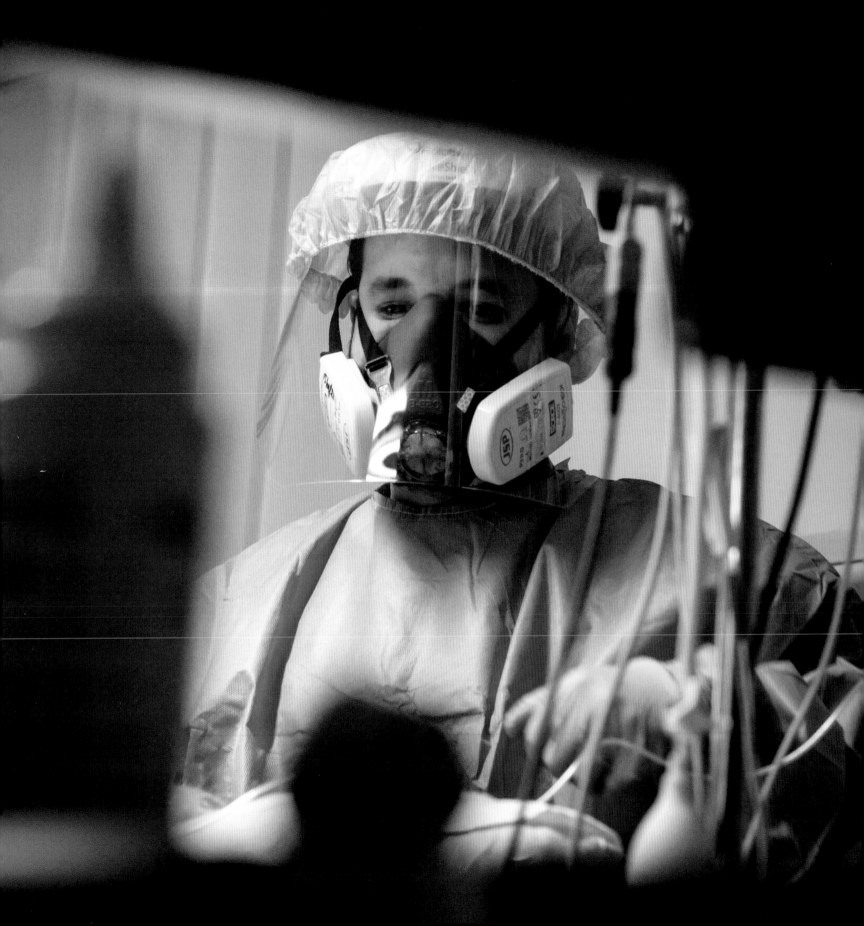

'I was only six months in to my job as an ODP before we became overwhelmed with COVID-19, and working throughout the pandemic has been a tough experience to say the least, but I am privileged to be able to play my part throughout the pandemic helping and caring for people in Theatres and ICU, and blessed to work with such an amazing team.'
James McGuire, ODP

'Every shift, I drove to work with a knot in my stomach, the anxiety of what was to come, the worry of the patients that had made it through the night. As I put on my PPE, I took deep breath before putting my mask on. It felt like I had to breathe before going into war. These patients were sick to a point I've never experienced before. The screams of families down the phone, the constant alarms of patients deteriorating rapidly and the pure look of fright of the nurses is something that will stay with me for ever.' **Tasha Meek, ITU Nurse**

'Working through the pandemic has been difficult, as you never knew what you were walking into, or what that shift might bring. I've had lots of support from the nurses in ITU in NHH. They gave me support making sure I was wearing the correct PPE before going onto the wards to clean. Cleaning in the PPE was so difficult as you got so hot and weren't able to have a drink until you left the ward. There was so much extra we had to do which we wouldn't normally do, plus I had so many questions about our new roles as domestics, ensuring ourselves, staff and patients were kept safe to the best of our knowledge at the time. Every staff member was so helpful and gave their best. Moving to the Grange Hospital was another mix to the pandemic, as no one really knew how the hospital was going to work or what to expect, but through helping each other and sharing our previous experiences from both NHH and RGH, we are starting to become a new and effective team.' **Leah Crystal John, Domestic**

'I just remember it being dark, not physically, but emotionally, no light at the end of the tunnel, dark emotions, pure sadness.'
Kyleigh Boxhall-James, ITU Nurse

'As expected, the second wave struck with a vengeance. Staff still exhausted from the first wave were called upon again to help out and support their fellow colleagues in ICU. The same staff were or are still struggling with stress and anxiety, but felt they had to go back on the front line. It was on a bigger scale this time, not having much notice to adapt to the new surroundings of a new hospital, a bigger ICU and different members of staff. Among the elderly and frail were patients younger than me and my friends, which really hit home. Everyone who asked me how things were looking in ICU was expecting me to say it was fine, but I couldn't lie, it was just as bad, if not worse than the first wave. One of the things that annoyed me is the fact we had gone from heros to zeros in the matter of months, with many members of the public annoyed because things had been locked down again and people taking to social media to vent their frustrations. Unfortunately, myself and other members of staff had the misfortune of reading such comments, which took its toll on us.'
Andrew Edwards, Theatre Assistant and Student Nurse

'Driving to work for a shift at Nevill Hall during COVID, my stomach would be doing somersaults with dread, hoping that I didn't catch this dreadful virus, or worse, take it home to my wife and young daughter. But then, when I got to work, that would disappear and all I wanted to do was help the people I transferred if I could. I knew as long as I wore the correct PPE myself, my family and the patient I was transferring would be ok. It was a scary time at work but one I'm proud of myself for working through and helping in any way I could.'
Mike Gwillym-Pitt, Porter

'I find myself taking a deep breath walking into work. What lies ahead today?

How long will this last this time?

Not sure I can do this again.

It's ok. We've got this!

Two very sick patients to look after.

Ahh, but I've got help... theatre guy, who looks terrified.

It's an extra pair of hands though.

Family FaceTime call.

Introduce self, best as I can. Hope they can hear me with respirator mask.

Hope they can see past my glasses and visor.

Son pleading for his dad to get better.

I love you, Dad, you can do this, keep fighting,

Wife crying, unable to speak,

Time to end the call,

All I can do is wave,

I can't speak,

For once, I'm glad to have a screen, mask, glasses, visor between us,

Theatre guy just stands looking,

Don't think he can believe it,

He touches my shoulder,

Don't, I'm holding it together,

Ok, we've got this.'

Karen Davey, ITU Nurse

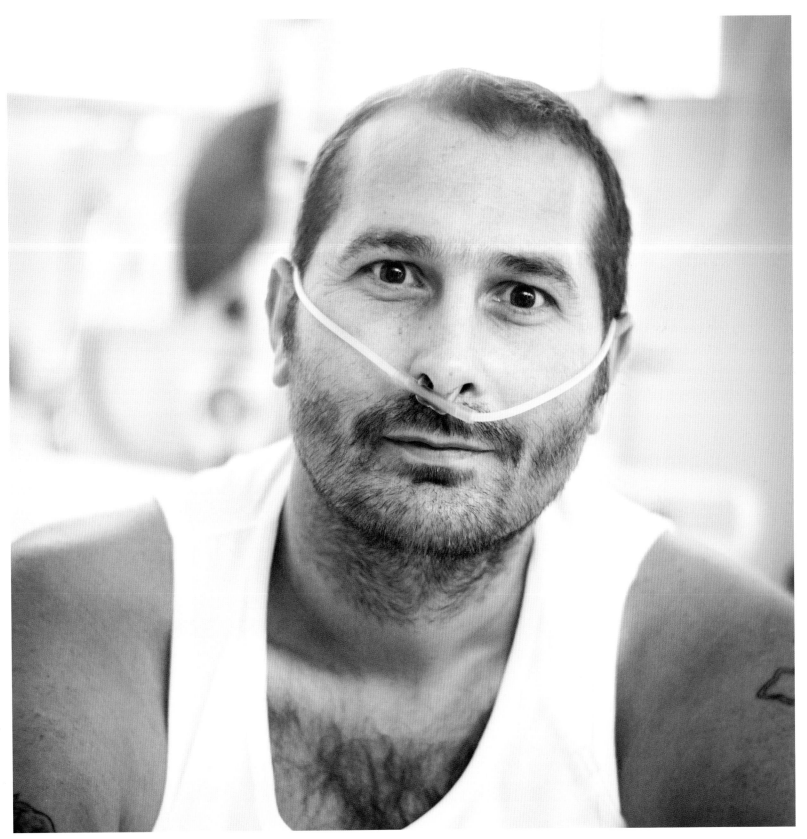

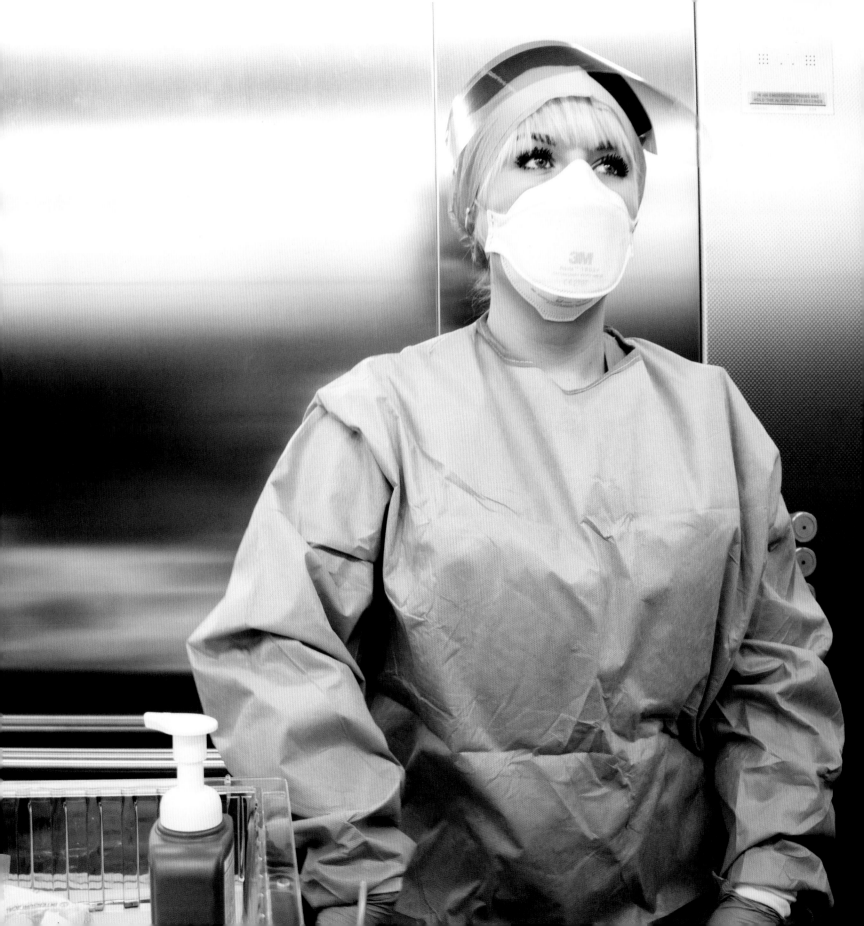

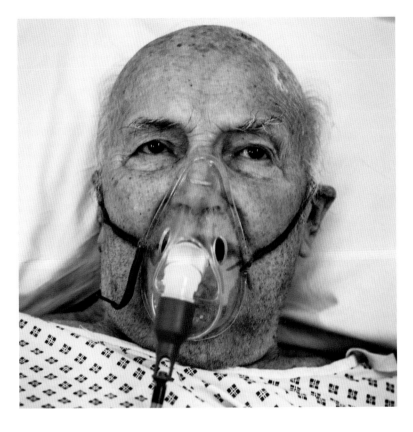
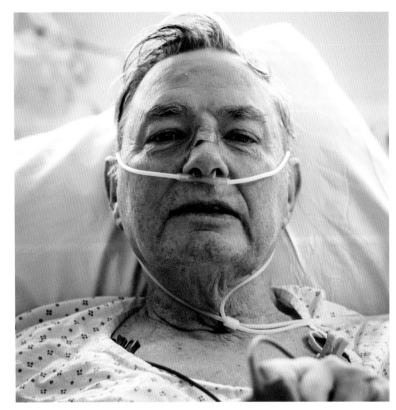
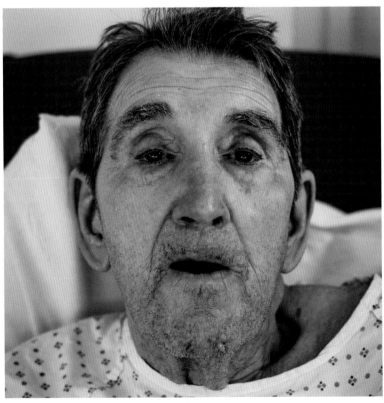
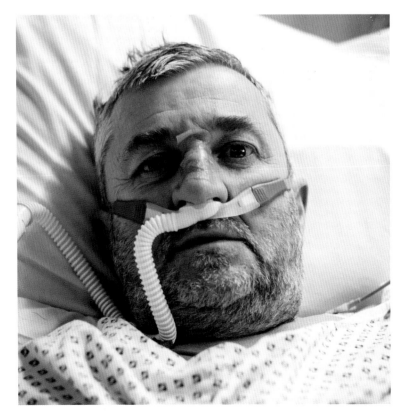

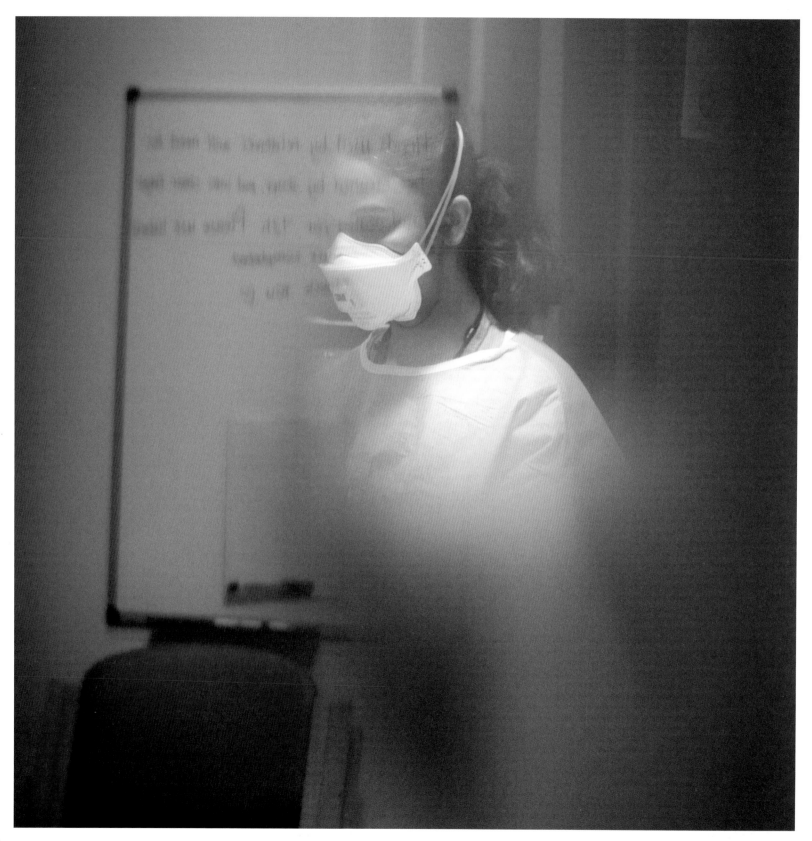

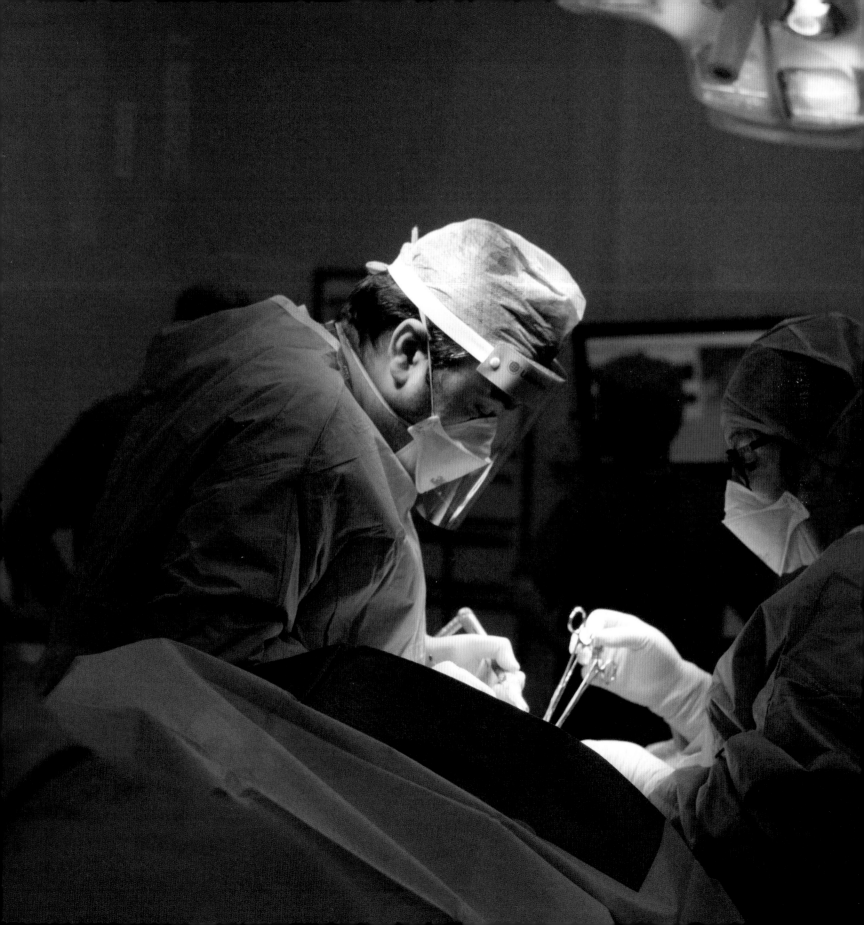

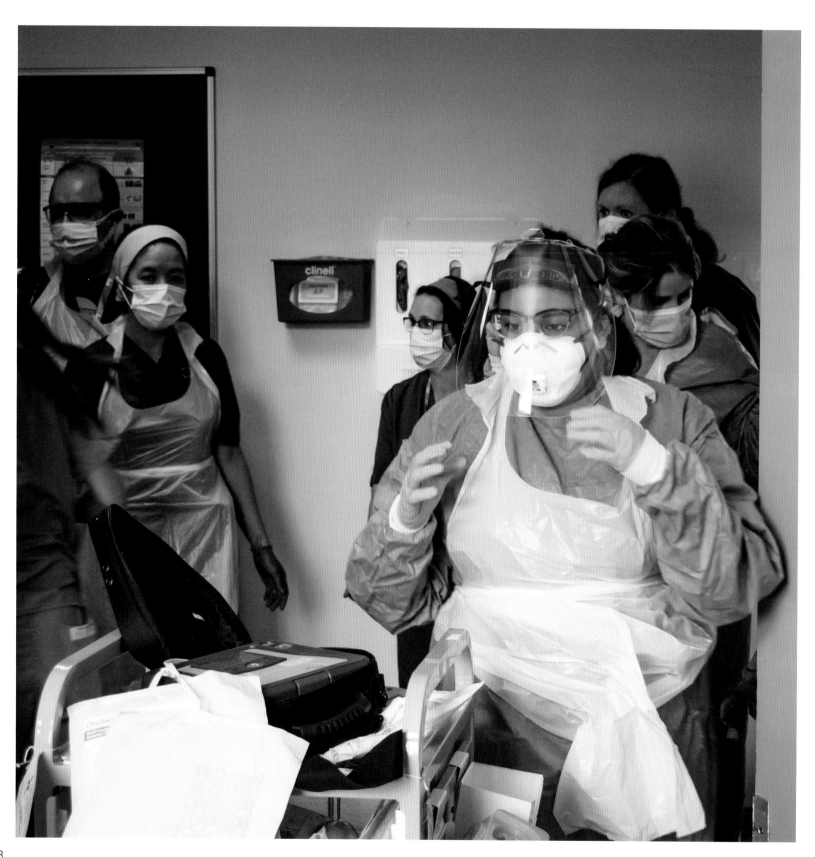

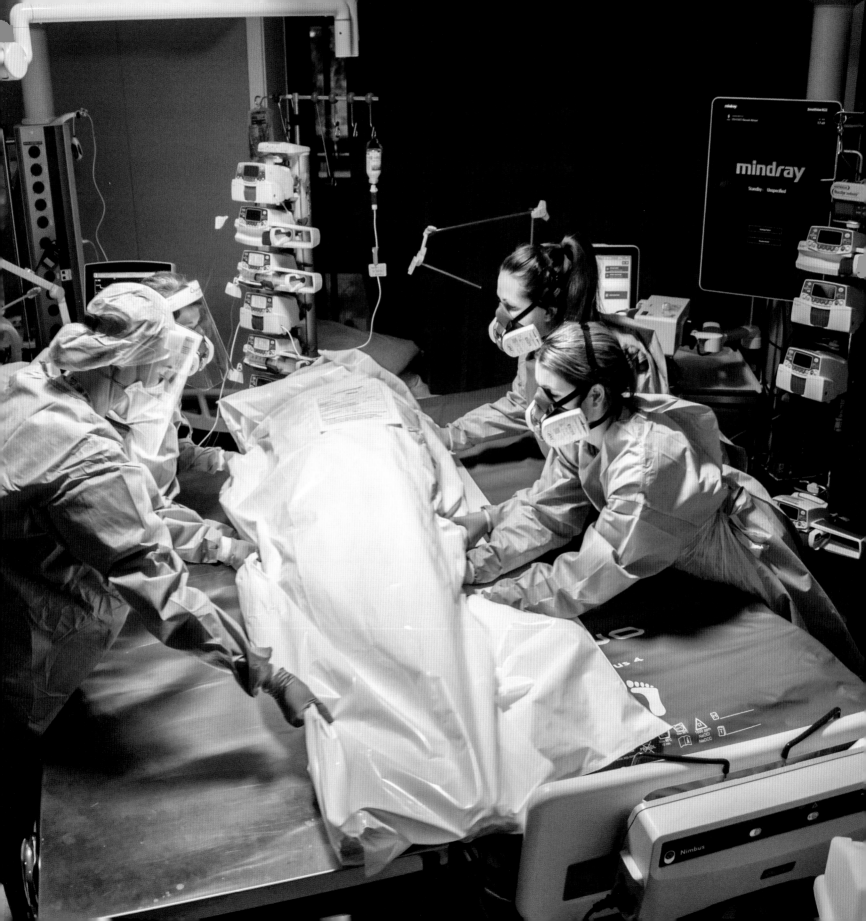

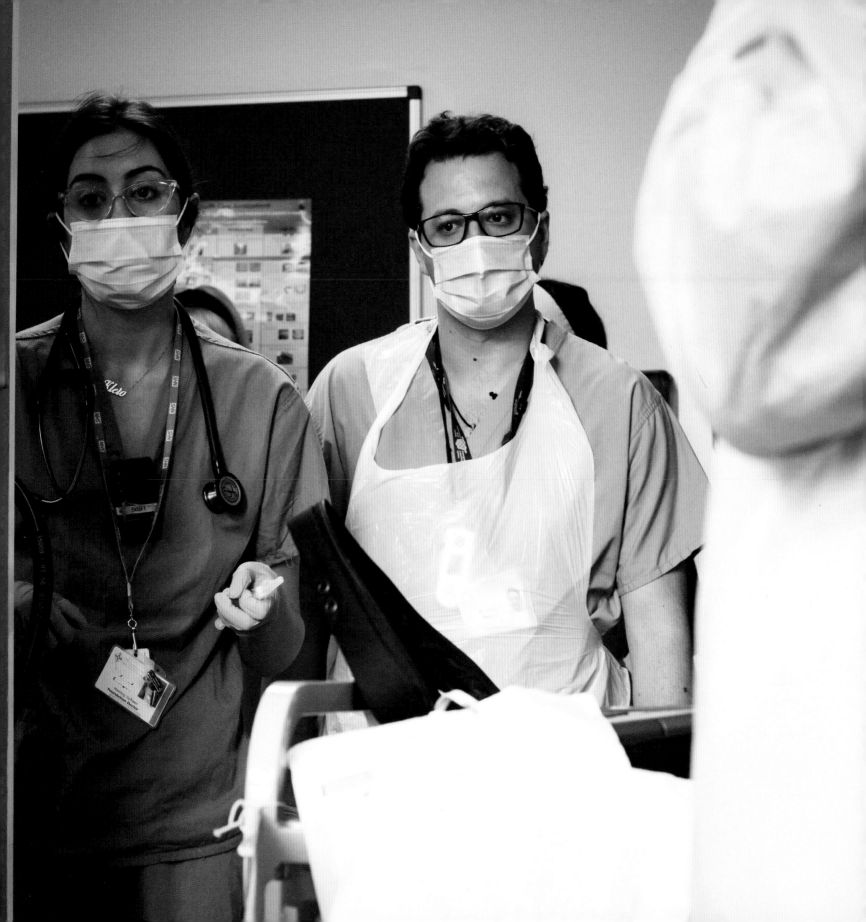

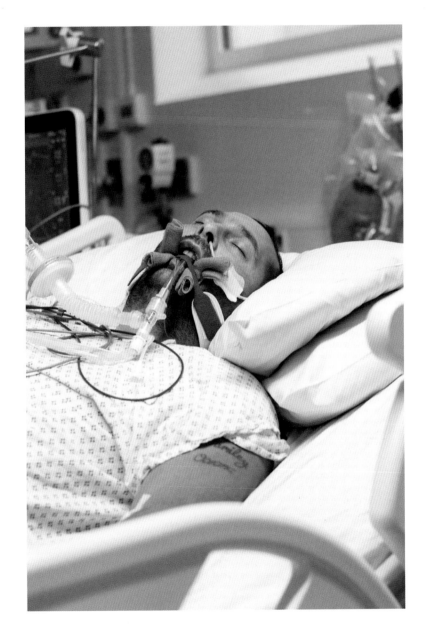

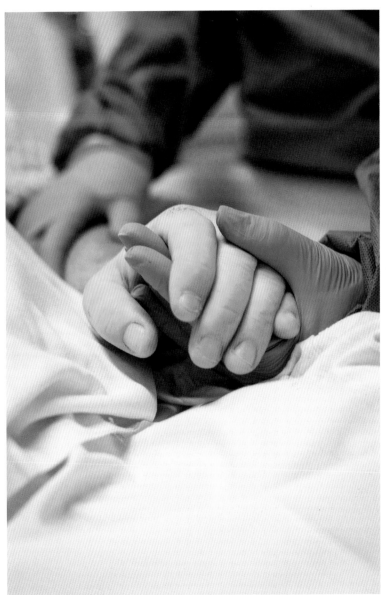

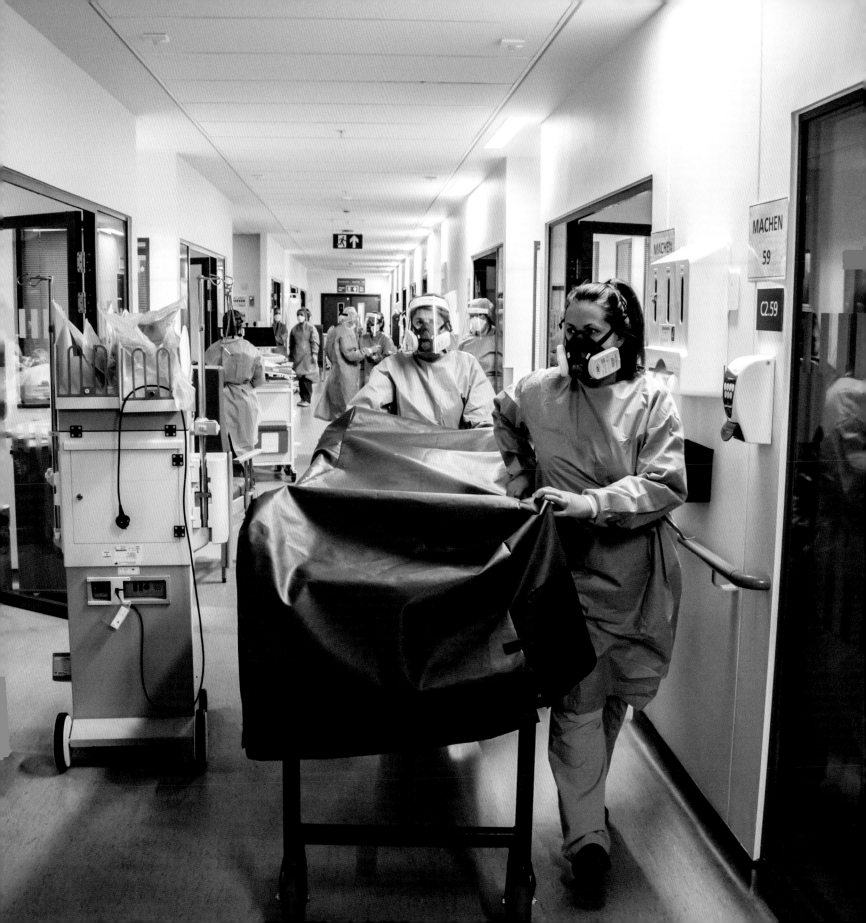

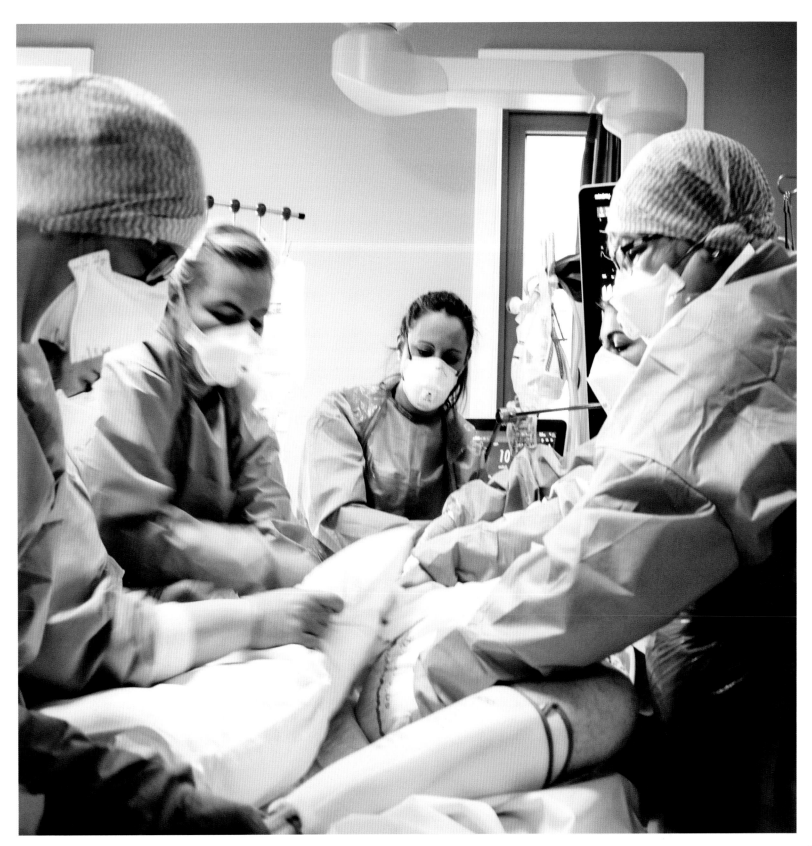

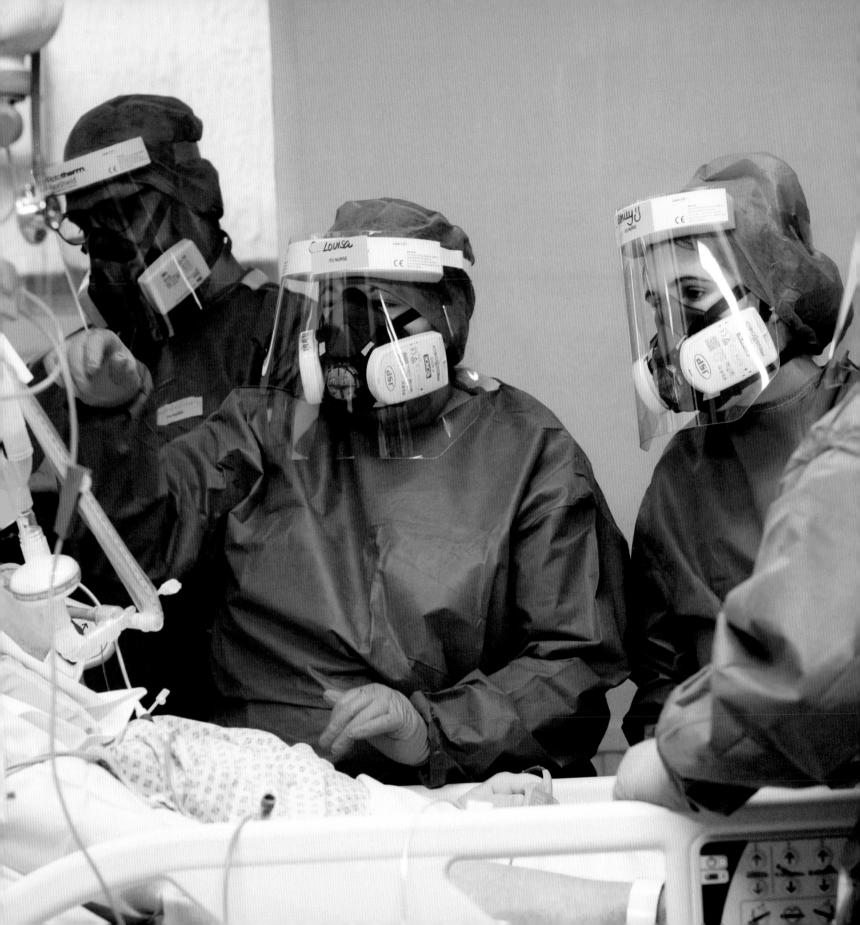

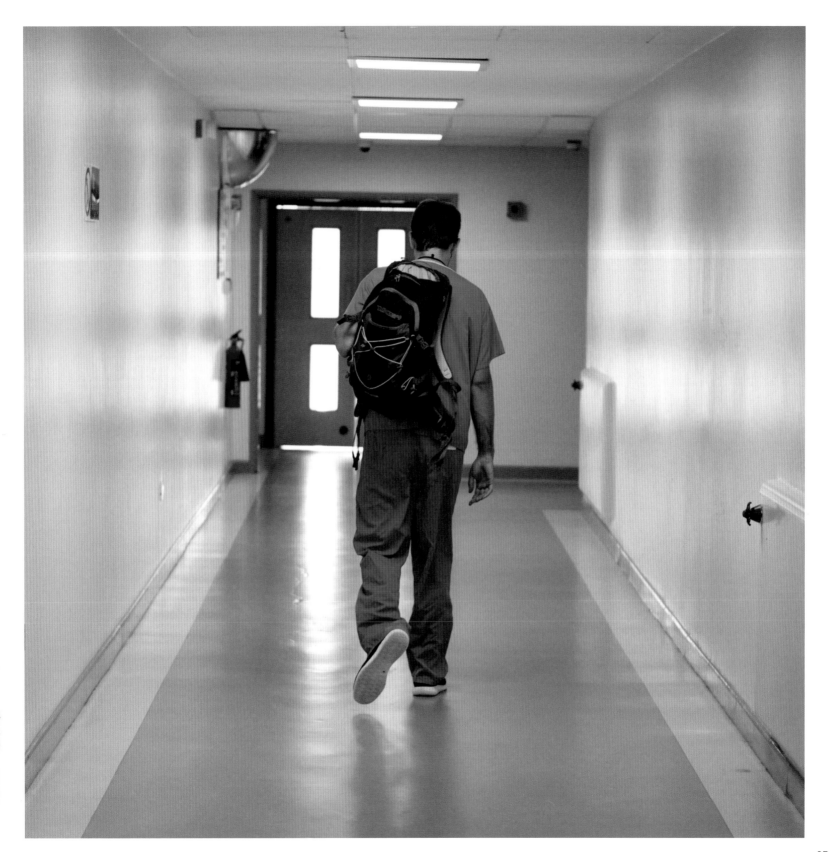

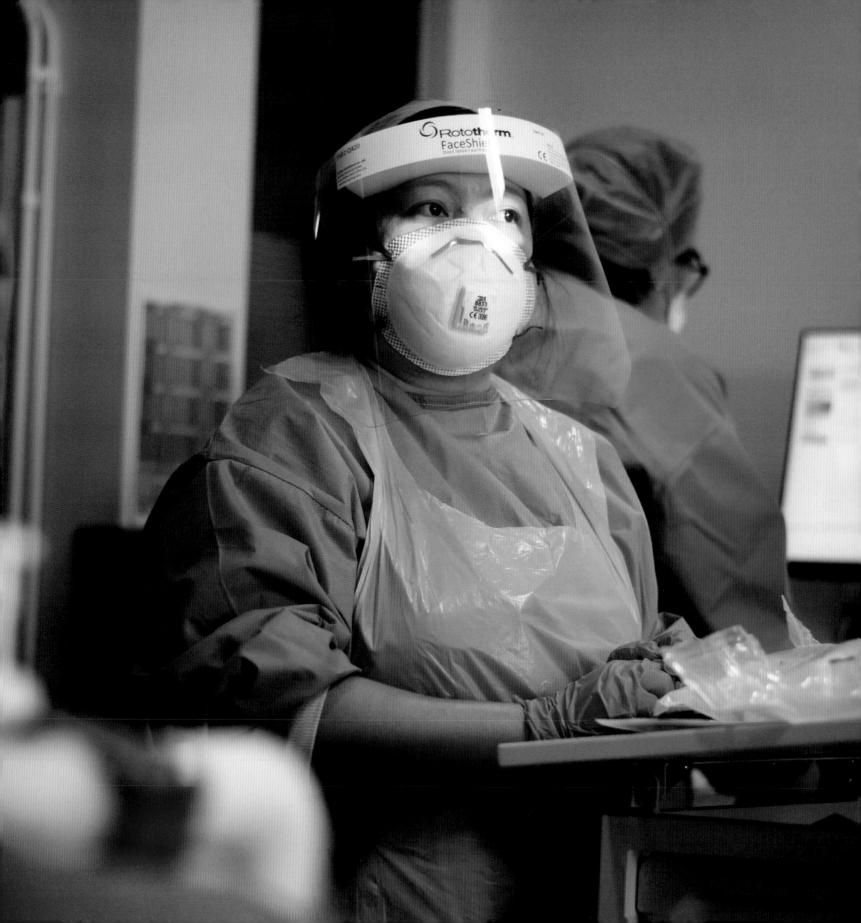

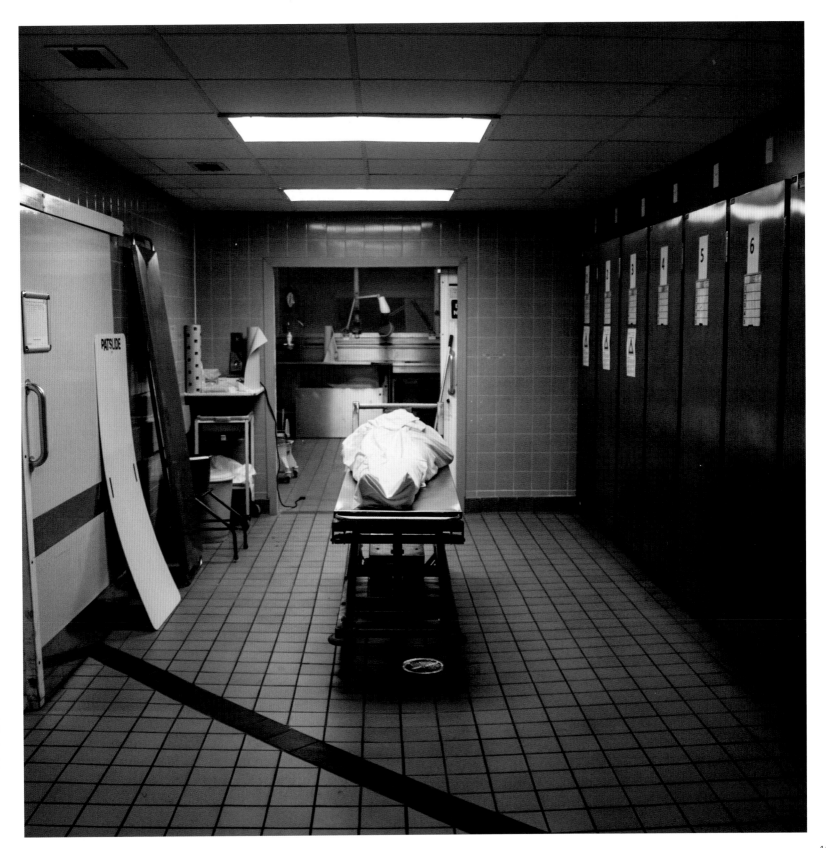

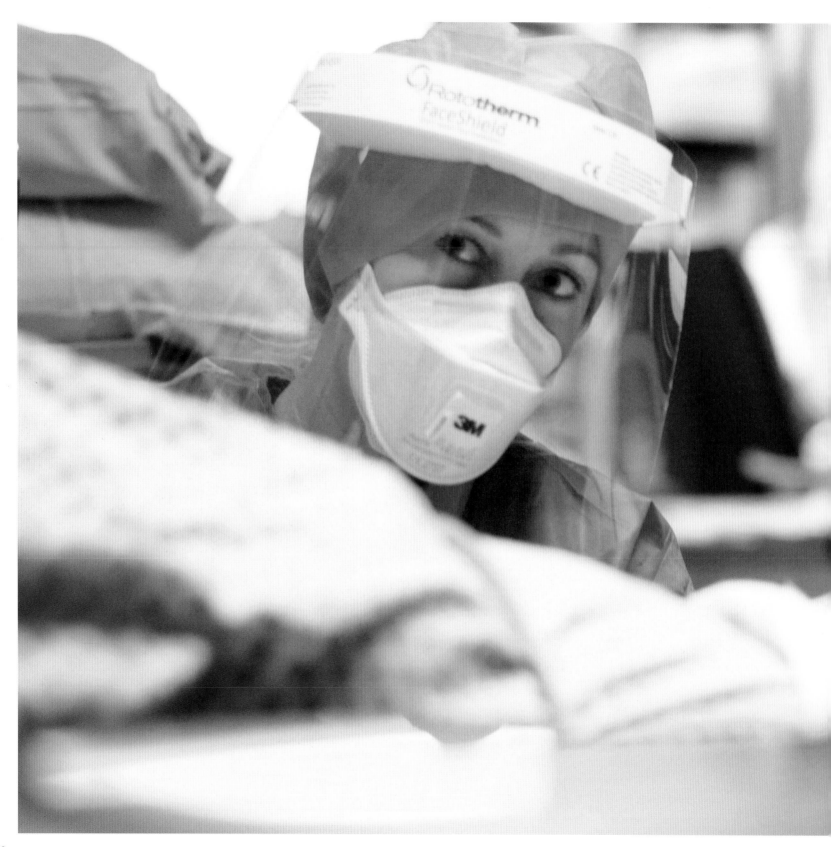

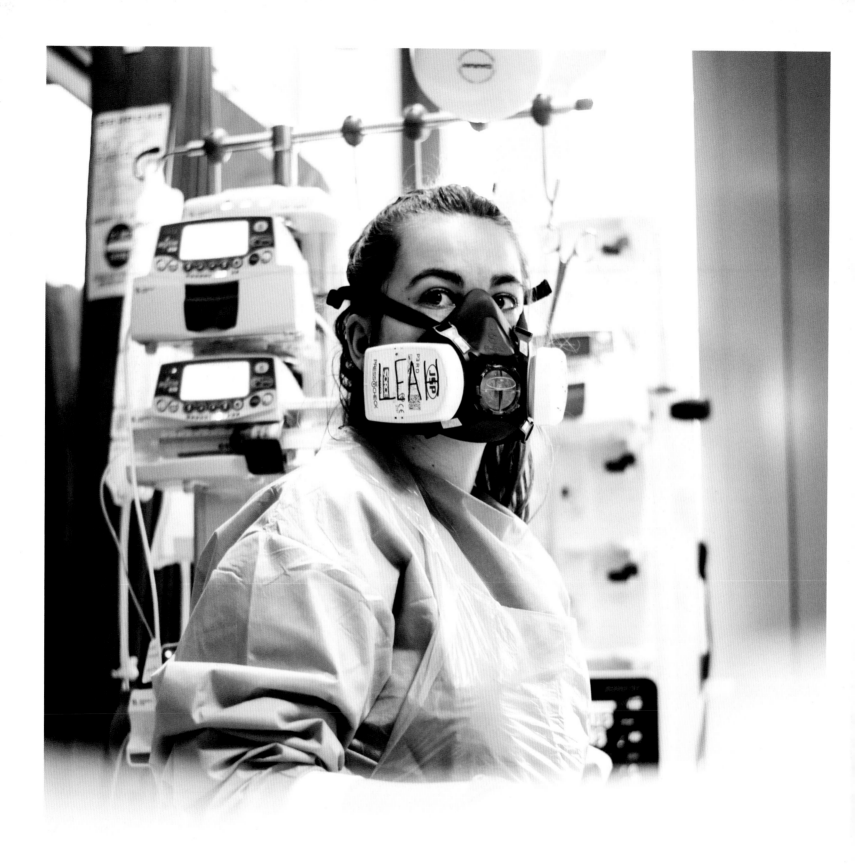

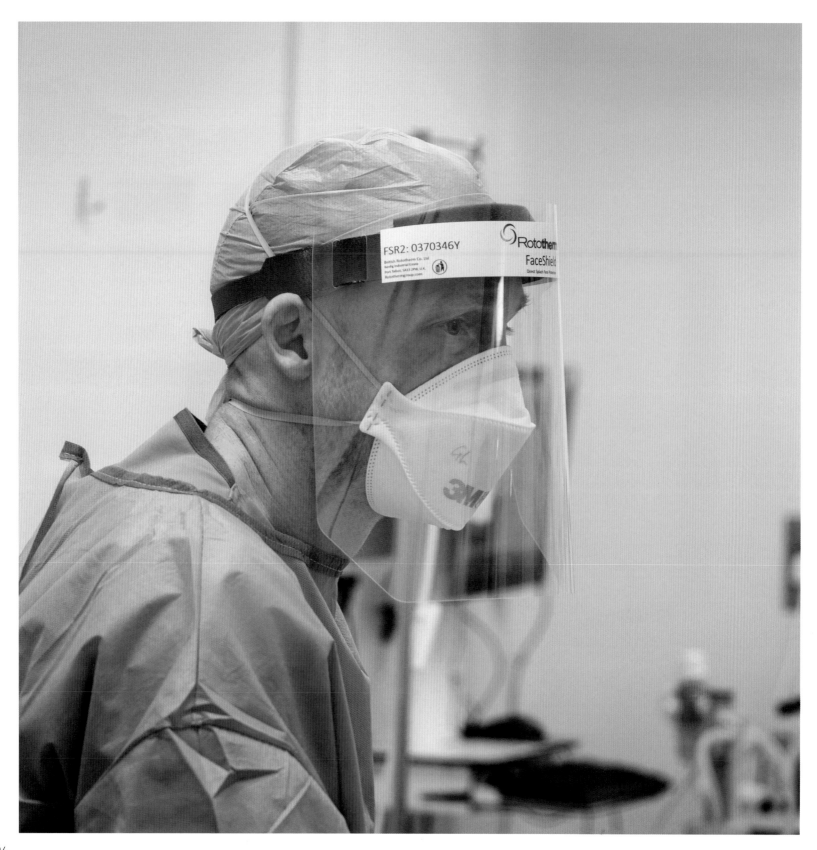

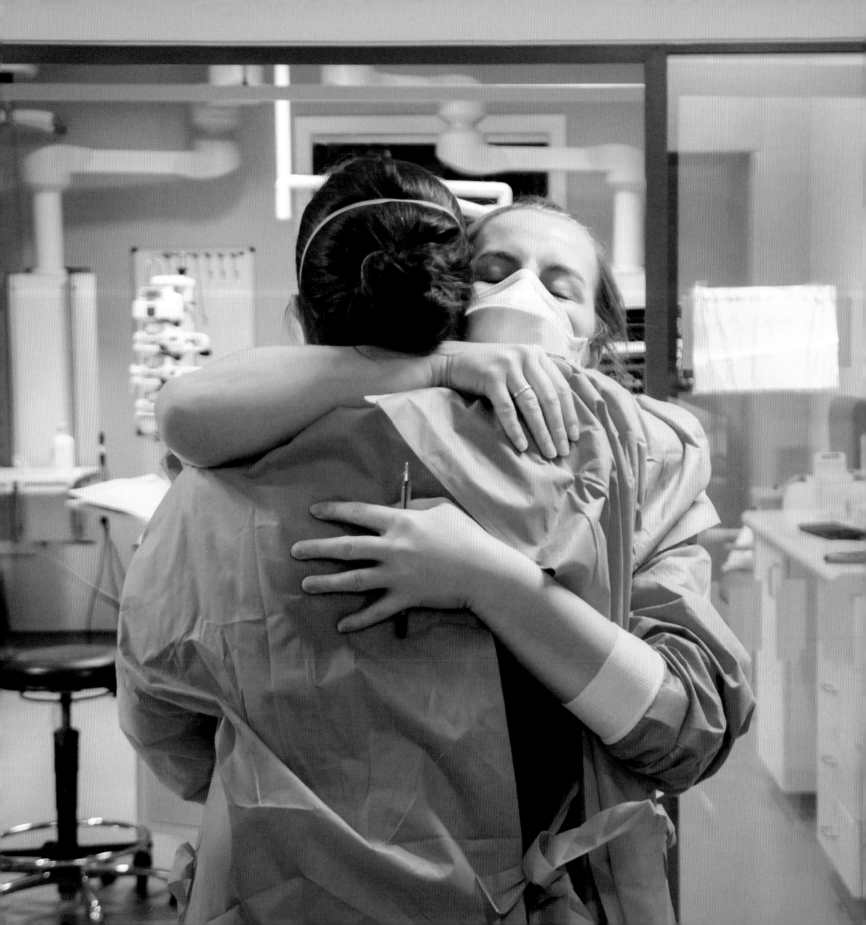

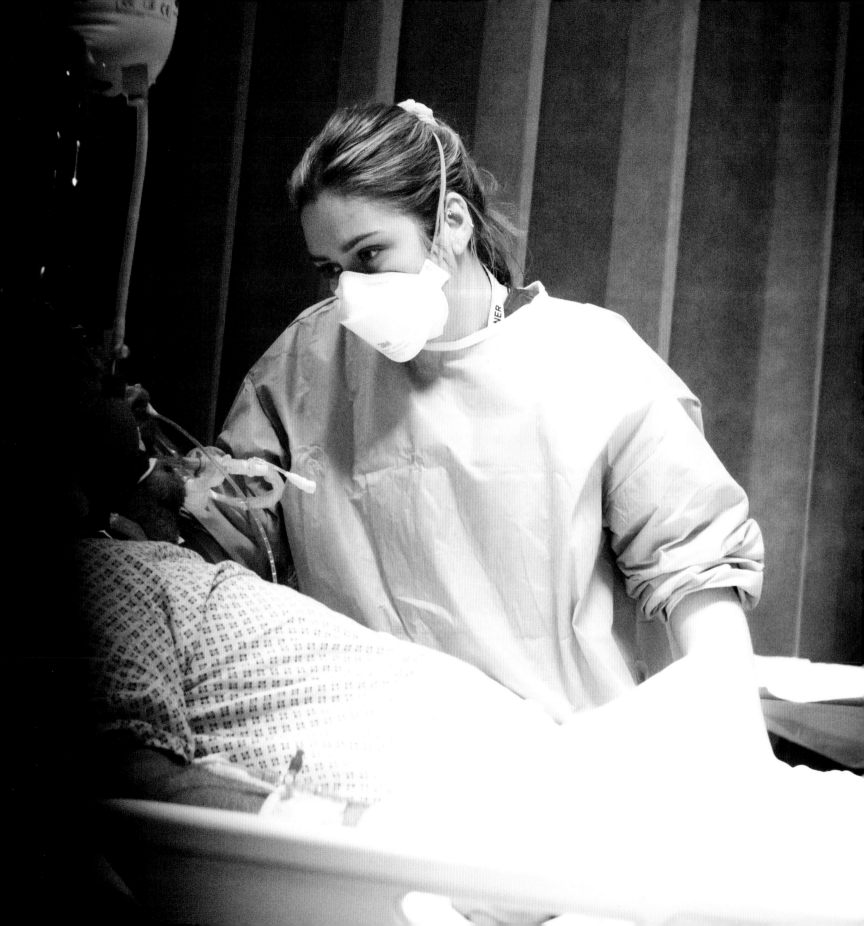

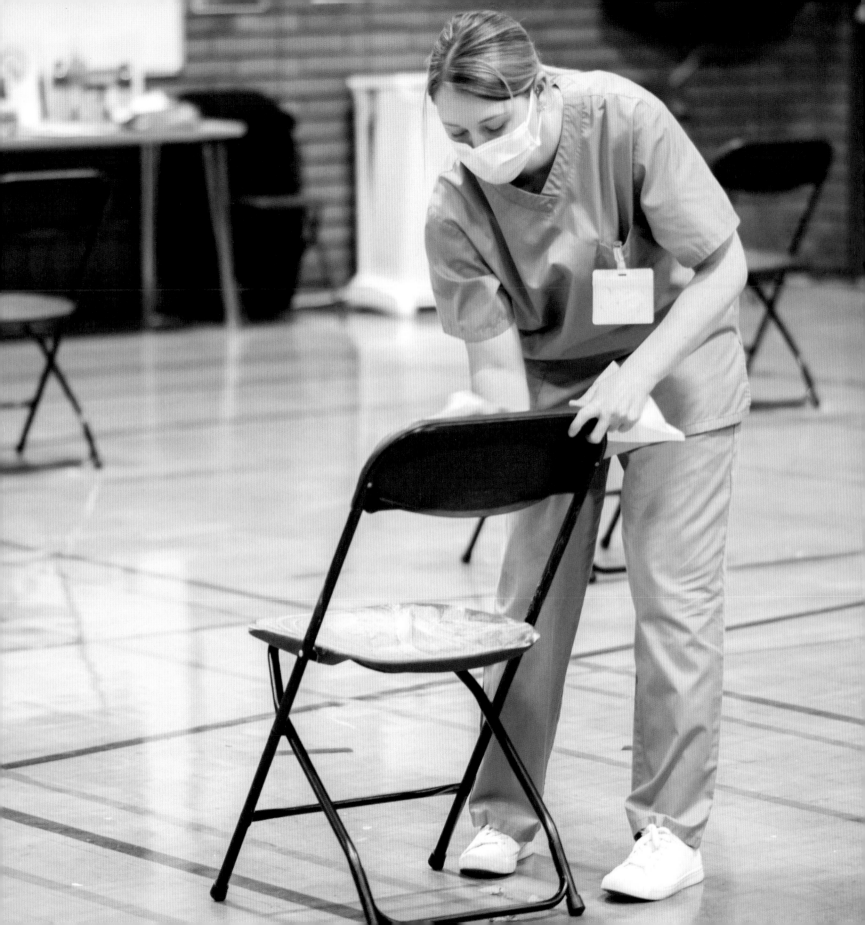

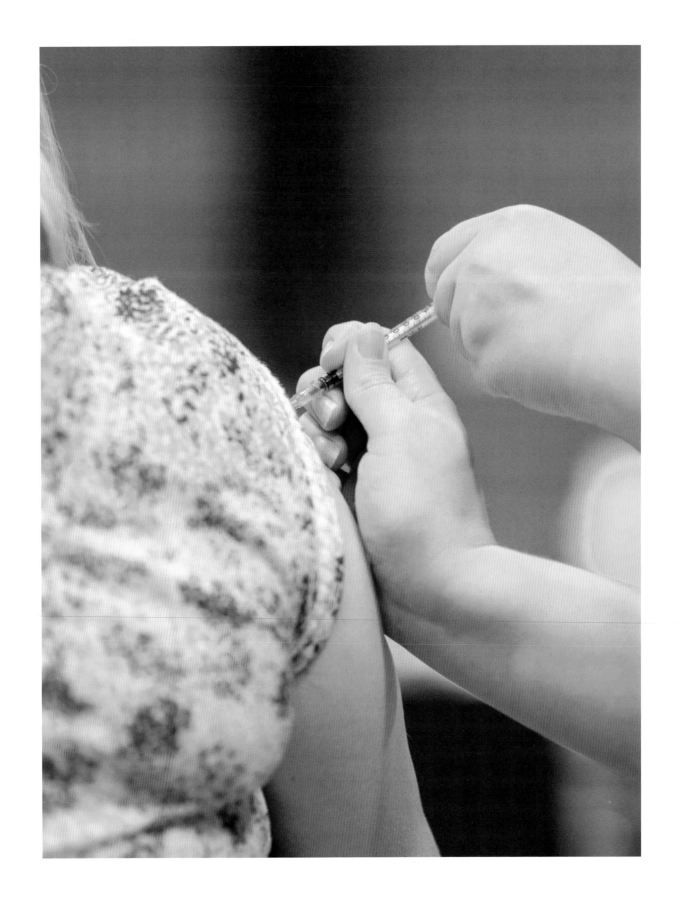

Glenn Dene

Glenn Dene is a South Wales-based Operating Department Practitioner who works for Aneurin Bevan University Health Board. He is also a photographer and writer. In 2017 his documentary photography project *Magpie,* which follows the lives of ten children with ASD, was published in fourteen countries. In 2019 he published his first novel, *Rotten Apples Comedy Club*. He lives in Abergavenny with his wife, children and labrador.

Dr Ami Jones

Dr Ami Jones MBE is a South Wales-based Consultant in Intensive Care Medicine, Pre-Hospital Emergency Medicine and Anaesthesia who works for Aneurin Bevan University Health Board and EMRTS Cymru / Wales Air Ambulance. She is also a Lieutenant Colonel in the Royal Army Medical Corps and has undertaken two tours of Afghanistan as the medical officer on the Medical Emergency Response Team. In 2017 she was awarded an MBE in the Queen's Birthday Honours for services to military and civilian pre-hospital critical care. She lives in Abergavenny with her partner, child and labrador.

The Second Wave
Published in Great Britain in 2021 by Graffeg Limited.

Photographs by Glenn Dene copyright © 2021. Written by Ami Jones copyright © 2021. Designed and produced by Graffeg Limited copyright © 2021.

Graffeg Limited, 15 Neptune Court, Vanguard Way, Cardiff, CF24 5PJ, Wales, UK. Tel: 01554 824000. www.graffeg.com.

Glenn Dene is hereby identified as the author of this work in accordance with section 77 of the Copyrights, Designs and Patents Act 1988.

A CIP Catalogue record for this book is available from the British Library.

ISBN 9781802580228
eBook 9781802580235

1 2 3 4 5 6 7 8 9

'I qualified at the start of the pandemic, the day we actually went into lockdown. What I've seen and experienced during the last year will stay with me for ever. One thing I'll never forget is the unbelievable teamwork, how everyone just came together and helped each other as much as possible. I'm so proud to be a part of such an incredible team.'

Emily Victoria, ITU Nurse

INDEPENDENT SPIRIT

TWO HUNDRED YEARS OF CATERHAM SCHOOL

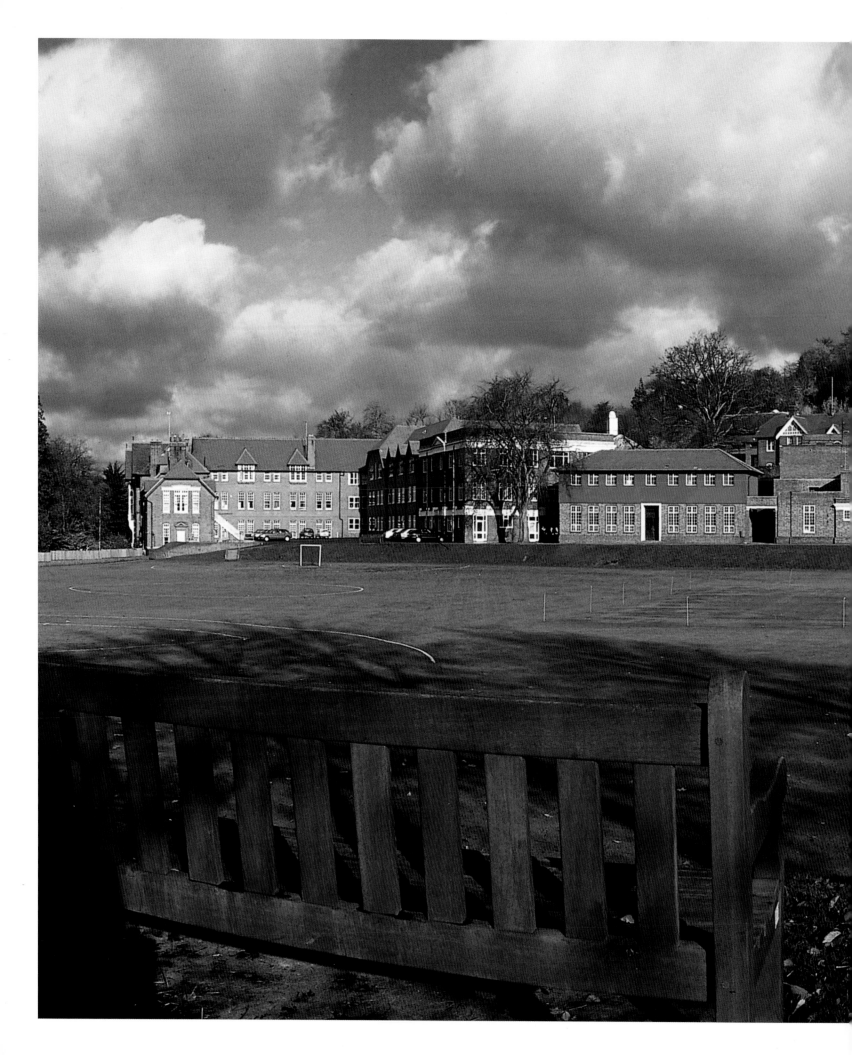

INDEPENDENT SPIRIT

TWO HUNDRED YEARS OF CATERHAM SCHOOL

NIGEL WATSON

THIRD MILLENNIUM
PUBLISHING, LONDON

INDEPENDENT SPIRIT: TWO HUNDRED YEARS OF CATERHAM SCHOOL
© Caterham School and Third Millennium Publishing Limited

First published in 2011 by Third Millennium Publishing Limited,
a subsidiary of Third Millennium Information Limited.
2–5 Benjamin Street
London
United Kingdom
EC1M 5QL
www.tmiltd.com

ISBN 978 1 906507 25 1

British Library Cataloguing in Publication Data
A CIP catalogue record for this book is available from the British Library.

Project edited by Susan Millership
Designed by Susan Pugsley
Production by Bonnie Murray
Reprographics by Studio Fasoli, Italy
Printed by Gorenjski Tisk, Slovenia

PICTURE ACKNOWLEDGEMENTS
Unless an acknowledgement appears below, the illustrations in this book
have been provided by Caterham School. Every effort had been made to
contact copyright holders but, if you have been inadvertently overlooked,
please contact Third Millennium Publishing.
P14 (top left) Lauren L. Elliott, p16 Private Collection/Bridgeman Art
Library; p17 (top right) TopFoto; p18 (left) Dr Jonathan Bowen; p19 (right)
Bridgeman Art Library; p22 Alamy; p23 (right) Alamy; p26 (top) Getty
Images, (bottom) National Maritime Museum; p28 Lewisham Local History
and Archives Centre; p28 (bottom) Alamy; p33 Mary Evans Picture Library;
p34 Mary Evans Picture Library; p40 Bridgeman Art Library; p42 (top) East
Surrey Museum, first appeared in *Bygone Caterham* by Jean Tooke, (bottom)
Caterham and District Local History Centre; p48 (left) Mary Evans Picture
Library, p50 (left) Getty Images; p56 (bottom left) East Surrey Museum,
postcard from Roger Packham Collection, (right)) Caterham and District
Local History Centre; p57 (right) Mary Evans Picture Library; p62 (right)
Caterham and District Local History Centre; p85 TopFoto; p87 (below)
Caterham and District Local History Centre; p89 (left) Mary Evans Picture
Library; p100 Peter Paces; p135, p147 (bottom right) Marie Crick.

Cover illustration: *Independent Spirit* by Adie Parker.

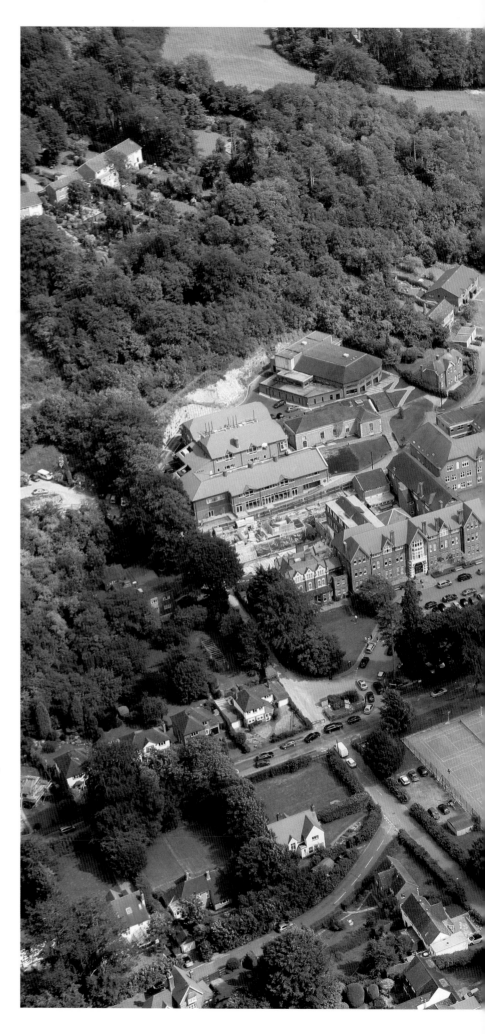

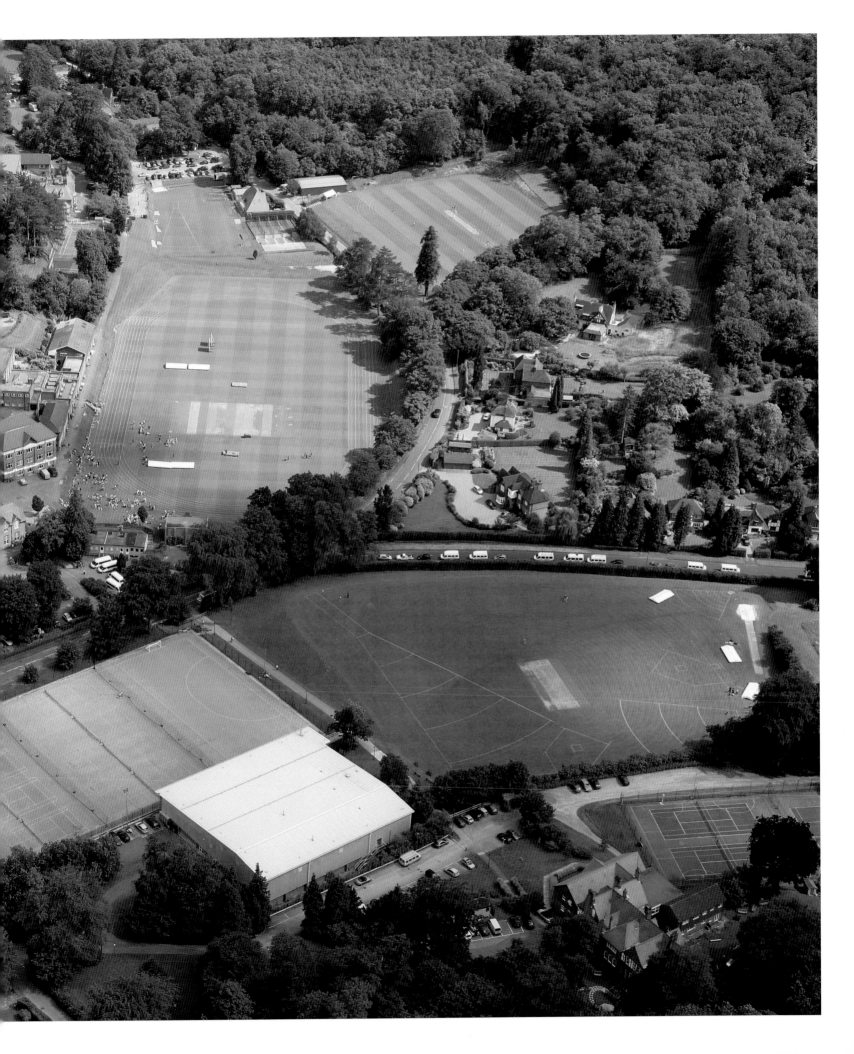

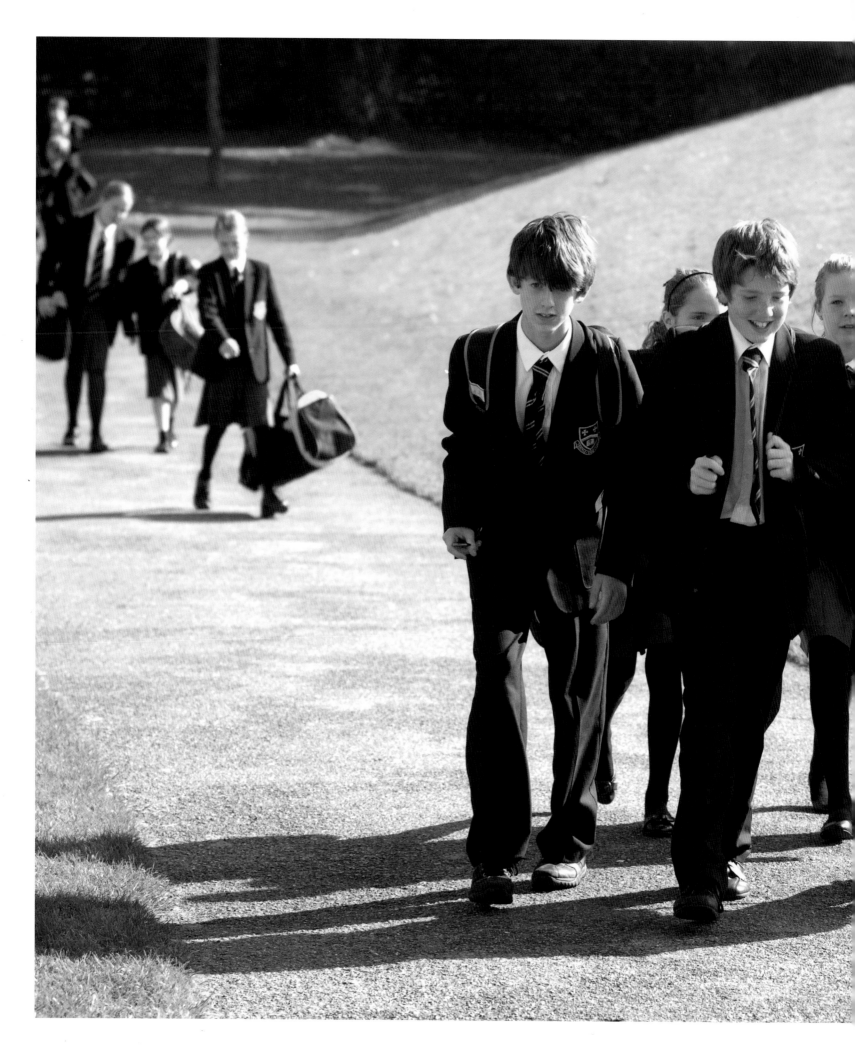

CONTENTS

AUTHOR'S ACKNOWLEDGEMENTS

Caterham is a friendly and welcoming school and I appreciated the warmth of the hospitality extended to me while I was staying there. This history could not have been completed without the generous assistance of many people. I wish to say a particular thank you to David Clark, Colin Bagnall, Brian Dunphy and Alina Rennie for all their help which made my task so much easier. I would also like to thank all those who kindly agreed to be interviewed or provided reminiscences for the book – Colin Bagnall, Anne Bailey, David Boardman, Bill Broadhead, Sally Carter-Esdale, David Charlesworth, David Clark, Rob Davey, Roger Deayton, Brian Dunphy, Roy Elliott, Michael Haines, John Jones, Sandie Kirk (Sandra Fullard), the late Mary Leathem, Don Mear, Rick Mearkle, John Mortimer, David Mossman, Martin Nunn, David Rogers, Jim Seymour, John Short, the late Stephen Smith, Julian Thomas, Denis Tindley, Hilary Trehane, Philip Tuck, Howard Tuckett, Nigel Uden and Alan Witt. Many of these people also gladly gave their time to look over the draft, as did John Grimshaw, which resulted in many improvements and for which I am very grateful.

Nigel Watson
Spring 2011

FOREWORD

Much has changed since the Reverend John Townsend founded The Congregational School for the sons of Congregational Ministers back in 1811. The first Headmaster – my namesake - Reverend J. Thomas, presided over a grand total of six pupils in a house in West Square, Newington. Today, I have the privilege of leading a school of more than 1100 students set in 80 acres of the beautiful Harestone Valley: a school with a national reputation for excellence.

Yet despite the obvious changes, some things have remained at the heart of the school throughout its first two centuries: from the very early days, the school placed great emphasis on an all round education. In 1924, Alan Mottram (Headmaster 1910–34) reflected upon his vision for Caterham: 'I conceive of an ideal school where staff and boys dwell in unity, where rules are common sense and few, where team-work and friendly rivalry hold sway, and where hard work and play fit us for the duties of life after school days are over.' Nearly a century later, this same spirit pervades the school today and is encapsulated in the phrase 'an education for life' – now a well known shorthand for our philosophy and aims.

Through this holistic approach to education, the school has created and nurtured a palpable sense of dynamism and vibrancy. It is a spirit passed from generation to generation of Caterhamians so that each group takes the lead from those that have come before. It is a very special atmosphere - unique in my experience: a spirit which I have no doubt will be fiercely protected by the generations to follow.

As I write this foreword, with the bicentenary year fast approaching, I am delighted to say that the school is stronger than it has ever been; firm foundations have been laid for the centuries to come. Nevertheless, the school has not always been able to look to the future with such confidence. In Nigel Watson's excellent account of the first two centuries, you will read of the twists and turns of the school's remarkable journey to this point. Who can fail to be moved by William Pickford's (OC) comments during parlous times in 1912: 'We will not let this old School die without a fight. And if sink it must, we will go down gloriously with the drums beating and the flag nailed to the mast. So far as we are concerned, there will be no surrender.' We owe so much to the extraordinary men and women who have adroitly marshalled and supported the school through good times and bad; their legacy to us is intertwined in the ethos and fabric of the flourishing institution we have today.

I would like to offer my sincere thanks to two people without whom this book would not have been possible. Firstly to Nigel Watson, the author, who committed himself wholeheartedly to the project and, by doing so, was able to understand and reflect the special ethos of the school in these pages. Also, to Colin Bagnall, the school's archivist, whose attention to detail, and ability to track down long-forgotten documents, photographs and artefacts, contributed so much to the vibrancy of the narrative.

This book is for all those who have ever been associated with the school in any capacity, whether pupil, staff, parent or friend: it tells the story of *your* school. I hope you enjoy reading it as much as I did.

Julian Thomas
Headmaster 2011

'THE PURSUIT OF KNOWLEDGE WITH ARDOUR'
Beginnings

Caterham School is one of a handful of schools in the United Kingdom whose roots are entwined with the history of Congregationalism in England. Those ties with what is now the United Reformed Church remain one of the school's defining characteristics. The spirit of Congregationalism, handed down over the generations, has been a strong influence in shaping the spirit of the school today. Over two centuries the school has developed from a tiny boarding school where the sons of Congregational ministers were educated free of charge to a thriving co-educational boarding and day school catering for students not only from the UK but also from many countries overseas. This is thanks to the determination and commitment of many people to overcome what at times appeared to be insuperable obstacles standing in the way of the school's development. This is the story of how their contribution paved the way for the flourishing school of today.

Congregationalism in Britain has a long history, stretching back to the Reformation. After the break from Rome under Henry VIII, there were numerous groups of worshippers who lamented the tardy pace of reform within the English church. They began meeting for worship apart from their local churches. Persecuted by the state, several were imprisoned and some were hanged. Prominent among them in the late 16th century was Robert Browne, who aspired to establish a church where the whole congregation played an integral part in its preaching, worship and discipline, under the guidance of its officers. His views, as well as those of others, helped to shape the development of Congregationalism both in England and overseas. Congregationalists, also known as Independents, were finally permitted to establish their own meeting houses as places of worship under the Toleration Act of 1689.

A

DECLARATION

OF THE

FAITH and ORDER

Owned and practised in the

Congregational Churches

IN

ENGLAND;

Agreed upon and confented unto

By their

ELDERS and MESSENGERS

IN

Their Meeting at the SAVOY,

Octob. 12. 1658.

LONDON

Printed for *D. L.* And are to be fold in *Paul's* Church-yard, *Fleet-Street*, and *Weftminfter*-Hall, 1659.]

Previous page: at work in the library under the watchful gaze of the school's founder, the Reverend John Townsend.

Left: the Savoy Declaration was signed in 1658 at the Savoy Chapel in London. It marked the first real gathering of Independent churches in the UK and gave Congregationalism a clear statement of faith and church polity.

Religious freedom did not entitle dissenters to participate freely in civil society. The phrase 'Nonconformist' arose when dissenters refused to conform to the practices of the established Church, a refusal which under legislation passed during the Restoration barred them from many public offices as well as attendance at the universities of Oxford and Cambridge. Discrimination extended to education. Nonconformists were prohibited from attending university by the requirement to conform to religious tests. Instead, they formed their own dissenting academies, providing training for the professions, including teaching. In 1826 University College, London was founded as the first university college to admit students regardless of their religion, but the doors of Oxford, Cambridge and Durham remained closed until the abolition of the tests in 1871.

While a few Nonconformist schools were set up, many dissenting families continued to send their children to the local Anglican school. For a long time many children from Nonconformist families were at an educational disadvantage, attending schools likely to be under the influence of the established Church and prevented from attending Oxford and Cambridge, the only two English universities until 1832. The problem was perhaps most acute for the children of Nonconformist ministers, who moved regularly from church to church during their careers, not just finding themselves

Left: University College, London opened in 1826. It was a haven for Nonconformists as Cambridge, Oxford and Durham only admitted Anglicans.

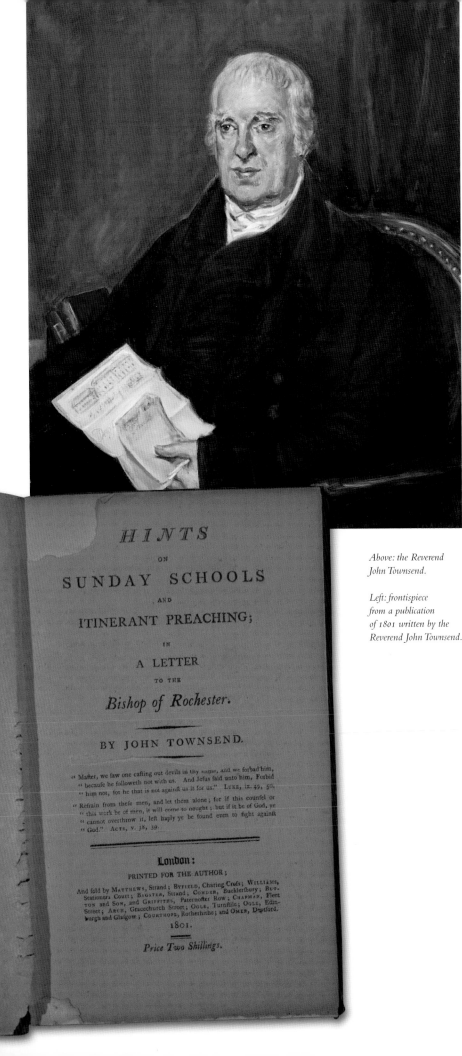

HINTS

ON

SUNDAY SCHOOLS

AND

ITINERANT PREACHING;

IN

A LETTER

TO THE

Bishop of Rochester.

BY JOHN TOWNSEND.

" Mafter, we faw one cafting out devils in thy name, and we forbad him,
" becaufe he followeth not with us. And Jefus faid unto him, Forbid
" him not, for he that is not againft us is for us." LUKE, ix. 49, 50.

" Refrain from thefe men, and let them alone; for if this counfel or
" this work be of men, it will come to nought; but if it be of God, ye
" cannot overthrow it, left haply ye be found even to fight againft
" God." ACTS, v. 38, 39.

London:

PRINTED FOR THE AUTHOR;

And fold by MATTHEWS, Strand; BYFIELD, Charing Crofs; WILLIAMS,
Stationers Court; BIGSTER, Strand; CONDER, Bucklerfbury; BUT-
TON and SON, and GRIFFITHS, Paternofter Row; CHAPMAN, Fleet
Street; ARCH, Gracechurch Street; OGLE, Turnftile; OGLE, Edin-
burgh and Glafgow; COURTHOPE, Rotherhithe; and OMER, Deptford.

1801.

Price Two Shillings.

*Above: the Reverend
John Townsend.*

*Left: frontispiece
from a publication
of 1801 written by the
Reverend John Townsend.*

distant from any school of their own denomination but also causing constant disruption to the education of their children.

This worried one Congregational minister in particular. In September 1810 the Reverend John Townsend published his *Letter to the ministers, officers and all other members and friends of the congregational churches in England*, highlighting the inadequate education received by the children of impoverished ministers. Townsend had been minister of the Congregational Church at Jamaica Row in Bermondsey since 1784. Educated for five years at Christ's Hospital, an Anglican institution, he became, like his father, a member of the church of the Calvinistic Methodist preacher, George Whitefield, Moorfields Tabernacle, off Tottenham Court Road in London. His elder brother George was already a minister and John followed the same path. He eventually took charge of the 'preaching station' at Kingston-upon-Thames in Surrey, establishing a new church by the time he was ordained in 1781. Differences with the congregation led him to resign his post but he was invited instead to become minister at Jamaica Row, where he remained for the rest of his life. He died there aged 69 on 7 February 1826.

Townsend worked actively to improve the lives of the disadvantaged. In 1792 he helped to establish in Bermondsey the first free school for poor deaf mute children in England. As the Royal School for the Deaf, under the auspices of the John Townsend Trust, this still flourishes in Margate on the Kent coast, where it moved in 1903. Townsend was an energetic and successful fundraiser, collecting £6,000 (the equivalent of nearly £400,000 today, based on changes in the retail price index) in 1807 towards new premises for the school. He helped to found *The Evangelical Magazine* in 1793, the profits of which assisted ministers' widows; the London Missionary Society in 1795; the British and Foreign Bible Society in 1804; and the London Female Penitentiary, for the rehabilitation of prostitutes, in 1807. When he died, he was raising funds to build an almshouse in Bermondsey.

The education of ministers' children was becoming a source of anxiety as the Congregational Church grew in size. Between 1811 and 1851 the number of such churches and chapels in England grew from less than a thousand to 3,244. The idea of a national union reached fruition in 1831 with the formation of the Congregational Union of England and Wales. Given the future growth of the Church, Townsend's appeal in 1810 was prescient. He asked for funds 'to embrace first the educating and boarding (and clothing if possible) of 80 or 100 children of Congregational ministers' but also to fund a retreat for a dozen or so retired ministers. But this simply did not provoke the same sympathy as the plight of deaf or

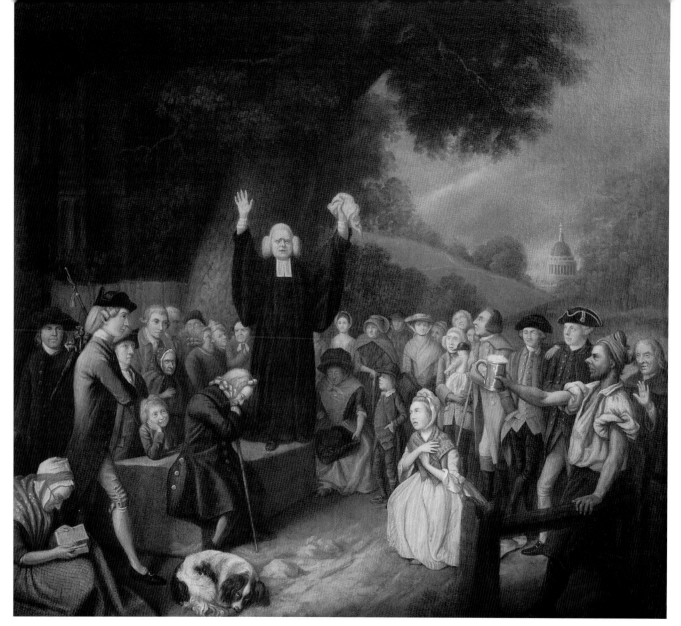

Left: Townsend became a member of George Whitefield's Methodist congregation.

Whitefield (1714–70) was famous for the evangelical style of his preaching. David Garrick, the notable actor commented: 'I would give a hundred guineas, if I could say "Oh" like Mr. Whitefield.'

mute children, raising just £200 (about £11,000 today). The financial anxieties this created for the nascent institution would constantly plague its future development.

Townsend and his supporters abandoned any idea of creating a ministers' retreat but pressed ahead with the school. A committee was established under the chairmanship of Mr. Burnhill which met for the first time on 22 April 1811 at the King's Head tavern in Poultry in the City of London. By 24 May guidelines had been finalised.

It was agreed that the Committee of the Congregational School, as it was called, would have 24 governors, of whom six would be ministers. Governors were not exclusive to the Committee; anyone could become a governor through payment of an annual subscription of one guinea (a coin equivalent to one pound and one shilling). This entitled each governor to one vote at the bi-annual elections which decided which boys from a long list submitted by the Committee would be admitted to the school. Multiple subscriptions earned multiple votes while ten guineas or more secured a place as a life governor, with one vote for every ten guineas. Anyone giving 200 guineas was

entitled either to 20 votes or, as the minutes recorded, 'to have one child during his lifetime in the Foundation'. The system appears to have been thought up as a way of raising income in the wake of the miserable conclusion to the appeal. Since the term 'governor' really meant 'subscriber' as applied at the Congregational School, quite different to what was normally understood at most other schools, it led to some confusion in later years. The anomaly persisted until 1981 when the title was changed to 'foundation member'.

A collector was appointed to take payment from subscribers in and around London but financial concerns prompted serious consideration during 1811 of charging fees to some parents. In the event, 24 years would pass before fee-paying boys were admitted.

No minister might have more than two boys at the school at the same time. In selecting boys, the Committee considered the minister's income and the size of his family. Each boy might be admitted at the age of nine and remain no longer than five years, or beyond their 15th birthday. All boys were expected to have been inoculated against smallpox, a

Right: pupils at Christ's Hospital, the school attended by the Reverend John Townsend.

disease which killed many children. Instruction was offered in reading, writing, arithmetic and English literature, with some Greek and Latin if possible.

An advertisement for the new school appeared in *The Evangelical Magazine* on 10 June 1811 and the first election of boys took place on 25 October 1811. From a list of 12, six were successful: S. A. Davies from Ipswich; S. C. Dennant from Halesworth; T. A. Hopkins from Linton; P. Hyde from Wivenhoe; J. Kerby from Lewes; and B. P. Price from Woodbridge.

Premises were found scarcely a month before the school was supposed to open. On 13 December 1811 the Committee agreed to pay 25 guineas a year for each boy to the Reverend J. Thomas, who ran the West Square Academy, off Newington Lane in Southwark. Thomas, who knew the arrangement was temporary, told the Committee on 10 January 1812 that 'if I meet with Young Students who are disposed to enter upon the pursuit of Knowledge with ardour, nothing shall be wanting on my part to aid them in attaining that excellence to which they aspire'.

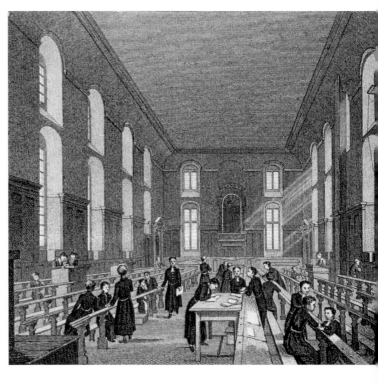

Right: a page from the Congregational School minute book signed by Townsend, 1811.

Above: the school started at 29 West Square in Southwark. The house shown here is in the same square and was the birthplace of J.A.R. Newlands, the scientist who devised the Periodic Table for the chemical elements.

The first boys entered the school on 20 January 1812. Regular inspections were made by a visiting sub-committee. After the first inspection in March, the Reverend John Townsend reported that they were 'much pleased with what they saw' and that the boys 'appear clean, healthy and cheerful'. But the lack of funds soon became a worry. In April 1813 it was reported that the Reverend John Townsend had 'made a short journey into Essex and Suffolk but after applying to a great number of Ministers and Deacons for liberty to Preach & make Collections, he pursued but two'. Such a response to requests for money would become all too typical. The Committee prudently queried all the bills they received from Thomas and instructed him to keep costs to a minimum.

At the same time the Committee was also beginning to draw up plans 'for the purchase of Premises capable of being converted into an Establishment for the purposes of the Institution'. These plans were accelerated in October 1813 when Thomas, whose school had moved to Clapham House in Clapham, gave notice he would cease educating the boys beyond Christmas. The reason appeared to be prejudice against Nonconformism from the parents of other potential pupils. He lamented to the Committee that 'I had no conception that amongst enlightened, liberal and wealthy individuals, such an impression could so strongly prevail'. In November 1814 the Committee agreed to purchase a freehold estate they had visited in Lewisham. It was a relatively new property, with 16

Yorkshire and Lancashire, preaching 26 times in 25 days, and collecting £371. The problems in raising funds, together with other obstacles, delayed the completion of the purchase until April 1815 when the property was acquired for £2,258 10s (worth £146,000 today). Among subscribers listed for 1816 was William Wilberforce, the most prominent leader of the campaign which ultimately resulted in the abolition of slavery in Britain and in most of the British colonies from 1834. As a member of the Clapham Sect, he worshipped at Holy Trinity, Clapham, and would have been aware of the Reverend John Townsend's efforts to establish the school. Liberal, philanthropic and committed to social reform, Wilberforce was sympathetic, and he donated 10 guineas, becoming a life governor, which he remained until his death in 1833.

In May 1815 the Reverend Josiah Richards was appointed as Master, and his wife as housekeeper. He furnished his own accommodation, with the Committee furnishing the rest of the property. Estimates were approved from local tradesmen, butchers, bakers, cheesemongers, grocers and brewers. The latter provided small beer, the weak ale considered healthier for boys to consume than water of dubious quality. Critically, the Committee secured credit ranging from three to six months from almost all these suppliers. At last it announced that the new term would begin on 21 June 1815. The formal opening took place on Monday 17 July, when a service of celebration was followed by tea.

Above: the Old Dining Hall at Caterham has been renamed The Wilberforce Hall after William Wilberforce (right), one of the school's early subscribers.

rooms, stabling, a hayloft, carriage house, wash-house, laundry and dairy, set in two acres of grounds, ample for 50 boys. They also advertised for a Master, stipulating a liberally educated single man who was both a Congregational minister and had experience of schools. He would be paid £100 plus board and lodging and was required to preach twice on Sundays and once during the week. After a campaign to find more subscribers to fund the acquisition, money began to trickle in from individuals but an appeal to Congregational churches proved less successful. The Reverend John Townsend made a valiant effort to help, travelling nearly 700 miles throughout

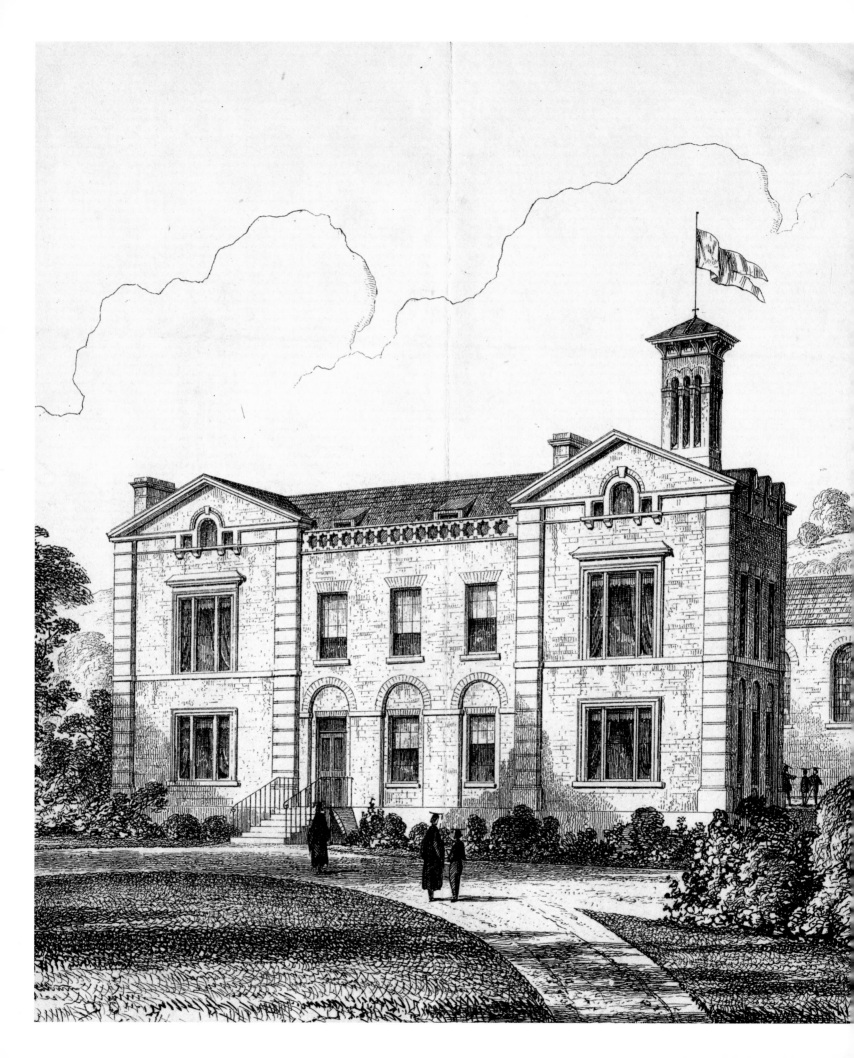

2

'SPARTAN SIMPLICITY'
1815—59

Home for many of the boys sent to the school must have seemed very remote from Lewisham in the days of travel by horse and carriage. Around this time one boy travelling to the school from the Midlands began his journey by taking a horse and trap 14 miles to Northampton, staying overnight with a friend of the family. The next morning they both took the 8am coach for London, which arrived at 5.30pm. Spending the night with another family friend, he caught the morning coach to Lewisham from Gracechurch Street, alighting at the Roebuck Inn in the main street. He finally arrived at school on foot nearly 48 hours after leaving home. It was scarcely surprising that some boys found the experience so upsetting that they wet their beds. Yet two such cases reported in January 1816 mystified the Committee and the local doctor.

The need for economy overshadowed almost everything else as the new school began, straining the relationship between the Richards and the Committee. In October 1816, convinced that they were incapable of running the school within the prescribed financial guidelines, the Committee asked the couple to leave at a time of their own choosing, either before Christmas or by March the following year. Richards chose the latter. Meanwhile, the meagre terms offered by the Committee to potential successors failed to attract any candidates. The post had to be re-advertised in February 1817, asking either for a minister or a Congregational layman 'of Evangelical Sentiments' who could deliver a curriculum 'intended to be Plain but substantial and sufficient, such as is generally given in seminaries for Boys'. At the end of the month the Reverend J. Simper from Poole was appointed as the new Master.

He arrived with his wife, child and two servants in Lewisham on 26 March 1817. Mrs. Simper had to buy new mops and brooms because the property was 'in a very filthy state'. Finances did not improve. In December 1818 the Committee persuaded Simper to take £25 a year per boy in return for assuming responsibility for all costs other than repairs and taxes. The Reverend John Townsend lamented that 'so far from the School being at last able to extend its admissions, it has not enough in hand to pay the last quarter's bills and not one single farthing in the funds. Some money borrowed to purchase the house and furniture is still unpaid. This Institution appears every day more important and useful, and yet it is in a languishing and dying state'. This state of affairs held back admissions because the Committee considered it unwise to elect more boys than necessary to replace leavers. As numbers fell to just 17, Simper insisted on the sum of £30 a boy.

In 1820, a problem arose of a different kind. Simper informed the Committee that a pupil living in Essex named Julius Mark had been reported to him as spreading stories in his neighbourhood about severe beatings, insufficiency of food and other ill-usages. Simper had gone to Essex to give reassurances, but he himself and his wife had become aware of 'a great spirit of insubordination' among the boys, in some cases caused or encouraged by parents directing their sons to write to them about the school in secret. Three boys in particular were the worst offenders – Julius Mark, George Betts and Seymour Porter. The Committee sent a deputation to the school to examine these boys and decided that Mark and Porter should be admonished in front of the school. Betts, who had been guilty of other misconduct, had been chastised by Simper and run away.

Within a few days, the Committee received a letter from Betts's father complaining of the severity of this punishment – the boy's mother 'had taken her son round to many persons to show marks' – and also the quantity and quality of the food provided by the school. The Committee conducted a thorough enquiry, holding seven meetings over eight weeks, setting up a sub-committee to investigate the allegations, demanding to see Simper's food accounts, and corresponding with all the parents. They concluded that the charges made by Betts's father and others could be summarised under three heads: insufficiency of food, cruel treatment in specific instances and general severity of discipline.

On the question of food, the Committee conceded that there might indeed be some grounds for complaint, and that Simper should be asked to provide a more substantial supper – although this would still consist simply of bread and butter and half a pint of weak beer or water.

On the cruelty charge, Simper was exonerated. His defence was that the conduct of Mark and Betts merited the corporal punishment they received. Mark (an orphan aged nine) had with an accomplice stolen money from a schoolfellow and lied about it 'most determinately' afterwards. 'I called all the boys together, and after addressing the two boys on the nature of their faults laid them on the desk and whipped them. I then spent about ten minutes in addressing the boys generally on the sinfulness of the conduct of their two schoolfellows, during which every boy in the school wept except Julius Mark and he, neither when he was whipped, or when spoken to, shed a tear.' Betts (aged 11) was reported as showing 'great obstinacy of spirit, and determined opposition to the authority of Mr. Simper, in refusing to learn the lesson pointed out, and openly avowing that he had not attended to it, by saying "I have not looked out one word from the dictionary".' Simper admitted that under this 'peculiar provocation' he had administered 'a severe chastisement'. Next day, 'the boy having been set to learn a task for irreverent behaviour at the breakfast table, whilst asking a blessing, absconded from the school, and as he travelled, it appears, between 20 and 30 miles without food, some of the effects ascribed to the chastisement may be easily accounted for.' The Committee resolved not to re-admit Mark or Betts.

Above: many boys travelled to school by horse and carriage. Their journeys were often long and arduous, involving overnight stays and changing coaches. This print shows a coach tavern in Kentish Town in the early 19th century.

Previous page: the school moved to Lewisham in 1815 and remained there until 1884 when it moved to its present site in Caterham. Lewisham in the early 19th century was still a quiet rural village.

older servant, at least three times a week; and that although boys should clean their own shoes and help in the garden, they should not be used for any other domestic and menial work whatsoever.

In May, 1821, the Committee learned that Simper was seriously in arrears with the tradesmen's bills, and contemplated giving him notice. They were persuaded to allow him another year to put matters right, but by 1823 he had gone.

His successor was the Reverend W. J. Hope. Orphaned at a young age, he had been taught by his brother at Annan Academy, where his classmates included Thomas Carlyle, the essayist and historian. Like Carlyle, Hope took a degree from Edinburgh University – there was no bar on dissenters attending Scottish universities – and then took up a teaching post at Blackburn Academy in 1818. Scholarly, conscientious, prone to anxiety, rather shy, nicknamed 'Daddy' by the boys, he remained with his family at Lewisham until 1852.

Eager to retain Hope, the Committee agreed in 1823 that he could augment his meagre salary by taking in private fee-paying pupils from lay as well as ministers' families. The mix of fee-paying boys and 'ministerials', as the sons of ministers taking up free places were called, may have helped the Committee in its efforts to dispel the impression it was simply

A third boy, named Walker, had received a mark on his face, according to Mr. Betts, which Simper explained satisfactorily to the boy's grandfather, and the boy remained in the school.

The third complaint, that Simper in general inflicted too much punishment, was not, according to the sub-committee, supported by the testimony of the other parents, and Simper was again exonerated. It was not true, the Committee stated, that boys had been removed from the school early because of severe discipline – Mark being the only exception – indeed, there were many cases of parents requesting a stay for their sons longer than their allotted time. It was true that two boys had run away 'in distress of mind' soon after arriving at the school two years before, but they had returned. The Master's examination of the boys' letters home was a practice common in other schools and therefore, although possibly questionable, not grounds for serious complaint. However, the Committee considered the practice of hitting boys on the head with the hand or a book and on the elbow with a ruler, and depriving boys of meat at mealtimes as a punishment, allowing them only vegetables and gravy, should be discontinued. They noted also that the Simpers and their assistant never took their meals with the boys. They recommended that this should change; also that the younger boys should be washed by, and the older ones wash under the inspection of, the Master's wife or an

running a charity school rather than one whose pupils should be of a reasonable academic ability on entrance. The Annual Report for 1828 noted that

> *the School was never intended to be a mere Charity school, in which poverty and destitution might find a temporary shelter, but rather a benevolent provision for furnishing the benefits of a most respectable, but not wealthy part of the community, whose rank and station in society, and whose services in the Church of Christ, entitle them to such consideration.*

Yet there was genuine poverty among some of the boys. Some parents were unable to clothe their children properly and Hope himself had to supply shoes to at least one boy. Many parents found it difficult to settle the bills they received for incidental expenses or to provide pocket money, which Hope often found from his own pocket.

The Annual Report for 1828 also summed up the purpose of the Congregational School, stating that it 'affords for a period of four or five years gratuitous board and all the advantages of a respectable English and Grammar School'. These were exactly the institutions from which the sons of Congregational ministers were often excluded. In terms of curriculum, size and penury, the Congregational School was reminiscent of a number of ancient grammar schools. Yet although the school was free of the hidebound traditions

which created a very restricted curriculum in some grammar schools, it failed to exercise this freedom for many years. Perhaps this was a reflection of the education which the masters and members of the Committee had themselves

received. A glimpse of the curriculum comes in the annual
examinations reported by the Committee in its 1826 Report,
covering classics (featuring grammar, the *Iliad* and Virgil's
Eclogues) and mathematics (including common and decimal
arithmetic, trigonometry and Euclid). One innovation was the
introduction of chemistry. A senior boy from the chemistry
class read an essay on water, illustrated by experiments. As a
classical scholar, Hope was eager for his boys to read Latin and
Greek. Four hours were given over every day to the classics,
even though, as one former pupil remembered, this was 'utterly
beyond the reach of some of us'. These two subjects dominated
the timetable, with little space for English composition or
geography and none at all for modern languages.

The days were long. In 1835 the boys rose at half past
five every morning from March to November, with an hour
longer in bed during the winter months. Depending on
the time of year, they began lessons at either six or seven
in the morning, stopping for prayers at eight, followed by
breakfast. Their midday break stretched from noon until
quarter past two, with lessons finishing at five. After tea, an
hour's preparation followed before bed at half past eight. On
Sundays the day began with prayers at eight and the boys
attended chapel twice at New Cross, the boys walking in pairs
the two miles to the junction of what are now Lewisham
Way and New Cross Road. They were expected to memorise
the second hymn and recollect the sermon in detail. But the
sermons were dull, particularly those given by Hope. Short-
sighted, and using two pairs of spectacles, he often ground
to a halt as he struggled to decipher his own handwriting.
The boys would count the grunts he made to fill in the long
pauses, taking bets on the number he would make. As one
anonymous attender would write later, 'Perhaps, too, if you
are a dull boy, and a man canes you at intervals, and on what
seems to you slight occasion, you do not receive what he has
to say to you on religious topics in a *con amore* spirit'. Sunday
lunch was usually cold boiled beef and boiled suet pudding.
The afternoons, given over to religious studies, palled, and
after tea of bread, butter and milk, the boys were on their
way back to evening chapel. Another nameless contributor to
the school magazine later recollected how 'the walk on dark
winter nights was often past a joke, especially as we had at
those times to encounter the hostility of the village lads, with
whom we were always more or less at war'.

There was little recreation apart from the re-enactment
of debates from parliament. In 1829 these featured one of the
controversial topics of the day, the Annual Report noting that
'the recent debate on the Catholic Question in the House
of Commons was delivered with considerable animation'.

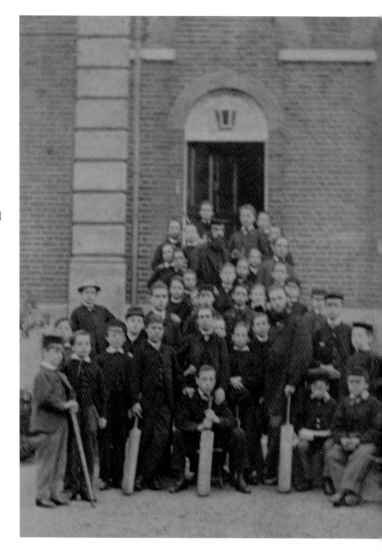

During the summer cricket was played every Wednesday on
Blackheath. The younger boys were often intimidated by the
boys from the Naval School at Greenwich who were in turn
chased off by the older boys.

One boy, Henry Hall, who attended the school in 1834,
recorded in later life that 'our pleasures were few; our pains
were many'. Fagging was practised, the junior boys running
errands, cleaning boots and brushing clothes, their only reward
being kicks and cuffs. John Robinson, who joined the school in
1839 and later became one of its most renowned old boys, hated
being a fag. He pledged with a group of like-minded boys that
when they reached the same point in their school career, they
would refuse to have fags of their own, liberate those already
acting as fags and punish those, he wrote, 'who demanded
forced service of little boys'. For those fortunate enough to
have their weekly 2d pocket money (worth about 65p today),
one boy remembered, there was 'Old Atley, the black man from
Greenwich, [who] knew pocket money day, and generally
succeeded in tempting us to part with it for sweets'.

For another boy at school in the early 1850s, 'the school life was one of Spartan simplicity'. They washed under a pump in the old dairy in the playground, bitterly cold in winter. Breakfast and tea were limited to two slices of bread and butter and half a pint of milk and water. Even in the 1850s, the school library barely justified the name, consisting mainly of back numbers of *The Evangelical Magazine*, although there was a copy of the recently published *Uncle Tom's Cabin*. Newspapers were banned, so news of the Crimean War, for instance, only reached the boys when they returned home for the holidays. Since travel was time-consuming and costly in those days – a single journey by coach between Liverpool and London in 1824 cost two guineas (more than £150 today) – many boys had no option but to remain in Lewisham during holidays. One boy at the school in Hope's day recalled that 'there was no Christmas home-going then for boys from a distance, and a few days' holiday at my London friends was the only change from my ten months' life at Lewisham'. In 1849 the boys asked the Committee to give them two weeks' holiday at Christmas to allow them time to get home, with a corresponding reduction in the lengthy midsummer break, but their plea was rejected. The one highlight of the year seems to have been bonfire night, although one parent complained to Hope about the bill for replacing a pair of his son's trousers scorched by fireworks.

Another peril faced by any group of people living together in those days was the threat from contagious illness. Cholera swept through Lewisham in 1832 but never reached the school. Scarlet fever and smallpox were just as deadly. In 1845 12 boys fell ill with scarlet fever and the remainder were withdrawn. The local surgeon, Mr. Smith, visited the school twice a day and Mr. Cox (Hope's assistant) sent daily bulletins to parents about the condition of their sons. Yet throughout this period only one death is noted, the sudden death of a Welsh boy named Price from an infected throat in 1852.

Despite all these privations and limitations – which it was impossible to write home about since all letters were inspected by a master until 1853 – an education at the Congregational School made all the difference to many of these boys. The gratitude of one parent in 1826 was typical – his son's education would allow him

to move in the more respectable walks of life; whereas, had he depended for education solely on the means which his parent possessed, he must have gone forth to the world without education, and his prospects must necessarily have been limited to the reward of agriculture or other labour, in a part of England where the mere labour of a man and his family commands no greater income than nine shillings a week.

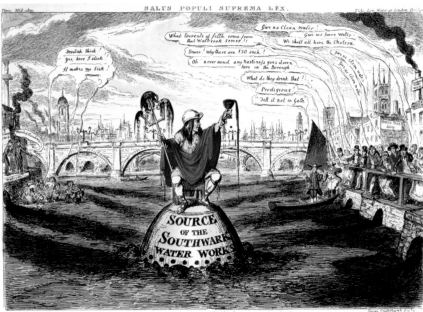

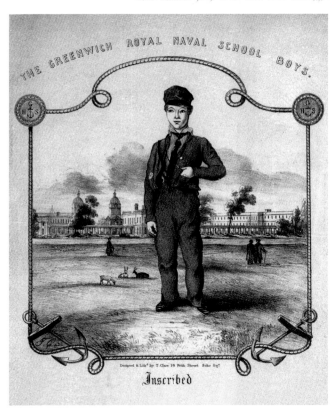

Education, for many ministers, saved their sons from poverty even worse than their own.

When Hope was appointed, he took an enlightened approach towards his pupils. He had few problems with discipline, partly because he asked the boys to help him keep order. Any boy charged with a serious offence could ask to be judged by a panel of six of his peers. A few months after his arrival, Hope would write to the Committee that

without any undue severities, without the use of either the rod or the fist, by firmness united with mildness, and by a system of government, of which part of themselves are the executors … we have happily found that the interests of morality among them have been secured in a degree beyond what was possible by the unassisted vigilance of a tutor; and that to habits of inattention and disrespect have succeeded those of respect and reverence for their instructors not exceeded, I am bold to say, in the conduct of any who bear the name of pupils.

This was not the entire story. Hope seems to have become more enthusiastic about corporal punishment as time went on. One former pupil recalled that in the 1820s 'corporal punishment was sometimes inflicted, but not often. As a more severe punishment, the culprit had to carry a heavy log of wood, attached by a chain over one shoulder, and this for one or more days, according to circumstances'. By 1830, remembered Ebenezer Butteau, another former pupil, a serious offence was dealt with by caning, 'when the culprit was laid across the desk, held by four appointed officials, each holding the culprit's arms and legs, while the President [Hope] inflicted the sentence'. Although another pupil, John Mark, would later recall that 'no master during my time [1838–42] ever struck a boy on the head with hand or stick', he also remembered that Hope was 'a great believer in the cane' and that on the rare occasions when his assistant, Mr. Cox, used the cane, 'he neither spared himself nor us'. Another boy from the same period wrote how 'the discipline was severe and the cane in frequent requisition. The indolent, the negligent, and, I fear, the incapable were punished for their failures as well as for their misconduct'. In 1836 one boy who admitted stealing a halfpenny from the missionary box, confessing he had stolen similar sums in the past but always replaced them, was given a week in solitary confinement on bread and water.

Another former pupil described Hope's denunciation of a boy who had taken the prize pear as well as other fruit from trees in the school garden. With other boys eager to take the fruit but wary of the caning that might ensue, the boy in question persuaded them that he and his accomplice could enter the garden unseen since they were in league with the devil. They even devised a ritual for membership of this 'satanic' club although only two others joined. Hope was clearly incandescent, writing that 'at the head of the wicked band was M., who, in plundering, blasphemy and murderous principles or intentions, seemed to have attained a perfection rarely to be paralleled in one of his age'. One boy was expelled, another suspended and letters were sent to the parents of others involved.

The school's finances remained parlous. In 1827 the Annual Report noted that the school was exceeding its means, 'the present state of their resources being unequal to the current demands upon them, notwithstanding that their expenses are regulated with the most scrupulous attention to economy'. In 1829 the Report lamented that 'a long time has now elapsed since any general repair and painting of the outside of the house took place, that for its due preservation, those repairs cannot much longer be deferred.' The Committee pointed with envy to the better funded and organised new schools for sons of ministers being founded by the Wesleyan Methodists. The school suffered in 1831 when it lost a number of subscribers to another Congregational school which opened at Silcoates in Yorkshire.

With their Congregational brethren turning a deaf ear to any appeals, collections remaining an uncertain means of raising income and the handful of legacies usually being used to fund revenue expenditure, debts began to mount once more. By 1835 the Committee had to admit that in 20 years it had failed to raise sufficient money to fund an economic number of pupils. Hope's intake of private pupils had been brought to an end in 1831. Now, compelled by circumstances to abandon its founding principle of total reliance on charity, the Committee decided that the school rather than its Master should profit from fee-paying pupils. The arrangement with Hope was terminated, his salary was raised to £200 a year in compensation and the Committee offered a number of fee-paying places to the sons of more prosperous ministers for the sum of £15 a year. It would be some time yet before boys from lay families were admitted. Hope was no longer expected to live in school and instead George Cox, the assistant master, took up this responsibility, with his wife acting as matron. With the financial benefit of fee-paying pupils accruing to Committee rather than the Master, it was possible to appoint a third member of staff. By 1840, when there were 50 boys in the school for the first time, 13 of them were fee payers.

With more money coming in, the Committee had cleared its debts by 1839. The Committee even managed to invest a surplus in stocks. Even so, this had been achieved largely through collections and legacies, and subscriptions were still falling well short of annual expenditure. This black hole, together with the cost of capital improvements, ate up the entire value of the invested stock within five years. In 1846 the Committee, which conducted many often anguished debates about money, announced that 'a crisis is now arrived and unless the Churches come forward more generously to our aid, the number of children must be diminished'. The

Above: the brick works in 1810 with a view across Lewisham.

churches did not and numbers did diminish, falling to 36 in 1852, of whom only four were fee payers.

A special sub-committee was formed which could see no alternative to cutting costs other than reducing salaries or replacing two masters with one. Hope's salary was reduced by half, the Coxes' by a third, one of the three maids dismissed and the fee lowered to £10. Sincere regret was expressed at the impact this would have on Hope, 'an old and faithful servant now in the decline of life'.

The Coxes consented to the reduction of salary, but Hope was devastated. He wrote to the Committee that 'not much relishing the idea of a residence in the Poor House or in the Queen's Bench', he and seven of his family were taking the drastic action of emigrating to Australia. In the 1850s, even in calm weather, this was a voyage which would take an ordinary sailing ship four months. He concluded his letter with bitter words: 'May it never fall to the lot of any member of the Committee to experience in his sixty-fifth year such a trial as has befallen the master of the Congregational School'.

Taken by surprise at the sudden loss of their Master and the difficulty in which it placed them, the Committee nevertheless wrote to Hope consenting to the termination of his contract in July, repeating their 'respect & esteem for his unimpeachable character & sterling integrity during the long period of nearly Thirty Years', and paying him his salary at the old rate for the six months up to Christmas.

His feelings obviously assuaged, Hope replied in cordial terms thanking the Committee for the money. 'Time has been, I frankly confess, when I have been almost tempted to call in question their regard for the late Classical Master of the school. I acknowledge that I did them an injustice, and regret that I ever, for a moment, harboured the thought. Uncontrollable circumstances, I now more than clearly see, necessitate their adoption of measures, which, under happier auspices, they would not have contemplated.'

Hope left after the summer term of 1852, eventually becoming a minister at a church in a suburb of Melbourne but dying soon afterwards, apparently in an accident involving other members of his family, though nothing is known about the details.

George Cox too was worn down by the stress of running a school bereft of funds. He wrote wearily to the Committee, lamenting 'how I am to get out for a holiday myself I know not, unless some charitably disposed person will pay my expenses'. However, in the new circumstances brought about by Hope's departure, the Committee took the opportunity to make a further big reduction in costs, and Cox and his wife, who had served the school faithfully for 17 years, were discharged at Christmas 1852.

The Reverend James Browne, a former pupil who had been engaged as temporary Headmaster from Hope's departure up to Christmas, was succeeded by the Reverend J.B. Lister, from Northallerton in Yorkshire, with his wife as matron. By this time, Lewisham was being drawn into the suburban sprawl of south-east London. The process had begun long before, for in 1827 the Committee complained of a new brickyard right next door to the school. This brought with it 'a body of workmen proverbial for their immorality'

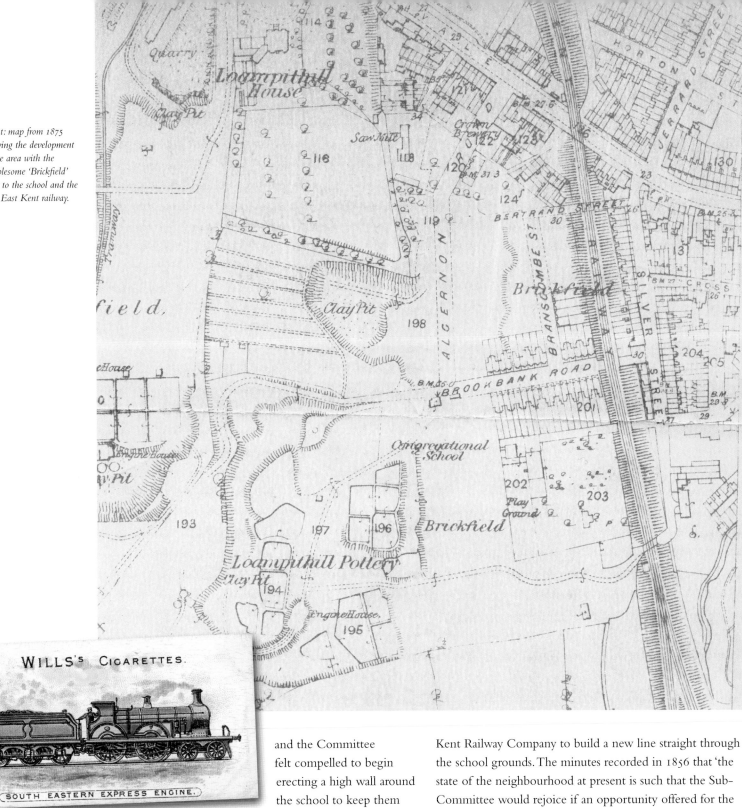

Right: map from 1875 showing the development of the area with the troublesome 'Brickfield' next to the school and the new East Kent railway.

WILL'S CIGARETTES.

SOUTH EASTERN EXPRESS ENGINE.

and the Committee felt compelled to begin erecting a high wall around the school to keep them away. Typically, shortage of money prevented the wall being completed until 1840. In the mid-1850s the brickyard was still causing trouble. Lister had to discipline one boy who had been caught throwing stones at a brickyard worker, commenting that 'the boys suffer much provocation, and that the neighbourhood is morally injurious to the school'. In 1859 the minutes recorded 'boys in the adjoining brickfields throwing stones and wounding some of the pupils'. Until the early 20th century, boys at the school would use the word 'bricky' as a derogatory term. Then there was the threat of the railways with the plans of the East

Kent Railway Company to build a new line straight through the school grounds. The minutes recorded in 1856 that 'the state of the neighbourhood at present is such that the Sub-Committee would rejoice if an opportunity offered for the disposal of the whole property, with a view to the removal of the Institution to some much more eligible site'. For Lister, appointed with a view to 'remodelling' the school, the contrast between the constant building going on in Lewisham and the sedate market town he had come from in Yorkshire was too great and he resigned in May 1859. His successor, the Reverend Thomas Rudd, from Clitheroe in Lancashire, arrived just as the Committee was debating how to mark the school's jubilee. Their priority was raising funds to remove the school from Lewisham. It would be 25 years before Thomas Rudd presided over that achievement.

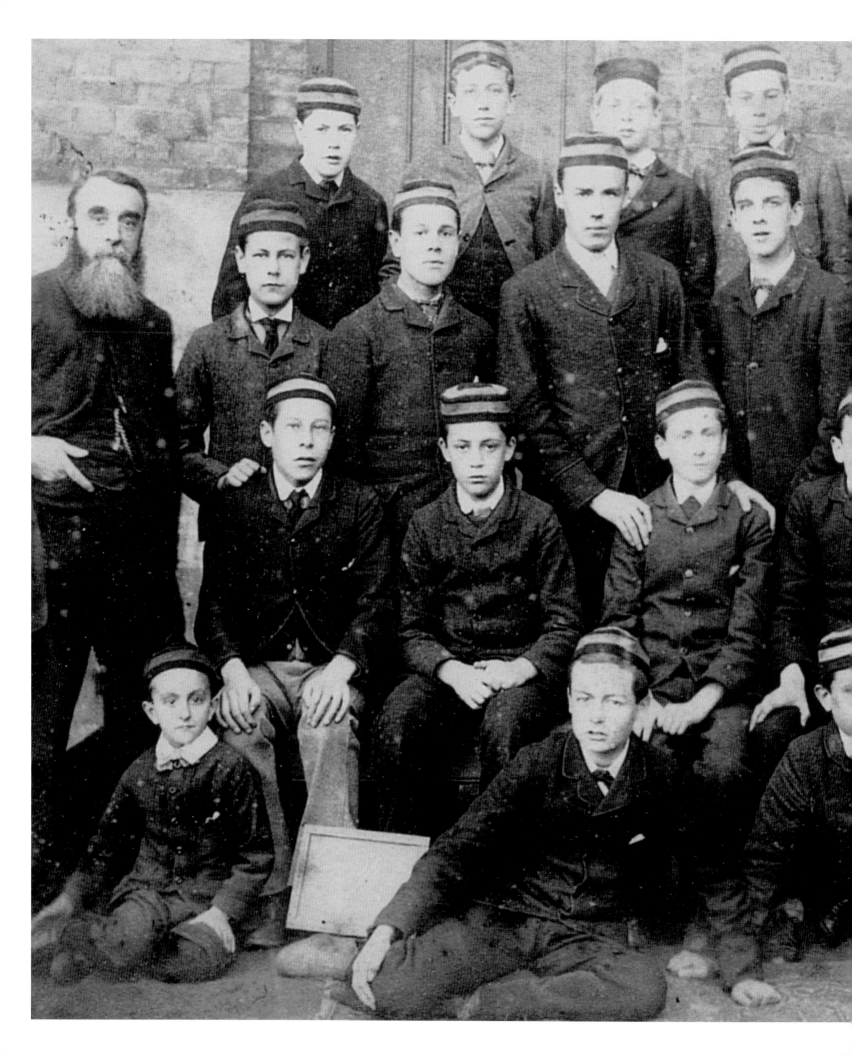

3

'COURAGE IS FAILING'
1859–84

Born in Guildford in 1829, Thomas Rudd moved with his family to Bradford where he was apprenticed to a bookseller. In 1851 he went to Airedale College, a long-established Congregational institution, where he trained as a minister and took an external degree from London University, the only university in England which then accepted Nonconformist students. In 1856 he took up his first post as minister of the church at Clitheroe. He came to Lewisham as Master in 1859 without any previous educational experience, taking over a school of 38 boys in a house with some 15 rooms, staffed by himself, his wife, an assistant master and a wardrobe keeper or matron. Yet over 25 years he built up the school under difficult circumstances, more than doubling the number of boys and extending the premises, and placing the school in a much better position to transfer to a new location. Rudd must have possessed determination, commitment and energy, although there are few reminiscences of him. Like his predecessor Hope, he too became known as 'Daddy'. William Pickford, one of the few former pupils to write extensively about their school days, found Rudd dominant and unbending with a volatile temper; his contemporary, H.H. Oakley, also mentioned Rudd's 'hasty and paroxysmal temper', and did not rate him as a great Headmaster, but found him to be 'essentially kind and just and manly'.

Rudd was faced with the fluctuating financial fortunes of the school. Until the mid-1860s, as a later school report put it, 'the School and debt were continually close acquaintances'. This peaked with the major crisis which occurred in May 1866 when the school's bank, the Consolidated Bank, suspended payment. The bank had become caught up in the tidal wave of panic sweeping through banking in the City of London which had

Previous page: the Reverend Thomas Rudd, far left, with pupils at Lewisham.

Far left: the Reverend Thomas Rudd, Headmaster 1859–94.

Left: the Reverend Josiah Viney.

begun with the collapse of Overend & Gurney. It turned out Consolidated was a solvent institution which was unable to convert its assets into currency sufficiently quickly to meet the unusual level of demand during the panic. The bank soon resumed payment but could not repay in full the monies owed to the school until July 1867. This temporary problem was eased thanks to loans from Committee members and a grant from the Congregational Union. The Reverend E.J. Evans was appointed the Committee's agent, and toured the country, succeeding in doubling collections from congregations.

Another key appointment came in 1864 when the Reverend Josiah Viney was made Secretary to the General Committee. After the Reverend John Townsend, Viney was probably the most influential minister in the history of the school. Another man of extraordinary energy, he would become the school's first President when he retired as Secretary in 1876, and remained a generous benefactor until his death in 1896. Born in Stockwell in 1816, he joined the London Missionary Society in 1839. He studied at University College, London, and was ordained at Herne Bay in 1841, before moving to Bethnal Green in London's East End, where he remained for 13 years. He raised £8,000 (more than £600,000 today) to build his new church, which opened free of debt. Suffering from overwork, he took up

what was expected to be a less strenuous position as minister in Highgate, the prosperous suburb of north London where support for Congregationalism was strong. There he took over a small congregation, increasing numbers, this time raising £10,000 for another new church. No doubt it was his impressive record in fundraising which brought him to the attention of the General Committee.

Viney's wise advice helped to keep the school financially more stable than it had ever been before. But this was a joint achievement, for Viney worked closely in tandem with the Treasurer of the General Committee, always a key post at the school. This was held by Samuel Morley from 1868 until his death in 1886. Undoubtedly one of the leading Congregationalists of his time, his contribution to the school has been largely overlooked. From a Congregational family of prosperous manufacturers, he took over and expanded the family business, and by the 1850s enjoyed a reputation as one of the country's leading businessmen. He was firmly committed to the growth of Congregationalism which led him to support a variety of related causes. He donated almost £15,000 (more than £1 million today) towards new chapels in the 1860s and contributed funds towards at least 11 Congregational training colleges. He also gave £6,000 to the construction of the Congregational Memorial

Hall in Farringdon Street in London, where the General
Committee would meet from 1875 onwards. His support
for the Congregational School probably stemmed from his
keen interest in voluntary education – for many years he
was strongly opposed to any government interference in
education. In the year he became Treasurer he was also elected
as MP for Bristol, which he remained until his death, refusing
a peerage from Gladstone in 1885. It was no doubt through
Morley's influence that the Grand Old Man of British politics
presented prizes to science and art pupils from Lewisham
and other schools at a ceremony in Greenwich Town Hall
in 1875. A man of utter moral rectitude, somewhat cold and
humourless, who despised laziness and self-indulgence, he
was a shrewd businessman who looked after his workforce
and supported the trades unions. Tireless in his public work,
he was reckoned to have donated as much as £30,000 a year
to charitable causes during his lifetime. The Congregational
School was fortunate to have his help and advice. Thanks to
him, subscriptions always covered the cost of improvements
made at the school and finances benefited from the stipulation
he introduced in 1869 that every parent should either become
a subscriber or organise an annual collection for the school.
When he became more sympathetic to state involvement in
education, he was also responsible for the school receiving

grants from the Department of Science and Art from 1876,
which went towards increasing the salaries of the assistant
masters. One of the most prominent public men of his time,
he deserves greater recognition for the part he played in
establishing firm foundations for the school.

This was a time of considerable educational change.
Many of the ancient grammar and other endowed schools
were being transformed from schools for the less well-off
into schools for the middle classes. The curriculum was
being liberalised, making particular provision for the sciences
and modern languages. A clear distinction began to emerge
between elementary and secondary education. By the end
of the century there was growing competition from the
state, with the provision of elementary schools with a wide
curriculum and higher grade schools established by local
school boards, equipped with their own science laboratories.
The Congregational School could not afford to be left behind.

The Reverend Thomas Rudd, no doubt guided by
members of the General Committee, was well aware of this.
In 1884 he noted that 'what the first proprietors of the School
considered as sufficient for the curriculum of the School will
not suffice now. The old subjects must be better taught, and
with better methods and appliances than of old, and beyond
this, additional subjects are demanded'.

Left: Samuel Morley (1809–86), leading Congregationalist and MP for Bristol, was a major benefactor to the school.

Far left: Morley helped to fund the building of the Congregational Memorial Hall in Farringdon Street, London.

Below: William Gladstone distributed prizes to Lewisham pupils in 1875.

He learned his lesson the hard way. In his early years he struggled to improve standards and came under sustained pressure from the General Committee to make improvements. After particularly poor examination results in summer 1862, he was instructed to make sure that every pupil had the necessary grounding in every subject. The impetus for improvement seems to have been adoption of external examinations, the Oxford locals, by 1865. Boys also sat the examinations set by the College of Preceptors. In 1876 an external inspection was carried out for the first time by a fellow of Clare College, Cambridge, appointed by the Cambridge Local Examination Syndicate. He was pleased with the level of work, concluding that 'I have seldom had to speak so uniformly well of any school'. By then the school curriculum conformed with modern developments, notably science, still under-provided at many schools. At Lewisham senior boys were taught chemistry, astronomy and geology and from 1874 there were weekly lectures on electricity and magnetism. Despite the lack of a laboratory, senior boys were taking experimental chemistry by the early 1880s. In 1884, 33

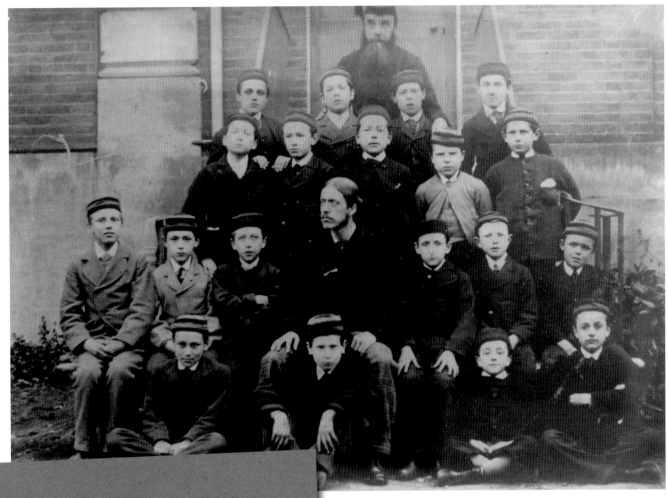

Above: upper II form in 1877 with the Reverend Thomas Rudd at the back and Mr. Hyde, known as a 'dandy with a sarcastic tongue', in the middle.

Right: Caterham has been at the forefront of science teaching throughout its history. Shown here is the range of science topics examined in 1880.

The Science and Art Department of the Committee on Education of Her Majesty's Privy Council holds, annually, Examinations in the following subjects of Science :—

1. Practical Plane and Solid Geometry.
2. Machine Construction and Drawing.
3. Building Construction.
4. Naval Architecture.
5. Mathematics.
6. Theoretical Mechanics.
7. Applied Mechanics.
8. Acoustics, Light and Heat.
9. Magnetism and Electricity.
10. Inorganic Chemistry.
11. Organic Chemistry.
12. Geology.
13. Mineralogy.
14. Animal Physiology.
15. Elementary Botany.
16. } General Biology.
17. }
18. Principles of Mining.
19. Metallurgy.
20. Navigation.
21. Nautical Astronomy.
22. Steam.
23. Physiography.
24. Principles of Agriculture.

The Examination is of two kinds—the Class Examinations and the Honours Examination.

The Class Examination is divided into two Stages, the Elementary Stage and the Advanced Stage,—except in Mathematics, in which subject the examination is divided into seven Stages. The successful Students in each Stage are divided into 1st Class and 2nd Class, according to their proficiency. The Honours Examination is of a more advanced character.

boys sat and passed science examinations. There was a nod to the commercial subjects found in other schools, often favoured by middle-class parents, with the introduction of shorthand in 1871, no doubt endorsed by Congregational ministers seeking commercial positions for their sons. Music had a lower priority. Although singing was taught, music was introduced only after the donation of a piano in 1873. Five years later, Mrs. Fairmaner began teaching music at the school, which she would continue to do until her retirement in 1919. By 1879 Rudd was reporting that all boys learned Latin and French while 30 out of some 90 boys in four divisions were also taking German and the senior class was studying elementary Greek. Rudd acknowledged the deficiency in arts subjects which he tried his best to remedy but found it difficult when his handful of staff – in 1876 there were just five, including the Head, teaching a dozen subjects to 86 boys – were so overstretched. This handful of staff included from time to time T.J. Bell, known as 'Grump' from his cutting remarks to disobedient boys, but considered a more sympathetic figure by many than the Headmaster, and Hyde, 'a dandy with a sarcastic tongue'.

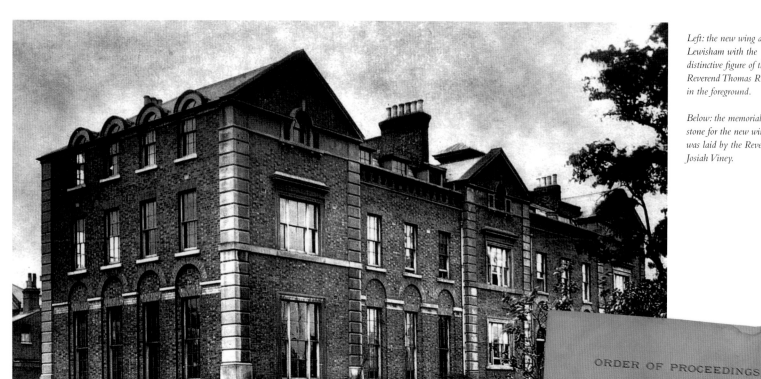

Left: the new wing at Lewisham with the distinctive figure of the Reverend Thomas Rudd in the foreground.

Below: the memorial stone for the new wing was laid by the Reverend Josiah Viney.

Raising academic standards, as Rudd appears to have done, had to be accompanied by an improvement in facilities if parents were to be content about sending their sons long distances from home. The first of these came as a result of the Jubilee appeal in 1861 which raised £1,281 9s 7d (about £90,000 today), not enough to relocate the school as originally intended, but sufficient to erect a new wing, with a better water supply, a gas supply and the school's first bathroom. In 1865, after an outbreak of scarlet fever, a separate sanatorium was built. The continued demand for more places at the school led to the construction of a new schoolroom and classroom in 1869, the costs entirely covered by subscriptions. In 1871 came another new wing, three storeys high, with a dining room and more dormitories. Once again subscriptions were raised to cover the cost of more than £3,000 even before the foundation stone had been laid. In 1872 a cricket field was rented and by 1876 some elementary gym equipment was being used by the boys in the school playroom. Another change came in the structure of the school year. The three-term year was being commonly adopted by schools and the Congregational School followed suit in 1876, adding three weeks' holiday at Easter. At the same time the school agreed

to pay the return fares for boys who lived more than a hundred miles outside London.

All this helped to attract more pupils. From 40 boys in 1860 the school grew to 95 by 1875 and exceeded 100 in 1883, which was as many as the property could contain. The increase was helped by the decision, no doubt advocated by Samuel Morley, to raise the number of fee-paying boys to half the number of free places in 1870, when fees were also increased to £20 a year. In 1873 it was agreed to admit the sons of some ministers for fees in excess of £20 – each boy, it was calculated at the time, was costing £27 a year to educate. In 1874 a £5 entrance fee was introduced and the age of entry was changed from nine to ten. Boys were still limited to a maximum of five years at the school.

In 1877 Viney and Morley eventually persuaded the General Committee to admit as fee payers the sons of lay families to bring in the additional income to cover the true

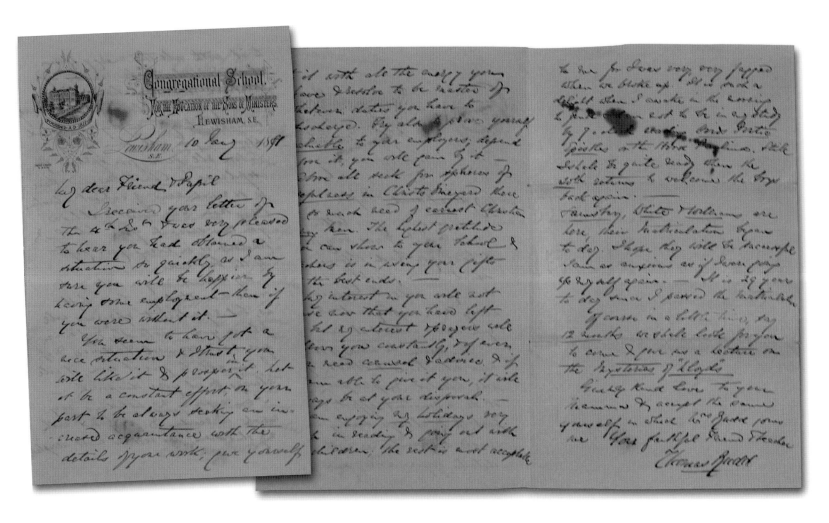

Above: letters written by the Reverend Thomas Rudd. He took a keen interest in his past pupils and they often wrote to update him on their news.

costs of educating each boy. Boys under 13 years of age would be charged 45 guineas a year, and those over that age 50 guineas a year, plus extras. The first lay pupils were the Thorne brothers from South Africa, the first known instance of overseas boys attending the school. From 1880 such boys were also allowed to remain at school until they were 17. Admitting lay pupils made it possible for the General Committee to contemplate the entry of many more boys, and the idea of relocation became even more attractive.

School days were still filled with their fair share of drudgery and boredom. Many boarders had to overcome the dread of returning to school, especially after the long summer holidays. Pickford paints a gloomy picture – the boy being waved off from the railway platform at home by his mother and failing to fight back a tear, even if he did have a full-term's pocket money and a full play-box; the dull and dismal approach to Lewisham, with the distinctive aroma of the brickfields; the backward glance as school neared, knowing that 'once within the portals freedom ceased, and you became a person without a Christian name, attached to a number and probably to a more or less annoying nick-name'. As 'Daddy' Rudd received you back, there was the prospect 'of the long term's canings'. And then, remarkably quickly, the boys began

to settle in as friends were reunited and talk passed to events of the summer and forthcoming matches.

Boys still rose as early as six in the morning, casting aside their nightcaps. Each boy was expected to have three nightcaps, along with sufficient paper collars and a pot of pomatum, a sort of perfumed hair gel. Although baths were taken only once a fortnight, boys washed themselves to the waist with cold water every morning. They still attended chapel twice on Sundays and still failed to remember much about the sermons. One retrograde step was Rudd's decision to read every letter penned by the boys on Sunday afternoons. Lecture courses were considered the most apt way of keeping them entertained during the winter months. In his 1876 report to the Committee Rudd acknowledged 'the need to relieve a little the monotony of school life' and had acquired a magic lantern, an elementary projector to display slides, a recent phenomenon made possible by photography. The boys sat through illustrated lectures on Switzerland, the Nile, an expedition to the Arctic and the legends of the Rhine. There was little liberty except the weekly excursion every Wednesday half-day to Blackheath or the Sunday walk to chapel. Senior boys did have the privilege of using a small classroom during break times where they could

Left, left to right: Arthur Houchin, Herbert Stowell and Herbert Morrison. The photographs come from an album that OCs made for the Reverend Thomas Rudd on his retirement.

Below left: letters written by pupils.

brew cocoa on a stove. The school was cold in wintertime. The weather often caused disruption as frozen pipes burst and the gas supply was cut off. Stoves were only installed in the dormitories in 1873. Pickford described how the schoolroom was impossible to heat during icy-cold weather and 'we had to bustle at times to keep warm'.

For exercise, there was drill and rugby. The introduction of drill proved problematic. One boy, wonderfully named Isaac Newton Moss, recalled how Dr. Lockhart, who lectured to the boys from time to time, had served in China as a missionary and returned full of enthusiasm for regular physical exercise. Around 1860 he engaged a retired soldier to give occasional instruction to the boys in drill. But the permission of the Committee was needed to make drill a permanent feature. The members came to watch one session and immediately decided it should be discontinued on the grounds it would encourage boys to join the army. Only four years later they relented, a member of the Royal Marines from Woolwich Arsenal was appointed and drill became a regular part of school life.

Rudd introduced regular organised games for the first time, usually held on Blackheath and mainly featuring rugby. The first reference to the game comes in 1864 when one boy broke his leg. Pickford recalled the cold, foggy winter days in the late 1870s when rugby was played on the field by the Ravensbourne. The XV, clad in their tiger-striped jerseys,

played matches against a number of schools, including the School for Sons and Orphans of Missionaries at Blackheath (now Eltham College), but the team often included several members of staff, common practice at many schools. One master in particular, a well-built Scotsman named Traill, was passionate about rugby. He had to restrain his strength when playing with the boys, and once bawled at Pickford, 'Peckford, man, why did ye no pass the baw?' 'Please, sir, Ashbery had me by the leg.' 'Awa' wi' ye, why did ye no anteecepate? Ye ha' no brains, man, fer footba'.' Pickford also remembered how Traill 'would take a few of us quietly out to the field for punting and drop-kicking practice, teaching us tricks and dodges that fell like seed on ripe ground'. Cricket continued to be played. The school bowling record, unbroken to this day, was set by T.S. White against Aske's School in 1879, when he took nine for one. There was the occasional game of hockey and an annual Sports Day was held. Swimming was limited to the occasional dip in the deeper pools of the Ravensbourne.

Excursions were limited. The first one took place in 1860 to the British Museum, but this was only for boys who remained at school during the holidays. Otherwise the only record is of the occasional visit to the Woolwich Arsenal.

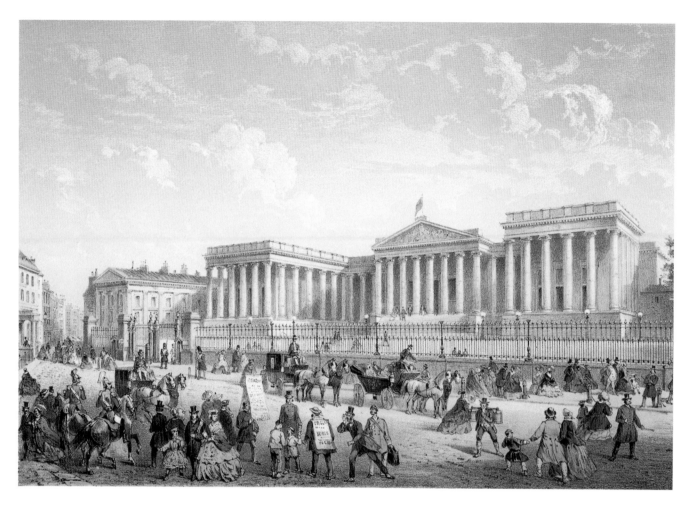

Left: the first school excursion was to the British Museum in 1860.

Since there was still no proper library, the boys swapped books from home and a few senior boys, who took comics such as 'Judy' and 'Fun', formed a Paper Club. They looked forward to spending their limited pocket-money every week. Most boys still had no more than 2d a week. 'Old Ball', the school's general factotum, remembered by Pickford as 'an ancient Father Christmas sort of man, very gentle and nice to us boys', would wheel out a small truck every week filled with Turkish delight, cakes and other goodies on which they could spend their weekly allowance. Tom, the school porter, could also be relied upon to ferry in goodies from outside on request. There was one entrepreneur who sold condensed milk to his peers by the spoonful, and once did a deal down in the village on some sprats, which he roasted on a shovel over the fire, making 4d profit from their sale. Pickford recalled that

the greatest game of all in the old-days was a fight – a real go-in between two angry boys after a long course of working up and an accepted challenge … the tip-top rung of the fisticuff ladder was when the Lower Form boys (at rare intervals) made a determined shot at routing out the First Formers from their snug little sanctum.

Joseph Lucas, who joined the school in 1882, recollected that a group of third- and fourth-form boys set up a society called the 'Druids'. These Druids would collect all the youngsters straying into their path in the playground or schoolroom, take them into the lobby and 'crush them in a heap against the play-boxes, shouting and shrieking all the time like Red Indians'.

Some boys did their best to break away from the tedium, making illicit visits into the village after dark. In 1864, when the Italian revolutionary Garibaldi made his hugely popular visit to London, a group of boys sneaked out to Greenwich to catch a glimpse of the great man. When communication with the outside world was only by letter, boys did their best to evade the censorship of the Headmaster. H.G. Williams, who entered the school in 1876, remembered that 'if a youthful lover wanted to write to his best girl, he had to smuggle the letter off the premises by the hands of the "booty-boy" or some fellow out "on leave"'. This was viewed as a serious offence. In 1860 one young man caught corresponding with a local girl was expelled.

The General Committee left discipline largely in the hands of the Head. There were as yet no prefects or monitors. When one mother wrote to Rudd asking him for assurance

that the cane was not used at the school, he replied that corporal punishment was applied only in exceptional circumstances – 'I disapprove of it, and find I can do better without it'. But there was at least one boy who recalled that Rudd's liberal inclinations were often overwhelmed by his volatile temper. On the other hand, when Rudd discovered that money-lending and buying and selling among the boys was getting out of hand, this behaviour was eradicated not by the cane but by his shrewd decision to place the

money held by every boy under his own control, distributing no more than 4d per pupil each week.

The school did not prepare boys for university. There was no sixth form and most boys left at the age of 16, usually to take up employment, with just a handful moving on to other schools where they could study until the age of 18. University was a privilege afforded to very few young men, and even fewer from Nonconformist backgrounds, even after Oxbridge and Durham opened their doors in the 1870s. It was also an expensive privilege which few Congregational ministers could afford to give their sons.

With the growing number of boys passing through the school, some began

Left: The Harestone Valley c.1876. The school boarding house Alleyne (formerly Josiah Viney's home) is the middle house of the three on the right. The field this side of Alleyne was divided into two plots, and the school's other boarding house, Richmond, was built on the one adjoining the house in the foreground. Harestone is on the left of the photograph.

to suggest that an association of former pupils should be set up. In May 1863 it was proposed that a Conference of Old Scholars should be held, and this took place in May the following year. As an annual fixture, this seems to have struggled, although there was a resurgence of interest thanks to the efforts of two former pupils, Duncan Bell and Robert Rudd, in the late 1870s.

The main challenge for the General Committee was the pressure of suburban development in Lewisham. The encroachment of housing consumed the school's cricket field and hemmed in the school on all sides, excepting the rear, which was now bounded by the railway. The South Eastern Railway had acquired a portion of land from the school for almost £1,000 in 1865 after taking over and expanding the line which ran through Lewisham. The idea of relocation, suggested in 1859, was never far away, and in November 1880 the Secretary reported to the General Committee that a mansion near Slough seemed suitable for the school and recommended a visit. After several visits elsewhere, the Committee made its first visit to Caterham in January 1881, followed three months later by a further deputation to inspect half a dozen properties. By then, Rudd was writing of the school's situation in Lewisham, 'Though I am not easily inclined to despair, it must be confessed that courage is failing'.

The options were narrowed down to two sites in Caterham, one on the hillside, the other in the valley. The latter property was preferred, a substantial building called 'Withernden', along

Harestone Valley Road, with 13 acres of land. The price being asked was £1,500 for the property and £180 an acre for the land. The General Committee proved nervous about making a decision because the financial commitment was significant. Some members also objected that the property was too remote and too far from the nearest railway station, located about a mile away. Caterham probably did seem to be in another world for members used to the hurly-burly of the bustling and crowded capital. A small settlement, with only a handful of shops, its isolated and peaceful rural position proved attractive to a number of better-off families from the city who had built substantial houses dotted all over the valley. Several of them were wealthy Congregationalist families whose support the school would enjoy in future years. The population was officially 6,000 in 1881, but of these, 2,000 were accounted for by the patients residing at the Asylum at St Lawrence's Hospital and another 500 by the officers, soldiers and others stationed at the Guards' Barracks.

Above: The Square, Caterham, c.1905. The drinking fountain, which is now in Church Walk, incorporated Caterham's first street-light and was donated in 1890 by Charles Asprey, the Bond Street jeweller, who lived in Stafford Road and is buried at St. Mary's Church. On the left are Kilby's livery stables – Kilby's cab was regularly used between the railway station and the school.

Right: Witherden *was purchased in 1882.*

Below: architect's plan for the ground floor of the new school.

At one point the Committee voted unanimously to proceed no further. One factor which perhaps persuaded them to change their mind was the thriving local church. The Congregational Church had been established in Caterham in 1868 and was consecrated in 1875. The minister, the Reverend Mr. Legge, and another resident, Mr. Clarke, the editor of the *Christian World*, were invited to join the Committee. Further support came from the school's President, the Reverend Josiah Viney, who had retired to Caterham. The negotiations dragged on but in May 1882 a contract was signed, a £400 deposit paid on the £3,900 purchase price and a loan taken out for £3,500. The Lewisham property was sold for £6,000 to The East London Industrial School, which occupied the premises until the school was closed in 1909. The buildings eventually became used as a furniture store but were gutted by enemy action in 1940 and demolished in 1954.

The financial implication of moving to Caterham became apparent when the Committee received the tenders for the new school building. The lowest, which included the cost of converting the existing house into a home for the Head, stood at £16,610 12s. With additional expenses, the total cost exceeded £30,000. Yet three-quarters of this sum was secured before building began. The Congregational Union donated £400, the Reverend Josiah Viney gave £500 and organised an appeal which raised nearly £9,400, and Mr. Clarke lent

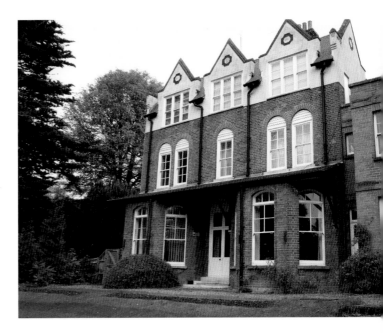

£2,000 at a low rate of interest. Planned to accommodate 150 boys, half as many again as at Lewisham, the building was designed with five large dormitories, five classrooms, a dining hall and schoolroom, a science laboratory, a Head's house linked to the main block, and separate domestic quarters. The foundation stone was laid by Samuel Morley on 23 October 1883 and the last Speech Day at Lewisham took place on 24 July 1884.

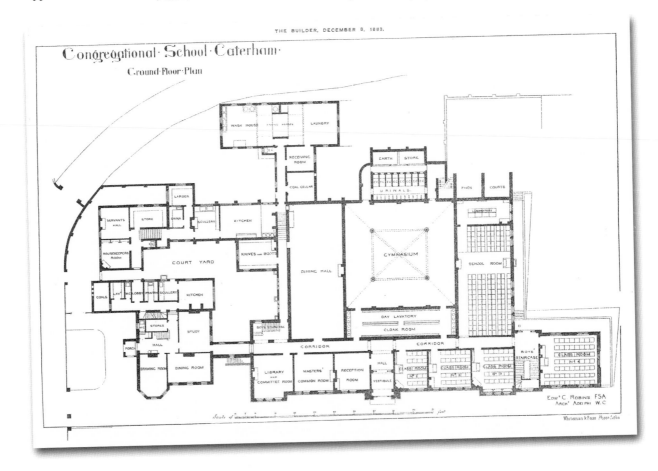

THE BUILDER, DECEMBER 8, 1883.

Congregational·School·Caterham·
Ground·Floor·Plan

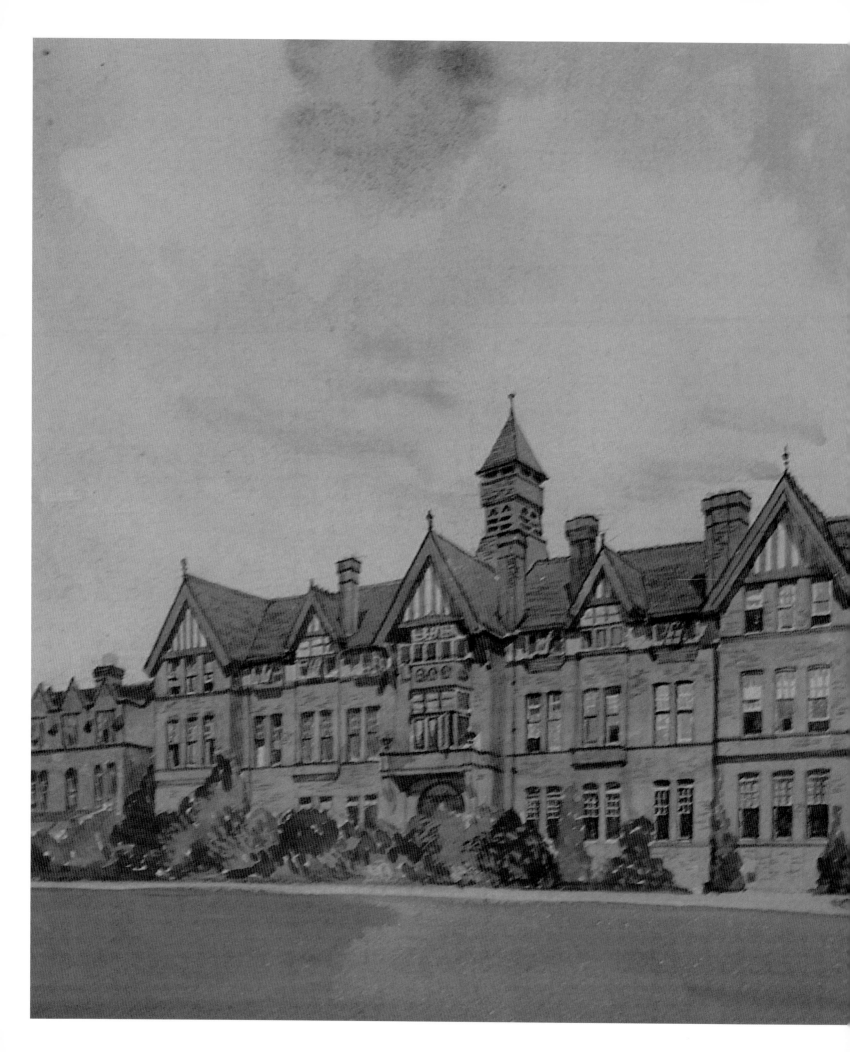

4

'RESPONSIBILITIES, DUTIES AND PRIVILEGES'
1884–1910

The first term at Caterham Congregational School began with 114 boys on 1 October 1884. The official opening took place on 10 October when a dedicatory service was followed by luncheon served to 300 guests.

The new school began well. By 1887 it was almost full, with 146 boys. A sanatorium was added in the following year at a cost of £800, to which the Reverend Josiah Viney, who took over as Treasurer from Samuel Morley in 1886, made another generous donation. The Old Boys raised money for a swimming-pool on which work began in 1888. The examiner who visited that year reported that the school was 'in admirable working order throughout'. The school enjoyed the support of several benefactors, including the Spicer family, distinguished Congregationalists, whose fortune came from papermaking. In 1889 the Reverend Thomas Rudd could declare at the annual Old Boys' dinner that 'the Institution at Caterham, with all its appliances, has no need to be ashamed when compared with any of the Middle Class schools in the country, and was a credit to the Denomination'.

The curriculum was much the same as at Lewisham, based on the requirements for the London University Matriculation, the Cambridge Locals and the South Kensington science examinations. Rudd remained keenly aware that many parents were eager for their sons to find respectable employment as soon as possible, although his plans to divide the school into classical and modern sides never materialised. The school liked to claim for itself those boys who had gone on to Oxford or Cambridge, even though they did so in every instance from schools they joined after leaving Caterham.

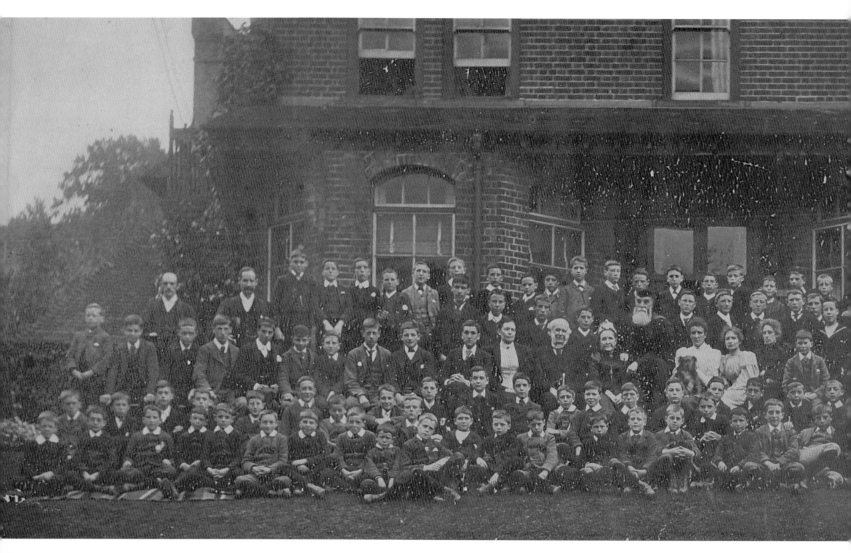

School life was stimulated by new buildings and new surroundings. The playing fields and countryside beyond them gave the boys plenty of opportunity for fresh air. The bonfire-night festivities enjoyed at Lewisham were now held every year on the hillside above the school. The celebration in 1891 was typical. The boys illuminated their way through the dark with torches and, once the bonfire had been lit, set off their own fireworks, which, said the school magazine, 'hissed, and whizzed, and banged on every side'. The better quality fireworks, made by Brocks and donated to the school, were lit by the staff. One senior boy, getting too close to the stand where Catherine wheels were being let off, found sparks setting off the fireworks he had stuffed into his pockets and very quickly, it was reported, 'was in a state of great excitement'. His only loss was his handkerchief.

A field club encouraged greater interest in the countryside surrounding the school. There were prizes for the greatest variety of wild flowers collected and the best collection of wild orchids. The boys were given half-day exeats so they

Previous page: the school opened at Caterham in 1884.

Above: the first photo of the whole school at Caterham.

Left: detail from stained glass in school entrance.

Top right: front cover of the school magazine, October 1887.

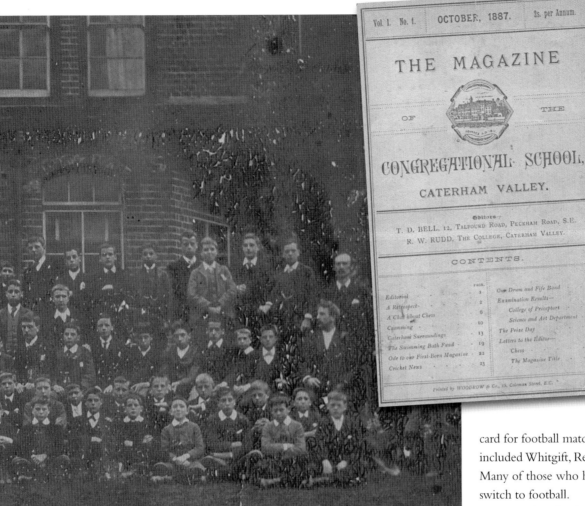

could spend their free afternoon roaming the Downs. A running club organised runs of up to five miles. One popular activity was the paper chase, with the boys, calling themselves the Harestone Harriers, following a route up the hillside through the woods and down to Tandridge via Godstone, then up Oxted Tunnel Hill and down to Woldingham and Marden Park before returning to Caterham.

The disadvantage of the school's location was its distance from other schools. Rugby had to be abandoned in favour of football because there were so few rugby-playing schools nearby; and even then it was difficult to find enough schools and clubs within travelling distance to fill the annual fixture card for football matches. Those which made it onto the list included Whitgift, Reigate, Dorking Standard and Horley. Many of those who had been at Lewisham regretted the switch to football.

The other disadvantage plaguing the school's attempts to attract other teams and raise its own standards was the deplorable state of the playing fields since there was never enough money to lay out the fields properly. Football matches were often abandoned, as the boots of the players chewed up the surface, and the ground was loathed by visiting cricket teams, who feared injury and rarely made a return visit. The asphalt tennis court was in little better condition, noted the magazine, with 'two large drain holes in the centre, and sundry mounds and inequalities all over the surface'. Other activities included fives and rounders as well as instruction in gym and fencing from the drill sergeant, Sergeant Scott. The school magazine reported that Scott's appointment roused the local Peace Society to complain about 'the presence of an ex-soldier on the premises who instructed in the art of killing'. He was popular with the boys, who always gave him presents on his birthday.

By contrast with the external games facilities, the school was immensely proud of the new swimming-bath. It was completed in time for the opening of summer term in May 1889, although when the boys took their first plunge the water was only three feet deep because of difficulties with the

Above: a meeting in March, 1906, of the Old Boys' Social Club, which for many years met every Friday evening between October and March at Walduck's Bedford Hotel in Southampton Row. J.H. Davenport (former President) and Landel Jones (later chairman of the School Board) are playing chess, Victor Jones is at the table immediately behind them, George Eynon (a notable benefactor) at the table behind that (wearing glasses), Bernard Kettle (magazine editor) directly under centre of back chandelier and Arthur Burns (another generous benefactor) standing on the extreme right at the back.

Above: the swimming-bath was opened in 1889 by James Whitehead (far left), the Lord Mayor of London. Whitehead was a business partner of Percival Rees (left), an OC.

supply. This was just as well since only seven of the 135 boys in school could swim. The bath was also unheated until 1891. The first of the boys to enter the water – stark naked as was the custom until 1980 – was Allan Mottram, who became something of a sporting hero at the school. He captained what was widely regarded as one of the best football teams the school had seen. Mottram was the first boy elected as captain of the upper forms, an innovation introduced by Rudd in April 1891.

The swimming-bath, a functional building measuring 50 feet by 21 feet, with an asbestos roof and walls of red brick, was formally opened on 6 July 1889, the same day as the athletic sports were held. It was a quite extraordinary event for the guest of honour was the Lord Mayor of London, James Whitehead, a leading Congregationalist, prominent public man and philanthropist, who was later knighted. He had been a member of the Reverend Josiah Viney's Highgate congregation and his business partner, Percival Rees, was an Old Boy. His journey to Caterham was greeted enthusiastically by the locals. The school magazine reported that

the inhabitants turned out of their houses to witness the coach-and-four, with livery servants, pass, and when Caterham

was reached, there was quite a crowd of persons near to the station. The gilded state coach, magnificent flunkeys, and four fine browns … excited plenty of comment.

As the coach drew up outside the school, the band of the 1st Volunteer Battalion of the Queen's Surrey Regiment

was playing, and the assembled boys and staff gave three cheers. The mace bearer, sword bearer and City Marshall were all in attendance. The opening of the swimming-bath created considerable interest locally, which the school found unwelcome. A local news-sheet reported that for the price of a 5d ticket available from a shop in the village anyone could take a swim. The school magazine was indignant: 'We distinctly object to turn our Private School Swimming Bath into Public Baths and Wash-Houses for the use of the neighbourhood'.

Rudd was in his element but, with just four masters to assist him, exhausted himself through overwork. The return of financial worries cannot have helped his health. Although the debts arising from the transfer of the school had been paid off by 1886, numbers were never sustained at capacity. The school had insufficient income to cover the costs of the education of 150 boys as so many of them were the sons of ministers, educated almost free of charge. Despite the fact that the school's fees were the lowest of all the Congregational schools, an attempt to increase the annual entrance fee by 50 per cent in 1892 was soundly rejected at the annual meeting of 'governors' and subscribers. The Annual Report that year,

noting that the school was full, remarked that such pleasure was 'diminished by the inability to equalize income and expenditure' as a result of 'a too liberal policy of receiving boys on the Foundation'.

In the midst of all this Rudd appears to have suffered the first of a series of strokes. He was granted a six-month sabbatical to recover his health, sailing with his wife to South Africa in June 1892. The school was run in his absence by the Reverend Josiah Viney and the minister of the Caterham Congregational Church, Mr. Heather, in conjunction with a committee of masters. To help them, prefects were appointed for the first time, with the games captain, Mottram, appointed head prefect, a post he retained until he left the school.

This team had to contend with the first serious outbreak of illness at the school since it had moved to Caterham. Scarlet fever struck during the first week of the autumn term in 1892. The sickness increased, more boys disappeared, routine was abandoned, new monitors had to be elected to replace those who fell ill, and some classes were reduced to three or fewer boys. Several staff contracted the disease as well. One boy, Charles Ingram, died suddenly from inflammation of the lungs and kidneys on the afternoon of 25 October.

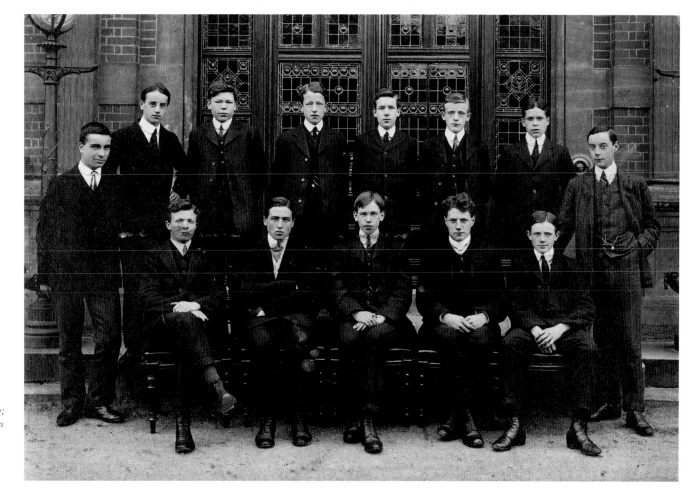

Right: monitors were first appointed in 1892. This photograph, taken in 1910, came from the Powell family. David Harold Idris Powell, standing, fourth from the left, came from a Congregationalist family; his father and four uncles were all ministers. He hardly knew his father as he died from cholera in 1900.

His funeral was held in the schoolroom before his burial in St Mary's churchyard, attended by a small group of staff and senior boys. In November all those boys who had not been infected were sent home.

Rudd returned in January 1893 only to face the financial consequences for the school of the collapse of the Liberator Building Society at the end of the previous year. On bonfire night in 1892 the effigy on the school bonfire represented Jabez Spencer Balfour, the swindler whose fraudulent activities had led to the collapse. As a result, the school suffered a steep fall in the number of subscribers and thus in its annual income. The Committee had no alternative but to reduce numbers until income matched expenditure. Without the continuing generosity of the Reverend Josiah Viney, the deficit would have been even more troubling. All this was too much for Rudd. He retired at the end of the summer term in 1894 with an annual pension of £200. Retirement was too late to bring about a recovery in his health and after suffering further strokes he died in May 1899, five months short of his 70th birthday.

His successor, the Reverend Horace Hall, was 39 years old. Himself the son of a Congregational minister, but orphaned at a young age, he had spent five years at Lewisham as a 'ministerial' from 1863 before attending other schools. He graduated with degrees from the University of London as a member of Cheshunt College, one of the Congregational academies which would move to Cambridge and later merge with Westminster College. Ordained in 1880, he took up teaching and eventually became principal of a private school, Summerfield, in Sheffield in 1886. Shy and retiring, wise and sympathetic, he tended to see only the good in people. He was also in delicate health and prone to anxiety, characteristics which scarcely boded well for his tenure at a school still beset by problems.

Hall described his approach to education as 'not merely to cram the boys with knowledge, but to develop their whole nature with all possible symmetry'. The school magazine was full of evidence for this. The description of the Easter term in 1895 was typical of life at Caterham: 'skating, snow fort building, rounders, lime-light entertainments, preparation for the May exams, and lastly, Mumps, helped the term along famously'. Hall blew away many cobwebs, including the dreaded Sermon Notes, when boys returning from church had to summarise the sermon. He was even less of an enthusiast for corporal punishment than his predecessor, and it was very rarely exercised. He revived debating and brought back Sports Day, which had not been held since 1891. Debates reflected the fickleness of schoolboy opinion, veering within one term from opposition to socialism and professionalism in sport to support for the abolition of the House of Lords and votes for

Left: the school had a tradition of burning an effigy on Bonfire Night. In 1892 they chose the swindler, Jabez Spencer Balfour, and a few years later a suffragette.

Below: the title page of a magnificent photo album presented to the Reverend Thomas Rudd on his retirement.

Right: the Reverend Horace Hall, Headmaster 1894–1910.

Below: whole school photo, donated by the Powell family, taken just after the Reverend Horace Hall took over as Headmaster. D.H.I. Powell, second row, second from right, was wounded at the Somme. He was the editor of the South Wales Evening Post *from 1936 until his death in 1957.*

women, with Gladstone being voted the greatest-ever English statesman. Hall introduced a morning break, extended the school bounds to cover the hillside behind the school and made allotments available for boys interested in gardening. A proper tuckshop was opened under Mr. Whitehead, a new master, which supplied everything from lollipops at eight a penny to notebooks at a penny each.

But boarding life remained Spartan. The dormitories could be so cold on winter mornings that water in the wash jugs froze over. There was no hot-water supply. The food was plentiful but monotonous, the boys applying nicknames to many dishes, such as 'Good Intentions' for a particularly hard bread pudding or 'Chariot Wheels' to round tarts. The prefects had their supper after the other boys had gone to bed and often hawked their blancmanges or rice puddings to the highest bidder. On Sundays the boys wore Eton suits and starched collars and, until they were abolished in 1913, mortar boards with yellow tassels, often dog-eared and broken. About a third of the boys came from Wales, where ministerial stipends were much lower. Some, according to Hugh Stafford, 'could scarcely speak English' and, as they naturally tended to stay together out of school, they made slow progress in becoming fluent. The school made a rule that Welsh should be spoken on Sundays only.

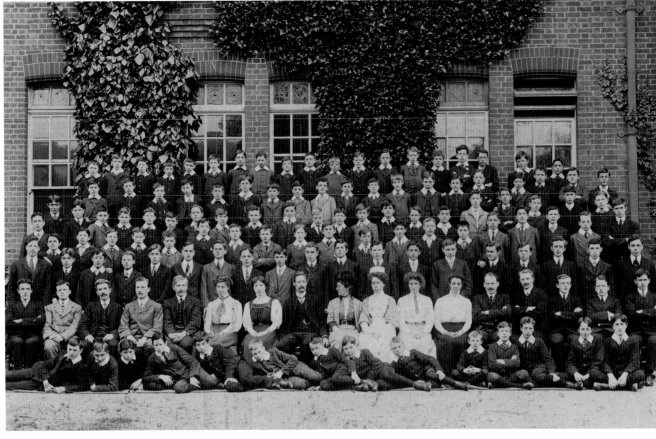

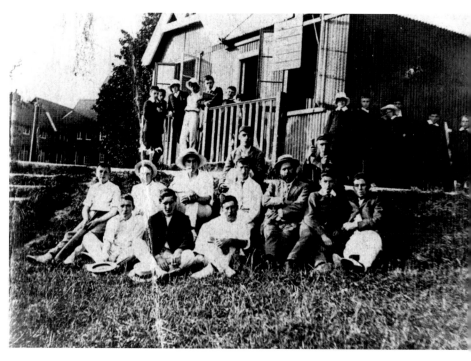

Hall retained the tradition of the annual bonfires, the guy one year resembling the latest bogeyman, the German emperor, and in another the assassin of McKinley, the US president. He also continued the tradition of awarding a half-holiday on the Headmaster's birthday. Half-days were often dispensed on celebratory occasions. During the Boer War, for instance, they were given when Ladysmith and Mafeking were relieved. On each occasion the flag was hoisted by Jack See, remembered by one boy as 'the grumpy old porter', who was prone to 'nipping' boys unawares.

Sporting standards were still hindered by the poor condition of the playing field. To allow the field time to recover for the cricket season, football was played on a field lent to the school in nearby Aldercombe. But a pavilion, a gift of the Old Caterhamians' Association (OCA), was opened in 1899, another playing field over the road was bought, and hockey was revived in 1905 by Allan Mottram who had joined the staff. The newly formed school hockey team played its first match in 1906 against the Caterham 2nd XI. Although, according to the match report, the opposition were 'very much bigger and heavier than us', the school beat the Caterham side 1–0. To give every boy the chance of playing sport regularly, Mottram introduced a games league which would eventually become an elementary house system. Masters still appeared regularly in many of the teams.

Many Old Boys took an active interest in the school, whether making suggestions for the future of the school or raising funds to improve it. Boys leaving school could now join a formal organisation, the Old Caterhamians' Association,

Clockwise from bottom left: the school cook; the dining hall; a dormitory; Old Caterhamians outside the new cricket pavilion, 1899.

founded in 1891 under the presidency of Martin Luther Moss, the brother of Isaac Newton Moss. This emerged from the first formal dinner held at the Holborn Restaurant in London in 1886. (In the provinces dinners were held in Birmingham in 1890 and in Manchester in 1897.) A separate club, the Old Boys' Social Club, which organised informal weekly gatherings in London, was formed in 1899. Absorbed within the OCA in 1901, it met for many years at Walduck's Bedford Hotel in Southampton Row and was disbanded only in 1968.

The school magazine was full of the doings of former pupils. One of the most eminent of early Old Boys was Sir John Robinson, who had been at Lewisham during the 1840s. He was a beneficiary of the generosity of Samuel Morley for whom he ended up working as the manager and later editor of the influential paper, the *Daily News*, in which Morley had a substantial interest. The first Old Boy to be knighted, he pioneered the use of the telegraph for news reporting. The second former pupil to receive a knighthood was Charles King, who had been at Lewisham in the 1860s, and became Controller of the Post Office Savings Bank. Joseph Nicholson, a boy at Lewisham in the 1870s, became professor of political economy at Edinburgh University. David Oliver, a Welsh minister's son, became a much respected lawyer, university lecturer and Fellow of Trinity Hall, Cambridge. John Morgan, also the son of a Welsh minister, attended Caterham during

the 1880s and 1890s, and went on to become a leading constitutional lawyer and professor of constitutional law at University College, London. He acted as defence counsel during the trial of Sir Roger Casement in 1916 and one of his last official tasks was to interrogate the major German war criminals at Nuremburg in 1946. Vernon Mottram, the younger brother of Allan, was an outstanding scholar at Cambridge and became a pioneering nutritionist. One boy at school during the 1900s was Paul, later Sir Paul, Dukes, whose work in espionage in Russia after the 1917 revolution was as exciting as much spy fiction. G. Ward-Price became a distinguished war correspondent, reporting from the front for the *Daily Mail* during the First World War. Clement Price-Thomas became an eminent thoracic surgeon who campaigned all his life for better research into the causes and prevention of alcoholism and was knighted for operating on George VI. The story goes that after Price-Thomas had finished, he stood away and started to take his gloves off and indicated to his assistant that he could close the wound. The surprised assistant said, somewhat nervously, 'But aren't you going to do it, Sir?' Price-Thomas replied, 'I haven't closed in twenty years and I am not going to start practising on a King!'

Of those less prominent, many became ministers, not just in the Congregational Church, but also in the Methodist and Anglican churches. Old boys could also be found in academia and teaching, the law, accountancy, insurance and banking,

Below: the Old Boys' Annual Dinner at the Holborn Restaurant in 1902, with Allan Mottram, second from left; J.H. Stafford, fourth from left; J.H. Davenport, President, standing; Sir John Robinson, editor of the Daily News, *second on Davenport's right; F. Carruthers Gould, well-known cartoonist for the* Westminster Gazette, *at the end of the table on the left.*

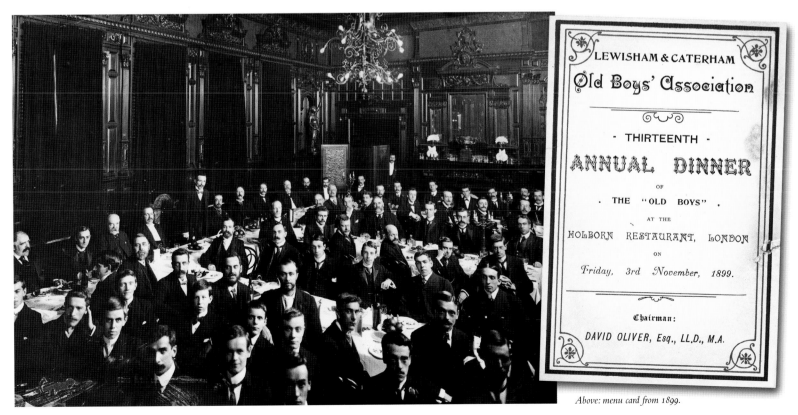

Above: menu card from 1899.

civil engineering and architecture, business and commerce, and the armed services. The Boer War saw the first deaths of former pupils on war service. One former pupil, Montague Atkinson, was described in the magazine in July 1906 as 'a motor manufacturer'. Quite a number went overseas, as missionaries or diplomats, in business or the colonial service. The section entitled *Letters from the Colonies* was for several years a popular part of the school magazine. Public service was a common characteristic, through local government or on school boards or on the boards of guardians for the Poor Law.

One of Hall's strengths was his ability to appoint capable staff although lack of money limited the number he could recruit. Hugh Stafford, for instance, graduated in classics at Cambridge, taught briefly at Taunton and came to Caterham in 1899. One of just six masters, he made a great impact on the

boys who found they had a much more personal relationship with him than any previous member of staff. He became senior Latin master and second master before retiring in 1937, for which sterling service he received 50 guineas and no pension. He also wrote the first history of the school in 1944. Allan Mottram returned to teach maths and science to the upper forms in 1902. He had graduated with a degree from London University in 1899, a route commonly taken by bright boys from poor homes for, as the school magazine had pointed out, 'the London university is the only one in this island whose degrees are accessible without residence'. This was a huge advantage for those who could not afford board and lodgings. Hall also appointed the first woman on the staff. Ida Hall, who had taken the National Froebel Union Higher Certificate in 1903, joined the school in 1904 as the first form mistress. Percy Cooling was appointed to teach English in 1909. He came with a degree from Victoria (Manchester) University and had trained as a teacher at Manchester and Cambridge. He became senior English master and died in 1937.

Hall recognised this was a time of transition for secondary education, writing in the Annual Report for 1894 that 'I have endeavoured to bring the masters of the School more in touch with one another with regard to their work, and we are thus securing a greater unity of purpose and method throughout the whole scheme of teaching'. Appointing men like Stafford was a recognition of the demand for better qualified specialist teaching staff, instead of relying on generalists. Hall's dilemma was that the school could neither afford to recruit many staff nor properly pay those already in post. In 1902 Mottram, the highest-paid master, earned just £130 (paid termly in arrears) yet the Secretary to the Committee received £200. In that year His Majesty's Inspectors found that 'the quality [of staff] is not sufficiently high'. In 1909 only half the staff had degrees.

Such constraints impeded any desire Hall had to raise standards. The school's deficiency in this respect was sharply pointed out in an editorial in the school magazine by a former pupil, Frank Evans, in 1896. He lamented the fact that the school had not yet reached 'the highest degree of educational efficiency' and went on, 'often and often is the remark made to us that boys on whose education an average of £34 per head per annum is expended ought not be occupying positions in small grocery or drapery establishments'. He identified several reasons for this situation – the antiquated admissions system, the admission of boys at the age of ten and the lack of an entrance examination. Combining an increase in the age of admission to 11 with the introduction of an entrance exam would eliminate the year spent in bringing new boys up to scratch with the basics. Instead, senior boys

Left: roller skating in the playroom.

Below: the Large Schoolroom.

Right: the Viney Laboratory was opened in 1898. At the door is Mr. F.C. Orpet, science, maths and woodwork teacher 1911–44.

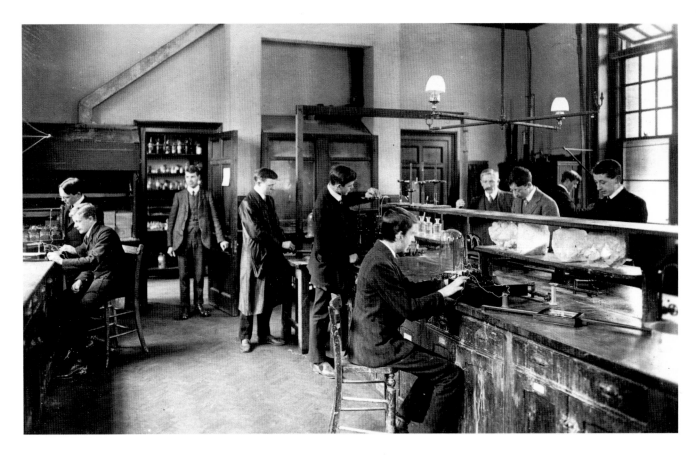

should stay on for an extra year. 'Let us show,' concluded the editorial, 'by our results in the fields of the ministry, scholarship, commerce and the professions that we are giving a liberal education fitted to modern needs'.

Hall did his best. Early on he reintroduced Greek into the curriculum. When the Reverend Josiah Viney died in 1896, leaving a generous legacy to the school, it was invested with other funds in the Viney Laboratory. Opened in 1898, built on the site of the fives court, it was praised by the education inspectors as 'second to none in the county'. In 1902 he introduced the Board of Education science course, with a course of practical physics established alongside practical chemistry. From 1899 Hall also dispensed with the examiner's annual inspection of the whole school in favour of public examinations, from the Cambridge Prelim in the lower school and Junior Cambridge in the middle school to the Senior Cambridge and London Matriculation in the upper school.

The decision to admit dayboys was made partly to raise more income but also because the school wanted to take advantage of the new system of county council scholarships which enabled the brightest boys from elementary schools to attend secondary schools. By the mid-1890s the school was aware of a latent demand for day-boy places from incoming families taking up residence in the new housing being built in and around Caterham. As the only secondary school in the local area, the school was in a strong position. Even though numbers were initially limited to ten, the decision was not a popular one. One boy, Alex Sandison, wrote home in 1896 how 'it is a shame it is getting a day school now, four day boys and two weekly boarders, the term before I came there were *no* day boys'. The issue became a controversy when a minority of Old Boys took umbrage in 1897. Airing their views at the half-yearly meeting of 'governors' and subscribers, they protested that the admission of dayboys was a fundamental change to the character of the school. There was a whiff of snobbery in all this, which Hall was quick to dispel, pointing out that at least a third of 'ministerials' came to Caterham from elementary schools. More was made of this furore than the opposition seems to have merited. The various meetings held to discuss the subject were sparsely attended, and the special meeting held by the Old Boys attracted just 20 members, with the resolution against admitting dayboys winning approval by just eight votes to five.

In 1902 there were just eight day scholars and three other dayboys out of a school roll which had fallen to 124. This number of scholars, however able, was scarcely sufficient to help to raise overall standards. A sixth form might have helped and it was an idea often talked about but until more boys brought more income into the school a sixth form would never be viable.

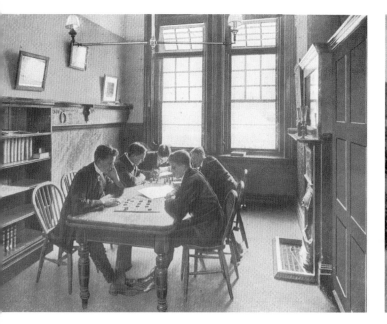

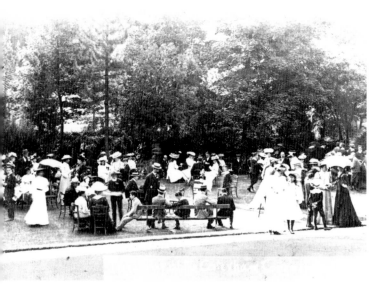

the staff were also overworked, every one of them teaching a full timetable every day, with several supervising prep in the evenings. As a result, concluded the inspectors, 'full justice is hardly being done to the [boys] which might be expected to yield results above the average'. In 1909 the report judged that staff had low expectations of their pupils and the most able had little incentive to make progress.

Reforming the admissions system had to go hand in hand with raising more money. Yet those in charge were reluctant to abandon the old way of doing things. By 1902, the bank overdraft had reached £1,000 and income had failed to cover expenditure for the previous six years. Donations, subscriptions and church collections were all inadequate and legacies were in decline. A third of boys were Foundation Scholars, essentially educated free of charge. Another sub-committee was formed 'to draw up a scheme for placing the school on a sounder financial basis'. Similar financial problems plagued other Congregational schools, such as Silcoates and Milton Mount. A joint appeal with other impoverished Congregational schools was considered but nothing was done.

The financial crisis came to a head between 1906 and 1909 as a result of a major outbreak of scarlet fever. There had been sporadic outbreaks of contagious illness since the previous serious epidemic in 1892. In December 1906 and March 1907 the disease closed the school, with all the disruption that entailed. After another outbreak in May 1907, it was decided drastic action had to be taken to prevent such disruption in future. The Committee agreed that the drains and sanitation would have to be completely overhauled. At Speech Day in 1908 it was said that the Committee had decided 'to have no half measures. Every pipe had been taken out, and

Clockwise from bottom left: speech day, 1906; senior boys playing draughts and a postcard showing the school's rural setting.

Standards were not helped by the lax entrance procedure which left decisions on admissions to the Secretary. This, said the inspectors in 1902, 'is obviously absurd. The Headmaster ought at least to have a large part in determining whether a boy is fit for entrance. The result of the present system is that no one is rejected'. What this meant, as another inspection team reported in 1909, was that many boys 'are very backward when they come to the school'. Yet the inspectors believed that it was mainly factors other than the calibre of the boys which was holding back any advance in standards. In 1902 they had found, for instance, that there was not enough science equipment even to allow boys in the same class to conduct the same experiment simultaneously. Desks were old and classrooms were crowded. The teaching was worthy but uninspired – the inspectors described it as 'monotonous' – but

Right: in 1908 the school was closed while vital work took place. Senior boys stayed at the Grand Hotel at Leigh-on-Sea during this period.

improvements carried out in all directions, so that they now claimed the School was in an absolutely sanitary condition'. The youngest boys were sent home, a group of others was housed in two rented properties in Caterham, and 35 senior boys went to the Grand Hotel at Leigh-on-Sea.

The improvements cost more than £3,000, a sum the school could scarcely afford and which, noted the Annual Report for 1909, 'sorely crippled our funds'. Parental

confidence in the school slumped and numbers fell further. A group of Old Boys proposed that the school should admit more fee-paying boarders. The appeal proposed for the centenary, it was suggested, should fund new boarding houses. More fee-payers would yield the money needed to pay for more staff and make viable the long-desired sixth form. One former pupil proposed an even more radical idea, believing the time had come for the school to admit girls.

The greatest objections to boarding school life are the complete withdrawal of boys at the most susceptible period of their lives from the humanizing influences of their homes into a system of monasticism, and the consequent blunting of the finer faculties and sympathies through lack of intercourse with the other sex by which means alone they can be adequately developed.

Needless to say, nothing was done about any of these ideas.

The annual deficit grew steadily larger, subscriptions were falling short and legacies had dried up. With the school losing money every day, the Annual Report for 1910 gloomily reported that 'the financial position is very serious, threatening even the existence of the School'.

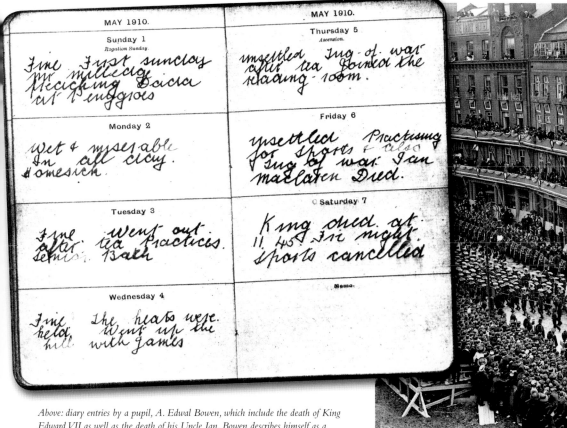

Above: diary entries by a pupil, A. Edwal Bowen, which include the death of King Edward VII as well as the death of his Uncle Ian. Bowen describes himself as a 'Missionary in Christ's Service'.

Right: the funeral of King Edward VII, 20 May, 1910.

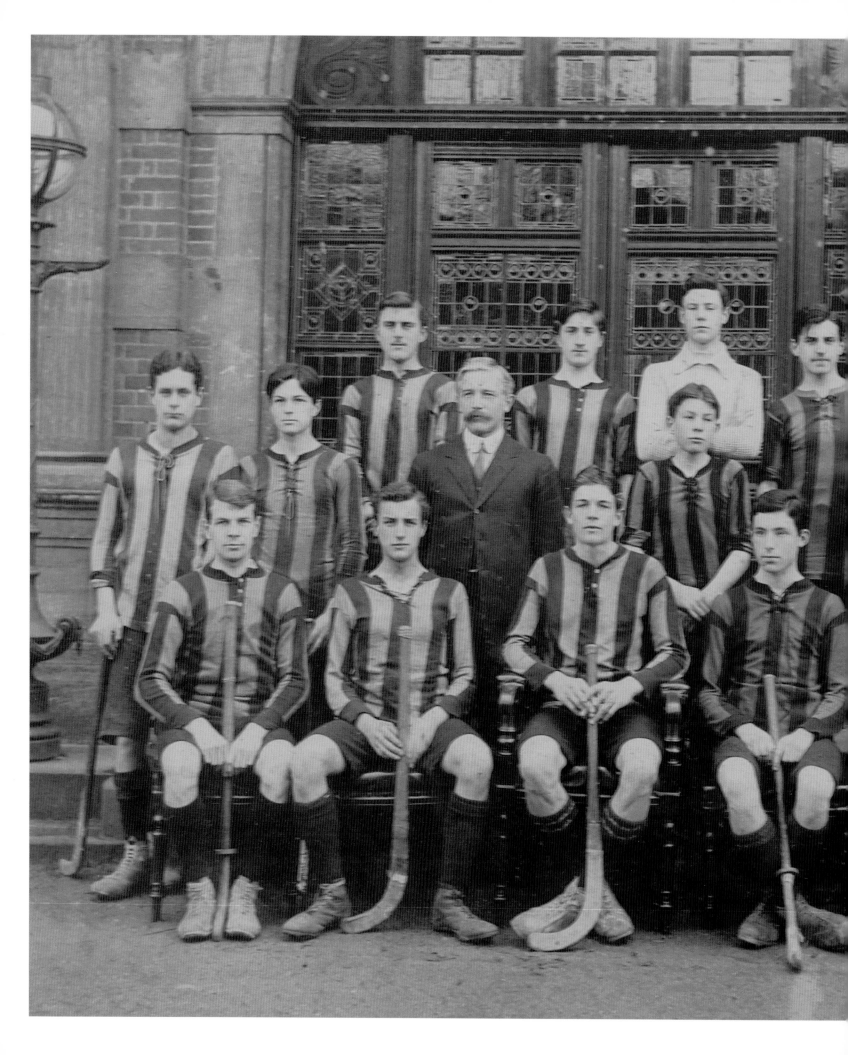

5

'THERE WILL BE NO SURRENDER'
1910–39

Running a school which lurched from crisis to crisis was too much for the Reverend Horace Hall. His health, like that of his predecessor, collapsed under the strain and he took early retirement at the end of the summer term in 1910. His popular successor was Allan Mottram. The first layman and only bachelor to become Headmaster, he lived and breathed Caterham School. His exploits on the games field as a boy had earned him a reputation which he amplified as games master on his return to the school in 1902. Yet he was not at all the extrovert, gung-ho personality this might suggest. Aged just 35 when he took over the Headship, he was described as shy, sensitive and matter of fact, nervous and retiring but forthright when he needed to be. With a keen sense of humour, he was sympathetic and fair, although inclined to side with the boys; one of his sayings was, 'Boys are always reasonable, masters sometimes, parents never!' He hated sentimentality and detested religious exhibitionism. His robust idealism had shone through during his schooldays when he had led a protest of boys from two dormitories against a member of staff regarded as unjust. According to the school magazine, the boys waylaid the master and 'intimated their displeasure in silent, but forcible, manner, in which the hardy bolster played an important part'. He was nearly expelled but his example impressed the master concerned who intervened on his behalf.

When Mottram took over, the future of the school looked precarious. Financial problems were so acute the Committee was even reduced to putting off payment for groceries from Sainsbury's. Mottram made proposal after proposal for saving a few pounds here and there which he could allocate to other priorities. The anxiety affected his health and he

Houston I 1916

CATERHAM SCHOOL

1812 — 1912.

Centenary Bazaar / Handbook & Souvenir

MAY, 1912.

Previous page: Allan Mottram with hockey team, 1912. (Mr Orpet on the right.)

came close to nervous exhaustion, suffering from serious eye trouble for a while.

There was, complained the Committee, an abundance of sympathy for its plight but very little help. From the Oxford Council of the Congregational Union in 1911 came the message that Caterham – and Milton Mount and Silcoates – should not expect any further financial assistance from the Union's central funds. The Union was criticised when 'governors' and subscribers met at the school for their annual meeting in 1912. William Pickford spoke of the debt so many boys from poor homes felt they owed to the school which had given them the decent education essential to moving up in the world. 'We will not let this old School die without a fight. And if sink it must, we will go down gloriously with the drums beating and the flag nailed to the mast. So far as we are concerned there will be no surrender.'

A handful of bequests helped. The most generous came from the estate of Stanley Atkinson, who died during his year in office as OCA President at the age of 37. He left Caterham £4,000 (worth more than £300,000 today) but his family objected and it was only after tense negotiations that the school eventually accepted the family's offer of £2,000. Further funds were raised through a bazaar organised in aid of the Debt Extinction Fund by the school matron, Miss Donaldson. Held over three days at Holborn Hall in London, this raised the remarkable sum of £1,300. The wider appeal

WORKER'S TICKET.

CATERHAM SCHOOL
CENTENARY BAZAAR.

Wednesday, Thursday and Friday,
May 8, 9 and 10, 1912

HOLBORN HALL,
GRAY'S INN ROAD, LONDON, W.C.

Hours of Opening :
WEDNESDAY, 12.30 p.m., THURSDAY, 12.30 p.m., FRIDAY, 3 p.m.

Signature of Holder *L. H. Stowell*

Top left: Allan Mottram, Headmaster 1910–34.

Left from top: front cover for the Centenary Bazaar handbook; L.H. Stowell's ticket to the bazaar; the Stowell brothers at Caterham.

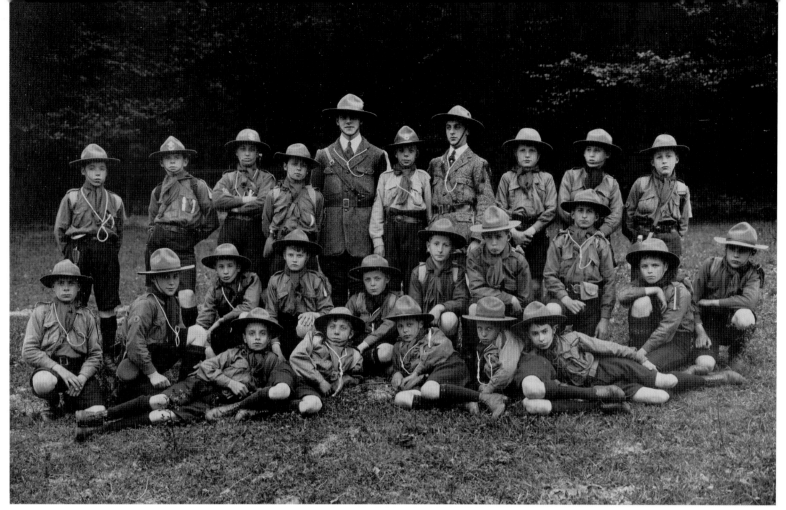

Above: Caterham Scouts, 21st Croydon, with Laurence Beauvais, 1916.

Right: scouts hiking with Beauvais.

originally proposed for the centenary by the Committee never took place, apparently because it was seen as pointless until the Union had completed its own fundraising campaign.

Increasing the school roll would prove more effective in solving the school's financial predicament than any amount of fundraising. Finally, on the advice of the Board of Education, the school's admission policy was at last overhauled. Admission by election was abolished, more sons of ministers were admitted as fee-paying pupils, foundation fees were increased and, to facilitate a sixth form, the leaving age was raised. In April 1911 there were just 109 boys in the school, of which 17 were paying full fees. Two years later numbers had risen to 162 (including 23 dayboys), with 83 paying full fees. In the same year G.C. Johnson was the first boy to leave the school as a sixth former.

The school did not stand still in spite of all these problems. Laurence Beauvais, the art master, formed a scout troop with three patrols of 23 boys in October 1912. The report in the school magazine noted that 'the country around the School is ideal for scouting games and once or twice a week we thoroughly enjoy ourselves tracking, dispatch running, cross-country running'. A Scientific Society was established, organising activities, visits and lectures. A pilot who had made his own biplane came to talk to the boys, a group of them made a wireless set and listened every day for the time signals broadcast from the Eiffel Tower, and visits took the boys to

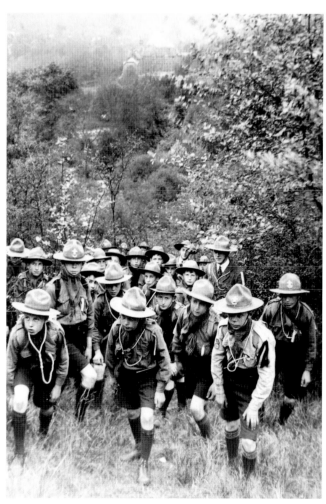

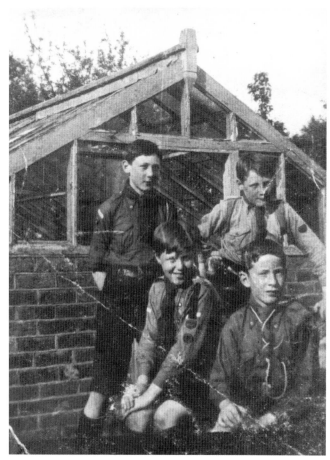

the dormitories, the laboratory, the swimming-bath, the tuckshop, music and neatness. In July 1913, Founders' Day for the first time became a whole holiday with various activities taking place during the day. There was talk of changing-rooms being provided and electric light being installed.

And then war came. The editorial in the school magazine insisted that although 'we are pacifists to a man', the government was right to go to war. The first change in school routine was the end of the traditional bonfire on 5 November – the last guy had been an effigy of a militant suffragette. The school Debating Society voted against conscription and, looking forward to the end of the war, opposed the carving-up of Germany in defeat. Senior boys left the school early to join up and several members of staff asked to do the same. By Christmas, Old Caterhamians joining the colours went equipped with woollens knitted for them by the girls at Milton Mount. But it was not long before Mottram began announcing the names of the war dead to the assembled school. Fate dealt differently with members of the same family. In 1915 Jonathan Rhys Evans was killed serving with the Royal Navy at Gallipoli, one brother was invalided home from France and another was saved from the sinking of the *Lusitania*. On the same ship, another Old Boy, J.S. Haigh, returning home to enlist, was drowned. Several former pupils who had made their mark at the school lost their lives. Lieutenant-Colonel D.B. Chiles-Evans, DSO, left Caterham as school captain in 1894, winning a scholarship to Aberystwyth and studying at Guy's before serving in the Boer War. Joining the British Expeditionary Force, he was wounded several times before returning to the front where

places as various as St Paul's Cathedral, a London brewery and a local printing works. The school took part in the Oxford University Extension Lectures, enabling them to hear the distinguished musicologist, Percy Scholes, on the lives of the great composers. The first attempt was made to create an elementary reference library with boys acting as librarians. For sporting competition, the boys were divided up into 'Territories', North, South, East and West. The prefects were reorganised and allocated specific responsibilities, including

Left: Howard Legg (left) working on a wireless set that he designed with another pupil.

Below left: scouts doing war service at Burntwood Hospital.

Below: Army recruiting parade in Caterham, 1915.

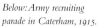

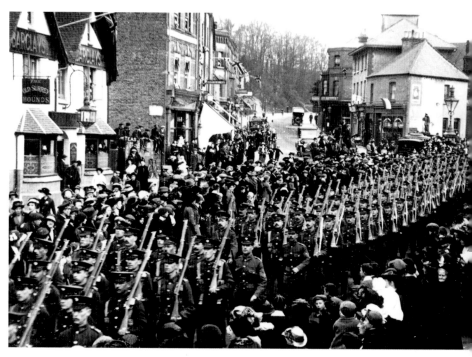

Right: the 69 former pupils who lost their lives in the First World War are commemorated on the War Memorial Tablet in the school entrance. Clockwise from top left: Donald F. Goold Johnson (1901–6), second lieutenant in the 2nd Manchester Battalion died of wounds in France 1916; he was a promising young poet. P.W. Bennett (1877–1881/2), Private, 8th Somerset Light Infantry, fought at Armentières, was invalided home, transferred to 2/5th Suffolk Regiment, contracted acute bronchitis in camp, died February 1917. D.M. Rees (1906–13), 2nd Lieutenant, Durham Lt. Infantry; captain of cricket, hockey and football; attended UCL; died of wounds, April 1917. M.R. Brierley (1892–7), Royal Fusiliers – 'perfect and prominent gamesman. One of the best cricketers the School ever turned out'; awarded DCM for valour; killed in France, 1917.

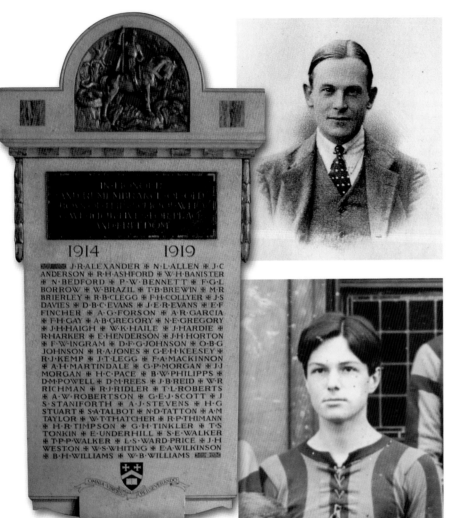

he was killed on 23 April 1916. Second Lieutenant D.M. Rees of the Durham Light Infantry, who died from his wounds in April 1917, had been captain of cricket, hockey and football and had studied at University College, London. Less than a year after Fred Gay had left school as captain of hockey and football in 1916, he was mortally wounded while on a reconnaissance flight over Vimy Ridge in March 1917. William Banister, captain of hockey and football, a school cricketer and prefect, joined up after leaving Caterham in 1917. Taken prisoner in April 1918, he died in a prisoner of war camp in July. Another casualty was Donald Johnson, who died of his wounds in France on 15 July 1916 at the age of 26. The son of a minister, he served as a second lieutenant in the 2nd Manchester Battalion. After the war his father published a small book of Donald's verse. A sensitive young man who became a convert to Catholicism, his verse showed that at the time of his death he was beginning to question the war. All told, 69 former pupils lost their lives, their names commemorated on the War Memorial Tablet unveiled by Professor Vernon Mottram in 1923.

A glimpse of the reality of war came in a letter from Arthur Ashford, serving in France in 1916.

It is scarcely pleasant to be shelled – properly shelled, so that the air is screaming and shrieking with the rush of shells of all descriptions, the earth is trembling and shaking and rocking with awful explosions, smoke and gases sting the eyes and dry the throat, and one wonders when the shell will come which is going to burst right inside one's own particular traverse or dug-out and put an end to the suspense; and this goes on minute after minute – sometimes even hour after hour and miracles happen and the shells burst everywhere – but just where I am.

The school, still in debt on the outbreak of war, was seriously affected by the dramatic rise in wartime prices. Fees were raised but many boys had been granted special rates. Staffing was reviewed even though there were scarcely enough masters to go round. Spending on repairs and maintenance on the

Food became scarce. The shelves of the tuckshop were almost bare. The boys grew vegetables and raised pigs. Mottram considered the government standard of rations to be 'too low for boys' but the school struggled even to meet this. In early 1917 even bread vanished from dinner and parents began to complain. The bread ration at tea was increased from six to eight ounces per boy but the bread was often rancid. Many boys went hungry and some began losing weight. Olliver Humphreys, who joined the school in 1916, remembered how desperately hungry boys would sneak into Caterham for a loaf from the local baker which they devoured whole as soon as they got back to school. Humphreys himself fell seriously ill as a result of near-starvation. With fuel in short supply, boys were cold as well as hungry. It did not help, as Humphreys later recalled, that the dormitory windows had to be left open all night, every night, unless it rained. 'Chilblains, on fingers, toes and ears, were the bane of my life.'

There was one major change to school organisation during the war. In the summer term of 1917 the existing 'territories' were turned into houses for sporting competition, each with several teams playing in the school leagues. A little later it was decided the houses would also compete for points awarded for examinations, weekly mark lists, entertainments and swimming. House tables were organised

Above: prefects, 1919, with three of the school's main benefactors: Arthur Burns (middle row, extreme left), Olliver Humphreys (front row, second from left) and Albert Maggs (front row, extreme right).

Top left: boys worked in the school's vegetable garden under the guidance of Mr. Pallister (below).

Below: Mr. Dear, the school bootman.

school buildings was slashed at a time when 165 boys were squeezed into accommodation designed for 150.

Even the peaceful sylvan surroundings of the school reflected the warlike times. 'The hills all round the School', noted the school magazine in 1915, 'are trenched, sentries are posted in our lanes, armoured cars with guns in charge of naval men pass and re-pass, there are rumours of arrested spies, and altogether we feel Caterham quite a military centre.' The school took in a group of Belgian refugees who were educated free of charge. One of the Belgian boys helped his peers with their French. There were visits from Old Boys serving at the front. The Committee agreed to the formation of a Rifle Brigade which boasted as many as 60 boys as members and a shooting range was set up in the swimming-bath. One evening the ghostly shapes of German Zeppelins hovered over the grounds as they made their way towards London. About eight or nine senior boys spent their weekends working in a local munitions factory while one summer others spent part of their holidays working on harvest camps in Sussex and Devon.

Above top: Alleyne became a new boarding house in 1918.

Above: the juniors' reading room.

the day off. Young Jarratt, just nine years old, and one of the youngest boys at Caterham, was among a group of friends who realised that the 20 or so soldiers sitting on the railings opposite the school were waiting for the servant girls to be let off duty and celebrate the Armistice with the rest of the nation. Realising that the military fort above the school (near what was then known as World's End and is now known as View Point) would be unmanned, the boys went up to find the gates wide open and the guard house deserted. With the war now over, they decided to help themselves to souvenirs. 'The brass shells looked lovely and would stand nicely on a windowsill.' At school one of the boys tried and failed to ignite a large flare so they decided to take the top off a shell and spill the contents onto the flare and light it. 'The result was so successful that it took my eyebrows and all the front of my hair off in one huge flare.' Humphreys, then senior prefect, found Jarratt trying to scrub the black off his face and sent him to Mottram, who accused him of stealing. 'No, sir,' replied the boy, 'only souvenir collecting.' But, Jarratt recalled, 'finding my pockets full of clips and rounds of ammunition, he ordered all the school into the schoolroom and had the prefects out to search everybody.'

At the beginning of that Armistice term the school, with 191 pupils, had more boys than ever before. Accommodation was stretched to the limit. More boarding and teaching space was urgently needed. As an interim measure, the school had leased the Reverend Josiah Viney's former home, which opened as a new boarding house, under the name of Alleyne, in September 1918. With the steady increase in the number of fee-paying boys during the war, and in the level of fees, the school had managed to reduce its indebtedness. The school magazine rejoiced in July 1918 that 'through the kindness of many friends and Old Boys, the debt has melted away. We are free, and once free, who knows what horizons may extend before us'.

This was an optimistic view. Although a school accountant, Cyril Davis, a former pupil, was appointed in 1918, the Headmaster would continue to act as de facto bursar until 1934, when Vernon Lee filled the newly created post. Fees accounted for 80 per cent of the school's revenue, with state aid providing ten per cent, a much better situation than the reliance before the war on subscriptions, collections and legacies. Even so, fees scarcely covered current expenditure. The Board of Education proved sympathetic. Schools in receipt of grants were expected to offer 25 per cent of their places free every year to pupils from elementary schools but Caterham received preferential treatment. In recognition of the number of sons of ministers educated almost free of charge, the figure was reduced to ten per cent. Since the

for dinner, presided over by the respective house masters, Dr. Denby, Mr. Cooling, Dr. Stafford and Mr. Douglas. In January 1918 the school magazine reported that 'house meetings are held, when esprit de corps broods over the scene'. But the house masters had no pastoral responsibilities and there was no dedicated accommodation for any of the houses within the school.

The school also seems to have established links with the neighbouring girls' school, Eothen, by the end of the war. Eothen, founded in 1892, lacked laboratories so girls studying science came to use those at Caterham every Wednesday afternoon.

The school heard of the Armistice at about 11.30am on Monday 11 November 1918. With the Union Jack flying from the flagpole, the boys gathered around and sang the National Anthem and 'Rule Britannia' before being given the rest of

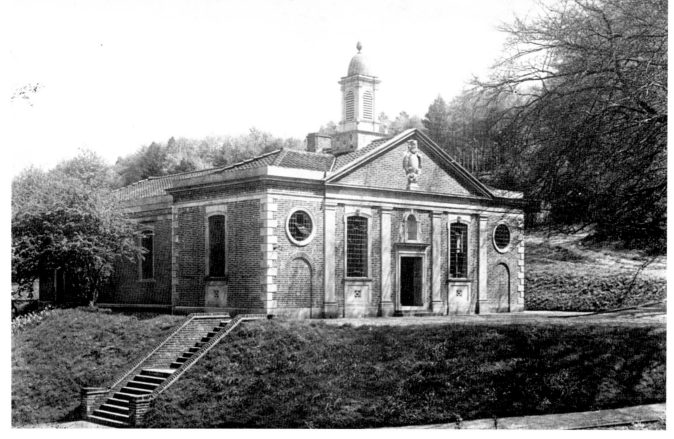

Surrey County Council revived its scholarship scheme, the Board still allowed the school to maintain the same percentage while in receipt of the full grant from 1929.

This helped to cover current spending but capital expenditure remained almost out of the question. The school could afford to expand teaching space only through the purchase of two huts. To do any more than this – and improvements were essential to cater not only for the increased number of pupils but to maintain the reputation of the school – Caterham relied on the generosity of the Congregational Union, the OCA and a handful of wealthy benefactors.

In this respect the role of the OCA since its formation should not be underestimated. Former pupils throughout the school's history have maintained a keen interest in the future development of the school. The Association had first raised funds for the swimming-bath in the 1890s and would follow this example repeatedly over the years, from the hall built as a memorial to those who had fallen in the First World War to the trust fund established in recent years to create bursaries for deserving pupils. The desire to help the institution stemmed not just from the need which arose at a time when the school was financially hard pressed. It also came – and still comes – from a feeling among so many returning leavers that, whatever physical changes may have taken place, the spirit and the values of the school remained undiminished.

balance was made up by scholarship boys funded by Surrey County Council, there was no additional cost to the school. Even when the Council ceased to send scholarship boys for a time after the war, the Board did not insist on the school making up the difference. After the regulations changed, and

After the war the attitude of the Congregational Union towards the Congregational schools changed. In the early 1920s it established the Forward Movement, intended to drive the Union forward in the new post-war world. The Union agreed to set up a £50,000 capital fund on which the schools

Above: pupils taking part in the service to mark the opening of the Memorial Hall.

might draw for approved projects; Caterham continued to benefit from the fund until the 1980s. Perhaps more important was the renewal of the school's relationship with the Union. For many, Congregationalism remained an integral part of the school. When the school wanted to change its name in the early 1920s from Caterham Congregational School to Caterham School, the idea was rejected by 'governors' and subscribers, as it had been before the war, although this time a compromise was agreed – the name would remain the same but the school could be *cited* as Caterham School.

The Old Boys worked hard for the school and organised an appeal for funds to build a school hall in memory of the war dead. Designed by an Old Boy, W.E. Keesey, the War Memorial Hall (now the Maggs Library) was built on the hillside above the main building. Opened by Viscount Leverhulme on 16 July 1925, it provided sufficient space to gather together most of the school's rising roll of 250 boys.

Below: W.J. Young.

The OCA raised £4,900 of the £5,400 total cost (nearly £230,000 today). In 1934, as a memorial to Allan Mottram, the OCA also took over from the Board the purchase and refurbishment of a nearby property, Foxburrow, to replace Alleyne as a junior boarding house.

Arthur Burns was an outstandingly generous benefactor. He had stepped forward shortly after the war, offering to buy on behalf of the school another nearby property, Shirley Goss, as an extra boarding house, a purchase completed in 1921, and now contributed £1000 towards the purchase of Foxburrow. Burns, the son of

a minister, joined Caterham in 1876, leaving four years later to enter a firm of Lloyd's insurers. In 1899 he moved to the firm of Cuthbert Heath and, as an obituary later noted, 'it was the happy combination of Heath's genius with Arthur Burns's grasp of detail which was largely responsible for the building up of the business of C.E. Heath & Co. Ltd'. Burns, who came up with the concept of credit insurance, became an underwriting member of Lloyd's in 1905 and director of C.E. Heath in 1909. He was deeply involved with the London Missionary Society and acted for many years as the treasurer of Cheshunt College. Burns was always willing to interview leavers for positions in his firm. Until his death in 1943 he was one of the school's major benefactors and played a part in almost every significant project that took place.

When the OCA raised most of the funds for the new Memorial Hall, the balance of £500 was given by another equally generous benefactor. W.J. Young became a member of the General Committee in 1921 and served until he moved away in 1946. By the time he died in 1951 he had given the school £20,000, which would be worth almost a million pounds today. As the school magazine reported on his death, 'again and again in the work of the School there would be something desirable which we could scarcely afford. Mr. Young would meet the cost. He would do it so quietly that the Committee scarcely realised what was done'. Both Young and Burns were obviously modest men for they both turned down the Committee's invitation to take up honorary positions as vice-presidents of the school in 1928.

Lord Leverhulme's generosity was completely disinterested. The son of William Lever, the founder of Lever Brothers, the phenomenally successful soap business which eventually became Unilever, he inherited his father's title and fortune in 1925, the same year in which he was invited to open the Memorial Hall. Quite how this privileged peer, educated at Eton and Cambridge, came to be connected with the school is uncertain but his involvement lasted until his death in 1949 and he served as President of the school from 1932. Caterham was not the only school to benefit from his generosity for he was also closely connected with Bolton School and Epsom College.

These three men contributed towards or financed entirely almost every one of the school's major capital developments before 1939. In 1926–7, Burns and Young together funded new fives courts, a prefects' room, an extra classroom and the extension of the large schoolroom, while Young presented the school with a Steinway grand piano for the Memorial Hall. In the following year, Young advanced £5,000 and Burns £1,000 towards a new laboratory. Young also endowed several scholarships and topped up the funds from the tuckshop,

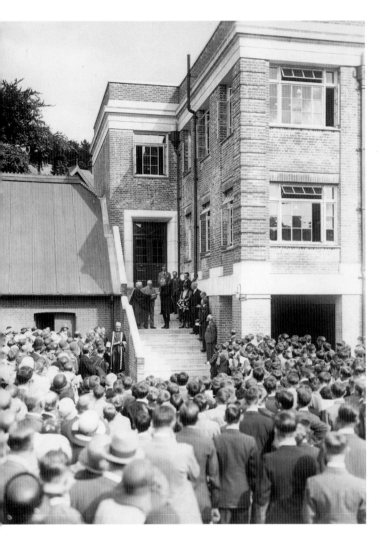

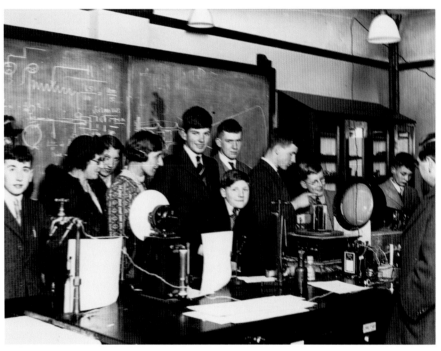

which in 1925 enabled the school to buy a film projector. With another donor, Sir James Carmichael, one-time Director-General of Housing in the UK, all three paid for the new science block opened by the Bishop of Birmingham in 1930, the single most important project completed before the Second World War. Leverhulme, Burns and Young also gave pledges covering almost the entire cost of ambitious plans drawn up in 1937 under Mottram's successor, Dr. Hall, for a new sports complex, housing a new swimming-bath, changing-rooms and a pavilion. This was partially completed in 1938, when a block containing a gym, changing-rooms and showers was opened. Rising costs were responsible for the failure to incorporate the proposed swimming-bath and pavilion and war then made completion impossible.

The school also benefited from the generosity of a Mr. Poate, an American businessman, whose son was in the school at the time. Poate acquired additional land to enable the school to build staff accommodation and, with Young, funded three-quarters of the cost of a new service wing in 1926 which included a smaller overflow dining room for the boys.

Arthur Astbury, who left the school in 1932, recalled an incident involving Poate Junior, the only American boy in the school. One morning in assembly no one answered the call to give the Bible reading. Poate, completely unprepared, was ushered by his friends towards the platform. When Dr. Stafford repeated the details of the reading, Poate casually began trawling through the Bible, even turning to the list of contents, in a vain and time-consuming attempt to find the right book, let alone the correct passage. According to another boy, T.L. Jones, who, Astbury remembered, 'rehearsed the whole affair with Celtic drama in the dormitory that night',

Clockwise from top left: the opening of the science block by the Bishop of Birmingham; Mottram and Lord Leverhulme enjoying a cup of tea after the ceremony; a laboratory open day in the 1930s.

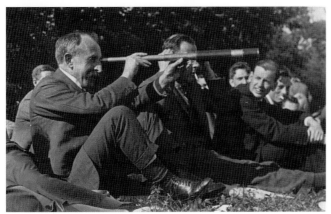

Clockwise from top left: Old Boys' sleep-over, 1929 (back row – G.M. Moncrieff, B.T. Gilling, A.F. Syer, Alan Moncrieff, A.W. Cozens-Walker, R.G.T. Rist, G.R. Tween, L.C. Rowe; front row – S.L. Jackson, H.L. Murray, E.O. Thomas, M.H. Jones, G.R. Cozens Walker, K.C. Moss); Dr. Hugh Stafford (classics, English and history master 1899–1937 and 1941–42, second master 1910–37, and author of A History of Caterham School, *1945) and Arthur Davies-Jones (see pp. 107–8) at the Old Boys' Reunion picnic, 1931; prefects taking provisions to the picnic; Landel Jones surveying the scene.*

Poate turned to Dr. Stafford and asked, 'Say, boss, where's this guy Nehemiah?', at which point he was promptly ordered to return to his seat, which he did in as casual a manner as he had sought the reading.

Poate Junior's casual approach appears to have been characteristic of the atmosphere in the school under Mottram. This did not mean that academic standards were unimportant for Mottram. He introduced the Advanced Science Course in 1918, which came with additional funding, and slowly built up the sixth form, which in a school of more than 300 pupils had more than 40 boys by the early 1930s. About four or five boys every year reached university, including Oxbridge. But the school inspectors were disappointed at overall standards. In 1922 they were pleased to find that work was not driven by the exams but, like the inspectors before the war, pointed out that this was no excuse for failing to achieve appropriate standards. They worried that the freedom they saw in the classroom was open to abuse. These remarks were echoed in 1931.

> *Considering the material that the School gets in the way of pupils (Ministers' sons – a brainy stock) generally higher academic standards might be expected … the place is a little too easy-going – an attitude that reflects the character of the*

Headmaster who certainly might be described as 'a good easy man'.

It was Mottram's sincere belief that the relationship between boys and staff must be one of friendship. Some staff believed he was not severe enough on the boys but he protested that he decided each case of indiscipline on its merits. He wanted the school to be a friendly place and invested great care and thought in the welfare of the boys. With the help of his staff, this approach, the 1922 inspection report recognised, produced 'an excellent corporate spirit' throughout the school. Mottram summed up his approach in the school magazine in 1924: 'I conceive an ideal school where staff and boys dwell in unity, where rules are common sense and few, where team-work and friendly rivalry hold sway, and where hard work and play fit us for the duties of life after schooldays are over'. He hated the way exam requirements continually narrowed the ability of the school to provide a broader, fuller education, speaking in 1928 of the 'iron grip of the examinations'. Roger Deayton, who started at the school in 1932, was among many boys impressed by the interest which Mottram took in him, although it was unsettling to be asked by the Headmaster, 'How's your soul today, Deayton?' Another pupil would later

recollect meeting Mottram outside the Memorial Hall. 'How are you?' asked the Headmaster. 'Very well, thank you, sir', replied the boy in awe. An uncomfortable pause followed. 'Why did you not ask how I am?' remarked Mottram.

Mottram's approach was largely shared by the men he appointed to the growing body of staff. Many would serve the school until their retirement, becoming indispensable to the effective operation of the school, from the classroom to the playing field and the stage. Most remained bachelors, the handful who did marry often doing so late in life. Among them was a clutch of returning Old Boys, such as Arthur Davies-Jones. Vernon Mottram, Mottram's brilliant younger brother, came back to the school briefly after the war to start the Advanced Science Course after it had proved impossible to recruit the necessary staff. He also brought Jack Foister to the school. A fellow Quaker, Foister had been a conscientious objector during the war. After appearing before several tribunals, he endured the nightmare of being smuggled out of the country with 16 other objectors to France where he faced an automatic death sentence for disobedience. Saved at the last minute, after the scandal was uncovered, he was sentenced instead to a term of hard labour in gaols in the UK. As a Quaker, pacifist and socialist, he would have found a post in few other schools but Mottram appointed him immediately after his release from prison and he remained at Caterham until his retirement. Known as 'Chick', he was a brilliant mathematician, famous among the boys for his lightning mental arithmetic in class, while the staff were in awe of his flawless organisation, as master-in-charge of athletics, of events on Sports Day and the speed and accuracy with which he completed the calculation of results. He did the *Observer's* 'Torquemada' cryptic crossword in his head while walking up Pepper Alley opposite the school. He was an impressive personality, with a deep voice and impish sense of humour. He felt completely at home with the school's educational philosophy, for he himself cared deeply that every boy should have the opportunity to make the most of whatever talent he possessed.

Another Old Boy was the Honoratus winner Norman Maddock, a physicist who joined the staff with first-class Honours in 1925 and, with his close colleague and friend, James Wenden (chemistry), and W.E. Wakefield (chemistry) made up a triumvirate of science teachers who became fixtures at Caterham until the retirement of Wakefield in 1970. Maddock caught the eye of the inspectors in 1931, picked out as the most outstanding teacher, described as 'thoroughly alive to modern methods in physics teaching'. He was a very popular man, quiet and self-contained and known as

Scenes from Old Boys' Reunion. Clockwise from top left: Newton Moss and C. Lowelby; action-packed tennis; Norman Maddock driving to the picnic spot with senior boys, including Roland Mathias (second from right at back).

'Moose' from his appearance and dour demeanour. Famed for his delight in what he called 'cunning gadgets', he was an expert in all things mechanical, and it was to him that the school owed amongst many other benefits the installation and maintenance of the swimming-bath chlorinators and filtration plant, the Memorial Hall film projectors, the sports-day public address system, and the electric clock system with first and second bells for ends of lessons. He organised with Wenden the fruit-picking camps, the Scientific Society's meetings and annual whole-school expeditions to factories and other places of interest, and the logistically challenging provision of tea for the Old Boys' hillside picnics at the summer reunions and refreshments for weary boys on school walks on the South Downs. As well as being a brilliant physicist, he was also an enthusiastic radio ham, and broadcast to other hams all over the world from a powerful transmitter (put together from old

A SKETCH-MAP
GEOGRAPHY

J. HUBERT WALKER

boys about the symptoms and problems of adolescence. He did not confine his teaching to the syllabus – instructing boys, for example, in the making of DDT – and was a keen gardener in the flourishing garden on the hillside created by C.F. Pallister, a master at the school for 36 years from 1894 to 1930.

Hubert Walker came to teach geography in 1930, retiring in 1963. He was remembered as an outstanding teacher, with many of his lessons based on the sketchmaps in his much-praised geography textbook. He was also the author of three books, illustrated with his superb photographs, on walking and climbing in the Alps and the Scottish Highlands, at least one of which is regarded as a classic. A short but strongly built man, he was the inspiration for many boys to take up walking, climbing, photography and geology. Genial and enthusiastic, energetic and warmly encouraging, his talent for writing and passion for photography were evidence of his artistic streak. He did the

Second World War equipment) which he had set up on the top of the science block. His teaching could be quirky – one experiment involved taking his class to the swimming-bath, asking for volunteers, who stripped off and were weighed before diving into the bath where they were weighed again on a spring balance to prove they weighed less in water than out of it. He kept bees in hives on the hillside and would give out a pot of honey for good performance in class.

In addition to his work with Maddock, James Wenden was a powerful presence in the lives of all boys, acting effectively as master-in-charge of discipline and as mentor to individual

his nickname as 'Weedy' or 'The Weed', to distinguish him from Hubert Walker, known as 'Geography' or 'Grinder' Walker, the cricket square inevitably became known as the 'weed patch'.

Arthur Baynon and Harold Milnes gave the first serious encouragement to music in the school. Baynon, who gained the nickname 'Banjo', joined the school in 1920. Slim, dapper, with smooth black hair, very businesslike for a young musician, he opened the eyes of the school to the wide world of music, even though he was given almost no money to spend on it. But he persuaded brilliant soloists leaving the Royal School of Music to showcase their talents at the school as well as famous choirs on their summer outings, although these were more appreciated by staff and local residents than boys. In 1926 he put on two performances of Vaughan Williams' opera *Hugh the Drover* in an abridged version with strings, flute and piano. The composer attended the second performance and said how delighted he was. It also received a creditable review in *The Times*: 'Here were just a lot of boys, some with treble voices and wearing girls' clothes, others with broken voices verging towards tenor or bass, but all thoroughly enjoying a rattling good play fitted out with exhilarating tunes'. Baynon wrote the music and Arthur Davies-Jones the words for the new school song, *Debtors*, in 1938, which was sung regularly at Speech Day until 1981. Baynon also directed the first full-scale Gilbert and Sullivan production, a performance of *The Mikado*, with

make-up for the school plays and, with a fine singing voice, always brought the house down with his rendering of popular Gilbert and Sullivan pieces, such as the *Policeman's Song*.

E.L. Walker was appointed to teach biology in 1934. Fond of pulling out in class a jar full of animals preserved in formaldehyde, he remained in charge of his subject until his retirement in 1975. He was also an outstanding coach of

Above: a scene from The Mikado *directed by Hubert Walker with Arthur Baynon in charge of the music. The Mikado was played by Mr. P.M. Soderberg (first headmaster of the prep school), Nanki-Poo by B.P. Jones and Ko-Ko by Hubert Walker.*

Left: Arthur Baynon taught music from 1920 to 1952.

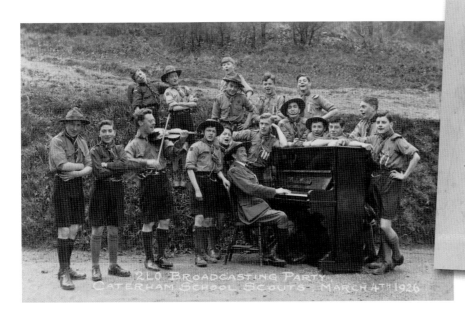

Above: Vernon Lee, on typically exuberant form with a group of Caterham scouts, with R.L. Hayward on the violin.

Top right: Caterham scout troop certificate for winning first place in Association Sports, 1924.

Right: Vernon Lee.

Hubert Walker in December 1930. In all this work Baynon enjoyed a happy partnership with Harold Milnes, an equally talented musician, who joined the staff in 1927. A cheerful Yorkshireman, he relished rugby and also cricket, coaching the 2nd XI for many years. His wife, Sheila, was a violinist who also played a part in the school's musical life. Towards the end of his career he was a firm supporter of the United Nations Association, for which he was the local branch secretary. Baynon retired in 1952, by which time Milnes was teaching in the prep school, only succeeding to the post of Director of Music in 1960, four years before his own retirement.

Baynon and Milnes were also helped by Vernon Lee who joined the school as school secretary and secretary to the Headmaster in 1920 and taught the boys to sing. He had first come to Caterham in 1916 while on leave from the front to see a friend on the staff and had become an instant hit for taking part in the school concert. Energetic, enthusiastic, with a relish for life, he was a great entertainer, who established a popular minstrel troupe and produced potted pantomimes in which he would usually star, being remembered particularly for his role one year as the Faery Queen. An expert conjuror, he was a member of the Magic Circle and was part of a command performance given before George VI in advance of the coronation in 1937. He was also scoutmaster from 1921 until 1934, running summer camps every year from Devon and St Malo to the Isle of Wight and Jersey. He relinquished this post in 1934, together with his secretarial duties, when he was appointed the first bursar. It was not a post he enjoyed and he resigned five years later to follow a professional career in entertainment.

It was not an easy life for staff. Almost all of them lived in school, in cramped and uncomfortable accommodation,

with little privacy. Their salaries were small and still paid in arrears, although this was now half-termly. With the help of the domestic staff, led by 'Ma' Donaldson, a stately and imperious Scot, feared by the boys but loved by the Old Boys, this small and devoted band directed by Mottram created a vibrant school community under difficult circumstances. These men, seen by later generations of boys as part of the fittings and fixtures, were only young when they took up their posts in the 1920 and 1930s. They helped to set up a string of new societies and activities, from the English Society (later the Literary and Dramatic Society) and Musical Society to

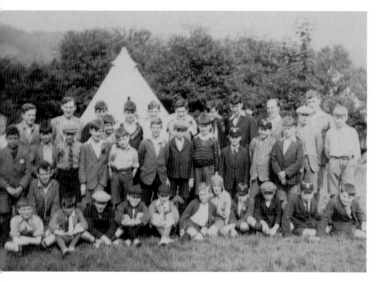

Above: the school held an annual camp for disadvantaged boys from London.

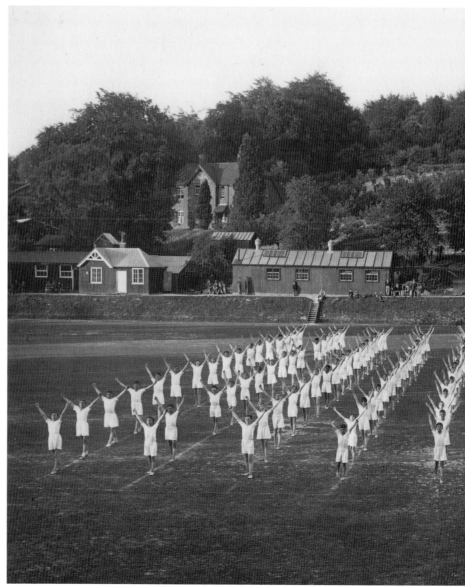

'COPEC' (Conference on Christian Politics, Economics and Citizenship), an exclusive invitation-only discussion group for senior boys held in the Head's drawing room on alternate Sunday evenings. In the aftermath of the war and the creation of the League of Nations, many schools formed League of Nations branches and Caterham was no exception. Given its Congregational ethos, it was no surprise that 15 prefects signed the Peace Petition organised on a national basis in 1931. The school magazine recorded that 'though we are by no means all pacifists, there is a good deal of League enthusiasm in the School'.

The school was conscious that, whatever its financial problems, it remained a privileged place in a world where so many had so little. For several years from 1924 Davies-Jones and Wenden, with senior boys, organised an annual summer camp at the school, shared by parties of Caterham boys and disadvantaged boys from London elementary schools. During the severe depression of the 1930s, when millions were unemployed and suffering great hardship, the school set up a fund supported by staff and pupils which assisted several local and national charities. A production of *HMS Pinafore*, again produced by Hubert Walker, raised money for the Jarrow Relief Fund, established to help the unemployed in the north-east of England. In 1932 Eric Liddell, the missionary and Olympic gold medallist, later portrayed in the film *Chariots of Fire*, stayed with Mottram and preached in front of the boys. The boys also contributed towards the Spanish Relief Fund in 1937, aiding those suffering from the consequences of the bloody civil war in Spain.

Many activities, reported Mottram in 1927, 'gave opportunities for self-expression and initiative which were sometimes missing in the class-room'. A hobbies scheme introduced in 1929 included the chance to study bookbinding and basket-making. The first overseas trip was the scout camp held near Dieppe in the summer of 1921 while the first non-scouting excursion abroad was at Easter 1927 when a party of 35 boys travelled to Corsica. Other Easter tours, which Mottram usually accompanied, included a trip along the Rhine in 1929, visits to Majorca in 1920 and the Ardennes in 1931, and a cruise which took in Gibraltar, Casablanca and Madeira in 1932. The scouts visited the Ardennes for a summer camp in 1934. Lectures, concerts and films were held in the Memorial Hall. The renowned French pianist Alfred Cortot gave a recital there in 1928, playing Beethoven and Chopin. Silent films typically featured Charlie Chaplin, Harold Lloyd and Buster Keaton, while the first 'talkie' was shown in 1932. The principal events of the year included Speech Day with its accompanying pageant, usually combining a dramatic

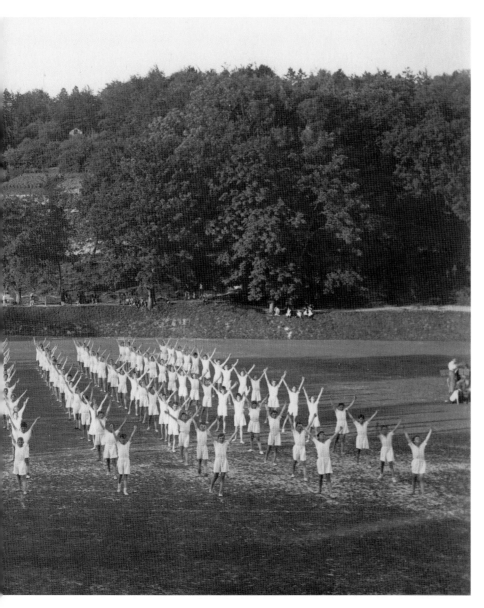

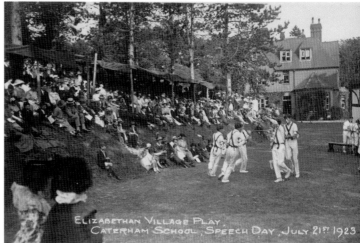

ELIZABETHAN VILLAGE PLAY.
CATERHAM SCHOOL. SPEECH DAY. JULY 21ST 1923

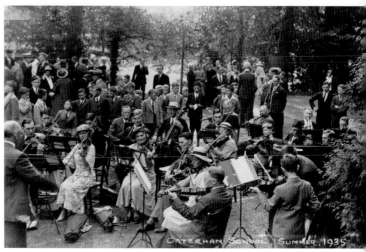

CATERHAM SCHOOL. SUMMER 1935

Scenes from Speech Day. Clockwise from above: PT display on the Home Field; The Last War, 1936; Elizabethan Village Play, 1923; a concert, 1935.

adaptation with musical numbers, when the school orchestra was supplemented by members of the Caterham Orchestral Society. From 1929 the pageant was complemented by a PT display given by 150 boys to music performed by the school orchestra. The first full play was W.W. Jacobs' *The Monkey's Paw* performed by the prefects in 1924 while the first production of any length was a performance of *The Rivals* in 1926.

Another characteristic of school life at Caterham was the long Sunday walk, which Mottram would often join with his dog Jumbo. In the early 1920s this took the form of separate parties of seniors and juniors walking to a local village before returning by train. A decade later, it had become known as the 'Orange Walk'. The boys could roam almost anywhere so long as they arranged to rendezvous with Maddock and Wenden at a particular point where they would be waiting in their car with a crate of oranges. As each boy answered his name, he

would be thrown an orange. It was possible to circumvent this supervision by having another boy respond to your name – as Roger Deayton and friends once did, heading off for an illicit lunch, with two chums who were leaving, to the Clayton Arms in Godstone, where the landlady gave them an upstairs room out of the sight of any visiting masters.

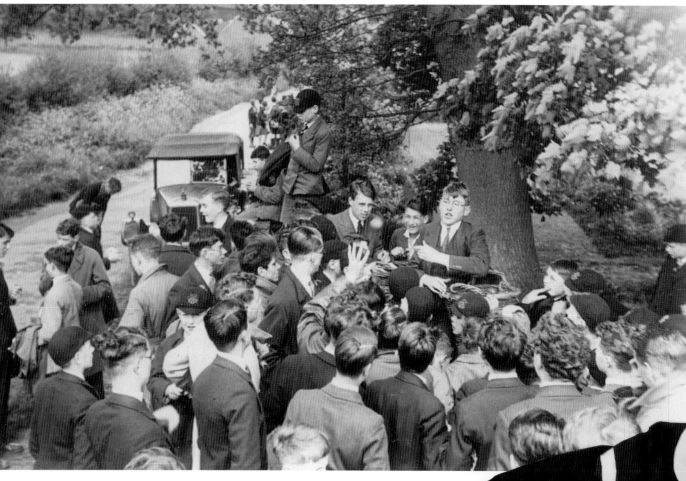

Left: oranges being distributed to participants at the end of the Orange Walk.

Below: the school crest was first used in the early 1920s.

One extraordinary event occurred on a foggy November morning in 1930. One boy, Gareth Evans, later recounted how 'a dull explosion interrupted our morning classes'. A man was seen emerging from the mist on the road down from World's End 'beating the flames from his burning flying clothes'. This turned out to be a well-known racing driver of the day, the South African, Glen Kidston. He had been on board a plane bound from Croydon for Paris. The pilot, lost in fog, decided to turn back but had insufficient height to clear the nearby woodland as he banked the plane which crashed into trees. Kidston, thrown clear, was the only survivor, yet ironically was killed in a flying accident in South Africa just six months later. The Pilgrim's Fort was used as a mortuary for the victims. Many boys went up to the crash scene and one even recovered the altimeter, which the police soon reclaimed from the school.

The school crest came into use in the early 1920s, designed by two Old Boys, A.P. Maggs and Bernard Kettle, in 1921, with the motto 'Omnia Vinces Perseverando'. Laurence Beauvais, the art master, had originally drawn the badge and crest and he was also responsible for designing the school flag, presented by Vernon Lee in 1937. The first record of

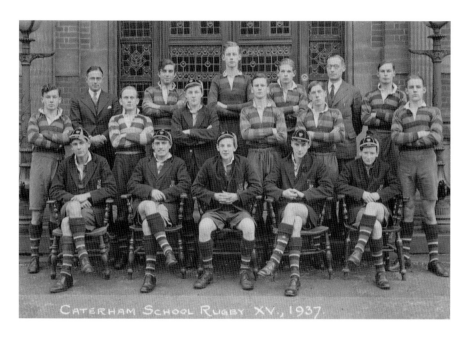

CATERHAM SCHOOL RUGBY XV., 1937.

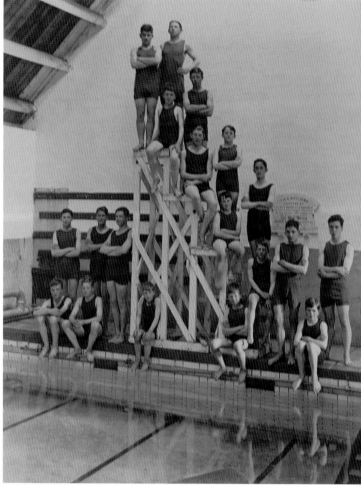

Above: rugby XV, 1937. The Headmaster's son Anthony (middle row, extreme right), S.W. Payne (on Anthony Hall's right) and K.G. Evans (behind them in the back row) died in the Second World War. In the back row are Mr. J. Hubert Walker on the left, and Dr. Hall on the right.

Far right: swimming display team.

the traditional leavers' ceremony which continues today comes in the school magazine for 1932 although it must have been performed for many years previously. Every boy leaving the school was presented with an inscribed Bible by the Headmaster at prayers on the last evening of the summer term. The end of term also brought form feasts as well as the traditional breaking-up supper when the school captain and senior prefect would say goodbye on behalf of the leavers. The tradition of commemorating the Head's birthday with a half-holiday continued and survives today.

After the war, with more boys, rugby was reintroduced. Initially extended only to junior boys in 1918, it was reinstated in 1923 as the autumn-term game throughout the school. This was possible because the original playing field had been levelled and doubled in size the previous year, thanks to the addition of land which came with Shirley Goss, and a sports field had been made available at nearby Queen's Park, large enough for another two rugby pitches. The reformed 1st XV enjoyed a successful first season in 1924, winning six of their first eight fixtures, although these were largely against 2nd XVs from other schools, such as Emanuel, St Dunstan's, Mill Hill, Eltham College and Whitgift. More boys were able to play rugby after the school at last acquired more playing fields, buying ten acres of land on the opposite side of Harestone Valley Road in 1931. This had an impact on the calibre of the 1st XV which had two record seasons in a row in 1934 and 1935. In the latter season, the team, captained by A.A.M. Heap, won 15 out of 16 matches, recording 516 points for and just 51 against. The swimming-bath was well used, although the first swimming matches would not take place until 1948. Of considerable interest to the boys was the use of the bath on

certain mornings by the girls from Eothen. (The girls would tell stories that the boys would remove a few loose bricks at one end of the bath and watch the girls as they swam or got changed; there were also rumours among the boys that the girls would come up and spy on them as they swam in the nude.)

The main reason for the growing size of the school was the admission of many more dayboys after the war. They grew so rapidly that in 1929 the Board of Management, as the General Committee had become, limited their number to a hundred. This was not strictly observed for there were 126 out of a school roll of slightly more than 300 by 1934. The demand for day-boy places was also accompanied by enquiries for the admission of boys under ten. The suggestion of establishing a prep school was first raised in 1923 and again in 1924, when a suitable nearby property called Beech Hanger became available, but negotiations for the purchase proved fruitless and the matter was dropped in 1925.

Under all the circumstances, the school had made progress under Mottram. But the Headship took its toll on Mottram's health. He had taken six months' leave in 1922 as a result of a recurring throat infection, travelling to Italy, where he

witnessed Mussolini's ascent to power. In 1924, the year in which the rising reputation of the school secured for him membership of the Headmasters' Conference, he underwent an operation. Five years later, the trouble with his throat, which may well have been cancer, returned. Anxiety over his health was compounded by worries caused by the onset of the depression. The number of boarders dropped and an Economy Committee was set up in 1931 to make cuts in spending. The number of staff was reduced, staff salaries were (temporarily) cut and a freeze was imposed on the admission of 'ministerials'. It was too much for Mottram. His health collapsed and he was given a further six months' leave in 1933, spent again travelling throughout Europe. He returned on the last day of the Christmas term to make a presentation to 'Ma' Donaldson on her retirement but it was clear that he was not himself. He was forced to ask for a further term's absence but on 13 February 1934 he took his own life in Eastbourne. His funeral, held at the church in Caterham, was attended by 200 senior boys and 100 Old Boys, many delayed by fog and arriving in time only for the graveside committal ceremony. The church was packed and the service was relayed to other mourners in the church hall. Few boys, reported the local newspaper, were dry-eyed. The OCA would later take over responsibility for the maintenance of Mottram's grave in the absence of any family.

Amid the eulogies, Dr. Whale, in his address, noted that 'some have said that our Caterham free-and-easiness tends to slovenliness … that our many-sided life has been gained at the expense of scholarship'. Perhaps it was for that reason that the Board of Management appointed an academic to become the next Headmaster.

Dr. Daniel Hall was born in Offley in Hertfordshire and educated at Hitchin Grammar School and King's College, London. After war service, he had taught history at Worcester and Bedales before accepting an appointment as professor of history at Rangoon in Burma. There he set up the history department in the new Rangoon University and became a

Clockwise from top left: Dr. Daniel Hall, Headmaster 1934–49; the opening of the junior school, 1935 (renamed Caterham School Preparatory in 1937. The house, originally called Foxburrow, was renamed Mottrams); prep school boys.

Right: Mottrams today.

college warden. By the early 1930s, the university had become the focus for nationalist opposition to the British, which may have been one reason for Hall's desire to leave. Caterham might also have been attractive, it was suggested in the second school history, *A Century at Caterham*, because he needed to educate his five children. (His three sons attended Caterham, his two daughters Eothen.) Known by the boys as 'The Pillar', he was given the support of a bursar as well as a secretary, the Board of Management no doubt seeking to prevent serious illness in the fourth Headmaster in a row.

Although he had a reputation for being a consolidator rather than a force for change, Hall quickly identified several areas for improvement. Perhaps the most important was his advocacy in his first term of a prep school, an idea which had been lying dormant for so long. The Board of Management agreed that the new school should be housed in Foxburrow, the junior boarding house, now renamed Mottrams, and

Shirley Goss. Percy Soderberg, whom the boys would nickname 'Sod', was appointed to take charge and the school opened in September 1935 with about 80 boys, split almost equally between boarders and dayboys. Three houses, Ashton, Emlyn and Pallister, were created (Phillips was added in 1946) and the school proved so successful that it was extended within a year to house more boarders and provide two more classrooms. Hall was also clear that it should act as a feeder for the main school. By 1937 there were 60 boarders and 56 dayboys in the school which was now formally known as Caterham School Preparatory.

For Hall, the opening of the prep school was just a start. He wanted to relieve the 'awful congestion' in the main school, where more space was needed and urgent repair work and refurbishment was required. The proposal for the new sports block was just the first part of a long list of improvements Hall had in mind which the war made

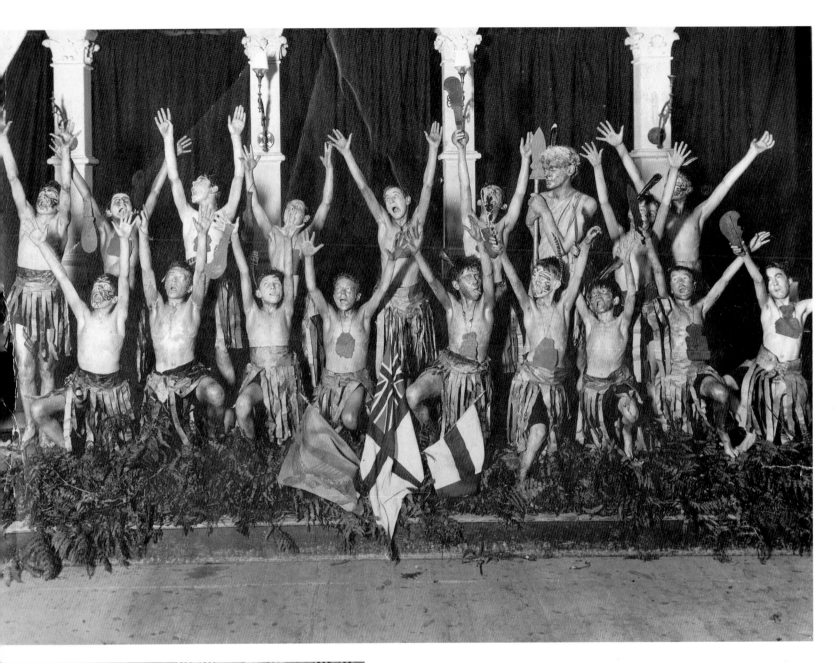

impossible. To relieve pressure on space, and swing the balance back towards boarding, he also persuaded the Board of Management that dayboys should be drawn only from the Caterham and Warlingham areas.

But Hall also had his sights on raising the school's academic standards. He tightened up the requirements for entrance scholarships and insisted that the academic development of every scholar was closely monitored. As the economy revived, and more parents took away their sons to take up jobs in banking, insurance and commerce, he also extolled the virtues of the sixth form. He was certain, he said at Speech Day in 1937, that 'the cultural value of education far outweighs all its other advantages and that boys should be educated for the good life, as the Ancient Greeks expressed

Above: a dramatic school production! Written by a boy for the end-of-term festivities at Easter, 1915, it was set in 'a Stone-Age school' remarkably similar to Caterham, with Mr. B.J. Phillips in charge.

Left: asphalt hockey.

Clockwise from bottom left: a spot of sunbathing – convalescents (from mumps?) on the science block roof, 1931; fun in the snow – on the Home Field, March, 1931; sports: 'Sacks', spring 1935; a big catch! Scout Camp, Noss Mayo, Devon, 1937 – N.A. Walker with a 15lb salmon, which he caught by throwing a stone at it.

it, rather than to become efficient cogs in the business or administrative machine'.

His plans were overshadowed by darker clouds on the horizon, symbolised by the arrival of an Austrian Jewish refugee, Dr. Adolf Ehrenfeld, to teach German in September 1938. In the aftermath of the Munich affair, Mr. Wenden distributed gas masks to the boys and supervised them as they dug trenches on the hillside. They were drilled to evacuate the school to the hillside trenches in under three minutes. Toilet-cubicle doors were removed to block up the dormitory windows. Although this crisis passed, less than a year later the Headmaster was informing parents that in the event of war breaking out during the summer holidays he would welcome back any boarders wishing to return early.

6

'COMPARATIVE NORMALITY'
1939–61

*'We are almost ashamed of the comparative normality of our life in a neutral area',
recorded the school magazine in January 1940. Many schools closer to London were
evacuated, causing great disruption which in many cases almost brought about their
disintegration and placed great pressure on their host schools. Caterham experienced none of
this and ended the war in a stronger position than it began.*

A number of boys returned to school early, even before war had been declared, while
some did not return at all. But numbers rose during the Christmas term, thanks partly
to the suspension of defined boundaries for dayboys, and, apart from a dip in the roll
during the Battle of Britain and the Blitz, that was the pattern for the rest of the war. In
January 1940 there were 339 boys in the school, a record, including 194 boarders in the
main school and 68 in the junior school. By September 1944 the roll had increased to 397
and there was a waiting list. During the early years of the war the school even welcomed
into the sixth form a few girls from Eothen. The first two, Josephine Heber and Cynthia
Gordon, came to study science, followed by several more during 1942 who attended
history lessons.

As wartime conditions fluctuated, the school had to deal with numerous requests for
dayboys to become boarders, for fees to be varied and for the remission of fees altogether
in cases where circumstances made it difficult for families to pay. Percy Soderberg,
shouldering the burden of the bursar's office in addition to his duties at the prep school,
gave invaluable assistance. The war once again revealed just how precarious were the
school's finances. The need to spend money on preparations for war, followed by the
drop in numbers during 1940, found the school more heavily in debt. A special grant of

Previous page: hockey match v. the Old Boys, 1960.

Left: filling sandbags as part of the war effort.

Below left: preparing food at harvest camp, Wisbech, 1942.

Normality was relative during the war. As one fourth-former wrote at the outset.

> We have not had to be moved and we have had none of the war itself. I suppose you can't forget the war very well. What with taking up your gasmask to bed and arranging your clothes in ARP style. But there are plenty of ways to forget it. There's rugger, running and the routine of the day. Still, soon we hope to have no war to try and forget about.

During that first term the school busied itself in preparation for war. The school day was altered to meet the requirements of the blackout, supervised by Mr. Wenden. There were as yet no air-raid shelters but the trenches on the hillside were in use, illuminated through the ingenuity of Mr. Maddock. Within a week of war being declared, the trenches had been used three times during air-raid warnings. Maddock also organised a reliable system to raise the alarm in case of raids and an ARP siren was fitted to the school tower. When the bombing began in earnest in the autumn of 1940, the school was turned upside down as a precaution with dormitories becoming classrooms, and classrooms dormitories. This also avoided the need to spend endless nights in the trenches. Proper air-raid shelters constructed by walling up the

£700 from the Board of Education in 1941 scarcely made any impression on a bank overdraft which had reached £21,000 (worth nearly £800,000 today), and which the bank, noted the Board, 'very strongly wished' to see reduced. 'Extreme economy' was practised and the school had further reason to be thankful to Arthur Burns, W.J. Young and Lord Leverhulme, each of them contributing a significant sum to bring down the debt in 1942. It was one of the last gifts Arthur Burns made to the school before his death in 1943.

spaces underneath the science block were completed only in December 1941, allowing the school layout to return to normal. Meals, services, prayers and prep all took place in the dining hall. Regular night patrols were organised, based on the top floor of the school, with masters and boys fortified by cocoa and ship's biscuits and protected against the winter weather by woollen helmets, known as 'pixie hats'.

It became increasingly difficult to find suitable replacements for the teaching staff who left for the services, but the school did find the occasional gem. Among them was Leslie ('Daddy') Daw, who came in 1942 with a first-class degree in History from Birmingham and another in Economics from LSE. 'It was quite interesting,' a former pupil recalls, 'in that era of post-war social change and in the context of a public school to be taught by someone of left-wing persuasions. He said to us once, "I really don't know why Dr. Hall took me on!"' It reflects well on Dr. Hall and Caterham's ethos that he did, and his politics had no detectable effect on his teaching unless it was in his profoundly knowledgeable coverage of themes like the growth of suffrage and the trade union movement. In general, he contributed much to the school's liberal outlook.

His occasional emphatic stutter and rather jerky gait only seemed to enhance what is unfailingly described by his pupils as 'brilliant' teaching. With him, History was dramatic. He was a compelling story-teller, drawing the class in and making vivid the narrative and its characters with humour, wit, satire, and passion, having what his friend Arthur Davies-Jones called in his retirement tribute a 'constitutional inability to be dull'. His ingenious blackboard presentations, summarising complex pieces of history, often in the form of acrostics with such titles as 'Bismarck in Brief' or 'Canned Cavour', showed his pupils

Below: the Battle of Britain took place in the bright blue summer skies above Caterham, 1940. Painting by Airforce Commodore Norman Hood.

how facts could be marshalled into easily-learned formats, and it was in his lessons that many pupils acquired similar arts of selection and abbreviation in note-taking. 'He was the only teacher I had,' another former pupil recalls, 'who demonstrated anything in the way of exam technique - efficient and exciting ways of absorbing and demonstrating knowledge and argument. One felt he was very modern and LSE-ish.'

Whatever he did for the school was done with flair, alacrity and commitment. He produced one-act plays for school concerts, handled the business side of full-scale productions and was an entertaining actor himself. He supported the Debating Society and for eleven years edited the school section of the magazine. He had great loyalty to his pupils and interest in them after they left. Colin George, for example, the founder of the Crucible Theatre in Sheffield, remembers that in spite of illness and being in a wheelchair, Leslie Daw came to see a production of *Hamlet* he was directing at the Haymarket Theatre, Leicester. He had to leave early – but came back for another performance. He left Caterham in 1955 to become Headmaster of Kibworth Beauchamp Grammar School.

The school was fortunate that many staff were also above the call-up age, providing the school with precious continuity, helped by the willing recall from retirement of Dr. Stafford. Dr. Hall was tireless in his work for the school, to the extent that his health broke down during 1941, causing an illness which lost him his left eye. The acute shortage of domestic staff placed equal stress on the school's matron who was ordered to rest, suffering from the consequences of overwork, in 1943. To make up for the shortfall in labour, the boys were pressed into service. They made their own beds and stacked their own plates, adding more tasks as the war continued, including carrying coal, laying tables and peeling potatoes first thing in the morning. The fourth form moaned about the food that, 'what with the bread ready buttered, no sugar at dinner, and other rations, things seemed very crestfallen'. As food became scarcer later in the war, the boys, remembered Ewart Okey, who was one of them, always felt hungry. Since bread was never rationed, the boys made sandwiches of everything, including shepherd's pie.

The school took in Dutch and Belgian refugees after their home countries had been invaded. The five boys from Belgium spent the entire war at Caterham before being repatriated in 1945. In the spring of 1940 Dr. Hall was indignant when a 16-year-old boarder named Leonard Auerbach, a German Jew, was taken away by police for internment, and wrote to the Home Office demanding his release. Later that year it was discovered that Auerbach had

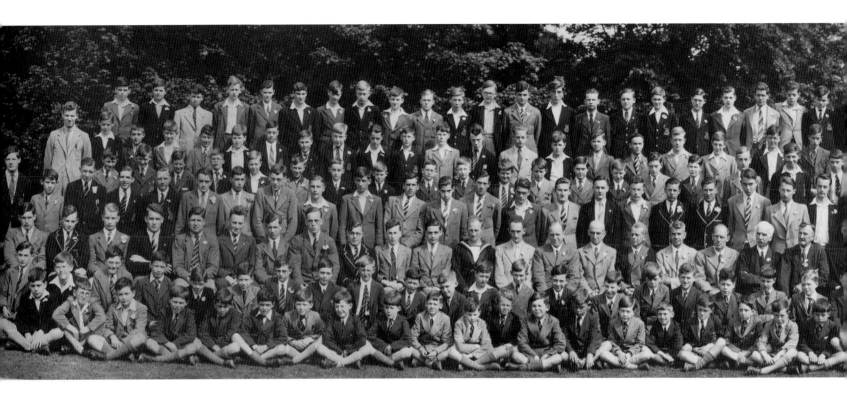

been evacuated for internment in Canada. The school offered to take full responsibility for him if he was allowed back but nothing seems to have transpired.

The reality of war came closer as the Battle of Britain took place in the bright blue summer skies above Caterham. The Board of Management, with the school's administrative offices, had been evacuated from the Memorial Hall in Farringdon Street in London and was meeting regularly at the school for the first time. The closing remarks of the minutes of the Board of Management for the meeting held at the school on 15 August 1940 noted that 'the meeting was brought to a close by a fierce air battle overhead'. Suddenly, the war felt much closer. One boy, Charles Corner, remembered walking home with his friend John Houghton while the battle raged above them, spent ammunition falling from the cloudless sky. With frequent low-level attacks, the boys were told to move around the school under the cover of the trees or close to walls, and cricket whites were abandoned for the duration on the grounds that they made the boys too conspicuous. In the early hours of the morning Mr. Phillips, the second master, who had postponed his retirement, came across a German airman who had just baled out, arrested him and marched him to the nearest warden's post. At the end of August it was reported that one boy, Cosh, a third-former, trying to reach his parents in Venezuela, had been on board the Dutch liner *Vollendam* when it was torpedoed crossing the Atlantic to Canada on 30 August 1940. He was at sea in a lifeboat for two hours before being picked up by an oil tanker in the accompanying convoy.

The proximity of war was accentuated when bombing raids began in earnest in the autumn of 1940. Corner and his friend Graham Cox stumbled one afternoon across the top gun turret jettisoned from a Dornier the night before. The guns were still loaded but the trigger guard had become bent during the crash, preventing them from firing. The boys unloaded the guns, took out the firing mechanism and removed the twin machine guns. Staggering back very late for supper to Mottrams under the weight of the guns, they decided disclosure would bring them fame – 'we were heroes for days with our fellows'. The school itself suffered very little damage – the nearest bomb fell a quarter of a mile away on the hill behind Underwood Road in December 1940, blowing out the glass in several windows, but there was little other disturbance and the boys remained in bed. But many local people were rendered temporarily homeless from time to time and the school provided food and shelter for several groups of up to 60 people during 1940.

In the summer of 1942 two boys, J.M. Constance and J.F. Murray, were seriously injured during the holidays when they stepped on a live grenade left lying in a field used for practice by the military. A year later a group of boys rushed after tea to the site of a downed bomber but their excitement was mixed with horror at the realisation that the remnants also included parts of human bodies. They suffered nightmares

Above: school photograph, summer 1941. The staff, left to right: H.R. Nayler (on naval leave), E.L. Walker, W.H. Milnes, A.J. Baynon, A.J. Davies-Jones, F.C. Orpet, W.N. Maddock, Dr. J.H. Stafford, the Rev. W.L. Lee, Dr. D.G.E. Hall (Headmaster), B.J. Phillips (second master), P.M. Soderberg (prep school Headmaster), H. Ward, J.A. Wenden, N. Montaro, J.H. Walker, R.L. Hayward, J. Foister, L. Beauvais, Miss E.M. Dixon.

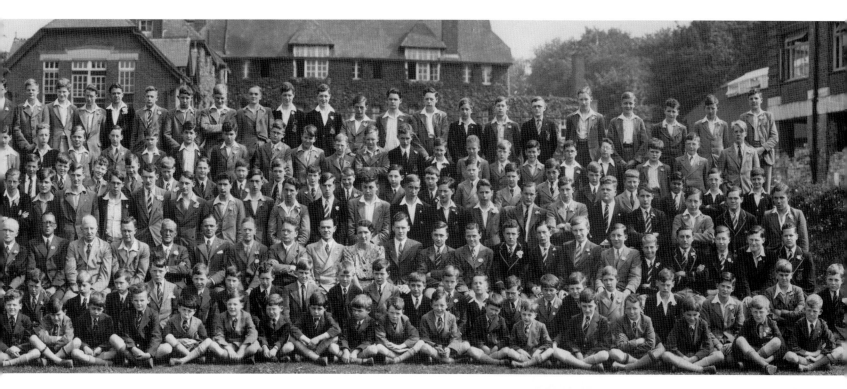

for several weeks. When three dayboys were caught stealing 'weapons of war and explosives from the military', as the Board of Management minute put it, in 1944, two were expelled and one was placed on probation; they were all given probation when they appeared before the local magistrates.

In the run up to D-Day in June 1944, Caterham was one of the many places used by troops as a stopping-off point. Ian Adam recalled mainly Canadian troops billeted in the big Victorian houses fronting Harestone Valley Road, with their jeeps and lorries littering the road. 'Then, one morning, nothing. Men and machines all gone overnight. We learned it was D-Day. Our Canadians had joined the Allied forces.' During that summer flying bombs menaced the capital and with the school lying on their flight path it was considered wise to abandon the formal Speech Day. At both the main school and the prep school, the boys spent every night of the last few weeks of term sleeping in the shelters. By then the main field had been requisitioned and a searchlight battery stationed on the prep-school cricket pitch. The school was not happy about this but did everything it could to make the battery crew, who were sleeping in the scout hut, as comfortable as possible. The crew held their own sports day in the school grounds in May 1944, when the boys were given a half-holiday to support them. By the end of the summer the crisis was over and the searchlight had gone.

Throughout the war the school enthusiastically engaged in activities which supported the war effort. Several staff and a number of senior boys joined the Home Guard who, with the

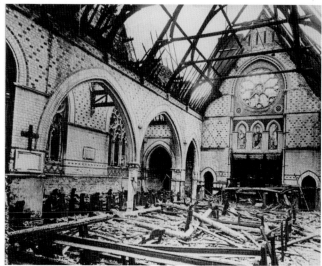

regular army, made use of the Beeches field. The formation of any type of military unit had been a sensitive issue at the school but a questionnaire circulated just prior to the war had indicated considerable support among parents. As a result, the Air Training Corps (ATC), Caterham School Flight No. 547, was formed on 1 February 1941, open to all boys and Old Boys between 16 and 18, under the command of Wenden and Maddock. Senior boys also attended ambulance classes and were given training in driving and maintaining tractors. They worked on the Marden Park estate in the early years of the war and from 1942 onwards groups of boys spent their summer holidays on harvest camps at the fruit farms near Wisbech managed by an Old Boy, Arthur Hailes.

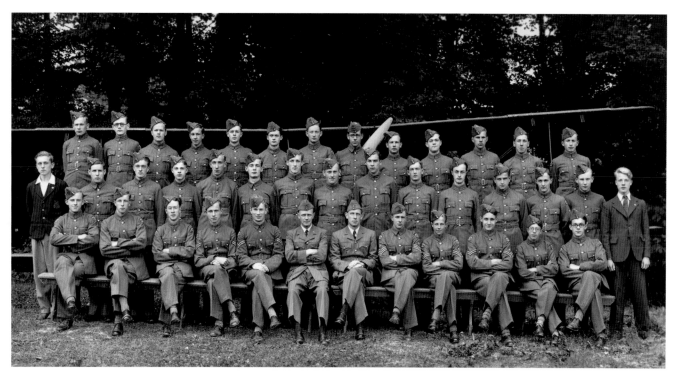

Left: 574 (Caterham School) Squadron ATC, formed in February, 1941, was commanded by Messrs. Wenden (centre left) and Maddock (centre right).

Below left: much interest was aroused on Speech Day, 1942, by the Corp's own Blackburn B2 Trainer.

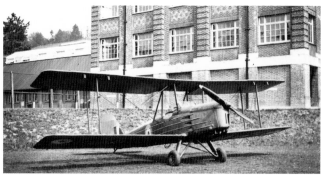

A Labour Corps was formed which worked on the school gardens during games periods in the summer term. The scouts zealously collected waste paper and fourth-formers enthusiastically grew potatoes on their allotments.

Fifty-six Old Boys lost their lives on active service during the war. The first two were Flying Officer Douglas Allison, listed as missing in January 1940, and Sandy Patterson, killed while serving with his anti-aircraft unit in Essex on 6 January 1940. Patterson's brother, James, was killed while serving with the RAF in November 1944. Midshipman Roy Knight, aged 22, was one of the many seamen lost when HMS *Hood* was blown up by the *Bismarck* in 1941. Before he joined the Royal Naval Reserve, he had been the sole survivor of the crew of a tanker which had been sunk. In October 1942 Lieutenant Tony Stephens was killed in North Africa. Captain of hockey, rugby and cricket, the school magazine noted he had been 'a real leader in school life'. Leaving school in 1937, he had studied English at Cambridge for two years, and had

been granted a wartime degree before joining the army. For Dr. Hall, the anguish of these losses was rendered almost unendurable by the loss of one of his own sons. Anthony Hall had left Caterham in 1939 and, as a flight sergeant pilot in the RAF, was killed in November 1943 serving with the Beaufighters of Coastal Command. Captain Richard Barrie, killed in Burma in January 1943, left behind a daughter he had never seen. Flight Lieutenant John Sloper, who already held the DFC and Bar at the age of 22, was killed in August 1943. He had been among those boys who had attended the first harvest camp in the summer of 1940. L.N. Grebby, a prisoner of the Japanese, died on the Burma railway in July 1943. His son John entered the school in 1945. The name of each one of these 56 men was read out at a moving memorial service held on Old Boys' Weekend in July 1947.

While waging war, the government was also planning for peace. Educational reform was high on the agenda. There was a fear among some schools that the direct-grant system, through which schools like Caterham received grant aid directly from the state in return for the annual allocation of a proportion of free places, would be abolished. The affected schools began to organise and in 1942 Hall accepted an invitation to join a fledgling body for their defence. He remained optimistic about the outcome, telling guests at Speech Day in 1942 that Caterham was well placed as a boarding school to supply any demand for boarding under a new national scheme. The topic was debated frequently and at length by the Board of Management. They also discussed the

Above, left to right: midshipman Roy Knight was one of the 1,415 seamen lost when HMS Hood was sunk in 1941; the first OC to be killed in the war was Flying Officer Douglas Allison; Dr. Hall's son, Anthony, who left Caterham in 1939, was killed in 1943 when serving with the Beaufighters of Coastal Command.

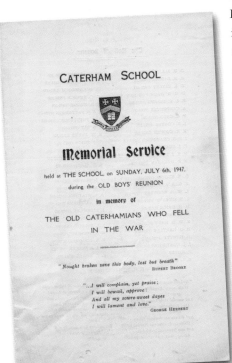

Fleming Report, which considered the integration of non-state schools into the state system, as a result of which the Board wrote to the County Education Officer for Surrey of 'our desire to do everything possible to make our School meet local needs and integrate it into the education provisions of the locality'. The reforms proposed by R.A. Butler, president of the Board of Education, which were enshrined in the 1944 Education Act, a major landmark in British educational provision, were wholly supported by the Board and the Headmaster insofar as they related to the future of Caterham School. There was never any question that the school would decide to do anything other than apply to continue as a direct-grant school. Financial considerations made complete independence out of the question. But the Board and the Head were also strongly in support of the principle that no boy should be denied an education at the school because of an inability to pay fees. And the Headmaster hoped, recorded the school magazine, that 'while preserving the high ideals for which it stands, our School may be able to play its full part in the great advance in the national system of education'.

The end of the war was broadcast on Monday 7 May, with a declaration that the following day would be Victory in Europe Day. As soon as they heard the news, the boys dashed onto the fields, hoisting various flags in celebration. Most boarders left for home after breakfast the next morning. Those left behind enjoyed a leisurely day, which culminated in a bonfire bearing an effigy of Hitler. Combined with a firework display, it was an impressive sight after so many years of the blackout. The school magazine described 'the flying sparks against the black sky, the red glow towards London, and, by no means least, the gangs of boys scouring the hillside for wood, or carrying great logs up from the Fives Courts'.

Just weeks later, the school heard that it had been granted direct-grant status. Surrey Local Education Authority agreed that it would take up no less than 25 per cent of the school's annual entry as free places for scholars who had passed the county's common entrance examination. As with many other schools, this constant influx of able boys would do much to lift academic standards and raise Caterham's reputation. By September 1946 Surrey was taking 34 places a year at the school.

Slowly, but only slowly, peacetime brought a return to normality. By the Christmas term of 1945, the blackout had gone, the annual bonfire had been revived and ice cream had returned to the tuckshop. On that first bonfire night after the war the boys made many of the fireworks themselves. One went off in the jacket pocket of a small boy during evening prayers, filling the hall with smoke. But the signs were also there of the cost of the war to the British economy, with a shortage of textbooks and sports equipment, while the changes wrought by the war in employment made it difficult to find domestic staff. The bitter winter of 1947 seemed in tune with the austere times. One boy, W.N. Hyde, later remembered how there was no hot water and 'the snow came through the ill-fitting dormitory windows and remained unmelted on the sill'. Another, Peter Calviou, wrote how the school was so cold that 'we used to have to go for a run on the field between periods to warm up'. The boys worked hard to clear the pitch of snow to allow the hockey match against

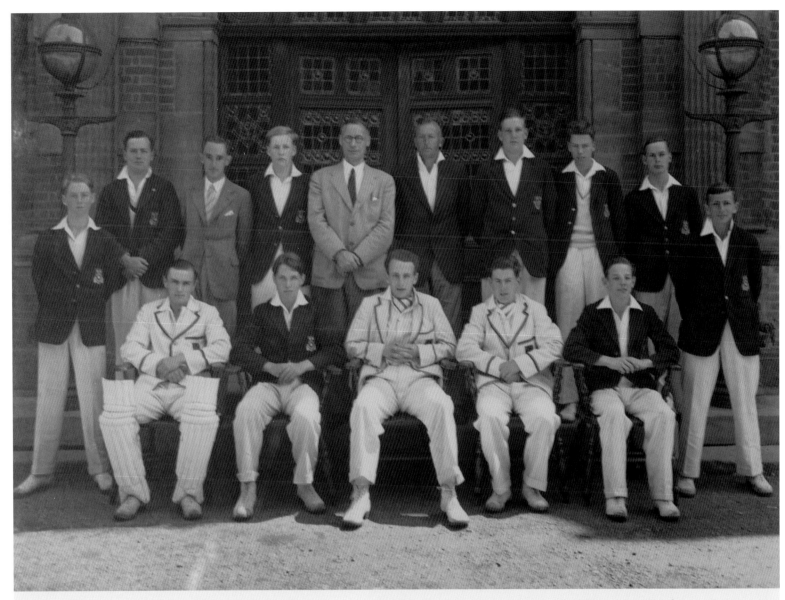

Caterham School 1937 1st XI cricket team. During the Second World War nine members of this team volunteered to join the armed forces. Two were killed and their names are to be found on the school's war memorials along with the other 120 OCs who died in the First and Second World Wars. Front row, left to right: J.J. Webb, D.K. Britton, A.J. Stephens, D.E. Jenkins, D.T. Whalley Second row, left to right: R. McNeill, T. Evans, A.J. Bligh, I.W. McDowell, D.G.W. Brind, K.G. Evans, C.R.C. Howard [3 boys didn't join up].

J.J. Webb: Started in the engineers' department at Deptford Town Hall and then joined the R.A.F. In May 1942 he wrote 'good luck to the School cricket team. I long for the day when I can play cricket again at Caterham. Happy memories!' In 1943 he was promoted to flight sergeant having fought in the battle of El Alamein. He was later transferred to Italy.

A.J. Stephens: Captain of all three sports and a gifted leader. The Headmaster said that he often wondered who was running the school 'me, or A.J. Stephens?' Stephens started at Cambridge University but left to join the army. Before heading off he returned to Caterham to play in the Old Boys vs. the School cricket fixture. After scoring a century, he wrote that he almost walked off the Home Field straight onto the boat. By March 1942 he was a captain in the Queen's Own Regiment. In April 1942 he married Miss Judith Drinkwater but was killed in North Africa on 26 October, 1942. He was 22 years old.

D.E. Jenkins: Joined the Royal Engineers. He wrote to the OCs' Association in September 1944, 'sorry for my three years of silence in which I have been posted overseas. The Association and its publication has been a very real, if sometimes bitter, link with happier days'.

T. Evans: Became a wireless operator in the Navy and survived the war.

A.J. Bligh: Started army life as a second lieutenant in the Gold Coast Regiment. He was wounded a number of times. His stories of the war were legendary and an OC remarked that 'AJ's stories will give us many happy evenings down at the Old Caterhamians Club'.

I.W. McDowell: Joined the Royal Artillery and survived the war.

D.G.W. Brind: Served as a lance bombadier in the Royal Artillery and was posted to India. In May 1943 he wrote, 'I am sorry to have missed so many Speech Days and Old Boys' Days but please be assured that memories of Caterham are still firmly rooted inside. The School has given me a crutch to lean on which has helped me bear the heavy burden or responsibilities of being an NCO in wartime'.

K.G. Evans: Evans was captain of all three major sports at Caterham. He started university but left to join the Royal Armoured Corps which, he wrote, 'is definitely the pick of the Army'. In 1942, while serving in the Middle East , his tank was hit by a shell. He died of terrible wounds. He was 20 years old.

C.R.C. Howard: Joined the Royal Engineers and was posted to India. In the later stages of the war, at the age of 22, he was in charge of over 600 soldiers, including, he was delighted to report, two Ardingly boys he played against in 1938!

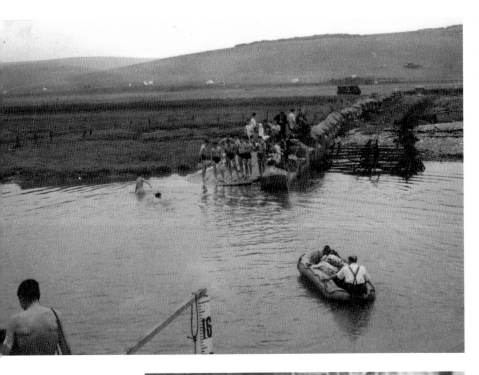

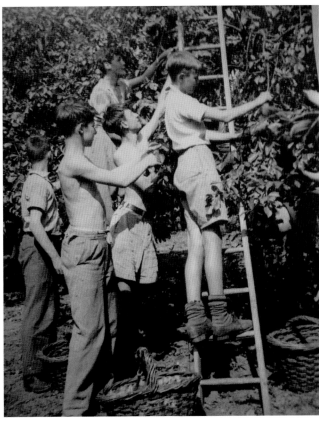

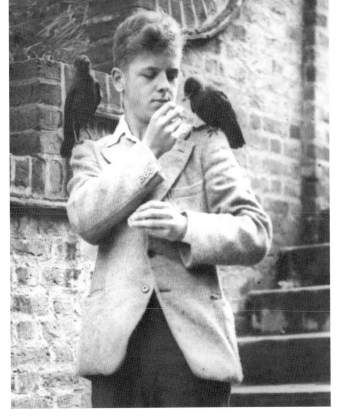

Clockwise from top left; senior expedition crossing the Cuckmere, 1947; helping with the harvest, Wisbech 1942; G.H. Russell with his pet jackdaws, Summer 1945.

annual expedition. Tennis, the most popular summer sport, was constrained because the frost had killed the new turf on the Shirley Goss courts and, although the asphalt was renewed on the hard courts, the school had only one net which did not let the balls through.

Rationing remained in place for several years and was extended to bread, which had never been rationed during the war. The boys were allowed to keep pets in huts on the hillside and one boy had several ferrets which he used to catch rabbits for sale to local residents to supplement their meagre meat rations. When bananas reappeared at the prep school, it was the first time many boys had seen them. Dr. Ehrenfeld, the Austrian refugee who had taught at the school for a while before the war, and who had emigrated to Australia, sent the school a large parcel full of jelly crystals and other goodies. All this hardship seems to have fortified the boys for when 169 of them were x-rayed under the national mass radiography scheme in 1948, not a single weak heart or case of tuberculosis was found.

By then, noted the school magazine, 'there are indeed nowadays so many out-of-school activities, often looking for leadership to the same boys, that we sometimes wonder if we are not in danger of sacrificing quality to quantity'. Fives was in decline but a badminton club was formed and basketball was played for the first time. Gradual improvements

the Old Boys to go ahead. It was played in a snowstorm, the pitch surrounded by high banks of cleared snow. Later, when a temporary thaw set in, these banks prevented the water from escaping, creating a lake which froze over, forming a perfect skating rink. The fuel crisis which accompanied the severe weather forced the Scientific Society to cancel its

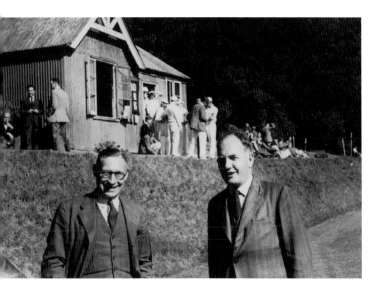

Left: Dr. Hall, left, with his successor, Terry Leathem.

Below: Caterham boys attended the Festival of Britain in 1951.

in transport helped school activities enormously, particularly in arranging school matches. In 1948 the 1st XV was the most successful since 1935 and the first school swimming fixture was arranged, a tripartite meeting with Ardingly and Hurstpierpoint in the latter's unheated open-air pool, which came as quite a shock. In 1949 the Board of Management also allowed football to be played informally on Sunday afternoons. This was the year when the 1st XI cricket team confounded the sports writer for the *Sunday Express* by beating a strong Alleyn's side by one wicket off the last ball of the match, prompting him to watch Caterham's next match, when they also disposed of Ardingly.

The post-war years opened up wider horizons for many boys. Sixth-formers took part in the local area activities of the Council for Education in World Citizenship, originally established as an offshoot of the League of Nations Union in 1940, bringing them into contact with other sixth forms. Closer links were sustained with Eothen School, mainly in the form of annual sixth-form dances, as well as occasional invitations to attend drama productions and other events. The dances filled some boys with dread. In 1949 those attending took the precaution of teaching each other dance steps in the gym; ultimately, they had little to worry about, noted the school magazine, 'thanks to the graciousness and fortitude of the hostesses'. In the same year a German boy, Gerhardt Doering, attended the school for two terms, confounding some boys who discovered Germans were just like they were after all. A television, acquired in 1948 for the school room, became very popular for watching rugby internationals and cup ties, although most sixth-formers were glued to every broadcast of Victor Silvester's *BBC Dancing Club*.

The popularity of the school with prospective parents continued unabated. They liked Caterham because it was

a very down-to-earth school, without airs and graces. 'Caterham,' recalled W.N. Hyde, 'was not snobbish and certainly not wealthy. It was in both senses of the term Nonconformist.' The demand for boarding places was strong and led the school to acquire another property across the road as an additional boarding house. This was Beech Hanger, formerly part of the Brigade of Guards' Girls' School, which was formally opened on 4 May 1948. The first school history recorded how this 'created a middle school which went some way to soften the change from the small, homely community of the Preparatory School to the large, rather stark life of the Main School'. By then, there were more than 400 boys at the school. In 1946 the main school had 255 boys, of which 144 were boarders, and the prep school 153, including 80 boarders. Shortly after the opening of Beech Hanger, the Headmaster regretted the school's inability to meet the ambitions of the development plan he had drawn up, a revised version of plans first prepared before the war. It was as much as the school could afford to carry out a long overdue programme of repairs and refurbishment at a time when building was still regulated by the state and materials and labour were scarce.

Dr. Hall's career was in any case moving in new directions. The school magazine in 1948 recorded how much of his time was taken up outside the school, contributing to the new *Cambridge Modern History*, supervising Oxford doctorates and supervising postgraduate research at the London School of Oriental Studies. This latter work led him to be invited to take up the first chair in South East Asian History at the University of London, and he announced to the Board of Management in June 1949 that he would leave at the end of that term. Hall was described in the school magazine as a man who had 'conserved the high traditions of his predecessor' but had been no innovator; but his room for action had been circumscribed by limited finance and the Second World War and its aftermath.

His successor, Terence Leathem, known as Terry, was taking up his second Headship. He was born in 1911, the second son of Irish parents. His father John lectured in mathematics at St John's College, Cambridge, but died when his son was 12. This was the college Terry would attend, reading history and modern languages, after leaving Marlborough School. He was a brilliant student, like his elder brother John, with whom he shared the distinction of

Prefects and monitors, 1955. Front row: D.S. Widdowson, S.D. Mayes, R.J.Warner, S.J. Rushworth, P.G. Croissant, G.W. Bevan, J.H. Darley, B.R. Skinner, J. Sheffield. 2nd row: D.L. Moseley, D.C. Wakefield, J.R. Mathias, T.E.P.Wiliiams, D.K. Tindley, A.G. Forson, N.J.W. Kippax, M. Haines, D.J. Hatch, C. Bagnall. 3rd row: S.M.Wheeler, M.W. King, R.H. Hensman, A. Baker, J.M. Free, J.R. Daw, P.N. Ball, C.M. Ebden, D.R. Mear. Back Row: G.C. Price, B.R. Short, H.F. Denman, G.M. Leach, A.M. Cameron, A.G.J. Rushworth, J.D. Syer, M.E. Dobrin, W.G. Atherton.

Right: Love's Labour's Lost, 1951 with left to right: D. Mear, D. Hatch, T. Knight, R. Hallam, T. Cunliffe and C. Bagnall.

Below: programme for Abraham Lincoln which had a cast of 55.

CATERHAM SCHOOL

ABRAHAM LINCOLN

by

JOHN DRINKWATER

Christmas 1958

SCHOOL PERFORMANCE - DECEMBER 11
PUBLIC PERFORMANCES - DECEMBER 12 & 13

Programme**6d.**

sister May later became matron of Townsend House. As at the prep school, Beech Hanger hosted a mix of dayboys ('daybugs') and boarders ('bedbugs'). Here they took their meals and had most of their lessons. It was, recalled Denis Tindley, who joined the school in 1947, a pastoral enclave set apart from the rough and tumble of the main school.

The main school was a much tougher place. The dormitories, of which the four largest accommodated 26 boys each, were, remembered Tindley, 'spartan but adequate'. The food was variable and milk puddings common. Baths, once or twice a week, were taken in big, deep, old-fashioned baths, which the boys were allowed to fill only to a certain depth, measured by a master with a ruler, because of the cost of heating the water.

The Headmaster largely left discipline to other staff and the prefects and monitors, although he kept a firm hand on the tiller. Bill Broadhead, who was a boy at the school during the 1950s, recalled how the boys once made the mistake of booing the name of one unpopular matron whom the Head had listed among that term's leavers. Leathem immediately announced the customary half-day holiday was withdrawn and

the time would be spent in class. Prefects were chosen by the Headmaster after consulting staff but the senior prefect and his deputy were always elected by the boys from among the appointed prefects. In maintaining discipline, every prefect was entitled to exercise a degree of corporal punishment. One former boarder recalled that it was common after lights-out for boys to be ritualistically summoned, after a calculated period of suspense, to the dormitory bathroom, where three hard whacks were administered with a gym-shoe, sometimes in front of a gallery of onlookers, the prefect using the length of

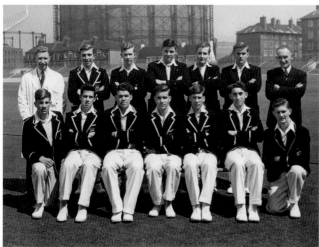

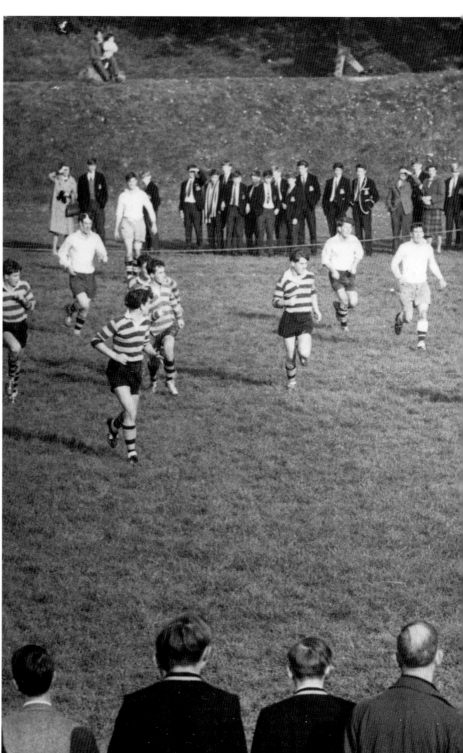

Clockwise from above: W.E. Wakefield, Norman Maddock and Terry Leathem at Sports Day with the sound system designed by Maddock known as the WNM Home Service; Caterham First XI at the Oval, 1955 – left to right, seated: P.C. Schumacher, D.R. Mear, G.W. Bevan, J.H. Darley (capt.), N.J. Harper, S.D. Mayes (England and GB), B.K. Jackson, (standing) Mr. T.H. Popple, G.A. Jordan, C.L. Dermer, J.R. Mathias, T.M. Raven, A.H.A. Cosh, Mr. E.L. Walker; Hockey First XI 1948 with three international hockey caps, 1954 – (seated, extreme left) R.D. Smith (England), (seated, centre) D.B. Campbell, capt., (Scotland) and (extreme right of photo) D.G. Griffith-Jones (Wales); Old Boys rugby; team that played the inaugural match of the Wenden Cup with James Wenden on the left.

the bathroom for a run-up. The boarders were understandably aggrieved that they were in pyjamas when this happened, whereas dayboys were beaten in their normal clothing.

The practice was open to abuse. Going to bed on the last night of his first year in the main school, one 14-year-old boarder was quietly warned by another boy to take care. The dormitory prefect, who was leaving school the next day,

next morning in front of the other prefects. When the same boy became a prefect himself, he too dealt out a beating on one occasion but felt so ashamed of himself that he never did it again. Little was done to prevent the abuses, which appear to have continued even after the Headmaster had introduced a tutorial system, allocating a member of staff to look after the academic and non-academic interests of every boy.

A more fundamental change to the organisation of the school came with the introduction of a full house system. One former pupil, writing in retrospect in the school magazine, remembered how the four houses in the early 1950s still contained roughly equal numbers of boarders and dayboys, competing against each other in sport, work and conduct. But this system encouraged 'mark grubbing' and lacked any element of pastoral care. Nor did any of the houses have any dedicated space within the school. It was all too easy for little problems to be blown out of proportion. Reform to rectify these weaknesses took place over several years. Initially, in 1952, two housemasters were appointed for each house, along with sixth-form tutors. Then, in 1958, Leathem created three boarding houses, Beech Hanger, Townsend and Viney, the latter two based on dormitories in the main school, and two dayboy houses, Harestone and Lewisham. There was never enough space in the school to provide the day houses with their own accommodation, even after two more, Aldercombe and Underwood, were created in 1973, and this had to wait until 1978.

The boys enjoyed a growing range of activities, with new clubs and societies rising as others fell into abeyance. The Headmaster became concerned at their proliferation and from 1953 the meetings of most school societies were confined to Thursday evenings, enabling more dayboys to take part, and making life less crowded for senior boys. The dances with Eothen also continued, while others were arranged with Milton Mount, events regarded by the school magazine as a

was determined to correct the fact he was the only boy in a dormitory of 24 boys who had not been beaten that year. Towards the other end of his school career, one of his friends, in the term before they entered the upper sixth, forgot to turn up one lunchtime to do his stint of roller duty on the cricket pitch. For this trivial offence, despite his advanced age, he suffered the indignity of being beaten by the senior prefect at break the

sign that 'the liberalisation of the public school regime is an established fact at Caterham'. School trips and expeditions were a regular part of the school calendar, from the South Downs to Lucerne. Sadly, one boy, Douglas Wapling, lost his life in a fall while on a visit to the Austrian Alps with the senior scouts at Easter 1957. Arthur Davies-Jones produced a number of dramas, of which the most ambitious were the medieval mystery play, *The World And The Child*, in 1957, and Galsworthy's *Abraham Lincoln*, with a 55-strong cast, in 1959. The lead in the latter was taken by Jon Finch who later became a professional actor. But music continued to struggle, although a performance was given in 1957 by the school chorus and orchestra, with soloists from the Royal Academy of Music, of Haydn's *Creation*, and in 1960 the Eothen choir joined the Caterham orchestra for a Christmas charity concert. Sporting glory was limited in the 1950s but the school achieved the distinction in 1954 of three former pupils achieving international hockey caps on the same day, playing for England, Wales and Scotland. In the same year a revival was reported in the fortunes of the 1st XV, evidence of the success of paying for additional sports coaching. Two years later the 1st XI cricket team under captain N.J. Harper was unbeaten. One of the highlights of the cricket season for senior team members was the annual match against St Dunstan's College at the Oval. Don Mear, who left the school in 1955, recalled the wonder of walking out to open the batting, even though the crowd was small, limited to a handful of parents, mostly fathers, augmented by three men painting the famous gasometer. But the lack of money still hindered the school's sporting ambitions. David Charlesworth remembered attending one local schools athletics meeting where the Caterham boys did not take part in races over the hurdles because the school did not have any.

The local Congregational Church in Caterham continued to play a large part in the boys' lives. Burnt out after being hit by an incendiary bomb in 1944, it was rebuilt with a larger transept to accommodate the growing number of boys attending morning services every Sunday (a smaller contingent attending the local parish church of St. John's), and reopened in 1951. Many boys were inspired by the dynamic preaching of Stuart Jackman, who came to the church in 1956 after being thrown out of South Africa by the apartheid regime. He took an active interest in the school where, like other ministers from the church, he assisted with the teaching of Religious Education and took Sunday-evening services. The minister and the Provincial Moderator were always in practice the statutory appointees of the Congregational Union on the school's governing body.

Academically, the presence of such a high proportion of county scholars stimulated an improvement in standards. Caterham boys achieved three Oxbridge open scholarships in 1953, six State Scholarships in 1953 and 1954 and eight in 1955. By the mid-1950s each boy was achieving an average of six passes at O level, an impressive record compared with similar schools. The practice of dividing entrants into A and B streams, however, left some in the latter stream feeling disadvantaged, labelled as 'also-rans' too early, particularly since the B-stream O-level course lasted six years, compared with five years for the A stream. A practice followed at a number

Above: Caterham Congregational Church reopened in 1951 after being badly damaged in the war.

personally encouraged those he considered had the best chance. Although the major growth in university places came in the 1960s, the opportunities for young men and women to reach university expanded gradually throughout the 1950s. By 1955 the school was sending 21 boys, about half of its upper sixth-formers, to university or medical school. Many of them were the first members of their families to reach university and some had to overcome family opposition to get there. Denis Tindley, who left the school in 1955, was a case in point and it was Leathem who persuaded his reluctant father to agree that his son should go up to Cambridge. Tindley regarded Leathem as 'the most influential person in my life' and was certain that he gained in self-confidence because the Headmaster 'believed in me'. University was still an expensive privilege, confined to relatively few compared with today, and the school did what it could to help boys whose families were not well off. The school made small university grants, usually £100, spread over three years, while state scholarships were available for the brightest boys.

Despite the limited facilities and opportunities of the time, common among similar schools, many boys retained an affection for the school, appreciating the benefits they gained from their education. It gave them social confidence and opened up wider horizons, inculcating a love of language and literature, music, drama and sport. The playing field taught many boys the value of teamwork while the school's Nonconformist ethos, with its emphasis on tolerance and personal responsibility, gave them an ethical framework for their lives. It was these enduring qualities which made the school a special place and led so many boys to maintain their links with Caterham for the rest of their lives.

of similar schools, this was eventually changed in 1957. Some A-formers also found that their academic progress could be rather haphazard. David Charlesworth, a county scholar, never felt he was given any proper advice about the sixth form or university, leaving school after O levels for an apprenticeship, ultimately leading to a successful career with a major global business. Bill Broadhead, who left in 1960, was advised to apply for Oxbridge, failed to gain the necessary grades and instead took an engineering sandwich course. Better advice about a more suitable university, he felt, would have accelerated his career development.

On the other hand, many boys from Caterham who might otherwise not have done so attended university thanks to the efforts of Terry Leathem and his staff. Leathem proved particularly successful in building up the sixth form which exceeded 100 boys for the first time in 1960. Membership brought only limited privileges, the most important being the entitlement to wear a suit, rather than uniform, and a trilby, although suede shoes were banned. While not all boys in the sixth form were expected to reach university, Leathem

7

'PROPERLY INDEPENDENT'
1961–76

Caterham celebrated its 150th anniversary year in 1961. A whole series of events was planned. The OCA anniversary ball was held in May at the Hurlingham Club, a dinner took place in the House of Commons and 13 motor coaches transported staff and boys to a commemoration service at the City Temple in October. The OCA President that year was Alan Moncrieff, a distinguished paediatrician, who had left school in 1918 and became the first Nuffield professor of child health at the Institute of Child Health in 1946. Knighted in 1964, he later became President of the school, a post he held until his death in 1971. The anniversary was also the stimulus for a major appeal which set out to raise £75,000 (about £1.25 million today) and achieved nearly £73,000, although it took over six years to do so. The funds paid for a variety of improvements, from the levelling of the Beeches field (1962) and a new wing for Beech Hanger (1963) to the North Wing classrooms (1963) and a new sanatorium (1965), as well as the conversion of the old sanatorium into married-staff accommodation. These were long overdue but the use of an appeal to fund them illustrated the challenges facing the school – other than the serendipity of finding individual benefactors, it was the only way to raise capital, for the school lacked significant reserves and was hamstrung by the controls exercised over the level of fees by the Ministry of Education.

The improvements made possible by the appeal partially remedied the lack of space to accommodate comfortably the existing numbers in the school; they did not provide room for expansion. In 1972 the main school actually had fewer boys than in 1959, 285 compared with 303; it was still a small school. Over the same period the prep school

had grown by a third, with 230 boys compared with 172. In fact, the growth in prep-school numbers was directly related to changes made in the school admissions policy, intended ultimately to boost numbers in the main school.

These changes were influenced by the debate about the future of the direct-grant system, under which the school had been receiving aid directly from the state since the early years of the century. This came under constant review from the moment the Labour government was elected in 1964. The case for the direct grant was more often than not a topic at the school's Speech Day. Caterham was included in a small group of direct-grant schools invited by the Headmasters' Conference to take part in a survey highlighting the strengths of the system. In February 1968 the Board of Management discussed the issue at length for the first time. One Board member in particular, Gerald Mortimer, an Old Boy, parent and a senior executive with Consolidated Gold Fields, played a key role in the discussion. He believed the matter was so important that it should be considered not in isolation but in relation to the future of the school. The time had come, he felt, for the Board to revise its role. It was, he said, too much like a Greek chorus, uttering approval or disapproval of the play unfolding before it, then moving on. It needed, he said, to adopt a more strategic approach. He emphasised that the school was at a watershed – 'the independent and semi-independent schools of this country are facing the most serious challenge in their history. It is even open to question whether they have a future at all'. Since he believed

Caterham School

150th ANNIVERSARY APPEAL
£75,000

A 150th ANNIVERSARY is a great moment in the life of any organisation: in a School like Caterham it is a very special occasion indeed.

In 1961, the School will be 150 years old. That proud landmark in her history, when the past, the present and the future join hands, will, of course, be celebrated as befits such a great occasion.

But such an anniversary would lose much of its meaning if it were considered solely as the celebration of a passing event. To the past, and, in particular, to the vision and purpose of men like the founder, the Reverend John Townsend, and the Reverend Josiah Viney, who brought the School to Caterham, we owe the Caterham School of the present.

Many Old Caterhamians will remember the School's Centenary in 1911. Fifty years on, in 2011, many of to-day's Caterham boys will foregather at the School to celebrate its bicentenary. Some

CATERHAM SCHOOL

fees would be the school's only major source of income in future, he considered that 'a significantly larger school is a necessity if Caterham is to be properly independent in future'. He foresaw a school of some 800 pupils, where one-third might be boarders, with fees dependent on the market. Of 'paramount worth', he was certain, were the school's moral and intellectual standards, grounded in its Christian principles and its Nonconformist character. He was unafraid of making controversial points, suggesting the school had no further need to fund the education of ministers' sons, that the rising tide of ecumenism rendered the school's Nonconformist links

Above: the School Fête, 1961.

Below right: Gerald Mortimer.

less relevant and that boarding was no longer essential to the school's future.

The general discussion on the matter noted that the school's social composition was bound to change if the direct-grant system ended, yet acceptance of grant aid, with the limits it placed on fees, made it impossible for the school to fund the capital improvements already long overdue and essential for survival. This, the Board believed, 'lays the School open to the criticism that its facilities do not measure up to State Schools'. It was agreed the school needed more boys but there was some uncertainty how any increase might be funded.

Entwined with all this was the future of boarding, as Mortimer had hinted. The school was only managing to fill boarding places by admitting boys with little pretence at selection. When John Jones took over Townsend House in 1972, the Headmaster told him that 'you'll probably be in charge of a sinking ship'. In 1959 the school had 261 boarders and 214 dayboys; in 1968 there were 239 boarders and 213 dayboys. Boosting day-boy numbers was attractive because there was a constant demand for places locally, making it possible to be much more selective. Leathem told the Board in 1968 that 'a significant number of dayboys with the necessary scholastic ability do not obtain a place at present'. It was believed that taking in more dayboys would shore up academic standards, which were showing signs of deterioration at O level.

The future of the direct grant was raised regularly at Board meetings during the next couple of years, during which it became clear the local education authority in Surrey would cease taking places at the school once comprehensive

reorganisation had been completed in 1972. In April 1970, during what the minutes recorded as 'a lively discussion', the consensus was that, in the event of abolition, the school should opt for independence, while retaining a significant boarding element. In preparation the school widened the catchment area for dayboys, incorporating south-east Surrey Surrey, Coulsdon, Purley, Croydon and Sanderstead, and from September 1971 a third stream was added, which led to a further 71 dayboys and 11 fewer boarders. It was calculated that by September 1977 the annual intake would be two-thirds dayboys and one-third boarders. To cope with the extra dayboys, a self-service dining system was introduced, two more day-boy houses (Aldercombe and Underwood) were created and plans were made for another science block. Since the Department of Education would consent to the new block only if it was not funded from fees, the school was fortunate to secure an anonymous £50,000 gift in memory of W.J. Young and another donation in memory of Paul Rignall, an Old Boy who had died at the age of 18 in an accident while playing for the Old Caterhamians' rugby team. The building was eventually opened in 1974, providing three chemistry and two biology laboratories and a departmental library. The school also built new classrooms at Shirley Goss for the prep school, funded by the sale of a small parcel of land on which planning permission had been obtained.

As the end of the direct grant became more likely during the early 1970s, parents were kept informed through a series of meetings. This led Leathem to encourage the formation of a Parents' Association, which was set up in 1972 under Dr. J.G. Owen, later a school governor and vice-president.

Left: in 1966 Percy Soderberg retired. He is seen here at Prize Giving in 1965.

Below: John Churchill, the new Headmaster of the prep school, with the 1967–8 football team. Nick Johnston on the left, and Tony Clowes on the right.

By the time the first wave of boys in the third stream was admitted, the prep school was under new leadership. In 1966 Percy Soderberg had retired after 40 years, leaving at the same time as Miss Burgess and Miss Odling, the matron and assistant matron. In retirement all three lived together in Brighton but Soderberg died only three years later. In Soderberg's place came John Churchill, from Ipswich School, and his wife Monica, who took over responsibility for boarding and domestic affairs. They would remain 15 years, expanding the school and its activities, and steadily raising its reputation and status. As part of this, Churchill wanted to apply for membership of the Incorporated Association of Preparatory Schools (IAPS), and to meet the terms of membership the Board agreed the head of the prep school should be termed Headmaster and should be given greater autonomy. The application was granted in 1971. A flavour of life at the prep school was later given by Tim Rose who joined in 1971.

Above: rugby was introduced to the prep school in 1970. This is the 1973–4 1st XV with K. Moore on the left and John Churchill on the right.

Right: prep school productions – Chris and Tim Rose in The Magistrate, *1974;* Arsenic and Old Lace, *1970.*

The Great Outdoors – walks along Pilgrim's Way with the Churchills and Sorrel, their dog, or straggling back from View Point on a cross-country run – was complemented by the Great Indoors. At Mottrams art thrived. Hobbies enjoyed a golden age. In the common rooms, craftsmen worked with a jeweller's eye and a surgeon's hand on all kinds of miniature projects. Others leaned over tables where the fortunes of France or Russia could change at the whim of the dice. On the verandah, music and literature contrived to live together, the Beatles and David Bowie barely ruffling the attention of the boy deeply into Tolkien or Alistair Maclean.

Music, drama and sport all flourished. The partnership of Tony Clowes and Nick Johnston reached its height in a string of musicals and dramas, such as *Our Town* and *Arsenic and Old Lace*. For prep-school sport, the introduction of rugby made 1970 a momentous year.

It was a time of change in many ways during the 1960s and early 1970s. The common-room in the main school was almost completely transformed as vacancies left by retirements were taken by newcomers. In 1965 Arthur Davies-Jones retired from the staff. His service to the school was truly outstanding, covering almost 70 years from his entry as a 12-year-old boy until his death in 1981, for he continued to act in effect as editor-in-chief of the school magazine after his retirement. As the son of a minister, he came to Caterham in the tradition of its founders. He was appointed boy editor and senior prefect and, after graduating, returned to the school, where he taught English for 43 years, was second master for 22 years and on two occasions acting head. Between 1951 and 1958 he produced seven full-length plays and throughout his career a large number of one-act plays and sketches for Old

Boys' Days, Speech Days and end-of-term concerts. He was master-in-charge of external examinations and hockey for many years. He wrote the words of the school song, *Debtors*, in 1938, produced a booklet of his own verse based on the school in 1956 and another of short stories in 1970. He did much work for the United Nations Association within the school and was a founder member, chairman and vice-president of its Caterham branch. His long service and editorship of the Old Boys' section of the magazine made him an invaluable link between the school and the Old Caterhamians, of which he was elected President, for the second time, on his retirement. His knowledge about the school and the Old Boys was said to be 'encyclopaedic and infallible'. He was always on hand to greet those attending annual reunions and kept in touch with many more through the letters he wrote regularly over half a century. His wife,

Maud, whom he married in 1941 and who, as Miss Knowles, had been the Headmaster's secretary, also shared Arthur's interest in former pupils. They always found a warm welcome, supplied with cups of tea and coffee, at the family house, Turnings, in Harestone Lane. Generations of boys were inspired by his love of language and literature. As well as for the obvious classics like Chaucer, Shakespeare and Milton, he brought to his pupils his enthusiasm for 20th-century writers like Shaw and Priestley, and had a special place in his heart for the poet of his home county of Shropshire, A.E. Housman. Renowned for his insistence on accuracy in language and composition, he loved the images which words had the power to create but detested over-writing and verbosity.

One of his pupils reflected that 'Arthur was the most loveable teacher I ever had and the one who most profoundly influenced the rest of my life, particularly, but not only, as a teacher of English myself, a choice of career which was partly made out of a desire to pass on what I had learned from him'. Forthright and energetic, fiery-natured and a commanding figure despite his short build, Arthur Davies-Jones was also a kind and generous man, passionately concerned about the future of those in his charge. He was the incarnation of the school's Congregational ethos in his belief that the school should be a warm, friendly and tolerant place, where discipline was governed by common sense rather than rules, where individuality rather than conformity was fostered. A defender of tradition, he was nevertheless consistently open-minded throughout his long life. On his retirement Terry Leathem observed that 'his advice had been an admirable mixture of

seeking to develop along existing lines rather than break sharply with longstanding tradition; yet he was anxious to move with the times and no resister of worthwhile changes'. His friend Leslie Daw would later say of Arthur that

> *while his devotion to the school was extraordinary, it was never blinkered or parochial, for it was enriched with a whole range of interests, such as his love of the Surrey countryside, his very wide reading, his concern for peace and social justice, the social weekends he organised for overseas students, and above all his very happy family life.*

Many newcomers to the common-room stayed almost as long as those they had replaced, their involvement in a wide range of activities demonstrating their commitment to the school. Don Seldon came in 1962 and stayed for 35 years, teaching French, instigating an exchange with a school in Lille, running Beech Hanger and supervising the rifle club. On the many school trips to the Continent Seldon organised, he was often accompanied by David Mossman, who was appointed in 1963, becoming head of modern languages, and retired 32 years later. John Bleach also worked for 32 years at the school, taking over art in 1964. He would later take charge of the reformed RAF section of the Combined Cadet

Above: Ray Howgego with cross-country team, 1970.

Force (CCF), while his involvement in other aspects of school life ranged from debating to coaching. In 1966 three new faces joined the staff, Robert Jarrams, John Beldham and John Jones. Robert Jarrams was a popular maths teacher for 32 years, often found leading trips abroad during the school holidays. John Beldham became a fixture in the prep school where he taught English for 34 years. John Jones served on the staff for 38 years, his talents ranging from heading the chemistry department and running an outstanding boarders' choir to compiling the timetable and refereeing rugby matches. He revived the tradition of a scientific society, renamed after Sir Alan Moncrieff and on Jones's retirement the Jones-Moncrieff Society, and breathed new life into boarding at Caterham, recognising that it could no longer be taken for granted, and that it had to become a positive aspect of the school. His ideas influenced Jim Seymour, who joined the school in 1972, and played an equally important part in ensuring boarding had a long-term future at Caterham. He would become head of biology, head of science and ultimately senior teacher in charge of boarding. With David Mossman and Peter Edwards, he also helped to produce several outstanding revues and plays. With David Rogers, Seymour also organised a number of school fetes, valuable fundraisers during the 1970s. Rogers began teaching at Caterham in 1969. Without a degree, he decided to take up the post of head groundsman for a year in 1972-3, in the vain belief he would find the time to complete his course, which he eventually accomplished only in 1979. A familiar figure throughout the school, armed with a remarkable knowledge of Caterham and the pupils he taught,

he retired in 2006. Ray Howgego, also appointed to the staff in 1969, taught physics for 28 years, coached cross-country and played a leading role in the CCF. In his retirement he devoted his time to his love of exploration which led to the invitation to write *The Encyclopaedia of Exploration*, the longest work produced by a single author in the English language. Michael Godwin, who joined in 1972, left in 1996 after teaching English, classics and the history of art. Martin Nunn arrived in 1973 and eventually became head of geography, a role he relinquished in 1989, although he continued teaching religious studies until his retirement in 1995. He set up the school weather station in his first year and in September 1998 attended a special Weather Dinner, along with 60 past and present pupils, to celebrate 25 years of continuous recording.

By the late 1960s, as at many direct-grant boarding schools, the quality of boarding in the main school left much to be desired. It had suffered from years of neglect, partly due to an acceptance of the way things were, partly due to financial constraints. John Jones recalled that when he first joined Townsend House, 'there was not a carpet or a curtain in sight'. He organised a jumble sale to raise funds to put up the first sets of curtains. When he became housemaster, he arranged for the dormitory to be broken up into cubicles, all done on a shoestring budget, but which the boys thought was a huge improvement.

Jones believed every effort should be made to make boarding as comfortable as possible for boys away from home. This was still a time when junior boarders took just one bath a week, on allocated evenings, and senior boarders two. Uniforms were worn all day, every day. Since half-terms were still no more than long weekends, some boys had to remain behind. Sundays remained the dreariest of days. Boys below the fifth form were allowed into town just once a week. It was perhaps unsurprising to note in the Board minutes for July 1964 that 'a fifth form boy had run away but has since been traced to Paris with relatives'; or to learn two years later that four Beech Hanger boys were suspended for visiting a London jazz club one evening.

For the parents and pupils of Townsend House, Jones introduced an 'At Home' at the end of every year, when boys could put on an entertainment, giving them all a chance to take part. At a time when he was still called by his surname in the common-room, he began calling boys by their first names. He ran the boarders' choir for nearly 20 years. As well as singing at school services on Sundays, the choir also visited Congregational and other churches all over the country, including Canterbury Cathedral. A concert was given in the Purcell Room on London's South Bank and a tour of Sweden

Hare-stones (or 'hoar-stones' – 'hare' and 'hoar' meaning 'grey' and having no connection with hares) are boulders of conglomerate rock known as 'pudding-stone', which in ancient times were used to mark land boundaries. The school's was recorded in 1605 and appears on a map of 1736 opposite Mottrams lodge, but was moved in about 1899 to adorn the grounds of Harestone House. Mr. Foister's daughter Elizabeth, who was evacuated in the Second World War to a house later built in the grounds, remembers using it when playing 'he' in their garden – if you were touching it you couldn't be caught! In 1961 it was presented to the school by the house-owner and transported to the front drive (above).

was organised with the help of Arnold Welch and his son Robin, both Old Caterhamians. House staff received little time off – Sunday afternoons if they were lucky – or extra money for their duties and usually taught a full timetable. Townsend House was lucky to have Jones and Seymour. Similar changes took even longer to make in the other boarding houses and it would be several years before significant improvements were made. But accommodation for the growing number of dayboys was little better. There were no common-rooms, just locker-rooms, the only concession being two very small rooms used by day-boy prefects.

The out-of-school activities available to boys in the early 1970s had changed little from those on offer in the late 1950s. Plays were performed regularly, often Shakespeare, sometimes Shaw, occasionally popular pieces such as *The Caine Mutiny* or *Journey's End*. David Wookey, who took over as Director of Music in 1964, revived the orchestra, organised orchestral courses during the summer holidays and put on a series of ambitious concerts. In 1970, Wookey wrote the

music and John Roughley the libretto for their own opera, *Tom*. Wookey's work was continued by his successor Graham Ireland, and the school's musicians, occasionally supplemented by outside forces from other schools, including Eothen, performed works including the *St John Passion*, *Messiah* and *Elijah*. New clubs and societies, like the Railway Society, the Numismatics Society, the Folk Music Society, came and went as usual. One activity which came to stay was the Duke of Edinburgh's Award Scheme, introduced in 1973. Within two years, gold awards had been presented to three Caterham boys, P. Gilbert, C. Waterson (the first South African to receive such an award) and T. Atkinson. The number of overseas trips increased and boys from both parts of the school journeyed to destinations ranging from the Swiss Alps and the Western Mediterranean to Norway and Russia.

While many boys enjoyed their time at school, making close friends, others found school life stultifying, turning their backs on Caterham after they left. There was a feeling by the end of the 1960s that the school had been left to drift. It was

not an easy time to be a Headmaster. As the tribute to Terry Leathem in the school magazine recorded in 1991, 'he stoically endured and survived the turbulence of the Sixties.' One boy who left in 1966 remembered that Leathem was 'a kind man who seemed to let the school swirl around him'. In 1973 39 of the 42 candidates at A level recorded two or more passes but only three achieved two or more A grades. At O level each boy averaged six passes but only a quarter recorded an A grade.

Terry Leathem retired at the end of 1973. He was much liked by the boys, who presented him with a giant teddy bear on his departure. His successor was 38-year-old Stephen Smith. He came from a strong Congregational background. His parents were missionaries and he was born in India, where he and his wife Helen would later spend five years teaching on behalf of the Council for World Mission. Educated at Eltham College, the school for sons of Congregational missionaries, he read geography at Cambridge, where he was captain of the university rugby team. He was also capped for England in 1959 and 1964. He taught at Harrow before he left for India and was a housemaster at Birkenhead School when he was appointed Headmaster of Caterham.

His style was a great contrast to that of his predecessor – and a great shock for many boys and staff. Some found him over-strict, but others saw in him the disciplinarian the school needed. At his first assembly he rebuked the boys for the ill-discipline he had witnessed on his way into school – 'the school', recalled a member of staff, 'was not accustomed to be shouted at at the beginning of term'. Strict, efficient, extremely hard-working, an able public speaker, he was determined to raise academic and sporting standards and to overhaul extra-curricular activities. His wife Helen was hugely supportive and became very popular within the school. He began by involving himself in everything to gain knowledge of how the school worked and then filled senior positions with able staff to whom he was happy to delegate. He also developed a close relationship with the Board of Management. He was approachable, remembered one member of staff, but could seem quite fierce, and often found it difficult to hide his frustration when he encountered obstacles.

Right: junior sports and rugby.

Below: Stephen Smith, Headmaster 1974–95.

Stephen Smith found a school in good heart but very short of money and in need of modernisation. The boarding accommodation badly needed investment. Smith recalled how his guest at Speech Day, the Headmaster of Harrow, was horrified by Caterham's boarding provision. The lack of accommodation for married staff was also a concern, since many were deterred from applying to Caterham because of the high cost of local housing. The imminent end of the direct grant posed two immediate challenges – the need to maintain numbers and sustain academic standards. Keen to nurture the school's Christian ethos, Smith persuaded the Board to appoint Caterham's first chaplain, an idea first considered in 1949. The Reverend Roy Robinson took up his post in early 1975.

Independence was growing closer. In October 1975, after the formal announcement of the cessation of the direct-grant scheme from 31 July 1976, the Board of Management unanimously agreed the school would become independent from 1 August the same year.

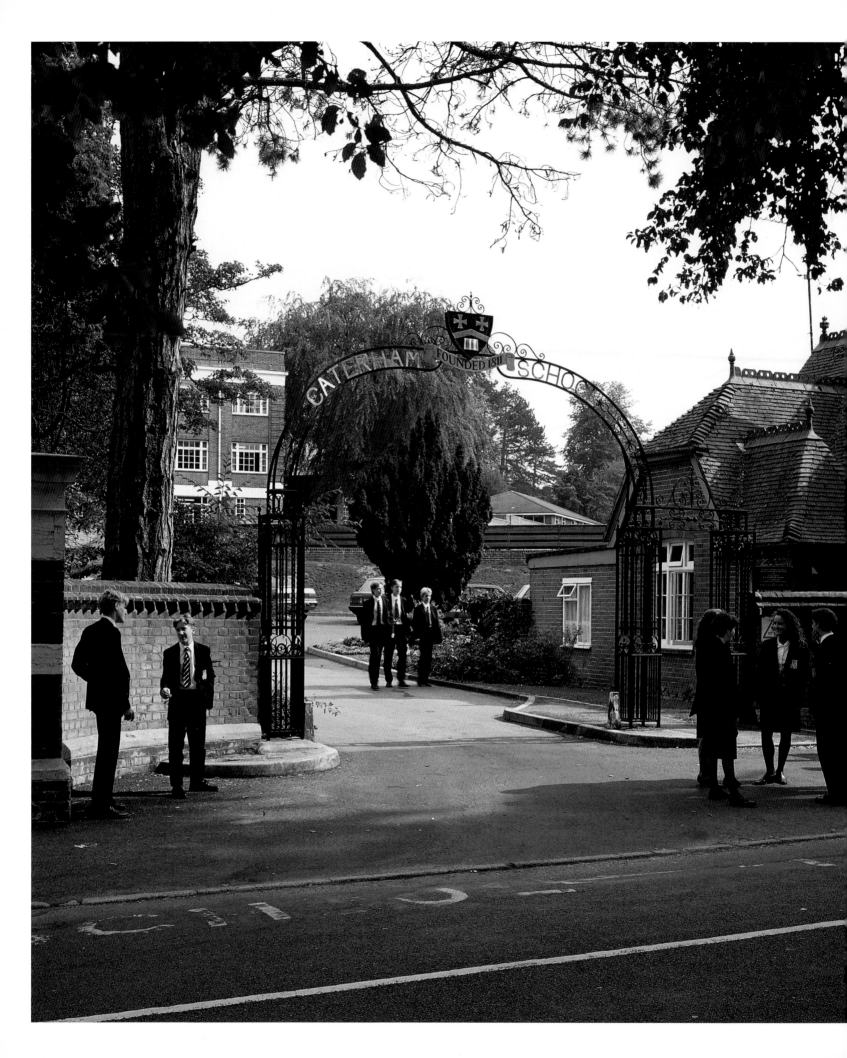

8

'THERE'S ONE!'
1976–93

Within a month of the school's decision to become independent, a financial appeal was being organised. A fête was also arranged to raise money to extend the library and improve the worn-out swimming-bath. A scholarship fund was financed by setting aside five per cent of fee income every year. And it was also agreed to begin accepting a few boys for entrance into the main school at the age of 13.

There was never any problem filling places overall. The intention had been to maintain around 650 pupils in the school, comprising 420 pupils in the main school and the rest in the prep school. On independence in 1976 there were 208 boarders and 424 dayboys. Although there was a dip in demand immediately after the direct grant ceased, this soon revived. In 1979, for instance, there were 221 applicants for 78 places. The difficulty was that day-boy vacancies were two or three times oversubscribed, while boarding places were two or three times undersubscribed. The decline in boarding accelerated from the late 1970s, and in many schools, including Caterham, boarding remained viable only through the recruitment of pupils from overseas.

But even as boarding was in decline, the school increased its total roll during the late 1970s and early 1980s. More dayboys were admitted, the prep school lowered its entry age to eight in 1978 and from 1980 the school took part in the Assisted Places Scheme, introduced by the Conservative government as a replacement for the direct grant. Boarding relied on boys from overseas who made up 20 per cent of all boarders at the school by 1980. This influx led to formal criteria for their admission, with academic criteria paramount. It was also felt important to ensure there was a diverse range of nationalities to prevent the formation of cliques. As the school reached 695 pupils by 1983, overseas pupils accounted for 30 per cent of all boarders.

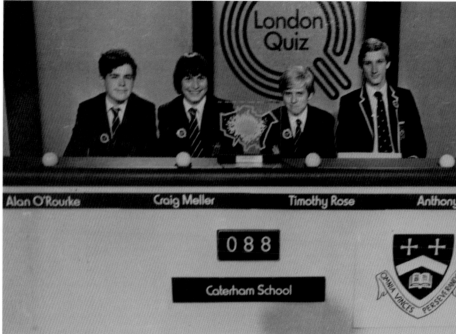

In 1985 the school also began accepting as boarders boys on government sixth-form scholarships from Malaysia and Thailand. This scheme began at Bedford School where the chairman of governors had links with Malaysia. It proved so popular that there were insufficient places to take all those able to come. C.I.M. Jones, the Headmaster, who had been at Cambridge with Stephen Smith, asked if Caterham would accept the additional boys. These links were extended when Smith and his wife visited Malaysia and Thailand during a sabbatical in early 1986, as a result of which the national banks in both countries began sending their own scholarship pupils to Caterham. Pupils were also recruited from Hong Kong and Taiwan which the Smiths also visited. The pressure on these pupils was considerable. Smith recalled dining with the elder sister of one boy, whose parents were peasant farmers, who explained that if her brother did not secure a university place, she would have to repay the scholarship on behalf of her parents. Her brother was successful and most of the pupils who came to Caterham from the Far East settled in well, studying while learning English at the same time. They contributed a great deal to the ethos of the school, helping pupils to appreciate each other as a fellow human beings, regardless of race. The school would later accept scholarship students from Eastern Europe under the scheme established by the financier George Soros.

Another fundamental change in admissions had taken place in 1981. Stephen Smith first asked the Board to consider the admission of girls in 1976. There was a national trend towards taking girls in boys' schools and Caterham was

receiving more and more requests from parents with sons at the school who also wanted to send their daughters.

At first the Board appeared lukewarm but teaching staff were overwhelmingly in favour. It was a sensitive issue, given the proximity of Eothen, whose numbers were much smaller. As with other changes in admissions policy over the years, money was part of the reason for the proposal. Finally, in March 1980, after taking advice from other schools, the Board agreed, with only one dissentient, to accept girls in the sixth form. Approval was also given by a special general meeting of 'governors' – or 'foundation members', as they would soon

Previous page: the Centenary Arch, presented by the Old Caterhamians' Association in 1984.

be called – held expressly to obtain their consent to altering the school rules, although it was, recalled Roger Deayton, chairman at the time, 'quite a lively meeting'.

The Headmaster discussed each of the girls with the new prefects, outlining their backgrounds. One of them he had described as a missionary's daughter, 'educated in the bush'; when he reached the girlfriend of one of the assembled prefects, one wag could not resist exclaiming, 'That was education behind the bush!' It was, according to John Grimshaw who was present, 'a never-to-be-forgotten moment of speechless embarrassment all round'.

In September 1981 11 day girls joined the sixth form. Several already had brothers at the school. Sandra Fullard was one of this pioneering band. On the day she came to attend an interview with her mother, she was greeted by boys leaning out of windows, pointing and shouting, 'There's one!' 'It took a long time for people to get used to us, not just the pupils, the teachers as well'. On arrival the girls were divided into their houses but as soon as the staff had left them, one boy pinned three of them against the wall under a snooker cue for interrogation. At lunchtime the girls were taken to the front of the queue, which was a mistake, not just because the boys resented this preferential treatment, but because they marked each girl out of ten as she walked past. Some of them found dead mice in their lockers. 'Out of necessity,' Sandra

Fullard would write later, 'we constructed invisible shields for ourselves.' The dedicated girls' block, somewhere without boys, was a much-appreciated safe haven, although they had less and less reason to use it as a retreat as time passed. Mrs. Judith Kearney, appointed to look after them, treated them with compassion but also saw through the mischief they got up to, and stood no nonsense. Almost all of them enjoyed their time at Caterham – 'We were celebrities all the time we were at school'. They threw themselves into school activities. They formed their own hockey team but were banned from playing five-a-side football with the boys because it involved too much bodily contact. A charity volleyball match against the staff attracted a huge crowd of boys. Sandra Fullard fought hard for girls' rights but found it hard breaking down traditional barriers – during a marathon 24-hour debate, for instance, she rose time after time to challenge every sexist remark, yet was flabbergasted to be singled out at the end for the presentation of a bouquet of flowers. Even when she was given her leaver's Bible, she found the printed inscription read, 'To Sandra Fullard on the occasion of *his* leaving school'. Most of the girls gained in self-confidence from standing up for themselves and many of them have remained in close contact ever since. But in those early days, Sandra Fullard was certain, girls were treated differently – and swapping Caterham for university proved to be a shock. This was partly because only a

dozen or so girls joined the school every year. In 1991 the 50 girls in the sixth form of 182 pupils remained a minority.

By then, thanks to a resurgent economy, there were a record 721 pupils at the school. With 278 pupils, the prep school was larger than ever, enabling the main school to admit a fourth stream. Under John and Monica Churchill, who retired in 1981, it had become a vibrant place. They were succeeded by John Hawkins and his wife Margaret. The new Headmaster was just 34 when he was appointed. He had been educated at Manchester Grammar School, Westminster Teacher Training College, Oxford and the Sorbonne, and came to Caterham from Eagle House, Sandhurst, the prep school of Wellington College. The prep school's growing contribution to the main school was recognised by the Board which established a separate prep-school committee. From the school magazines of the period, the prep school comes across as a thriving miniature version of the main school. There was enormous variety in music and drama, while pupils took part in hockey and cricket, swimming and athletics, sailing and badminton. One of the first overseas tours by the prep school took its rugby team to Dublin in 1989. In the following summer a party of 22 boys and five staff spent four weeks in Zimbabwe.

The Hawkinses left after ten years to take over Belmont School at Mill Hill. In their place came Andrew Moy, who had been in charge of a co-educational prep school in Worthing. He arrived just as the first seven-year-olds joined the school,

reflecting changes in the local state sector, where pupils transferred at seven from first to middle school. Although numbers in 1991 reached a record high of 285, making up 40 per cent of the total school roll, only 29 were boarders.

Within the school as a whole boarders now accounted for just 22 per cent of pupils. Stephen Smith had been pressing the case for the admission of girls as boarders for several years. He believed this would not only strengthen boarding but also give a further boost to the sixth form. A number of boys' schools had already taken this step. In 1988, highlighting once again the continuing demand for boarding places for girls, the Headmaster also told the Board that 'those schools which have upgraded their boarding facilities seemed to be finding no difficulty in attracting boarding pupils'. But the Board remained unconvinced about the return from any investment in better boarding accommodation, especially when capital funds were so limited. David Charlesworth, now a member of the Board, recalled that many members believed that boarding would eventually disappear from Caterham. Stephen Smith remained a staunch defender of an aspect of the school he regarded as integral to its character. As he later recollected, 'boarding was at the heart of the school'; the school was always open, activities were constantly going on, food was always available. The Board sought not to deter applications from prospective boarders through adjusting the level of fees. When the age of transfer from the prep to main school was changed from 13 to 11 to coincide with the introduction

Left: John Hawkins with his wife, Margaret, and pupils in 1981.

Below: Andrew Moy, right, took over the Headship of the prep school in 1991.

Above: the school staff – July 1983. Left to right: Back row: R.J. Day, R.J. Howgego, P.R. Tuck, J. Moulton, P.C. Worley, A.R. Parkes, R.P. Harrison, P.R. Hoad, N.F. Moores. Third row: A.D. Leach, A.G. Simon, R.C. Harding, J.P. Armitage, J.H. Bleach, M.A. Godwin, I. Lycett-King, M.P. Connolly, J.A.B. Beldham, J. Baxter, A.E. Smith, J.P. Seymour, J. Poulson. Second row: R.A. Hopkins, M.W. Nunn, D.A. Seldon, D.J. Rogers, R.W. Jarrams, N.R.E. Johnston, B.R. Martin, D.O.R. Mossman, P.S. Phillips, W. Richmond-Pickering, J.W. Jones, D.J . Tooze, P.C. Edwards. Front row: Mrs. C. Pickering, Mrs. J.M. Kearney, E.J.F. Roughley, A.E.N. Skues, Revd. R.W. Lewis, J.D. Bloom, A. Horwood, S.R. Smith (Headmaster), J.R. Hawkins (prep school Headmaster), G.H. Beaton (Bursar), A.E.B. Clowes, J.H. Robinson-Fuller, P.S. Burns, Mrs. J.R. Hawkins, Mrs. J.A. Blackhall.

of girls from Eothen School in 1994, boarding ended in the prep school. In the main school boarding then ran from 11 to 18, sustained by the termination of boarding at many other schools. By 1991 the decline in boarding made it possible to suggest that Beech Hanger could become a sixth-form girls' boarding house, an idea strongly supported by Smith. This time his persistence brought some dividends. The Board agreed to give limited support to girls' boarding, fearful of the cost implications. The first two girls were boarded out with a local family, a first step which encouraged more applications. By 1992 a small group of girls were housed in a school house, Hillside, under the Reverend Derek Lindfield and his wife, again with minimal expenditure. By then, there were just 35 in each of the boys' boarding houses. Girls' boarding numbers by contrast grew year by year.

The scholarship scheme instituted on independence, the influx of able overseas scholars and the constant demand for day-pupil places helped the school to sustain academic standards. By 1983 35 per cent of boys were achieving two or more A grades at A level, compared with 22 per cent in 1977. In 1988 the pass rate at GCSE was 83 per cent, with 30 per cent of pupils securing A grades. Three years later league tables burst onto the educational scene. The school did not submit its A-level results but, with 28 per cent of pupils achieving A grades, these would have been sufficient

to secure 12th position nationally. The school did submit its GCSE results which, with 53 per cent of pupils recording A–B grades, placed it midway down the second division in the league tables published by the *Daily Telegraph*. Although the Headmaster was wary about the value of such tables, and critical of their composition, he told the Board that 'Caterham's position is a reflection of the good all-round teaching in every department, and the commitment of the staff'. Two years later, with a 96 per cent pass rate at A level, and 98 per cent of pupils taking up university places, the school was placed 112th out of the top 1,000 schools in England and Wales. Moreover, it was placed ahead of competing local schools like Whitgift and Trinity in Croydon and Reigate Grammar School. At GCSE, 95 per cent of pupils were achieving five or more passes and 38 per cent were awarded A grades. Although the advent of league tables began the relentless pressure on schools to focus on grades, Caterham, for many staff, was a school which sought to bring out the best in every pupil, not just the most able.

Pupils were also benefiting from the improvements made to facilities since independence. In September 1976 the Board approved the long-term development plan drawn up by Stephen Smith. The appeal launched in the following month was intended to meet most of the costs of implementing the plan. It raised £270,000 in two years, and was formally

Left: the City Temple, where the school held commemorative services in 1961 and 1984, and performed Messiah *in 1978.*

Below: as part of the centenary celebrations a brewer's dray went from Lewisham to Caterham carrying Stephen Smith, dressed up as the Reverend Thomas Rudd, and pupils wearing period costume.

closed with a performance of *Messiah* in the City Temple in November 1978. Initiated by an Old Boy, Dr. Kenneth Abbott, Director of Music at the City Temple, it featured a choir made up of Caterham School, the City Temple, Berkhamsted Girls' School and Luton Choral Society, ranging in age from eight to 80. The focus of the appeal was more classroom space, improved boarding accommodation and better facilities for day pupils. An additional teaching wing was opened at the rear of the existing buildings in late 1978 by Sir Olliver Humphreys. From September 1978 each day-boy house had its own prefects' room, senior and junior common-rooms and housemaster's study. Staff finally received a larger common-room, as well as a work-room, part of a scheme which carved additional accommodation out of the central area of the school. The prep school also gained more classrooms, a craft centre was completed and the swimming-bath modernised. This programme was supported by the Parents' Association which financed many of the fixtures and fittings.

There were also welcome improvements to boarding accommodation. Study-bedrooms for older boys were

converted from the large dormitories in Townsend and Viney, while smaller dormitories were created for junior boys. Similar arrangements were made at Beech Hanger. Common-rooms were completed and toilets and washrooms improved or rebuilt. Nevertheless, for many boys at the time, boarding life remained relatively basic, with limited toilet accommodation and an adherence to the old ways of doing things. There were times when frustration overflowed. In the early 1980s,

Right: Sir Keith Joseph talking to R.D. Deayton on his visit to the school in 1984, with left to right Stephen Smith, Martin Briggs, Helen Smith and Gerald Mortimer.

after chips had been served almost continually at every meal time for a week, the boarders protested, refusing to have anything other than milk and fruit when meals were served. This seemed to have the desired effect for there was some improvement in the quality of food.

A number of developments reached fruition during the centenary celebration in 1984 of the move from Lewisham to Caterham. Sir Keith Joseph, the Secretary of State for Education and Science, opened the Craft Design and Technology and Art Building. This exhausted the available funds, not all of which had been spent on the fabric. A small number of much-needed scholarships was also set up for boys from less well-off backgrounds. The Old Caterhamians' Association presented the school with an imposing wrought-iron archway for its main entrance.

The centenary itself was marked in several ways. A brewer's dray carried a number of upper sixth-formers and others from Lewisham to Caterham. Among the passengers were descendants of staff and pupils who had made the original move, including the great-nephew of the Reverend Josiah Viney and the great-great-grandaughter of the Reverend W.J. Hope. They were joined along the route by Stephen Smith disguised in gown and false beard as the Reverend Thomas Rudd and met

at the school's front door by the chairman of the governors, Roger Deayton, representing Dr. Joseph Parker, chairman of the Congregational Union, who presided on the original occasion. On 19 October 1984 several hundred boys took a special train to Holborn Viaduct for the centenary service at the City Temple, where the address was given by the secretary of the United Reformed Church, the Reverend Bernard Thorogood.

The centenary also involved the launch of a second appeal but this proved less successful. The second phase of the development plan, featuring a music and arts centre as well as more staff housing, was completed thanks only to generous gifts from three benefactors, who had all been at the school together – Olliver Humphreys, Douglas Burns (the son of Arthur Burns) and Albert Maggs, a former partner in the long-established London antiquarian booksellers, Maggs Brothers. This was possible because the Maggs bequest, consisting of shares in a newspaper company, proved much more valuable than anticipated. A takeover bid for the company resulted in the value of the shares soaring from £100,000 to more than £400,000.

The music and drama complex was opened as the Humphreys Hall by Sir Olliver Humphreys in September 1988. The music centre became known as the Burns Music

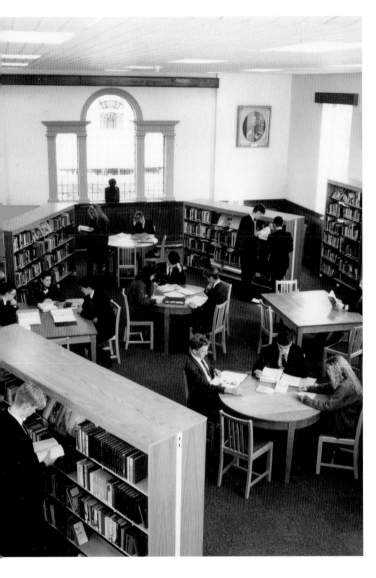

School. The new development allowed the entire school, both prep and senior, to assemble together for the first time in many years although it was still a somewhat crowded occasion. The hall did not prove entirely satisfactory since donor and recipient had to compromise over the design because of the cost. The school had wanted a much more flexible space, which ultimately it was able to obtain when a serious fire in 1999 led to the reconstruction of the interior. The new building enabled the Memorial Hall to be converted solely into a library, which was also funded from the Maggs bequest, with the previous library used for more classrooms. This was particularly appropriate, since Albert Maggs had been charged with raising money from Old Boys in the publishing and literary world for the original appeal in the 1920s.

Humphreys was a good friend to the school, contributing to various other building projects and endowing a scholarship. He had had a distinguished career in business, becoming vice-chairman of GEC, and had also been president of the Institution

of Electrical Engineers and the Institute of Physics. He had joined GEC to conduct research in 1925. When he became technical director in 1960, he took over responsibility for GEC's electronic and telecommunication interests, in which he had already obtained an international reputation. He was knighted in 1968 and four years later became President of the school, which he remained until 1994, two years before his death.

But such generosity could not disguise the scarcity of resources. Brian Dunphy took over as school caretaker in 1985. He recalled how 'you made do with what you had, you mended furniture, you didn't buy it'. He was on call all the time because maintenance was so poor that something was always breaking down or needing repairs. It was not

Clockwise from top left: the Memorial Hall was converted into the Maggs Library; pupils at work in the new craft room; a percussion lesson.

Right: Sir Olliver Humphreys at Speech Day.

until the arrival of John Kidd as bursar in 1990 that a regular maintenance programme was instituted.

Pupils at Caterham were given the choice of more and more extra-curricular activities. The school magazine for March 1985 listed the art club, the amateur radio society, the astronomical society, the badminton club, the boarders' choir, the charities committee, chess, the Christian fellowship, the computer club, COPEC, current affairs, debating, the electronics club, the film society, the history society, the hobbies society, the meteorological group, the Moncrieff Society, the photographic society, the rifle club and the Duke of Edinburgh award scheme. Under Andrew Leach, who arrived as director of music in 1982, participation in music continued to grow. He formed a second school orchestra, resurrected the summer music course, inaugurated instrumental evenings and initiated a chamber music competition. In 1983 the first orchestra gave a complete performance of Haydn's *London Symphony* while over the next three years *The Creation*, Mozart's *Requiem* and Bach's *St Matthew Passion* were all performed with school soloists for the first time. Exchange

visits were arranged with schools in Germany and France. The ATC was disbanded in 1980 in favour of a Combined Cadet Force, incorporating an RAF as well as an army section, which had 90 members by the late 1980s.

Games were timetabled for the first time in 1976, a move which relieved pressure on time after school, allowed late school (that is, lessons taking place later in the afternoon to allow games to be played during daylight immediately after lunch) to be abolished during the winter and gave much more choice. With increased numbers, new tennis courts were opened for the prep school at Shirley Goss in 1982, followed by two more courts for the main school in 1985, while another seven acres of land were acquired adjacent to the existing playing fields on Caterham-on-the-Hill in 1983. A scheme was drawn up in 1981 for a sports hall with swimming-pool for the site below Beech Hanger but there was never enough money to fund it. From at least 1980 tours were organised on a regular basis for most senior teams. In the centenary year of 1984, for instance, the 1st XV travelled to Yugoslavia. Among the outstanding achievements of the time, the 1st XI hockey team under David

Gasparro won 17 out of 19 matches in 1984 and represented the South West in the National Schools Hockey Tournament. Alistair Brown received the Cricket Society's award for the Public Schools All-rounder of the Year for 1986, having scored 898 runs for the school at an average of more than 81 and taken 37 wickets at less than 18. He went on to play for Surrey and was capped for the England one-day side. His success was followed by David Sales who captained Northamptonshire and James Benning who also played for Surrey. In 1990 the Caterham Sevens beat Sevenoaks 20–12 in the final to win the Festival Tournament at the Rosslyn Park National Schools Rugby Sevens. Girls' sport grew steadily under Mrs Fletcher, and they were taking part in swimming, hockey, netball, rounders, tennis, athletics and cross-country by the early 1990s.

Above: cricket on the Home Field.

Top left: batsmen David Sales and Ben Barton broke school records with an opening partnership of 280 not out against the Royal Grammar School, Guildford in 1992.

Left: Alistair Brown.

Stephen Smith was also eager to maintain the school's ties with the United Reformed Church (URC). From 1979 Caterham and the other URC schools, Silcoates and Wentworth Milton Mount (formed after the merger of Milton Mount with Wentworth in 1961), began meeting regularly, and were later joined by Eltham College, Walthamstow Hall and Taunton. The chaplains played a key pastoral role. The Reverend Raymond Lewis succeeded the Reverend Roy Robinson as school chaplain in 1982 and was followed by the Reverend Derek Lindfield in 1987. The first Muslim pupils had joined the school during the 1970s and gained immediate acceptance. Although they were expected to attend daily assemblies, a separate act of worship was eventually organised with the local imam, held in the school library on Sundays.

During his time as Head, Stephen Smith was faced not only with the growth of the school, but also the increasing complexity of educational administration. The traditional system of Headmaster and second master became inadequate, placing both positions under considerable pressure. A senior management team was created in 1980, consisting of the Head, the Head of the prep, the second master (overseeing academic affairs), the bursar and a new post, a senior master in charge of pastoral care, which was filled by John Bloom. In 1987, when Tony Horwood gave up the post of second master, Stephen Smith also took the opportunity to advertise for the first time for external candidates to fill the role. Nigel Thorne, a housemaster from Harrow, was appointed, and proved a great success. After the retirement of John Bloom in

1990, the senior management team was revised. The Reverend Derek Lindfield was appointed senior master, combining the pastoral roles of senior master and chaplain. Two new posts were created, a head of boarding and a director of studies. As the first holder of the latter post, Judith Kearney proved particularly influential. In 1991 Nigel Thorne left to become Headmaster of Rydal School and the vacancy was filled by David Humphreys, who had been a housemaster at Wellingborough School. All these external appointments showed Stephen Smith's fine judgement. David Humphreys, for instance, just 29 years old on his appointment, would later become Headmaster of Woodhouse Grove School.

By then the recession was aggravating the long-term decline in boarding. As the roll fell below 700 in 1993, the school was forecast to record a financial loss. The outlook was bleak for boarding at the prep school, where falling numbers had an impact on boarding at the main school. In January 1993 the Board was presented with a paper prepared by the Head, the Head of the prep school and senior staff, which forecast a crisis in main-school boarding in 1995 unless urgent action was taken. Their proposal was the admission of girls throughout the school, both as day girls and boarders. The Headmaster believed Caterham had to become completely co-educational if it was not to be just another day school. The idea of converting Beech Hanger into a girls' boarding house was revived, and it was also proposed that Mottrams should become a pre-prep school. Co-education and the appointment of more female teaching staff would, argued the staff, strengthen the pastoral side of the school and make boarding more attractive. This had already happened at schools such as St John's, Leatherhead, Oakham, Rugby and Oundle. The closure of boarding they found unthinkable for it would destroy the ethos of the school. It was, they insisted, no time for indecision.

Above: main school staff, 1993. Back row: Keith Simpson, John Armitage, Mary Brewis, Jeanette Guppy, Tony Harmer, Bob Hopkins, Mike Hayward, Alan Simon, Sean Hayes, Brian Flecknoie, Gillian Power, Sue Herbert, Pat Lavery, John Hendry, Jean Keen. 3rd row: Laurie White, Darryl Paterson, Malcolm Bailey, Alistair Tapp, Andrew Leach, John Moulton, Andrew Furnival, Gerald Killingworth, Nigel Patteson, David Cook, Duncan Davidson. 2nd row: David Shackleton, Paul Hammerton, Nick Rugg, Jim Robinson, Ian Sheffield, Peter Markham, David Jackson, Colin Laverick, Paul Becher. Front row: Martin Nunn, Michael Godwin, Ray Howgego, John Jones, John Bleach, Don Seldon, the Reverend Derek Lindfield, Stephen Smith, David Humphreys, Judith Kearney, David Mossman, Robert Jarrams, David Rogers, Jim Seymour, Bill Richmond-Pickering.

Right: winners of the Festival Tournament at The Rosslyn Park National Schools Rugby Sevens. Left to right, standing: Mr. Peter Wakefield (referee), Dominic Mulier, Adam Newell, Ian Armitage, John Lee, Tom Maynard, Simon Scott, Mr. Pat Lavery. Front row: Hiroshi Jayaweera, Charles Abban (capt.), Kwabena Amaning (v-capt.), Daryl Edwards.

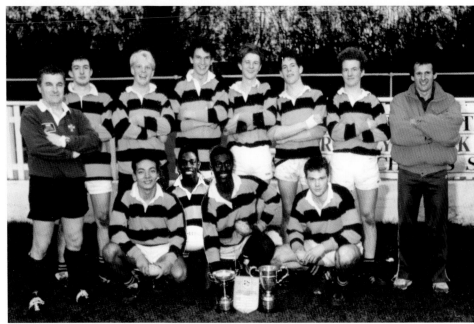

9

'THE SCHOOL WE BUILD TOGETHER'
1993 onwards

The immediate financial outlook for the school was pessimistic. The Board began looking for savings from the annual budget. There was a realisation among staff, as one of them put it, that 'things were getting pretty tight', with the freezing of departmental allowances and the postponement of planned classroom redecoration. Co-education, for some members of the Board, seemed unaffordable, although the Board had agreed in principle to establishing a pre-prep school. As Don Mear, then chairman of the Board, later recalled, 'We just had to watch our pennies the whole time'.

Although the discussions about co-education were confidential, a rumour began circulating that Caterham had decided to admit girls throughout the school. This prompted the recently appointed Headmistress of Eothen School, Anne Coutts, to contact Stephen Smith and express her concern. Eothen had always been a much smaller school and was struggling in the recession of the early 1990s. As they talked, Stephen Smith suddenly asked her if she had ever considered the possibility of Eothen merging with Caterham. The two Heads agreed they would discuss the idea with the chairs of their governing bodies, both of whom also proved sympathetic to the suggestion. Eothen referred the idea to the Church Schools Company, later the United Church Schools Trust, the school's parent body. On 10 June 1993 the general secretary of the Church Schools Company, Ewan Harper, and Anne Coutts took lunch with Don Mear, the chairman of the Caterham Board, and Stephen Smith at the Public Schools Club in London.

Eothen School had been founded by Catherine Pye in 1892 in a house called West View on Harestone Hill, a mile away from Caterham School. There were just eight girls

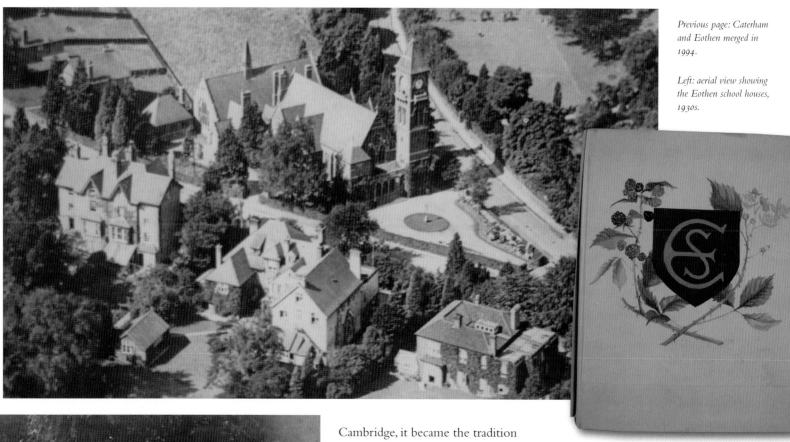

Previous page: Caterham and Eothen merged in 1994.

Left: aerial view showing the Eothen school houses, 1930s.

Above: a book of girls' creative writing and artwork presented to Miss Morris on her birthday, 7 March 1946.

Left: Eothen pupils, 1900s.

and two staff. The first two boarders were admitted in 1897 when the main school was built on a site adjacent to West View and took the name of Eothen, a Greek word meaning 'from the dawn' or 'from the East'. By 1901 there were 55 girls and a new hall was built to accommodate them. The extension was one of several designed by the art mistress, Miss Burrow. The ethos of the school was 'to learn for life' and Eothen took the same view of examinations as Allan Mottram at Caterham. After M.I. Barnes became the first Eothen girl to enter Oxbridge in 1908, winning a place at Newnham College,

Cambridge, it became the tradition until the First World War to celebrate every university place by lighting up the school grounds with Chinese lanterns and fairy lamps. Such occurrences were still rare and women were still subject to considerable discrimination. Oxford, for instance, did not admit women to degrees until 1920 and Cambridge only relented in 1948.

As Eothen expanded, a nearby house was acquired for boarders and bedrooms were added above the hall in 1913. Among the girls joining the school during the war was Imogen Holst, the daughter of the composer Gustav Holst. When the school celebrated its silver jubilee in 1917, funds were raised to begin the nucleus of a much-needed library, although a dedicated building was not constructed until well after the war.

In 1923 the school passed from the private ownership of Catherine Pye and her sister Winifred with the formation of Eothen School Ltd, and a school council was established as the governing body. Among those who were instrumental in providing advice and guidance to the school was one of the earliest chairmen of the council, F. Bradbury Winter, OC, who played a similar role as chairman of the governors at Caterham School for over 30 years. He was faced, as at Caterham, with the challenge of governing a school which was without any significant endowments and relied almost entirely on fees for income.

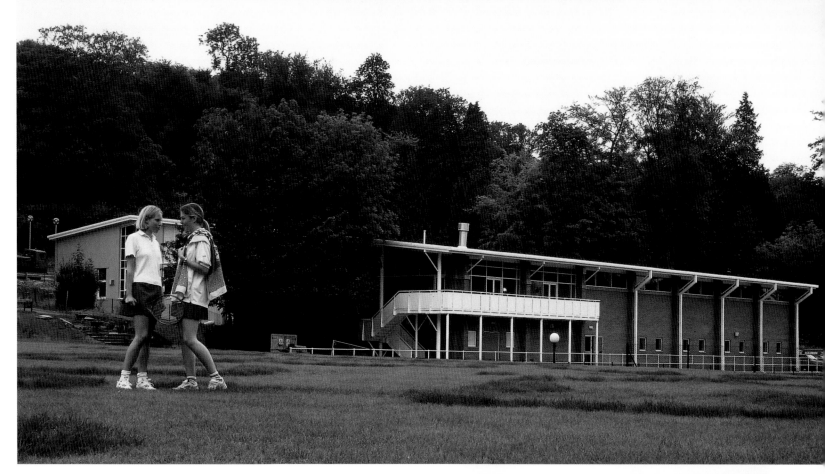

Right: opening of the Sports Centre, 1996. Forefront, left to right: John Kidd (bursar), Roy Milliams (school engineer), the contractor's representative, Rob Davey (Headmaster), Brenda Winterbotham (governor), Don Mear (chairman of governors), David Charlesworth and Jeremy Joiner (governors).

the process would begin a year earlier. In September 1994 the two prep schools merged, lower-sixth girls moved from Eothen to Caterham, the same GCSE syllabus was taught in both schools and Eothen's pre-prep school admitted boys prior to moving to Mottrams a year later. It was expected that the merged school would have about 750 students.

By June 1994 development plans for the merged school had been submitted to the local council and outlined to local residents and other groups. Beech Hanger would at last become a girls' boarding house, a new teaching block would take the place of the old swimming-bath, an enlarged all-weather pitch would be laid down and a sports hall, including a new swimming-pool and fitness centre, would be built. By October that year permission had been granted for all the proposals except the sports complex and work had begun on several of the projects. (The sports centre was completed in 1996.)

Although all subsequent development has been funded from the school's own resources and banking arrangements, this initial investment was made possible by the contribution of nearly £3 million made by the Church Schools Foundation following the sale of the Eothen property. The new developments also helped to perpetuate the memory of Eothen – the teaching block was named after the school and in 2010 the art gallery took the name of Christine Walker. Much later, the sixth-form building would be called the Pye Centre, and an additional day house, Ridgefield, took its name from the sixth-form building at Eothen. As Bill Broadhead, who later chaired the Caterham governors, remembered,

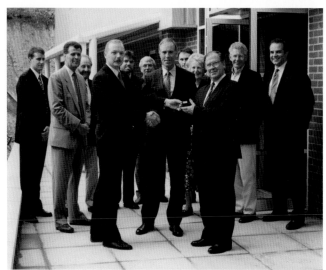

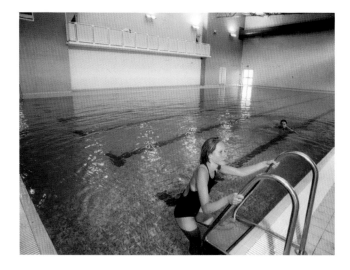

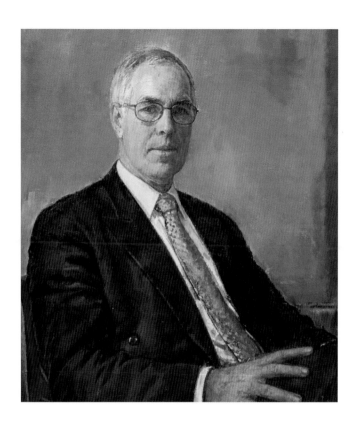

'If we had not merged, the school would not have been able to develop as it did'.

Stephen Smith had indicated he would retire at the end of the spring term in 1995 to permit his successor one term before Eothen girls joined the main school. He had begun his Headship by taking the school independent and he ended it by working hard to secure the success of the merger which allowed the school to flourish as a co-educational day and boarding school. The development plan he had initiated, although delayed by financial considerations, had almost been completed by the time of his retirement. He had also done much to nurture the Christian ethos of the school and to sustain academic standards (the school was placed 39th in the national league table for A level results in 1995). Given the constraints he faced, his achievements were considerable.

His replacement was Rob Davey, deputy head of the Cathedral School at Wells in Somerset. A softly spoken, gentle Ulsterman, he was the son of Raymond Davey, the Presbyterian minister who had co-founded the Corrymeela Community, dedicated to reconciliation and peace-building in Northern Ireland, in 1965. Graduating from Trinity College, Dublin, Rob Davey then spent a year in France, where he discovered his love of teaching and working with young people. After a teaching qualification at Oxford, where he gained a blue in rugby, he was appointed to teach modern languages at Mill Hill in north London and later moved to Rydal School in north Wales. He became involved with

the Boarding Schools Association and at a conference held in the Lake District he met Stephen Smith who marked him down as a possible candidate to take over from him at Caterham. From his time at Rydal and Wells, Davey found that he enjoyed innovation and came to believe that the most effective way of leading a school was through consensus and collaboration.

He arrived at Caterham at the start of the summer term in 1995. Warm and welcoming, his obvious concern for individuals and his high visibility around the school, always talking to students, made him a popular figure. In that last term before the merger Davey worked hard to reassure staff, to demonstrate his firm commitment to true co-education and to cultivate self-belief throughout the school by recognising ability, effort and talent wherever it was found. He told staff his three priorities were to make the merger work, ensure there were enough students and develop the new staff team. Anne Collins, as head of girls' games, ensured a wide range of sporting opportunities was available from the outset. Several girls would achieve representative honours at county and national level for netball and lacrosse. The school also enjoyed the advantages of a good record at A level – 86 per cent of students achieved grades A-C – as well as being the only co-educational day and boarding school in a catchment area dominated by single-sex schools.

Nevertheless, the first year of the merged school was difficult, and Davey had to draw deeply on his ability to assuage, pacify and encourage. Change proved disruptive to discipline, and there was a spate of minor offences and a string of suspensions. Although 168 girls joined the merged school, they were still substantially in a minority, sometimes with just three in a class of 24. But the Head was pleased with the calibre of the first-year intake, which set a pattern for the future, and, in his words, 'created a really warm culture of looking after each other'. The new school began with 706 students, with 23 girls among the 147 boarders. Townsend House had been extended, as Rudd House, for 11–13-year-old boy boarders.

It was not an easy time for staff, particularly those at Eothen. All staff had to compete for posts at the merged school and as a result the atmosphere in the early days was tense. Among some long-serving staff from Caterham, there was also resentment at what they saw as a loss of independence and at the perception that this was a 'new' school. But the early retirement of many older staff, the appointment of new staff without any connection to either school, and the admission of boys and girls who had never known the separate schools, quickly helped to eliminate any

Left: Rob Davey, Headmaster 1995–2007.

Opposite: Isaac Quinton performing at Lunchtime Live.

Above: boarding at Caterham has been rated 'outstanding'.

Right: the chaplains play an important part in the life of the school.

Opposite: the Vestibule.

governors formed the Master Plan Committee to establish the long-term needs of the school and how they might be funded from the school's annual surpluses. With members drawn from the governors and from staff, this was indicative of the closer understanding being forged between the governing body and the common-room. Discussions soon focused principally on the provision of better science facilities, a new refectory hall and kitchen, and improved sixth-form accommodation. A ten-year programme was drawn up and the school's relationship with its bankers, the Allied Irish Bank, allowed significant loans to be taken out to fund the largest projects. Within the school John King, the bursar, played a leading role in supervising the implementation of the programme.

For Rob Davey, priming the new school was a process which took six years. In 2002, the Headmaster told guests at Speech Day that opting for co-education 'wasn't an easy path, as many here know, but today we celebrate Caterham as a successful school. Not a boys' school with girls tagged on, but a fully integrated co-educational school'. By then, few students knew anything other than the merged co-educational institution, with the balance between the genders settling at around 45 per cent girls and 55 per cent boys.

A key attribute in the success of the school was the calibre of the staff. While several committed long-serving staff retired, their places were taken by high-quality candidates. Among those who retired were John Beldham, the Reverend Derek Lindfield, John Jones and John Moulton, while in tragic circumstances the school also lost Robert Jarrams, who took his own life in 1998. On the non-teaching side, Roy Milliams retired as school engineer in 1999 after 40 years' service. Women featured strongly in the new appointments, and within four years of the merger, one-third of the heads of houses, heads of department and heads of year were women. The quality of the senior management team was reflected in the number of staff who later went on to Headships. When

tension. David Rogers remembered that 'the merger went much more smoothly than people expected'.

For Don Mear and David Charlesworth, who would succeed Mear as chairman of the Caterham governors in 1998, the association with the Church Schools Trust brought considerable advantages to the way in which the merged school was run. The much more commercial and professional operation of the Trust opened the eyes of many governors to better ways of doing things. In particular, the school was able to draw upon the Trust's central support services, notably finance and human resources.

The school's new-found financial security gave it the opportunity for the first time to plan ahead. In 1999 the

David Humphreys left in 1996, the post of deputy headmaster was filled by Mark Bishop, who would become Headmaster of Trinity School. Lindsay Redding had joined the school from Eothen, taking over the senior girls' boarding house. Appointed to the Senior Management Team in 2003 and as deputy head in 2005, she would move to her own Headship, at Greenacre School for Girls in Banstead, in 2009. Several other staff would also leave for posts as deputy heads. In 2004 Kim Wells was appointed to the new post of director of learning and teaching. Caterham was among the first schools to create such a post, with its focus on encouraging independent learning, and Wells proved highly successful in bringing parents and students together.

Teaching benefited not only from the calibre of staff. Investment in buildings made teaching more effective, the Eothen Building allowing related departments to be located close to each other. There was a heavy investment in information technology, not only for the classroom but also for the school administration, and Paul Hoad, a long-serving member of staff, became the director of ICT development in 1998. There was a conscious effort to extend the most able students and Greek returned to the curriculum for the first time in many years.

The result was that when the boys and girls of the first intake sat their GCSE examinations in 2001, the pass rate was 100 per cent at grades A★-C, with 46 per cent achieving grades A★-A. In subsequent years this success translated into improved results at A level.

Co-education, substantial investment and focused leadership proved a winning combination as far as parents

were concerned. By 1999 numbers in the school had reached almost a thousand. The main school comprised 710 students, while numbers in the pre-prep and prep school, where Susanne Owen-Hughes would take over from Andrew Moy in 2000, consisted of 117 and 150 respectively. The school took a deliberate decision to maintain numbers around this

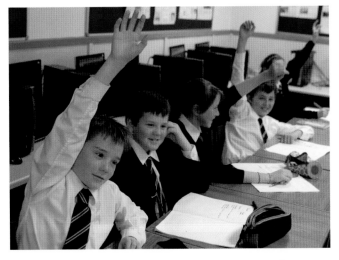

Far left: an art studio.

Above: Chemistry Week.

Left: David Clark teaching a history lesson.

Top right: a geography lesson and (below) a Young Enterprise meeting.

Far right: Caterham students launching the political magazine Preview *at the Palace of Westminster. Left to right: Joe McLaren, Samantha Moore, Imogen Ware, Alex Gordon, John Bercow MP, Peter Ainsworth MP, Matthew Grant, Sophy Colman, James Hutchings.*

his predecessor, made several visits to the Far East. Secondly, the interest in girls' boarding continued. Beech Hanger, the girls' house, became the largest of the boarding houses. Thirdly, a phased programme of long-overdue improvements to boarding accommodation began in 1999, designed to meet modern standards and expectations. This also attracted parents interested in weekly boarding arrangements for their children. Fourthly, the level of pastoral care was outstanding. The report of the boarding inspection carried out in 2007 described the school's boarding houses as the happiest and best organised they had come across. A further inspection in 2009 would rate the overall quality of boarding as outstanding and emphasised the 'outstanding level of care' offered to boarders. Much of this was down to the leadership of Jim Seymour, appointed senior teacher in charge of boarding in 2001, and his staff. As Jim Seymour remarked, 'You can never replace the family home but we create a friendly place here thanks to the commitment of a small group of dedicated people'. Another contributory factor was the appointment, beginning in 1999, of young gap-year graduates from overseas. Recruited mainly from the USA, New Zealand and South Africa, they came with sporting expertise and boarding experience, instilling a strong sense of discipline and strengthening the international atmosphere within the school.

With the boarding community made up of more than 30 different nationalities, it was important to make the whole school aware of different cultures, showing every pupil how similar and yet how different each was from the other. The chaplains, Derek Lindfield and Rick Mearkle, who took over in 2000, played a crucial role in this aspect of the school. With many boarders coming from a diverse range of religious backgrounds, the service of worship for boarders used the free, open tradition of the URC to foster the sense

level, resisting the temptation to expand further and dilute the character of the school. Applications rose steadily, attracting affluent families with high expectations for their children's education, who were able to afford the higher fees necessary to invest in the standards which met those expectations. In the main school fees had risen from £1,340 (day) and £2,460 (boarding) a term in 1990 to £2,030 and £3,710 in 1996, reaching £4,223 and £7,823 today. To fulfil the intention that the school should be accessible to all talented students, regardless of parental income, the scheme of scholarships and bursaries was steadily extended. Today a third of students benefit from this scheme, with academic scholarships offering a maximum 50 per cent reduction in fees, and other awards a reduction of as much as 25 per cent.

Although the heyday of boarding was past, its future at Caterham was no longer in doubt. There were a number of reasons for this. Firstly, despite the ups and downs of the international economy, the school maintained the tradition of a strong overseas boarding contingent, and Rob Davey, like

of a single community while being sensitive to differing cultural backgrounds, giving each student space for spiritual reflection. Weekly themed assemblies were introduced, as well as international weeks, when students learned about life in different parts of the world. In 1997 the Melting Pot Society was formed, where overseas students make presentations to other boarders or to the whole school on their own countries and cultures.

Further encouragement for students to take a broader view of the world came from the extended overseas links established by the school. Following the participation of staff and students in the World Challenge Expedition in 2000, staff floated the idea of doing something more practical and purposeful. Some time earlier, former pupil John Grimshaw, later President of the Old Caterhamians, had suggested that the school might become involved with a primary-school project at Lerang'wa in Tanzania, which he visited with the Headmaster and his wife in 2006. As a result of that visit, a long-term relationship was established and groups of Caterham students have travelled regularly to the school. They must make a formal application for consideration to go and must raise funds to cover part of their expenses. It is a practical expedition where everyone helps out at the school – one year, for instance, the plumbing skills of one Chinese boy were particularly appreciated. In 2002 David Clark, who played a key role in organising the visits to Lerang'wa, also established an annual exchange with the Western Reserve Academy in Ohio in the USA. More recently, Rick Mearkle has helped the school to forge links with a small school run by the Hungarian Reformed Church in the Ukraine. Located just across the border from Hungary, the school serves a poor

and struggling minority population in fear of persecution, and staff and students from the school assist primarily with English teaching. All this exposure to other cultures at home and overseas is part of helping to make Caterham students more rounded people with a wider vision of the world.

The example of Ansel Reed, a young American who spent his sixth-form years at Caterham, illustrated the impact an individual could have on the school. When Ansel joined the school in 2002, he took up one of the free ministerial places since both his parents were ministers. He had been afflicted by serious illness for most of his life and had spent nine months in Great Ormond Street Hospital during his GCSE year. Yet this seemed to stimulate his determination as a committed Christian to make a difference to those around him. He took a pastoral interest in the younger students in his house, comforting those who were new or homesick or shy. In his assemblies he raised awareness of the needs of the disadvantaged throughout the world. He encouraged his peers to donate blood, carry donor cards and join the bone-marrow register. He took a full part in school activities, from

Bottom left: Caterham's association with a primary-school project in Lerang'wa started in 2005.

Left: Iceland expedition, 2006 and (below) CCF cadets, RAF Boulmer, 2007.

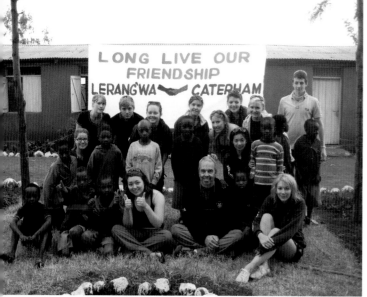

Above: the Duke of Edinburgh expedition to the Lake District, 2007, at Aira Force, Ullswater. Left to right: Laura McCartney, Laura McVitty, Hemant Tandon, Rachel Pickford, Jack Pearce.

Far right: Jess Puntan on the Dale Fort Biology field trip.

his prominent role in the politics department to representing the school at cross-country and supporting drama and music. His idiosyncratic influence was shown through rousing his peers early on a summer morning to watch the dawn rise from View Point or creating the 'five to eleven club' which set aside five minutes before lights out to compose verse about the events of the past day. As David Clark, who joined the staff in 1996, recalled, Ansel 'embodied everything that is good about Caterham School and we were proud to know him'. Ansel achieved good grades in his A levels but lost his battle against illness and died in New York in 2006. Today his name is remembered in an annual prize awarded to the boarder who gives most to others.

Pastoral care throughout the school received increasing thought and attention. It became focused on the year group rather than the house system, with the appointment of individual heads of year and a head of sixth form. Eventually assistant heads of year were also appointed. In 2000 the school appointed a head of special needs and a part-time school counsellor joined the staff in 2002. The creation of year heads provided the stimulus for reinvigorating the house system. Sean Hayes, who had run Harestone for 16 years, took over as senior housemaster and greatly expanded house competitions,

with points awarded for each event. This included not only sporting competition but also drama, music, debating, chess and even boules during Modern Languages Week. The winning houses were presented with the Stephen Smith Cup for boys and the Diane Raine Cup for girls at the end of the Easter term each year.

Rob Davey stepped down as Headmaster at the end of the summer term in 2007. He had been in charge of the school for a tumultuous 12 years. His quiet wisdom and gentle leadership had proved hugely effective in melding two schools into one. He had superintended perhaps the most ambitious capital programme ever undertaken by the school and had overseen the revival of boarding, so important for the character of the school. He left a school which was flourishing, with more students than ever before, with a growing volume of applications, with high academic standards, and perhaps most importantly with its Christian ethos reinforced.

A feature of the latter part of Rob Davey's tenure was significant and controversial constitutional change, which continued into the early years of his successor, Julian Thomas. With the agreement of the Caterham Trustees, the Church Schools Company and Foundation (later renamed respectively the United Church Schools Trust and United Church

Far left: Bill Broadhead speaking at the opening of the Pye Sixth-form Centre, watched by Dr. John Hood and Julian Thomas, 2008.

Below left: the opening of the Stephen Smith Sports Centre with Julian Thomas, Bill Broadhead, Stephen Smith and Rick Mearkle, 2008.

Left: the Pye Sixth-form Centre.

Schools Foundation) carried out a review of the partnership arrangement to establish whether it was now possible for the merger of the charitable trusts to take place as originally intended. But the school, backed by the Trustees, saw little need to change the existing agreement, appreciating the benefits of its relative autonomy, and there was no longer any support for full merger. In any case, legal opinion on the possibility of merger proved divided. When the governing bodies of the Church Schools and Caterham Trusts met with senior staff from the school in Beech Hanger in June 2004, it was agreed to maintain the existing arrangement.

In the altered circumstances the Church Schools Trust felt it was unable to fund any investment in Caterham from its own central resources. This led the Caterham Trustees to incorporate the Caterham charity as a limited company with a constitution that provided the borrowing powers necessary

to realise the school's ambitious building plans. John King, the school bursar, made a major contribution towards achieving incorporation for Caterham in 2005.

The bursar's expertise in relation to property matters also proved invaluable following the rent review which took place in 2005. The governing body was unable to reach agreement on a new rent and the matter took some years to resolve. An agreement was finally reached in 2009, with the new arrangements taking effect early in the following year. At the same time the unwieldy two-tier structure of governance was simplified. A single body of trustees was created, with an equal number of nominees from the Caterham Foundation and the United Church Schools Foundation. As well as the bursar, Bill Broadhead, who chaired the Trustees from 2001, invested a great deal of his time and expertise in resolving this difficult issue. Martin Newlan, the vice-chairman, and the chairman-designate, Jonathan Bloomer, were also deeply involved.

Julian Thomas graduated from King's College London and subsequently studied at Queens' College, Cambridge, where he gained a PGCE, and the University of Hull where he gained an MBA in Educational Leadership. He was a keen sportsman having played cricket for Essex Schools U19 and won a half-blue at Cambridge for Rugby League. He spent five years working in the city for Lloyds Bank and BP but moved into teaching as he felt it was a more fulfilling and rewarding career. Prior to Caterham, he worked in several independent schools including Portsmouth Grammar, where he was director of studies, and Hampton, where he was second master.

He believed strongly that excellent education was about far more than academic achievement alone. Good schools, he felt, should nurture in their students a passion for learning through inspirational and innovative teaching, develop wider

Right: pre-prep pupils.

Below: Howard Tuckett, prep school Headmaster.

interests through a broad range of co-curricular activities and instil the responsibilities of good citizenship. He strongly supported the emphasis Rob Davey had placed on the education of the whole person.

Under the new Headmaster and his team, the school has continued to develop. Academic standards have further improved, with 93 per cent grades A★-B at A Level and 91 per cent A★-B at GCSE in 2010 and the school has become a national leader for its focus on independent learning and innovative teaching techniques. These results also rely on the calibre and commitment of staff throughout the school. With growing applications, the school's catchment area for day pupils has widened to cover the area bounded by Reigate, Sevenoaks and Croydon. Boarding, whose future was for so long in doubt, has undergone a renaissance, with all 170 places filled, and a new girls' boarding wing recently completed. This gives life to the school, with many staff living on site, and allows day pupils the chance to take part in weekend activities. A sixth form in excess of 200 enjoys the modern facilities provided by the Pye Sixth-form Centre, completed in July 2008 at a cost of £4.2 million.

With the near completion of the original ten-year development plan, the school began to plan ahead once again. During 2010 work began on restoring the pavilion and creating a new facility for spectators and hospitality overlooking the Home Field which is intended for completion during the bicentenary year in April 2012. A review of boarding accommodation is also being undertaken. A major part of the new programme concentrated on requirements for the prep school. In particular these included additional teaching accommodation, specifically for music and science, while proposals for a prep-school sports hall, sports pitch and training pool are also being considered.

The prep school, led by Howard Tuckett since 2005, is a vibrant and integral part of the school. The concept of Caterham as a unified school was illustrated in 2009 when eight students became the first to progress right through the school from reception to the upper sixth. The links between the prep and main schools have become stronger, with the progress of those moving into the main school helping to develop the teaching of new entrants into the prep. In recent years, to increase the confidence of pupils, the school has worked hard to raise sporting standards. For instance, the prep-school girls have reached the finals of the national netball championships three years in a row.

The range of activities available to students in the main school has become even more extensive. In recent years the last week in every summer term has been devoted to a Personal Enrichment Week, with an organised programme of activities. With greater opportunities for more pupils to take part, music, drama and art are stronger now than they have ever been. More than 200 pupils are learning to play an instrument. The CCF has 160 members, almost half of whom are girls. Recent destinations for overseas visits have

Left: the unbeaten 1st XV of 2009. Front row, left to right: Craig Moore, Freddie Page, Ben Carew-Gibbs, Chris Munns, Matthew Foulds, Ben Doney, Sam Fullalove, Chris Elliott, Bertie Bayley. Middle row: Tom Street (coach), Pat Lavery (coach), Ben Lewis, George Sakandelidze, Chris Kendell, Chris Payne, James Weller, James Miles, Rob Leatherby, Jonny Osbourne (coach). Back row: Alastair Bownas, Matthew Wilson, Alasdair Brown, Matthew Trayner, Ben Davidson, Will Harvey.

Far left: Rob Willson playing for the 1st XI hockey team.

Left: Joe McLaren in action for the 1st XV rugby team.

ranged from Austria, Germany and France to Iceland, the Ukraine and Tanzania. Students have also been involved in the local community, working with local charities and local state schools. Under director of sport Pat Lavery, who retired after 24 years in 2009, high standards of sporting achievement have been exemplified in recent years by the performance of the 1st XV under captain Matthew Foulds in 2008, the first side to remain undefeated since 1935.

The science faculty at Caterham has played an important role in the recent academic success of the school. Building on the solid foundations of the past and now re-housed in

Right: U13A lacrosse team, winners of the Coloma Cup. Back row, left to right: Jo Simons (coach), Chloe Downes, Bethany Quinton, Ella Donald, Harriet Wildman, Sarah Slater, Joanna Upward, Louise Gardner, Georgia Arnold. Front row: Bronte Rowlands, Millie Hopkins, Ella Faulkner, Paige Stapleton (capt.), Robin Hunt-Williams, Francesca Adams.

a new purpose built premises, it has developed into one of the leading science faculties in the country. The energy and commitment provided by head of science Dan Quinton has been instrumental in seeing growth in student numbers and a healthy expansion of science related enrichment activities and societies. Under his guidance for example, the faculty's flagship society, Moncrieff-Jones has gone from strength to strength. Equally, students of all three sciences have been very successful in recent years in securing places at Oxford and Cambridge and an unprecedented number of students have taken up places to study medicine – again at the top universities in the country. In recognition of the outstanding examination results, the science faculty has won 12 *Good Schools Guide Awards* over the last six years – a rare and proud achievement. What is

Far right: Loulou Rowlands playing for the tennis team. Loulou has been one of Caterham School's most successful female athletes. She played lacrosse for England U19, won the silver medal in the 2009 English Schools 800m championship and won the English Schools cross country championship in 2009.

Right: Jayde Cook in action for the 1st team netball.

remarkable about this growth and success is that it has taken place during an era of national decline in school sciences and the closure of several university departments due to the lack of student interest.

The school would be impossible to run without the many administrative, maintenance and domestic staff, from the cleaners, maintenance men and ground staff to the catering staff, nurses and matrons, and admissions and bursarial teams. Brian Dunphy, the long-serving caretaker, celebrated 25 years' service in 2010 – he had only intended to stay three months.

The Old Caterhamians' Association continues its support for the school by providing bursaries for five pupils a year and donating annually to the bursary fund. It also contributes to international sports tours, gives careers advice, provides the annual prizes for the head boy and head girl in the senior school and contributes to the prizes and leavers' books in the prep school. A bequest from Stephen Bonarjee and an annual donation from Julian Darley are the latest in the long history

of substantial donations to the school by Old Caterhamians, the former resulting in 2007 in the development of the ground floor of the Viney wing into bursarial offices and a boardroom.

The impressive progress made by the school under Julian Thomas and his team was highlighted by the inspection carried out by the Independent Schools Inspectorate during 2010. The conclusions of the inspectors illustrated the school's success in offering an all-round education which prepares its students for their future lives in every respect. The inspectors remarked that 'The school is highly effective in meeting its aims of stimulating all pupils to achieve their academic potential, and promoting independent thinking and lifelong learning. Pupils throughout the ability range are highly

Above: the cast of Les Misérables.

Left: cast members from A View From The Bridge – *Rosie May, Katy Atkins and Alex Kerr.*

committed to strengthening its partnership with the United Church Schools Trust, of which it is an associate school.

The ethos of the school, as the most recent inspection noted, still owes much to its Congregational roots. For Rick Mearkle, the key characteristic of the school is its friendliness and its openness to newcomers, as it strives to create an inclusive community today just as the Reverend John Townsend sought to do in 1812, when the school gave an education to those boys excluded from the existing system to enable them to take their place in wider society. Today, as then, the school still offers places for the sons and daughters of URC ministers.

As the Head told the guests gathered for Speech Day in 2009, 'We must ensure that Caterham is the school we build together: staff, pupils, parents and other members of the School community all feeling that their views are worthwhile, that they are trusted and that they are an intrinsic part of building something remarkable'. Throughout the school's long history, this emphasis on people working together towards shared goals, on a collaborative enterprise, has not only allowed the school to survive in difficult times; it has proved to be the keystone on which today's flourishing institution has been built.

Clockwise from bottom left: winners of the Leatherhead Drama Festival 2010 receiving their award from Sir Michael Caine for their play Silent Scream. *Left to right: Lisa McMullin, Cole Campbell, Elliott Gordon, Rebecca Ward, Imogen Ware, Hannah Spence, Anjali Bhat, Gina Sherlock, Emma O'Brien; Monsters of Rock – a charity concert; members of the circus club.*

successful in their learning and personal development'. They also noted that 'the pupils' personal qualities are outstanding and are promoted by the friendly and supportive atmosphere'. And they highlighted the importance of the school's Christian ethos which helps to 'nurture a spirit of endeavour and compassion for underprivileged people'.

The Headmaster is clear about future challenges – continuing to offer an education for life for all students based on an extensive range of co-curricular provision; and furthering the school's work to ensure that as many children as possible are able to receive an education at Caterham regardless of their financial circumstances. With the latter in mind, a major bursary appeal will coincide with the celebration of the school's 200th anniversary. Caterham is also

Appendix I

School Presidents

1878–96	The Revd. Josiah Viney
1897–1925	The Chairman of the Congregational Union of England and Wales
1926–7	Mr. Alexander Glegg, JP
1928	Mr. W.J. Young
1929–30	The Revd. Sidney M. Berry, MA, DD
1931	Mr. Angus Watson, JP
1932–49	The Viscount Leverhulme
1953–64	The Hon. Sir William Gorman, LLD
1965–71	Sir Alan A. Moncrieff★, CBE, MD, FRCPJP
1972–94	Sir Olliver Humphreys★, CBE, BSc, CEng
2007–	General Sir Alex Harley★ KBE CB

Sir Olliver Humphreys *General Sir Alex Harley*

Chairmen of Governing Body

1891–6	The Revd. Josiah Viney
1897–1904	The Revd. R.T. Verrall, BA
1904–36	Mr. F. Bradbury Winter
1936–9	Dr. A.G. Sleep, DD
1939–45	Dr. E.H. Landel Jones★, LLD
1946 (Jan to July)	The Revd. Maldwyn Johnes★
1946–51	Mr. F.H. Elliott, DL, JP
1951–3	Mr. J. Rockingham
1953–62	Mr. K.M. Kirby★, LLB
1962–6	Mr. J.R. Pigott, BSc
1967–0	Mr. L.F. Durman★, FCA
1970–5	Mr. E. De C. Blomfield★, FIA
1975–9	Mr. M.H. Briggs★, OBE BSc (Eng)
1979–89	Mr. R.D. Deayton★, VRD, ACIS
1989–98	Mr. D.R. Mear★, BA, FCA
1998–9	Mr. D.P. Charlesworth★
1999–2001	Mr. D.R. Mear★, BA, FCA
2001–10	Mr. W. Broadhead★
2010–	Mr. J. Bloomer

★Old Caterhamian

Mr. M.H. Briggs *Mr. R.D. Deayton* *Mr. D.R. Mear* *Mr. D.P. Charlesworth*

Mr. W. Broadhead *Mr. J. Bloomer* *Mrs. B.M. Winterbotham, Chairman of Eothen Governors at merger in 1995*

Headmasters

1811–15	The Revd. J. Thomas
1815–17	The Revd. J.J. Richards
1817–23	The Revd. J. Simper
1823–52	The Revd. W.J. Hope
1853–9	The Revd. J. Lister
1859–94	The Revd. T.L. Rudd BA
1894–1910	The Revd. H.E. Hall MA
1910–34	Mr. A.P. Mottram★ BSc
1934–49	Dr. D.G.E. Hall MA, DLit, FR HistS, FRAS
1950–73	Mr. T.R. Leathem MA (Cantab.), JP
1974–95	Mr. S.R. Smith MA (Cantab.)
1995–2007	Mr. R.A.E. Davey MA Palmes Academiques
2007–	Mr. J.P. Thomas BSc(Hons), MBA, FRSA

Prep-School Heads

1935–66	P.M. Soderberg BA
1966–81	J.H.R. Churchill MA
1981–91	J.R. Hawkins BA
1991–2000	A.D. Moy BSc
2000–05	Mrs. S. Owen-Hughes BEd, BSc, MBA
2005–	H.W.G. Tuckett MA

Mrs. S. Owen-Hughes

Three generations of headmasters, Stephen Smith, Julian Thomas and Rob Davey, in front of the Davey Building, 2007.

OLD CATERHAMIANS' ASSOCIATION PRESIDENTS

1891	M.L. Moss	1921	A.H. Homewood	1951	A.B. Clark	1981	D.K. Britton
1892	P. Rees	1922	E. Evans	1952	A.F. Syer	1982	J.R. Mathias
1893	T.D. Bell	1923	V.H. Mottram	1953	J.A. Plaskett	1983	E.D. Starmer
1894	T.D. Bell	1924	J.H. Burgess★; C.C. Brown	1954	B. Dermer	1984	S.J. Mew
1895	R.W. Rudd	1925	C.E. Dukes	1955	C.R. Allison	1985	M. King
1896	B. Kettle	1926	G.W. Harrison	1956	L.H. Stowell	1986	J.M. Rose
1897	H.E. Hall	1927	R. Oliver	1957	T.H.R. Hern	1987	E. Bevington-Smith
1898	T.S. White	1928	J. P. Edwards	1958	P.M.B. Rowland	1988	R.V. Elliott
1899	D.T. Oliver	1929	A.J. Ashton	1959	G.W. Pay	1989	R.V. Elliott
1900	C.C. Brown	1930	B. Evans	1960	R.M. Gold	1990	M.L. Jackson
1901	J. Lucas	1931	J.S. Whale	1961	A.A. Moncrieff	1991	R.C. Hallam
1902	J. Davenport	1932	D.P. Martindale	1962	B. Blake-Thomas	1992	R.D. Deayton
1903	W.W. Lucas	1933	L.H. Snell	1963	W.A.L. Jackson	1993	K.J.D. Abbott
1904	F.F. Evans	1934	A.P. Maggs	1964	O.B. Gatward	1994	A.D. Chambers
1905	S. Palmer	1935	H.E. Sawdy	1965	A.J. Davies-Jones	1995	M. Haines
1906	A. Burns	1936	A.J. Davies-Jones	1966	O.W. Humphreys	1996	D.K. Tindley
1907	E.H. Landel Jones	1937	I.A.E. Mottram	1967	C. Price-Thomas	1997	D.J. King
1908	E.H. Snell	1938	C.G. Henderson	1968	A.G. Allnut	1998	E.O. James
1909	S.B. Atkinson	1939	P.D. Wilcock	1969	A.E. James	1999	D.H. Lissaman
1910	G.L. Eynon	1940	P.D. Wilcock	1970	G.J. Mortimer	2000	P.R. Tuck
1911	W. Pickford	1941	P.D. Wilcock	1971	M.H. Briggs	2001	P.R. Tuck
1912	B.J. Snell	1942	P.D. Wilcock	1972	L.F. Durman	2002	D. Hatch
1913	A.P. Mottram	1943	A.A. Moncrieff	1973	V.H. Martindale★; R.D. Deayton	2003	I. Adam
1914	A. De Buriatte	1944	A.A. Moncrieff	1974	R.W. Cartwright	2004	S. Kirk
1915	V.C.B. Jones	1945	A.A. Moncrieff	1975	R.D. Deayton	2005	S. Kirk
1916	G.H. Ashbery	1946	A.A. Moncrieff	1976	S.J. Mew	2006	R. Lyons
1917	F.A. Parnaby	1947	B. King	1977	E de C. Blomfield	2007	R. Lyons
1918	I. Thomas	1948	S.L. Jackson★; L.H. Stowell	1978	L.G. Rignall	2008	J. Grimshaw
1919	A.M. Jarratt	1949	A.W. Cozens-Walker	1979	W.R. Broadhead	2009	J. Grimshaw
1920	S.W. Attwell	1950	K.M. Kirby	1980	I.S. Kiek	2010	D.K. Tindley

★*Died in office.*

Recent OCA Presidents and officers not appearing elsewhere

M.W. King

M.L. Jackson

R.C. Hallam

E.O. James

His Hon. Judge
D.H. Lissaman

P.R. Tuck

R. Lyons

Dr. J. Grimshaw

I.S. Kiek, also OC
Co-Editor of The
Caterham School
Magazine *1965–81 and*
Editor 1981–9

J. Mortimer, OC Editor of
The Caterham School
Magazine *1990–2004, OC*
Editor 1990–2007

D.K. Tindley, also OCA
Treasurer 1987–, Chairman
of the OC Trust 2000–11

D. Craft, OCA Chairman,
OC Trustee 2000–11

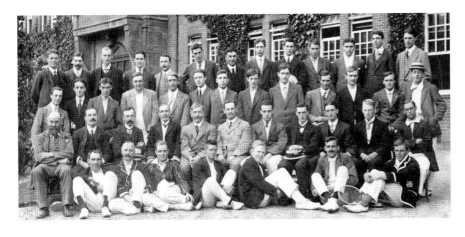

First Summer Reunion 1912

Left to right, top row: S.C. Woodhouse, [?], Idris Thomas, W.M. Morgan, C.L. Davis,[?], F.W. Ingram, [?], G.K. Davies, [?], C.D. Gay, Raymond Oliver, H.H. Morgan, R.C. Burt, [?], R.C.L. Baker. Second Row: C.C. Cattermull, Markus Dukes, W.E. Pratt, F.N. Tinkler, V.H. Mottram, A.E. Walden, E.E. Caffyn, Ll. Ap. Ivan Davies, [?], Paul Dukes, [?], T.B. Brewin, H.E. Sawdy, L.C. Perry, C.G. Henderson. Third row: Mr. Winter, B. Kettle, Landel Jones, Duncan Bell, A.P. Mottram, Gilbert Scott, Evander Evans, [?], L.H. Snell, [?], P.C. Warner. Front row: Victor Jones, T.S. White, H.P. Plowright, G.L. Eynon, G.D. Brough, E.T. Budden, A.H. Griffiths.

F.W. Ingram, T.B. Brewin and Gilbert Scott were killed in the First World War. (Sir) Paul Dukes was a British spy in Revolutionary Russia. H.H. Morgan and G.L. Eynon were notable benefactors. (Professor) Vernon Mottram, the Headmaster's younger brother, began the school's Advanced Science Course in 1919. Bernard Kettle and the art master Laurence Beauvais designed the school crest. Landel Jones was chairman of the school Board 1939-45. Handel Jones, Kettle, Duncan Bell, T.S. White, Idris Thomas, Evander Evans, Vernon Mottram, Raymond Oliver, L.H. Snell, H.E. Sawdy, and C.G. Henderson were former or later presidents of the Old Boys' Association. (Dr.) S.C. Woodhouse died in 1997 aged 102.

OCA Presidents, Foundation Day 2011

Left to right: R.V. Elliott, (Mrs. B.M. Winterbotham), (Dr. J.G. Owen), S. Kirk, M. Haines, Prof. D.J. Hatch, (Gen. Sir Alex Harley), R.D. Deayton, I. Adam, D.K. Tindley, (M.C. Newlan), (D.G. Bailey), S.J. Mew, W.R. Broadhead.

FOUNDATION MEMBERS, JANUARY 2011

Left to right: Gen. Sir Alex Harley★, D.P. Charlesworth★, A.J. Brown★, Mrs. S. Kirk★, Dr. J.G. Owen, R.V. Elliott★, S. May★, Mrs. B.M. Winterbotham, I. Adam★, Prof. D.J. Hatch★, Mrs. L.T.L. Mew, Mrs. A. Bailey, Mrs. A. Fletcher, Dr. R.G. Orr★, D.K. Tindley★, C.A.K. Bagnall★, J. Bloomer, R.D. Deayton★, Mrs. S. Whittle, W.R. Broadhead★, M.Haines★, R.F. Back★, J. Kidd, M.C. Newlan★#, I.R.M. Edwards★#, R. Fairall★, D.G. Bailey, S.J. Mew★, P. Graham, J. Thomas (Headmaster).

Absent from photo: M. Atkin, W.S. Bannister, G.H. Beaton, P.S. Burns, D.P.G. Cade#, A.D. Chambers★, A. Chapman, M.D. Clarke★, D. Craft★, J.R. Darley★, R.A.E. Davey, K.P. Edwards★, P. Friend★, C. George★, K. Greener, J.J. Hilton★, A.V. James★, J. Joiner★#, M.W. King★, A.M. Latham★, S.M. Latham★, Hon. D.H. Lissaman★, Mrs. L.M. Lissaman, R. Lyons★, A.G. Mack, J.R. Mathias★, D.R. Mear★, G.S.A. Mew★, Mrs. L. Myland, Mrs. P. Parker, J. Pearson★, Mrs. N. Perricone, W.C. Pike★, M. Prewer, Miss D. Raine, Dr. H.H Richards★, P. Sharp★, E.D. Starmer★, G.M. Stowell★, J.E.K. Smith#, Rev. N.P. Uden★, W.S. Sondhelm★, R.J. Southwell★, R.J.S. Tice#, G.M. Walter#, P.F. Watkinson, N. Whittaker★, Mrs. P. Wilkes#, G. Williams.

★Old Caterhamian

#Trustee

APPENDIX II

Senior school

Back row, left to right: Adam Assen, Kate Hanford, Joanna Walsh, Elizabeth Harris, Catherine Jackson, Alice Martin, Toby Cooper, Peter Holman.

Henry Jones, Joanna Woolley, Neil Parker, David King, Bob Jones.

Mathew Owen, Rob Clarke, Aimee Henry, Stephen Gilburt, Carlos Garcia, Daryl Todd, Vanessa Mesher, Kathryn Mills, Rebecca Bownas.

Conrad Ware, Steven Marlow, Simon Bird, James Burnside, Neil Evans, Alina Rennie, Gareth Algar, Collette Pateman (below), Samanth Schrum, Jaclyn Leach (below), Lorne Barnard.

Stephen Lander, Andrew Patterson, Stuart Terrell, Alice O'Donnell, Jennifer Dodd, Sophie Carpenter, Lisa McMullin, March Broughton, Colin James, Anna Church, Nick Mills.

Sally Carter-Esdale, Jim Miller, Kim Wells, Lucy Thomas, Kristain Waite, Amanda Symss, David Keyworth, Kathriona Wallace.

Lloyd Dannatt, Nicole McVitty, Willi Jaundrill, Jan Whyatt, Natalie Lomas, Campbell Smith, Clare Quinton, Andion Van Niekerk.

Natalie Francis, Stuart Thompson, Clare Brown, Angela Cox, Rick Mearkle, Mark Sherrington, James Ogilvie, Dan Quinton, Tony Fahey.

Catherine Clifton, Andrew Taylor, Rosie Stowell, Malcolm Bailey, Gerald Killingworth, Tom Murphy, David Clark, Rob Salem, Nancy Dawrant.

Front row: Lydia Tapley, John Armitage, Sean Hayes, Jim Seymour, Julian Thomas, Tracy Ridge, Paul Hoad, Hilary Trehane, Richard Smith.

Absent from photo: Sally Dall'Oglio, Allison Davis, Sarah Fothergill, Elizabeth Gibbs, Marilyn Kyle, Julia Laverick, Michael Lesser, Helena Richards, Liz Rivers, Alexandra Smith, Patricia Watkins, Ben Wilkinson, Alexandra Yankova.

Prep school

Back row, left to right: B. Thompson, J. Hopkins, J. Luff, A. Ingrassia, M. Bartlett, J. Driscoll, A. Bullen, J. Moy, P. Wright. Middle row: M. Nott, M. Brown, J. Chapman, P. Groves, H. Tuckett (Headmaster), V. Gocher, J. Dyer, K. Thorpe. Front row: A. Petrou, K. Rose, S. Costerton, R. Deale, L. Woodhouse, J. Cowan, R. Sparrow.

Pre-prep

Centre front: K. Shearman. Front row: A. Noble, M. Epperlein, G. Woods, H. Tuckett (Headmaster). Second row: A. Maskatiya, O. Bradshaw, J. Findlay, E. Webster. Third row: K. Haughey, D. Wilson, J. Smith, J. Bartholomeusz, M. Hudson. Back row: N. Rolfe, K. Cox, B. Sutehall, S. Jackson, F. Walker, P. Kulp.

BURSARIAL STAFF – DECEMBER 2010

Back row. left to right: Robert Brooks, Colin Hitchins, Kevin Marshall, Mark Wheeler, Paul Brushett, Toby Sims, Adam Forbes, Jodie Williams, Peter Ray, Nigel Mason, Graham Nott, David Barrow. Middle row: Jess Uden, Krystyna Helowica, Maxine Fisher, Marilyn Teece, Maureen Cody, Allyson Aranha, Linda Gooda, Sue Chappell, Louise Henderson, Val Stowe, Jen Killick, Rachael Thorpe, Nikki Heber, Wendy Gibson, Peter Goodey, Paul Skaria, Ian Lunt.Front row: John Dodwell, Jean Carney, Roger Meek, Marie Dodwell, John Baldwin, Rosemary Fisher, Robert Charlesworth, John King, Eleanor Kilduff, Gordon Wilkinson, Roy Battison, Brian Dunphy, Johanna Field, Alan Howe.

Absent from photo: Catherine Aldren, Lesley Barker, Jane Barrett, Sam Barton, Ken Bird , Ruth Bird, Clinton Bruno, Evelyn Brushett, Sylvia Brygola, Nuala Buffini, Maurice Byrne, Alex Canlas, Lorna Chantry, Heather Conway, Marie Crick, Jane Damesick, Jennifer Davis, Allison Douglass-Pullin, Jackie Evans, Jackie Ewart, Tim Falkner, Gillian Farr, Karen Greenwood, Patricia Guershon, Hermelo Herrera, Sheila Hill, Sharon Hurley, Alexander Husch, Christine Ingham, Lesley Keith, Jimmy Killick, Derek Macey, James Marshall, Anhony Mathew, Laura Mitchell, Deborah Nye, Samantha Ogden, Lesley Paine, Alexandra Palmieri, Jose Epraim, Heidi Parsons, Alison Pullin, Klemia Redon, Sheila Rooks, Joanne Simons, Sheila Starbrook, Justy Stephen, David Streatfield, Asha Sunilkumar, Samuel Taylor, Thomas Parambil, Moncy Thomas, Jacob Thomas, Paul Traish, Colleen Tuckett, Sunny Varghese, Caroline Warner, Katie Watson, Belinda Whyatt, Margaret Wilkinson, Judith Wright.

EOGA Members – Opening of Christine Walker Gallery

EOGA ladies.

Front row, left to right: Alina Rennie (OC Administrator), Lindsay Redding[2,3] (former Deputy Head, Cat.), Pauline Dand[2,3], Vanessa Wagstaff[1], Sheila Hanley[2], Diana Raine[2] (former Headmistress), Mary Robinson[2], Deborah Schneebeli-Morrel[1,4], Jess Uden (Gallery Curator), Anne Bailey[1] (EOGA Secretary). Behind: right to left: Frances Loveless[1], Joan Hetherington[1], Pat Schleger[1,4], Marilyn Kyle[3] (Head of Art, Cat.), Joanna Ford, [?], Julian Thomas[3] (Headmaster, Cat.), Pam White[1], Susan Skinner, Joan Cairncross[1,2,3], [?], (at back) Sarah Dubois[1], (2nd row) Hilary Trehane[2,3], Barbara Hill[1], Martin Nunn[2], Jean Wright[1], Sally Corbin[1].

[1] *former Eothen pupil*
[2] *former Eothen staff*
[3] *present or former Caterham staff*
[4] *Trustee, Christine Walker Foundation*

APPENDIX III

First Year

Ria Acharya
Rachel Ackerley
Lucy Acton
Maxwell Arnold
Andrew Aubertin
William Ayres
Henry Beck
Breck Bednar
William Bennett
Alexander Best
Chloe Blatchford
Alexandra Brown
Elise Butcher
Mark Chatfield
Aaron Cooke
Louis Crane
Callum Cripps
Gabriella Criscuolo
Tolulope (Mayo) Daniel
Daniel Davidson
Megan Davies
Rachel Dawson
Chester de Meester
Luke Derry
Michael Doble
Ella-Mae Duncan
Joseph Earl
Aislinn Flatley
Joseph Foggin
Rock George-Kalu
Natalie Goodwin
Thomas Green
Nadine Greenhalgh
Phoebe Harrison
Arun Henley
Katie Herbert
Cavan Homewood
Dawn Howe
William Huke
Lauren Hunt-Williams
Eloise Ibrahim
Oscar Ingrassia
Owain John
Harry Jones
Stephanie Kellaway
Joshua Kennedy
Anna Knight
Oliver Locket
James Lovell
Maisie MacHugh
Olivia Mason
Jonathan-Joseph McGrath
Yasmin McLean de Boer
Meghan O'Connor

Harrison Paice
Lauren Parker
James Parkin
Riha Patel
Shrina Patel
Charlotte Pearson
Oritsetimeyin (Timeyin) Pinnick
Tiernan Quantrill
Alex Rayment
Luke Romp
Karan Saraf
Christopher Scott
William Sparrow
Katie Starns
Amy Stephenson
Michael Stewart
Elizabeth Stronach
Aisha Symmons
Katie Thompson
Samuel Thorpe
Amelia Tocher
John Trantor
Clare Wandless
Mark Williams
Chloe Wyner
Isobel Yewman
Jake Young

Second Year

Fleur Abel
Catherine Andrew
Amalie Aspinwall
Rachel Bashford
Robert (Anthony) Baston
Melissa Berry
Isabel Blake
Charles Blatt
Christopher Bowen-Long
Verity Brooks
Daniel Castle
Amelia Claringbull
Victoria Clarke
Emma Coleman
Oliver Colman
Benjamin Cowlard
Alexander Craston
Molly Daniels
Sidney Driscoll
Lauren Eyres
Michael Fahey
Alexandra Fernandes
Alexander Findlay
Cameron Furley-Smith
Rachel Galvin
Miles Gamble

Thomas Gardner
Simon Gordon
James Graham
William Gwynn
Annabel Hayes
Elizabeth Hayes
Lydia Henke
Timothy Henley
Natasha Hibbert
Harry Higginson
Marcus Hodgkinson
Israel Ibuoye
Tilly Ip
Laura Johnston
Thomas Kent
Anna Kokashinskaya
Cameron Lagerberg
Thomas Land
Jonathan Latimer
Sam Lefevre
Nathan Lewis
Olivia Lewis
Elizabeth Lloyd
Giselle Mackinlay
Emily Marcovecchio
Eleanor Maskatiya
Jessica Maskatiya
Patrick May
Charles McAree
Reece McGovern
Jack Medlock
Katherine Mercer
Elizabeth Michael
Hasan Moosa
Megan Morley
Katie Notman
Sophie Nye
Alexander Orbell
Lily Parsons
Alexander Pearce
Hannah Pearson
Edward Peet
Natasha Phillips
Lucie Prego
Jack Price
Holly Ramsden
Jemima Rawlings
Abigail Rawson
Samuel Saunders
Edward Shambler
James Shopland
Mark Strong
Todd Styles
Sean Tanner
Lucy Taylor

Samantha Terry
Annabelle Van Dort
Ellie Vincent
Georgina Waterman
Richard Webb
Jacob Welsh
Simon Whelan
Angus Whitfield
James Willmott
Emily Yates
Benedikte Gibson
Man Yuet (Speed) Fung
Kar Long (Jonathan) Ho
Kai Amaning
Edit Kruk

Third Year

Francesca Adams
Cameron Affleck
David Andrews
Erin Armour
Georgia Arnold
Dominic Bailey
Richard Barton
Izabele Batkovskyte
Georgia Bird
Emily Blatchford
Guy Branson
Rebecca Bridson
Leo Cammish
Anthony Carter
Yin Chung (Andre) Chan
Yu Fung (Franky) Chan
Edward Chatfield
Adam Chevreau-Kareliussen
Harry Claydon
Eleanor Crouch
Ewan Davidson
Henry Davies
Katherine Davies
Daisy de Meester
Alina de Villiers-Hill
Ella Donald
Chloe Downes
Eleanor Durham
Jamie Dyer
Archie Dymoke
Thomas Edgerton
Dylan Ellis
Christopher Engeham
Alex Everitt
Michael Eyres
Ella Faulkner
Caoimhe Flatley
James Foggin

Chelsea Forsdick
Alistair Gallivan
Louise Gardner
Thomas Gerry
Michael Gibbins
Kelly Gibson
Toby Goddard
Steven Greenhalgh
Katherine Ham
Euan Hamilton
Fraser Hart
Lauren Hawksworth
James Heaton
Rebecca Hellard
Robert Hill
Lok Tin (Victor) Ho
Alannah Hoban
Michael Hodge
Julia Hollis
Millie Hopkins
Nicholas Horton
Elena Houghton
Oliver Hull
Robyn Hunt-Williams
Luca Ingrassia
Carys John
Katharina Jungclaussen
Charles Kellaway
Chung Hin (Kathy) Lai
Fredric Lipman
Matilda Lucas
Benedict Malby
Shauna Matthews
Jodie McDonagh
Joseph McNeice
Joshua McPherson
Annabelle McVeigh
Rachel Milliams
Adam Morley
Samuel Murphy
Yana Nesterovitch
Josephine Niemira
Phillip Palmer
Elle Pardew
Hannah Parker
Jasper Parr
Sarah Parsons
Ilianna Patel
Vandan Patel
William Paxton
Marco Perasso
Joseph Percival
Jack Phillips
Serhiy Pikho
Ross Powell

Amelia Price
Daniel Puntan
Jonathan Pye
Alexander Quessy
Bethany Quinton
Daniel Ramsay
Rosie Riches
Katherine Roberts
Charlie Robertson
Bronte Rowlands
Francesca Rowson
Samuel Russell
Emily Seager
Nikita Sharapov
Nikita Shokin
Sarah Slater
Emma Sloan
William Smith
Joseph Stanley
Rebecca Stannard
Paige Stapleton
Daniel Symmons
Georgina Tatton
William Thomson
Joanna Upward
Rory Walton
Zachariah Waterstone
Daniel Webb
Harriet Wildman
Tai Kiu (Marco) Wong
Daniel Worthington
Andrew Yates
Joseph Young

Fourth Year
Maxwell Mitchell
James Alexander
Thomas Alexander
Emily Ashmore
Thomas Aubertin
James Baker
Anne-Marie Baston
Miranda Batki-Braun
Lucy Beaumont
Sophie Belchambers
Chloe Berry
Matthew Bird
Christopher Bishop
Henry Blass
Ruari Bride
Callum Brooker
Rory Carter
Emily Claringbull
Romany Colligon
Patrick Colquitt

Murphy Cook
Rory Court
Anna Craston
Ellie Dadds
Ryan Dale
Hope Davidson
Amy Earl
Matthew Eason
Harry Elgar
Joshua Elliott
Imogen Fitzgerald
Ben Foreman
Charles Friend
Alexander Fullalove
Benjamin Fullard
Harry Galliano
Madeleine Gallivan
Anna Gibson
Alexander Golubtsov
Eliot Gordon
Samuel Grayston
Madeleine Greenwood
Oliver Gregory
Sam Griffiths
Raphael Hage
Charlotte Hall
James Hall
Lois Hatch
Angus Hayes
Oliver Henke
Matthew Hill
Ella Hodgkinson
Jacob Holme
Nasseer Hulkhory
Alexander Jackson
Gavin Jackson
Saskia Jiggens
Fraser Kenny
Ryan King
Zoe King
Jamie Lagerberg
Chun Yin (Justin) Li
Jack Lidiard
Stephanie Lindo
Rebecca Littlejohns
Emily Lock
Amelia MacHugh
Mariella Mackinlay
Luoh Yan (Vincent) Man
Nikita (Kitty) Marryat
Eleanor Marsh
Harrison Maude
Ivan May-Jones
Ellen McLaren
Takumi Mead

Antonia Millington
Jasper Moore
Charlotte Morris
Olivia Murch
Charles Negus
James Nye
Harrison Osterfield
William Owen
Katherine Parkin
Christopher Parkins
Amelia Paton
Alexander Peet
Jayson Pepper
Holly Prince
William Rady
Alexander Richardson
Abigail Riches
Samuel Roberts
Edward Rolfe
Gemma Rumsey
Ciaran Ryan
Zachary Sabri
Matthew Scott
Olivia Seaby
Connie Shaw
Romy Sherlock
Hannah Shopland
George Skinner
Alexander Smith
George Smith
Christopher Starns
Shannon Sturm
Toby Styles
Anthea Thipaharan
Callum Thompson
James Todd
Dominic Turner
Alfie Vincent
Harry Wandless
Philippa Waterman
Charlotte Watson
Findlay Williams
Jack Williams
Elisha Wilson
Marcus Wilson
Christopher Yates
Lucas Desclos-Dukes
Pok-Hin (Edwin) Law
Thomas Phillimore-Kelly
Georgi Paunov
Zhemin (Frank) Cao
Man (Waris) Choy
Tsz Ki (Keven) Ko
Wing Kei (Vicki) Kwong
Wing Tung (Tiffany) Lai

Sheung Yin (tommy) Lee
Yiyang Ning
Yuan (David) Zhang
Selina Schyberg
Holly Hendron
Greta Strelyte
Gor Melkonyan
Maria Pekarskaya
Arman Samsonyan
Nikita Tomilin

Fifth Year

Emily McCarthy
Sean Addley
Cahit (Jack) Ali
Amy Andrews
Luke Andrews
Samuel Armitage
Patrick Armour
James Arrol-Barker
John Asaad
Arkady Aspinwall
Leonard Baart
Matthew Baker
Katherine Baldwin
Connor Banister
Maxwell Bennington
Haig Binnie
Lucy Blackwell
Alexander Blair
Caroline Bowen-Long
Charlotte Bradley
Max Campbell
Wing Hei (Nickie) Ching
Matthew Clare
Alexander Clarke
Alexander Denning
Bylli-Harpreet Dhupat
Kamila Donald
Richard Douty
Jamie-Lee Duncan
Joe Dyer
Angus Dymoke
Stephen Earl
Zoe Everard
Kathryn Fenton
Georgia Fitzsimmons
Amy Flower
Sophie Foggin
David Gardner
Timothy Graham
Ryan Greenhalgh
Rachel Gwynn
Abigail Haffenden
Charles Hammond

Polly Hanford
Guillaume Hearn
Alastair Hellard
Stephanie Hibbert
Jack Higgins
Harry Hopkins
Jack Howe
Daniel Hurley
Ayodeji (Deji) Ibuoye
Thomas Ingham
Samuel Jarman
Mark Johnston
Angus Kennedy
Alayna Kenney
Gregory Kite
Jack Leakey
Joseph Long
Vivienne MacCallum
Ellen Mann
Matthew Marston
Isabella McMillan
Richard McVitty
Rosie Meade
William Morley
Natasha Moses
Henry Mundell
Emily Murphy
Harvey New
Lauren Newland
Alexander Niemira
Lauren Noble
Emily Palmer
William Parsons
Francie Payne
Emily Pettifor
Luke Price
Duke Quinton
Joshua Rawson
Sophie Rennison
Elizabeth Robson
Laura Roden
Sian Rodney
Flavia Rowson
Oliver Rushton
Jonathan Sampson
Joshua Sanmogan
Christopher Sargant
Mollie Schubert
Andrew Shaw
Michael Slape
James Sloan
William Soer
Georgia Sturm
James Tatton
Andrew Thomas

Michael Whelan
Lydie Whiteley
Sadie Whitfield
Aled Williams
Cameron Williamson
Frankie Winters
Rachel Wright
Camilla Ella Yavas
Stella Matias-Wiles
Chun Yin (Boris) Li
Erika Barron
Rachel Wong
Ryan Wong
Chi Lam (Jonathan) Chong
Shan Ho (Tony) Huen
Pei Yu (Jenny) Kuo
Hoi (Rachel) Lee
Jun (Charles) Lee
Ho (Alex) Mui
Ying Kit (Tony) Tsoi
Benny Wong
Michael Groombridge
Man Wai (Vivian) Sit
Ye Rin Jung
Yoon (Justin) Yang
Maxim Aleshin
Egor Lyasko
Nikolay Martazov

Lower Sixth

Shola Abbasova
Hugh Allan
Matthew Babai
Olivia Bailey
Alex Baldwin
Karolina Barasneviciute
Rawan Basma
Madeleine Bayley
Taylor (Ross) Bennington
Amelia Borley
Jasmine Brand-Williamson
Hamish Brooks
Stephen Brooks
Nathan Brown
Helena Buckles
Sui (Kenneth) Chan
Yam Nok (Joey) Chan
Yan (Lilian) Chan
Daniel Chaney
Thomas Chatfield
Ruitao (Edward) Chen
Camilla Clark
George Clarke
Samuel Clarke
Callum Connolly

Catherine Conquest
Thomas Court
Jessica Davidson
Elinor Davies
Antonina Davydova
Mia De Villiers-Hill
Elisabetta Di Lauro
Benjamin Dillon
Samuel Douglas
Louis du Sauzay
David Eason
Georgia Faulkner
Georgia Feldmanis
Georgia Flanagan
Tom Fouracre Reid
Alexander Freeman
James Friend
Yeung Fu
Oliver Fullalove
Timo Funke
Bianca Gamble
Lewis Gibson
Scott Gibson
Frederik Gibson
Glen-Oliver Gowers
Nicholas Graham
Khristianne Greenhalgh
Julian Groombridge
Jonathan Ham
Natasha Hart
Ross-William Hendron
Kristina Hill
Daisy Hopkins
David Hopkins
Maxwell Horgan
William Houghton
Adam Howe
Ting (Kevin) Ip
Nicole James
Alexander Jobson
Lisa Kehle
Andrew King
Kenji Kinoshita
Takeru Kumon
Nicole Lacour
Aline Lahaye
Isabella Laudenberger
Eloise Lawlor
Yue (Michael) Leung
Chun Yu (William) Leung
Shuk Ki (Suki) Leung
Ling Chi (Thomas) Li
Benjamin Littlejohns
O Tik (Eugene) Lo
Julian Lobbes

Eleanor Lord
Frederick Marryat
Katherine Marsh
Priscilla (Amittai) Martins
Jonathan May
Sophie McCartney
Douglas McClumpha
James McDonald
Callum McLaren
Rebecca McMillan
Luke Mills
Poppy Moore
Bethan Morgan
Gregory Morris
Felicia Munde
Samir Nasirov
Dat Nguyen
George Noble
Robyn Noble
Ohiowele (Ohis) Ojo
Meera Patel
Galina Pekarskaya
Alexander Penny
Freya Pickford
Christina Pontin
Maxim Pyuman
Thomas Rady
Andrew Ramsdale
Charlotte Sadler
Bethan Sanderson
Ellie Scott-Smith
Helen Shaw
Alina Shvartsman
Kwan Yu (Kenny) Siu
Ting Hin (Alex) So
Lina Sprogyte
Sai (Steven) Tai
Charlotte Taylor
Adel Thabet
Annabella Turner
James Turner
Vadim Vasiliev
Qizhen (Claire) Wang
George Warr
Edward Watson

Andrew Webb
Zoe Webb
Jessica White
Andrew Whitley
Rebecca Williams
Pui Yi (Steffanie) Wong
Christ (Chris) Wong
Yan-Long (Ivan) Wong
George Woodhouse
Kai Ho (Kyle) Yeung
Wenyue (Gracie) Zhang

Upper Sixth
Michael Adams
Harley Allen
Elizabeth Armitage
Megan Armitage
Michael Asaad
Nicholas Ashford
Tatiana Aspinwall
Sam Banisadr
Katie Barrett
Anthony Batki-Braun
Harry Beaumont
Connel Binnie
Adam Blackwell
Alexander Bratza
Eleanor Budge
Yee-Ki (Cathy) Chan
Ching Ho (Raymond) Cheung
Chiu Wing Cheung
Ho (Ernest) Choi
Ka Kam (Kenneth) Chui
Oliver Claydon
Hollie Coleman
James Cooper-Parry
Adebola Daniel
Kehinde Daniel
Taiwo Daniel
Charles Davies
Daniel Devlin
Hallam Dixon
Jasper Dymoke
Richard Fairall
Phoebe French

Chun Him (Justin) Fung
Harry Gallivan
Tom Ganley
Timothy Gooden
Alexandra Gordon-Brown
Ashley Goulding
Thomas Gregory
Connor Halliday
Samuel Harper-Booth
Lucy Harris
Ryan Harrison
William Harvey
Harry Hawkridge
Clarissa Hearn
Alec Hill-Reid
Christopher Hitchin
Joe Holleran
Tiffany Hon
Emma Houlden
Charles Huke
Wing-Hong (Winson) Hung
Natasha Hunt
Bethany Hutchings
Jeremy Hutchinson
Alexander Jenkins
Chi Yan (Tweety) Jim
Adam Jones
Aaron Kasza-Martin
Gleb Khitrin
Jamal King
Shun (Sally) Ko
Katerina Kobzova
Chuen King (Edward) Kwok
George Kyle
Pak Kit (Andrew) Law
Thomas Leatherby
Hok Sze (Pauline) Lee
Man (Angel) Leung
Tung (Yobi) Li
Janice Li
Huseyn Mammadov
Joseph Mann
Thomas Marsh
Harry McInley
Amy Miles

Lisa Mill
Amrik Nagra
Azuoma Obikudu
Joanna Odling
Ekaterina (Kate) Osipenko
Andrew Paine
Thomas Pearce
Aleksandr Piskunov
Hoi Yin (Emily) Poon
Yik Tung (Pansy) Poon
Jessica Puntan
Samuel Puntan
Samantha Rawlinson
Natasha Reynoldson
Joshua Richards
Hans (Franz) Richter
Vivian Schiller
Robert Searle
Ricky Shah
Zhaochen (Harry) Shan
Harriet Shaw
Yasmin Shuttleworth
Harrison Smith
Angel Szeto
Ho Cheong (Kelvin) Tang
Wai Hin (Edmond) Tang
David Thomas
Samuel Thompson
Daniel Tiernan
William Tittle
Natalia Tkacheva
Christopher Toomey
Gareth Tuckett
Danielle Vaughan
Matthew Waters
Chloe White
Romilly Whiteley
Charlotte Williams
Sarah Wilson
Holly Worthington
Shihui (Siria) Zhang
Zhiyang (Roger) Zhang
Weilan (Nancy) Zhao
Ange Zhou
Huafei Zhou

PREP SCHOOL

Nursery
Benjamin Anderson
Caleb Betts
Joshua Betts
Jack Bradley
Emily Broughton
Sienna-Rose Bullock
Theo Ellis
Adam Goodwin
Lars Hansen
Ruby Kollek
Casey Mear
Orla Osborne-Walker
Benjamin Roberts
Samuel Robinson
Zoe Terrell
Oliver Walker
Edward Whelan
Ben Whyatt
Isabelle Young

Reception
Oliver Allen
Victoria Allison
Joseph Batchelor
Isabella Beadle
Dexter Bishop
Isobel Cawood
Samantha Charters
Reuben Chauhan
Ava Clarke
Ellen Connolly
Max Delaney
Finn Devlin
Louis Devlin
Alex Dunne
Zach Ferguson
Lana Golesworthy
Nicholas Herbert
Lilia Jackson
Joseph Lander
Samuel Lander
Alice Lewis
Jennifer Lomas
Philippa Mallinson
Henry Matthews
Evie McClean
Thomas McCloskey
Jack Minikin
Liam Moloney
Philip Morgan
Ethan Nichols
Matilda Park
Xavier Parker
Louis Preston

Angus Robertson
Oliver Rose
Joshua Rowan-Bayley
Stuart Scott
Anthony Sessi-Knott
Pia Shah
Katia Smirnova

Year 1
Patrick Agnew
Isabella Amitrano
Maaduri Anbukumar
Joseph Anderson
Sarra Awan
Oliver Bailey
Isabelle Bartsch
Luke Bishop
Nina Blay
Holly Bradley
Laura Brooker
Nia Bullen
Isabella Burns
Theo Charlesworth
Joshua Downes
Sophie Hayes
Salina Henley
Aaron Houlton
Harry Kite
Robin Kollek
Imogen Lack
Eleanor Maddock
Scott McGarvie
Harry Millar
Penelope Ogden
Willow Park
Anaiya Patel
Annja Russell
Isabel Sampson
Ellie Shipsey
Eloise Smith
Leo Smith
Olivia Stone
Alexander Svendsen
Sophia Termanis
Ronnie Thomas
Hamish Walker
Christian Whelan
Jess Whyatt
Emily Worrell

Year 2
Lucy Allen
James Allison
Joshua Baker
Nicholas Challier

Carrie Charles
Serena Clyde
Sophia Clyde
Benjamin Colbourne
Alexander Davies
Justin Deale
Lily Devlin
Jamie Flatley
Annalise Hansen
Louie Heaton-Armstrong
India Henke
Caitlyn Hocking
Cameron Hudson
Andrew James
Toby Kerr
Sanuji Kodituwakku
Isabelle Oliver
Jenna Sam
Ananya Saraf
Laura Sessi-Knott
Matthew Sharpe
Oliver Vickars
Zoe Wisniewski
Georgia Young

Year 3
Sebastian Ahmed
Zachary Allen
Samuel Anderson
Finlay Arnold
Emma Betts
Alan Blay
Daniel Blythe
Phoebe Cornish
Darcy Dubell
Alexandra Frackiewicz
Suzannah Greenhalgh
Elizabeth Hammer
Catherine Hillier
Lucy Hocter
Isabelle Ibrahim
Crispin Kellaway
Maud Lewis
Emily Malone
James Martin
Ella McCarthy
Caitlin Mear
Ben Moore
Husayn Moosa
Mollie Oakes
Harriet Park
Zara Paul
William Rose
Alexander Simonov
Phoebe Sparrow

Hannah Stone
Max Termanis
Christian Thomas
Oliver Vancliff
Jasmine Vickars
Dominic Wells
Hannah Wells
Tobias Whelan
Amelia Wildman
Toby Wyner
Georgina Young

Year 4
Jacob Angell
Nathaniel Arnold
Natasha Awan
Charles Bolton
Toby Carter
Owen Cawood
William Charles
Louis Charlesworth
Harvey de Meester
Krista Goodwin
Katie Hudson
Shayaan Khan
Sophie Kingston
Dinil Kodituwakku
Michael Land
Ned McGarvie
Madeleine McMillan
Charlotte Mercer
Ben Oliver
Ankush Patel
Jaiden Patel
Max Robertson
Zara Russell
Ben Sharpe
Leah Slattery
Jessica Small
Alexander Smith
Sorrel Smith
David Stevenson
Daniel Svendsen
Caelan Thomas
George Thomas
Benjamin Thompson
Jack Thompson
Joshua Thorpe
Daniel Vickars
Mai Wallace
James Watt
Matthew Willmott

Year 5
Zak Acharya

Camara Barry
Megan Batchelor
Cameron Betts
Rowan Bradbury
Oliver Cox
Alexander Criscuolo
Rowan Deale
Natasha Derry
Helena Fahey
Rowena Field
Ross Furley-Smith
Anna Gardner
Graham Gibbins
Charlie Heaton-Armstrong
David Hocking
Annabel Jairaj
Charlotte Jairaj
Anton Joseph
Alistair Kellaway
Roberta Lack
Steffi Lagerberg
Alice Locket
Giles Malone
Thomas Mason
Hamish McAree
Annabel Mitchell
Rory Moore
James O'Connell
Yegor Pyuman
Charlotte Roberts
Jack Savage
Alexander Travers
Georgia Tuckett
Nicholas Van Dort
Max Wilson
Theo Wright
Lewis Young

Year 6
Catherine Allen
Aaron Aspinwall
Abigail Barrett
Mark Bartholomeusz
Natalie Bishop
Leon Blatch
Sophie Bolton
Charlotte Bridson
Rhiannon Bullen
Holly Castle
Oscar Charlesworth
Aoife Daniels
Esme Driscoll
Finley Dubell
Miles Findlay
Daniel Greenhalgh
William Hammer
Jessie Hayes
Lewis Hunnisett
Grace Kingston
Suzy Latimer
Katie Lloyd
Kira McGovern
Edward McMillan
Danielle Mercer
Hannah Owen
Maja Pardew
Isaac Quinton
Guy Raeburn
Jessica Sampson
Max Santana
Anna Simonova
Emelie Speak
Oliver Young

Index

THE ART OF
Christmas
Crafts

THE ART OF

Christmas
Crafts

PUBLISHED BY

SALAMANDER BOOKS LIMITED

LONDON

A Salamander Book

Published by Salamander Books Ltd.
8 Blenheim Court
Brewery Road
London N7 9NT

ISBN 1 84065 099 0

© Salamander Books Ltd 1994, 2000

Printed in Spain

CREDITS

Contributors: Rosalind Burdett, Jan Hall, Karen Lansdown, Suzie Major, Susy Smith and Sarah Waterkeyn

Editor: Jilly Glassborow

Designers: Kathy Gummer, Barry Savage and Tony Truscott

Photographers: Terry Dilliway and Steve Tanner

Typeset by: Barbican Print and Marketing Services, London, and The Old Mill, London

Color Separation by: Fotographics Ltd., London – Hong Kong, and Scantrans Pte Ltd., Singapore

Printed in Spain

CONTENTS

INTRODUCTION

It's that time of year again when our thoughts turn to parties and presents, when we bedeck our homes with paper chains, tinsel and holly, and wear funny hats at table. And what better way to get into the spirit of Christmas than to make your own decorations — hours of fun for all the family and so much cheaper than buying them.

With fully illustrated step-by-step instructions this colourful book will show you how to make over 150 dazzling designs. There are Christmas tree decorations, paper chains, stars, bells, baubles, garlands, greeting card trellises, and party hats and masks. And for that special festive dinner party or the big day itself there's a stunning range of designs to brighten up your table — centrepieces, napkin folds, placemats, name cards, crackers and other attractive table gifts.

Flowers are always a favourite at Christmas and, as well as featuring some colourful flesh flower displays, there's an exciting array of dried flower designs that will see you through the whole festive season — and on to the next! The section on gift wrapping and greetings cards is packed with original ideas for making your own paper, tags and decorative ties and bows and also includes lots of ingenious ways to disguise gifts such as records and bottles to keep the recipient guessing.

A gift is more special if it's handmade; the 35 ideas featured in the last chapter of the book range from seasonal soft toys (a Santa Claus, a snowman and a polar bear) to floral gifts, stationery and painted china.

O f all the Christmas decorations, the Christmas tree is without doubt the most dazzling. This chapter contains a wealth of designs for decorating trees, including fake baubles, mini crackers, edible stars, sugar bells, paper lanterns and many more. Or, if you prefer a more sophisticated look, you could copy one of the stunning, though slightly more expensive, designs shown on the opening pages. The chapter also features colourful ribbon trees — a good substitute for the real thing — a host of pretty paper chains and garlands, some ingenious ways of displaying Christmas cards, lots of delightful wall hangings and a small but fun range of party hats and masks.

—— GO FOR GOLD ——

T his traditional tree (right) is covered in tinsel, baubles and lametta (icicles), all in gold. A similarly elegant effect could be achieved using silver on a fake white tree; or if you have a fake silver tree, try bright pink or blue. Stick to one colour only for the most professional-looking results. If the children want to hang chocolate figures on the tree, buy some colour-coordinated ones!

Start by hanging a string of white or gold lights over the tree. Lights always make the vital difference to a Christmas tree; it is lovely to switch them on when night falls. Next, trail thick gold tinsel around the branches, concealing the light cord.

The baubles can then go on, followed by strands of lametta (icicles). At the top of the tree you could place an angel or star. The star shape shown is made from loops of tinsel — simple, but very effective. The finishing touch is a pile of gold-wrapped presents at the foot of the tree. Choose some shiny wrapping paper and cover empty boxes. If you put your presents under the tree, add a few fakes too; otherwise it looks terribly bare once the presents have been opened.

For a more old-fashioned look, omit sparkly baubles and lights, and stick to lace, ribbons and a few paper doilies. Start with some silk flowers wired onto the branches or simply placed on them. Take some wide lace edging and thread thin rose-coloured ribbon through the straight edge; gather it into a rosette over the ends of the branches. Allow the ends to hang down as shown.

In the gaps place some fans made from circular white paper doilies, cut in half and lightly pleated. Onto these, staple little ribbon bows, again letting the ends hang down. The pot the tree is standing in has been wrapped in plain brown paper and decorated with a large paper fan made from a rectangular doily.

Here is an unusual and very attractive way of decorating the tree. First take a set of candle lights and fasten them onto the tree. Next, you need a large bunch of gypsophilia (baby's breath). You should be able to get this even at Christmas from a good florist.

Split up the gypsophilia and simply poke it into the tree until all the gaps between branches are filled. Although bought fresh, gypsophilia should last a few days on the tree. Next you need a piece of tartan fabric, about half a metre (yard). Cut it into strips and tie them into bows on the ends of the branches. Cover the pot or stand in coloured crepe paper and tie a large bow around it.

Dried flowers always look beautiful but are especially decorative at Christmas. Brighten up the Christmas tree with sprays of dried flowers tied with tartan ribbon. Choose warm red, russet and golden yellow coloured foliage and as bright a coloured tartan as you can find so that the colours will stand out against the tree. Balance the flowers amongst the branches.

Tie a larger spray upside down at the top of the tree. Next, tie together some cinnamon sticks with tartan ribbon and hang them from the branches on fine thread. As a finishing touch, hang fir cones on narrow ribbons. Stand the tree in a basketwork pot decorated with dried flower heads glued around the rim and tartan ribbon fastened with fine wire.

This tree's stunning effect is easy to achieve. Cut star shapes from silver cardboard (see template on page 162) and position them between the branches. Then make bows from pink paper rope and place them in the gaps. The trimmings can also be hung on fine thread if the branches are rather sparse. Top the tree with a large silver star, attached with a length of wire taped to the back.

For the bows, cut a 33cm (13in) length of paper rope or use a 10cm (4in) wide crepe paper strip; bend the ends to the centre and tightly bind with sticky tape. Cut a 20cm (8in) length for the tails. Bend in half and squeeze the centre, then stick behind the bow. Bind the tails to the bow with a narrow strip and trim the tail ends diagonally. To finish, cover the tub with crepe paper.

SWEET TOOTH TREE

This is especially for the kids; but be warned: you will have to exert extreme control, or the tree will be looking very bare by Boxing Day (December 26th)! On this tree we have hung iced cookies (see the instructions on page 12), little meringues and, for the grown-ups, some Amaretti biscuits — nice with the after-dinner port!

Also hung on the tree are some cute wooden cut-outs in the shape of Santa Claus, teddy bears and other favourites. You could easily make them into a mobile after Christmas, to hang in a child's bedroom. To complete the effect, some huge gingerbread men, one at the top of the tree, some in the lower branches — perhaps too well within reach of small fingers!

PRETTY PASTELS

This is a very pretty way to treat a synthetic white tree. The lights used are large, cone-shaped white tree lights. Next, hang on lots of baubles: pastel satin, white satin with pink bows, silver with embroidered flowers.

Now simply take lengths of pastel ribbon, such as the pink, green and blue shown here, and tie them onto the ends of the branches — some in bows, the others hanging down in strands. Tie a large bow at the top of the tree. Cover the pot or stand in silver wrapping paper, and tie a large pastel bow around it.

These ornaments are very easy to make; all you need are some bells from last year's tree. If you haven't got any, look for suitable moulds in the cake decorating section of a department store. Take some ordinary granulated sugar, put a few spoonfuls in a dish, and moisten it with food colouring.

Here is another cute tree decoration that is fun to make: tiny Christmas puddings. You start with ordinary ping pong balls. Spear each one onto a fine knitting needle and paint it brown. After two or three coats, for a dark rich colour, finish off with a clear varnish to give the 'puddings' a lovely shine.

When the colouring is thoroughly mixed in, push the sugar into a bell mould, pressing it in firmly to fill the entire cavity.

Now take some modelling clay, the sort you can bake in the oven, and roll it into a ball, the same size as the ping pong balls. Over this, mould a thick circle of white clay, to look like custard sauce. Bake this in the oven, and then remove it from the clay ball straight away, and pop it onto a pudding, so that it fits as it cools down and hardens. Don't forget to poke a hole in the top at this point.

Now simply tap the sugar bell out of the mould. Leave the bells to dry out overnight. To hang them on the tree, cut out a little tissue paper flower, thread a loop through it and glue it to the top of the bell. (These ornaments are not edible, and should be placed out of the reach of small children.)

When the clay is cold, glue it to the pudding. Now take a double thread, knot the end and thread it through the pudding from the bottom upwards. Trim off the ends, then finish each pudding by gluing on foil holly leaves and red bead berries.

These little boxes make charming tree decorations. If you haven't got any suitable ones that you can wrap for the tree, you can easily make your own from cardboard. For a cube, you need to mark out a Latin cross shape. The lower arm of the cross should be twice as long as the top and side arms. Also add a 1.5cm (½ in) border to all arms except the top one for gluing the cube together.

Fold along all the lines as shown, then bring the cube together, gluing all the sides in place.

Now simply wrap the box in attractive paper, and tie it with ribbons and bows to look like a parcel. Pop it on or under the tree.

These pretty ornaments can be made any size. For a cube shape the pattern is a Latin cross (as shown), the long piece being twice the length of the others; all the other sides must be of equal length. Cut this shape out in satin, then cut a piece of iron-on interfacing, 1cm (½in) smaller all round. Iron on the interfacing. Also iron in creases to form the sides of the cube.

Placing right sides together, sew all the seams, using a small running stitch, cutting into the corners and using the interfacing edge as a seamline.

Leave one edge open so that you can turn the cube right side out. Stuff it with polyester filling, then slipstitch the opening edges together. Decorate the cube with ribbon and bows, then set it on a branch of your Christmas tree. For a rectangular box, simply widen the long section of the cross. The round box is a purchased box with satin glued onto it.

These decorations are made from a basic recipe of 250g (8oz, 2 cups) plain (all-purpose) flour, 125g (4oz, 2 tablespoons) butter, 150g (5oz, ⁵/₈ cup) caster (fine granulated) sugar and 2 egg yolks. Cream butter and sugar until fluffy, add egg yolks and flour, and mix them into a firm dough. Roll the pasty out until it is about 1cm (½ in) thick, and cut out the chosen shapes.

Skewer a hole in each, so that you can push a thread through later. (This may close up during baking — in which case you will have to pierce another hole in them when they are cold — but very carefully, as the biscuits have a habit of breaking!) Put them onto a greased baking sheet, and bake them at 180°C (350°F), or gas mark 4, for 15 minutes.

When the cookies are cool, make up some fairly stiff icing using icing (confectioner's) sugar and water, and ice them. Thread them onto some waxed thread — or ribbon if the hole is big enough — and hang them on the tree straight away; they won't stay there very long!

Make a pattern for a Christmas stocking and cut it out double in one piece by placing the pattern on the fold of a double layer of felt. Cut a strip of fake fur to fit the stocking, about 5cm (2in) deep. Catch the fur to the felt, top and bottom, by hand, with small stitches.

Now overcast the two sides of the stocking together, starting at the ankle and working around the foot and up the front. Turn the stocking right side out.

Turn the fur down about 2.5cm (1in) to the right side, catching it down around the edge. Decorate the stocking with sequins, bows, etc., and sew a loop of ribbon just inside the edge to hang it from the tree.

By the time Christmas arrives, you may not have much extra cash for Christmas tree baubles, so these colourful fakes are a great way of economizing. First cut some circles, with a little loop on the top, from some lightweight cardboard. Now mark out a pattern on each in pencil. Simple zigzags and curved lines are effective, but not too complicated to fill in.

Paint each bauble with several different colours, waiting for each to dry before painting the next. If you have some gold or silver paint, make good use of this, as it is very effective. Use black to make definite lines between colours.

These miniature crackers can be hung on the Christmas tree or on the wall. First take a piece of cartridge (drawing) paper or light cardboard about 8cm (3in) wide and long enough to roll into a tube. Hold it together with a little sticky tape.

When the baubles are dry, attach some thread, ribbon or, as shown, some tinsel wire, so that you can hang them up.

Cut a piece of crepe paper or foil twice as long as the tube, and roll the tube in it. Stick the edges together with double-sided tape. Squeeze the paper together at both ends, and tie some thread around them. Fluff out the ends and make small cuts in them to make a fringe.

To decorate the cracker, cut some extra, narrow pieces of crepe paper or foil, fringe them at the edges and wrap them around the tube as before. Alternatively, tie a bow round the cracker or stick a silver star in the middle. Tie a length of ribbon or sparkly twine to the ends by which to hang the cracker.

If you haven't any shiny bells for the Christmas tree, it's not difficult to make some from foil, beads and a little string. First take a saucer and mark around it onto the back of some coloured foil. Cut out the circle, then fold it in half, and cut along the fold line. Fold each half of the circle into a cone and glue it in place.

For the clapper, string a bead onto a length of thread — preferably waxed — and tie a knot over the bead. Lay the thread against the bell so that the clapper is at the right level, then tie a knot level with the hole in the top. This prevents the string from being pulled through the hole when threaded. Pull the string through the hole from the inside and thread on a smaller bead at the top; knot in place.

Finish each bell by dabbing a little glue around the bottom edge and sprinkling on some glitter. When you have made three bells, string them together, and attach them to a ring so that they can be hung on the tree. Wind a little tinsel wire around the string, and tie a couple of bows for that final touch of glamour.

These miniature lanterns make attractive Christmas tree ornaments. First take a piece of foil-covered paper 11cm (5½in) square. Fold it in half, and rule a line 1.5cm (¾in) from the loose edges. Now rule lines 1cm (½in) apart, from the fold up to this first line. Cut along these lines and open out the sheet of paper.

Hold the paper with the cuts running vertically, and glue the two sides together. When this is firm, set the lantern on the table and gently push the top down to make the sides poke outwards.

Finally, cut a strip of matching paper 13cm (5in) long and 1cm (½in) wide. Dab some glue on each end, and glue the strip onto the inside of the lantern, at the top, for a handle.

Add a touch of regal splendour to your tree with these golden decorations. To make a miniature wreath, first wind the wires of two silk leaves and two small glass balls together, and bind with white florist's tape. Cut a 16cm (6½in) length from sequin waste. Next cut a long strip of gold crepe paper, fold the edges in and bind around a small wooden ring.

Tie a loop of gold thread around the ring at the paper join. Twist the leaf and ball stems around the ring over the thread, folding in the wire ends to secure.

Fold the ends of the sequin waste into the centre so that they overlap, with the selvedges at each side. Thread a long length of fine florist's wire down the middle, through all the layers. Then thread the wire back and pull up gently to make a bow shape. Twist the wires tightly to secure and bind them around the leaf wires. Arrange the leaves, bow and balls attractively over the ring.

To make a jewelled sphere, first wrap a polystyrene ball with gold crepe paper: cut a square of paper to fit generously, and pull it up tightly over the ball. Tie firmly around the gathered paper with a length of gold thread, and knot the ends of the thread to make a hanging loop. Cut a strip of crepe paper to make a bow and fold the raw edges in. Pinch the strip into a bow shape.

Run a line of clear adhesive around the ball and press a strip of beading trim into it. Repeat with a line of beading crossing in the opposite direction. Stick 'jewels' between the beads and large sequins, held in place with a pearl-headed pin. Trim the paper at the top of the sphere and attach the bow with a sequin trimmed pearl-headed pin.

M ake these delightful decorative baskets. Measure 4cm (1½in) up from the base of a yoghourt carton and cut round. Cut a 20cm (8in) diameter circle from crepe paper and cover the pot, stretching the paper up over the edges. Cover a cardboard circle with crepe paper to fit inside the base. Cut a handle 22cm (8½in) by 1.5cm (½in) from thin cardboard and wrap with crepe paper.

From sequin foil waste cut a strip long enough to wrap around the pot. Run a line of glue along the top and bottom of the pot and in one vertical line. Wrap the foil round, pressing into the glue, and trim, straightening the overlap along the vertical line of glue. Cut two strips 5cm (2in) wide from sequin waste, fold in half, selvedges level, and cut into bow shapes.

Staple the handle and foil bows each side of the basket. Tie bows from lengths of satin ribbon and stick over the foil bows with double-sided tape. Stick a pad in the bottom of the basket and arrange a bunch of glass baubles on top.

H ere's an attractive way to add sparkle to the Christmas tree. You can buy these plain glass balls from craft suppliers, so look in craft magazines for stockists or try your nearest craft shop. As you are decorating a curved surface, it is advisable to keep the design simple. Draw the outlines of your design using a fine multi-purpose felt tip paint pen.

Try to place the motifs evenly, remembering you will see the far side of the design through the glass ball. Fill in the design with the same colour you used for the outlines. You can rub out any mistakes with a cloth soaked in turpentine.

Outline your motifs in a contrasting colour, combining colours such as red and green, yellow and black, pink and purple. Add tiny dots between the motifs using the same colour as that used for the outline. Hang the baubles from your tree with gold gift wrapping thread.

A shiny foil star makes a striking decoration for the top of the Christmas tree. Using the instructions on page 35, cut out a pattern in cardboard. Now cut two squares of cardboard, slightly larger than the star template, and cover each side with a different coloured foil. Next cut out two stars, one from each foil-covered square.

Take a ruler and pencil, and placing the ruler between two opposite points, mark a line on each star from one point to the centre. Cut along these lines and then simply slot the two stars together.

Use sticky tape to hold the points together and attach a piece of green garden wire to one set of points. You can then use the wire to attach the star to the tree. Finish the star by dabbing some glue onto the points and sprinkling glitter over them for an extra-sparkly effect.

This traditional English Christmas tree-top decoration makes a charming addition to the festivities. Using a saucer, cut a circle out of silver foil paper. Cut the circle in half and fold one half into a cone, taping it in place.

Take a pink pipe cleaner and tape it to the back of the cone; then bend it into arms and hands. On top of this fix a triangle of doily to represent wings, using double-sided tape. For the head, take an ordinary ping pong ball and skewer it onto a wooden toothpick (or cocktail stick). Push the stick into the cone.

The hair is made from grey crewel or Persian wool, stuck on with double-sided tape, and the crown is a small piece of silver sequin waste. Draw the facial features with a fine-tipped silver pen. For the wand, spray a toothpick with silver paint and stick a small silver star on one end.

Cut a 3cm (1¼in) square of cardboard to use as a template for the doors. Draw around the square twenty-three times on the back of the tree, positioning the doors at random but leaving the trunk clear. Cut three sides of the doors, leave the right hand side 'hinged' so the door opens the right way on the other side.

On the right side of the tree, score the hinged side of each door lightly so it will open easily – but do not open the doors yet. Number the doors one to twenty-three with a silver pen.

Cut out small Christmas pictures from wrapping paper and used greeting cards. On the back of the tree, stick each picture behind a door by spreading paper glue on the tree around the doors.

Decorate the calendar with a gold star on the top and circles of metallic cardboard between the doors.

Write the number twenty-four on the front of a small red gift box with a silver pen. Stick a ribbon rosette on the top and glue the box onto the tree trunk. Fill the box with sweets. To finish, stick a picture hanger on the back of the calendar at the top.

This Advent calendar can be used every year at Christmas. First make the Christmas tree pattern. Cut a piece of paper measuring about 63cm x 50cm (25in x 20in) and fold in half lengthwise. Draw half the tree with a trunk against the foldline and cut it out. Open out flat and use the pattern as a template to cut out the tree in green cardboard.

Eat a chocolate a day until Christmas! Use the template on page 164 to cut out a cardboard star and iron-on interfacing. Cut out a silver fabric star, adding a 12mm (½in) allowance all around. Iron the interfacing centrally to the wrong side of the silver fabric. Cut out 24 red felt stars, making one larger, and stitch to the silver background, leaving the tops open.

Position the cardboard star centrally over the wrong side of the silver fabric. Trim the fabric allowance away at the corners and the edges over onto the cardboard, sticking in place with glue.

Cut two cardboard cracker ends, using the template on page 164. Cover with red felt, cut 12mm (½in) larger all around, gluing the raw edges over to the wrong side as before. Decorate with rows of braid, ribbons and sequins.

Position a spare piece of cardboard in each red 'pocket' in turn and stencil on a number using a silver pen and plastic stencil. Stick the cracker ends on either side of the silver star, and glue sequins between the pockets to decorate. Finally, pop a silver chocolate coin in each pocket.

Hang this Oriental mobile at a window this Christmas and watch the winter sun shine through the coloured tissue paper. Use the template on page 162 to cut out a pair of lanterns in black cardboard. Cut out all the sections, taking care not to cut through any of the 'bridges'.

To achieve the stained glass effect, cut out coloured tissue paper a little larger than the sections to be covered. Glue the pieces of tissue paper to the back of one lantern. Trim the edges. Glue a silky red tassel to hang from the bottom of one lantern at the centre. Now glue the two lanterns together enclosing the tissue paper. Suspend the mobile on red embroidery thread.

This makes an ideal Christmas wall hanging, particularly if you haven't room for a real tree. First make a paper pattern of a tree, about 75cm (30in) high and 59cm (23½in) wide at the widest point across the bottom branches. Also cut a pattern for the pot, about 25cm (10in) high. Make it about as wide as the base of the tree, with a slightly wider, 8cm (3in) deep 'rim' at the top as shown.

Cut out two pieces of green felt from the tree pattern and two pieces of red for the pot. Also cut out a piece of wadding (batting) for each. The wadding for the pot should be about 4.5cm (1¾in) shorter, since the rim of the pot will be turned down. On the front of the tree mark diagonal lines for the branches as shown.

Place the tree pieces together, with wadding on top. Pin, tack (baste), then stitch 1cm (³⁄₈in) from the edge, leaving the lower edge open. Clip the corners and turn tree right side out. Stitch along marked lines. Make up the pot, sewing up to 4cm (1½in) from the top. Turn it right side out and slip the tree inside; sew it in place. Sew the upper sides of the pot together and turn the rim down.

To decorate the tree cut out little pockets of red felt and sew them in place as shown. Insert little gifts — either real ones or gift-wrapped cardboard squares.

Finish off by adding plenty of ribbons and bells. Curtain rings also look good covered in ribbon and sewn on. Sew a loop to the top of the tree to hang it by.

TINSEL BELLS

GRACEFUL BELLS

All you really need for this decoration is some garden wire, a little bit of tinsel and a couple of baubles; but a pair of pliers will make it easier to manipulate the wire. Bend the wire into the shape of a bell. (You could, of course, try much more complicated shapes once you get the hang of it.)

This decoration can be made with tissue paper, coloured aluminium foil, thin cardboard or construction paper. Cut between six and twelve bell shapes (depending on the thickness of the paper you use). Fold each shape in half and then open it out again.

Now just wind tinsel around the wire until it is completely covered. A couple of layers will be sufficient.

Lay the cut-outs carefully on top of each other with all the creases in the centre. Now take a needle and thread, and starting at the top, make three long stitches down the middle. Bring the needle up and over the bottom to secure the shapes in place. Next make a small stitch between each long stitch. At the top, knot the two ends together.

Finish off with a bauble, tied on to represent the clapper, and some bright red ribbon to tie the bells together.

Ease the bell open, piece by piece, until it forms a rounded shape. You could easily do exactly the same thing with other shapes such as a heart, ball or tree.

Pull the cord and watch Santa dance. Use the template on page 163 to cut out the cardboard pieces. Cut one body and a pair of arms and legs from red cardboard. Mark the crosses on the back. Cut a pink face and glue to the head. Cut a white hat brim and beard, bobble and two cuffs. Glue the hat brim and beard over the face and the bobble to the top of the hat.

Add some Christmas cheer with this festive ring. Cut a strip of crepe paper the length of the roll and bind a 20cm (8in) embroidery ring, securing the ends with double-sided tape near the hanging loop. Cut narrow gold ribbon about 110cm (43in) long and wind around the ring, securing with tape. Cut the same length from a gold sequin strip and wind between the ribbon.

Cut out two green mittens, a black belt and two boots. Butt the straight ends of the mittens and arms together and glue cuffs over the joins. Wrap gold sticky tape around the middle of the belt and glue to the body. Glue the boot tops under the legs. Cut out a pink nose and glue on the face. Draw the eyes and mouth with felt-tipped pens.

Cut crepe paper 1m (40in) long and 20cm (8in) wide; fold in half lengthways. Cut the same length from sequin waste and place over the crepe strip. Bind the centre with a long piece of florists' wire and trim ends into a V shape. Measure 23cm (9in) each side of the centre, bind with wire and fold the strip into a bow, lining up the wired points. Secure with a double-sided adhesive pad.

Mark dots on the limbs and attach to the body with paper fasteners at the crosses. Pull the limbs downwards on the back and tie the arms together with thread fastened through the dots. Tie the legs in the same way Thread a small ring onto a double length of fine cord. Knot the cord around the legs' thread and then the arms' thread.

Use the trailing centre wires to secure the bow in position at the ring and arrange the ribbon ends over the ring. Finally, wire three small glass balls together and wrap these around the bow centre.

Deck the hall with sprigs of holly, made from felt and suspended from tartan ribbon. Make a holly pattern from paper and cut out two pieces of green felt and one of wadding for every sprig. Place two felt pieces together, with wadding in between, and pin in place. Overstitch all around the edges with embroidery thread.

Measure a length of tartan ribbon from which to hang the holly. Now cut shorter lengths to make the bows. Tie the sprigs to the garland with the short ribbons, finishing off with a bow. Finally, cut a V in the tails of the bows and hang your garland in place.

Thread your sewing machine with green cotton thread and stitch 'veins' onto each holly leaf – one down the centre and the rest sloping from the centre to the points. Next, take four red wooden or plastic beads for each leaf and sew them in place, close to the inside edge, using six strands of red embroidery thread.

This garland is made from different coloured tissue paper stars. Refer to the template on page 163 to make the basic pattern. Fold up six layers of tissue paper into quarters, place a quarter of the paper pattern on top, edges level and cut out. Fold the tissue paper in half again, (separate some of the layers if too bulky) and cut two slits in the positions marked in the photograph below. Cut a collection of different coloured tissue paper 'stars' in this way, plus two stars cut from cartridge paper for the garland ends. Glue a tissue star to each paper star using spray adhesive. Stick a small piece of double-sided tape to the centre of one tissue star and press this onto the centre of the tissue-covered paper star.

Next place double-sided tape on four opposite points of the tissue star, and stick another star on top, aligning the points and slits. Keep repeating the sequence, pressing pieces of double-sided tape alternately to the centre, then to the four points, of each star, building up the layers until the garland is the required length. Finish by attaching the other end section.

Use this attractive frieze to decorate shelves, or to hang along a wall. From a length of foil gift wrap cut a long strip 23cm (9in) wide. Make a tree template from paper using the pattern on page 163 and line it up along one short edge of the gift wrap. Draw around the outline marking a fold line down the centre of the tree shape. Mark an X on each section to be cut out.

Fold the gift wrap concertina fashion along its length and staple the layers together above and below the pattern area to prevent the folds from slipping. Cut out through all the layers, using a craft knife to cut out the enclosed areas between the star and the bell shapes. Be careful not to cut through the folds at the edge.

Open the frieze out. The foil can be left in gentle folds, or pressed flat with a cool iron. Stick self-adhesive foil stars all over the trees. You can make the frieze to the required length simply by joining several frieze strips together end to end, with sticky tape.

For those with a sugary tooth, here is a garland covered in brightly wrapped sweets — to be enjoyed long after the party is over. Cut a length of ribbon about 135cm (54in) long and mark the centre. Next cut three 112cm (45in) lengths of ribbon and make them up into three bows, stapling the loops into an open position as shown and trimming the ends into points.

Tape the bows onto each end and onto the centre of the main ribbon length. Then use silver thread to hang clusters of baubles from the centre of the bows. (Hang the baubles at varying lengths for the best effect.) Glue the threads to the centre of the bows and cover them up with an adhesive ribbon rosette.

Decorate some sweets with silver stars and staple them along the top edge of the ribbon between the bows. Use double-sided tape to attach the underside of the sweets to the ribbon. Finally, sew curtain rings onto the back of the ribbon for hanging the garland.

For the rosettes, cut a circle of silver cardboard, 10cm (4in) across. Take a piece of ribbon 80cm (32in) long, fold it in half and staple it to the centre of the circle. Trim the ribbon ends into points. Staple the sweets in a circle around the cardboard as shown, then stick a ribbon star in the centre. Using sticky tape, attach a curtain ring to the back of the circle for hanging up the rosette.

This simple paper chain takes only a few minutes to make. All you need are two different-coloured crepe papers and a touch of glue. Cut 7.5cm (3in) off the end of each crepe paper roll. Place the strips at right angles to each other, and glue one end over the other as shown.

Bright-coloured foil paper makes a festive version of the simple link chain. Begin by cutting lots of strips about 18 by 3cm (7 by 1¼in). Stick the ends of the first strip together with double-sided tape (neater and quicker than glue) to make a link.

Bring the lower strip up and fold it over the other, then fold the right-hand strip over to the left as shown.

Now simply thread the next strip through and stick the ends together. Continue in this way, alternating the colours, until the chain is as long as you want it.

That's all there is to it; just keep folding the strips over each other alternately until you reach the end. Glue them together at the ends and trim off any extra bits.

This is another fun way to hang up your Christmas cards. Simply take three long pieces of gift wrap or woven ribbon in red, green and gold, and plait them tightly together. Knot them at each end to hold them in place.

Now take some clothes pegs, lay them on several sheets of newspaper and spray them with gold paint. Turn them until all the sides have been covered and leave them to dry.

Hanging up your Christmas cards always poses a problem. Here is a simple way to overcome it while making an interesting 'picture' for your wall at the same time. First take a piece of wooden garden trellis, extend it, and spray it with gold paint.

Fasten the ribbon to the wall at each end, and use the gold pegs to attach your Christmas cards to it. (If you prefer, and if you have some to spare, you could use tinsel instead of ribbon.)

While the trellis is drying, lay out some ordinary wooden clothes pegs and spray them gold as well. You will have to turn them over a few times so that all sides are covered.

When the trellis is dry, take some thick strands of tinsel and wind them all around the edge of the trellis to make a frame. Now hang the trellis on the wall, and use the pegs to attach the Christmas cards as they arrive.

Here is a lovely sparkly garland to hang at Christmastime. Cut Christmas tree and bell shapes from foil-covered cardboard, marking the shapes out first on the wrong side. Be careful when cutting as foil cardboard tends to crinkle at the edges.

Make a tiny hole in the top of each, using a hole punch, or the tip of a skewer. Using red twine, tie each shape to a long strand of tinsel, leaving even spaces between them. At the top of each bell, fix a bow of gold-covered wire; on the trees, a little star.

The paper used for these crackers is similar in texture to curling gift wrap ribbon and has a lovely shiny satin finish. Cover empty toilet paper rolls or cardboard tubes with white sticky-backed plastic, which prevents the colour from showing through. Now cut pieces of shiny paper, twice as long as the tubes, and wide enough to go easily around them.

Wrap the tube in the paper and fix in place with double-sided tape. Don't twist the ends; scrunch them in with elastic (rubber) bands, which you can then cover with strips of curling ribbon. Decorate the crackers with boiled sweets (hard candies), stuck on with double-sided tape. Staple the crackers onto a strip of tinsel and trim the garland with sweets and baubles.

A large foil star to hang in the centre of the ceiling or over the fireplace. Try it out on a piece of ordinary paper first, as it is a little fiddly. Cut a piece of foil paper about 45cm (18in) square. Fold it in half from corner to corner, then in half twice again, making a small triangle.

Bend the single-fold edge over to the edge with three folds. Open it out, and rule two lines from the corners at the base of the triangle to the centre crease. Cut along these two lines.

Refold the crease and rule two more lines, forming a small triangle as seen here. Cut this out. Now snip the point off and open the star out. Glue it to another piece of thicker foil paper for backing and cut the star out carefully when the glue has dried. Finish it off with a ribbon rosette in the centre.

You can always have snow at Christmas, even when the sun is shining outside. Make this snowflake in foil or in plain white paper and hang it over a window-pane. First take a square of paper, fold it into quarters, then in half diagonally, then lastly back on itself as shown.

Make a pattern of the chosen design, then mark it on the folded paper with a black felt pen. Shade the areas that are to be cut away, then cut them out. Open out the snowflake. If you use a very flimsy foil, glue the snowflake onto a piece of paper, and cut out around it. This will make it easier to hang.

Finally, decorate the snowflake with sequins in bright jewel colours. The more patience you have, the more sequins you will use and the better it will look!

Make these shiny decorations from foil wrapping paper. Cut out eight circles in each of the following diameters: 9cm (3½in), 7.5cm (3in) and 6cm (2¼in). Then from cardboard cut out four circles 2cm (¾in) in diameter and two of 1.5cm (½in) for the centres. Fold the largest foil circles into quarters and staple four of them onto a large cardboard circle.

In the same way, staple the other four foil circles to another cardboard circle. Glue the two cardboard circles together with a string between them. Leave a long piece hanging below for the other two balls. Fluff out the edges of foil to make a good shape.

This simple star can be hung on the wall or from the ceiling. First make the pattern for the star. Using a ruler and protractor, draw an equilateral triangle (each angle is 60°). Cut out the triangle and use it as a pattern to make another one. Then glue one triangle over the other to form the star. Use this pattern to cut a star from foil paper.

Now make the other two balls in the same way, using the smaller cardboard circles for the tiniest. Fix the balls to the string as you go.

Fold the star in half three times between opposite points. Next fold it in half three times between opposite angles as shown. Every angle and point should now have a fold in it.

The star will now easily bend into its sculptured shape. Make a small hole in its top point with a hole punch or a skewer, then put some thread through the hole to hang it up.

This unusual decoration adds a festive touch to a mirror or favourite painting. Make it in separate sections, one to be horizontal, the other vertical. You need fake ivy, fern and other foliage, plus pine cones, gold baubles and gold curling gift wrap ribbon. Cut off the long stems and wire everything up as shown, using florist's wire.

For the top section gradually lay pieces on top of one another, binding the wires and stems together with tape as you go along. The arrangement should be relatively long and narrow.

For the second section, use the same technique, but make the arrangement fuller. Hold the two pieces as you would like them to sit on the frame, and wire them together. Bend the stem wires back so that they will slip over the frame and hold the arrangement in place.

These small fir trees are fun to decorate and add a festive touch to any Christmas sideboard or buffet table. For a gold tree, make small bows of fine gold ribbon. Drape a string of gold beads in a spiral over the tree, starting at the top, then fix the bows in between the loops of beads.

Wrap some tartan ribbon around the pot and secure the ends with fabric glue. Make a separate bow and attach it with glue or pins.

Carefully roll the sheet of icing over the rolling pin and unroll it onto the cake. Shape the icing around the cake, keeping your hands wet to smooth out any cracks.

Add rows of edible cake balls to suggest garlands draped across the tree.

Place tiny red ribbon bows on the cake. (You can use a glass-headed pin to secure the bows, but take care to remove them all before serving the cake.)

Place a selection of 'presents' around the bottom of the tree — the ones used here are Christmas tree decorations.

Push red wax candles into the icing around the edges of the tree to complete the effect.

This festive Christmas tree cake will be the featured attraction at a Christmas tea. The cake can be made to your own traditional recipe and should be baked in a Christmas tree cake tin. The simplest method for icing the cake is to use ready-to-roll fondant icing. Knead the block into a ball and work in some green food colouring.

Roll the coloured icing out flat on a cool surface, first sprinkling some icing, or confectioner's, sugar on the worktop to prevent the icing from sticking.

GLITZY FRUIT BOWL

AUTUMN GOLD

A touch of gold gives this platter of fruit and nuts extra richness. Begin by spraying ivy, clementines, bay leaves and fir cones with gold paint. (If the fruit will be eaten, make sure that the paint you are using is non-toxic.)

This centrepiece is very effective, but simple and long-lasting. If you or any of your friends have any plastic fruit that has been sitting around for some time and is ready to be thrown away, this is the perfect opportunity to give it a new lease of life. First take a deep plastic plate and spray it gold. Next take a paper doily and spray it gold also. When they are both dry, glue the doily to the plate.

Meanwhile, take a selection of plastic oranges, apples, bananas, grapes, etc., plus some fake ivy and some pine cones, and spray them either gold or bronze. Using both colours makes for variety. Let a little of their real colour come through; it adds interest. Wind the ivy around the edge of the plate, gluing it here and there to keep it in place.

Place the ivy leaves around the edge of a plain oval platter. The flatter the plate, the better, for this will allow the ivy leaves to hang over the edge.

Now fill the middle with the fruit and pine cones. Again, you will have to dab a little glue here and there so that it withstands any movement.

Arrange the clementines on the platter, surround them with dates and nuts, and place a bunch of shiny black grapes on top. Add the gold leaves and fir cones for a luxurious finishing touch.

T his stunning centrepiece looks grand enough to grace the most formal dinner party this Christmas, and yet is very simple to make. Using a pastry brush, coat each piece of fruit with egg white.

Working over a large plate, sprinkle granulated sugar over the fruit so that it adheres to the coating of egg. Alternatively, the fruit can be dipped into a bowl of sugar, although this tends to make the sugar lumpy.

T hese attractive miniature crackers form an eye catching centrepiece, and the surrounding sweets make a delicious accompaniment to coffee at the end of the meal. For the name tags, cut small squares and rectangles from white cardboard. Trim the edges decoratively, then write the names and embellish the edges of the card with silver or gold paint.

Cut lengths of gold and silver ribbon or braid about 15cm (6in) long. Tie a ribbon around one end of each cracker. Dab a spot of glue on the back of each name tag and press it onto the ribbon.

Ivy leaves are used here to form a decorative border; but remember to use a doily to separate the poisonous leaves from the fruit if you intend to eat the fruit later.

Pile the crackers onto a large plate covered with a gold doily. Place those with name cards near the top of the pile. For a finishing touch, surround the pile of crackers with gold and silver dragées.

Clementines are a favourite at Christmas, and here an attractive effect has been created by hand-painting a plain wicker basket to match the colour of the fruit. Paint the basket inside and out with a water-based paint in the back-ground colour, using a small decorating brush. Leave the basket to dry.

Exquisite marzipan fruits deserve special presentation. Nestling in little tissue 'parcels' and piled into a cake stand, they make a colourful centrepiece. All you need is several different colours of tissue paper and some pinking shears. Instead of marzipan fruits, you could use chocolates or marrons glacés.

Dip a sponge into a saucer containing the contrasting colour of paint. Dab the sponge a few times on a piece of scrap paper to remove any excess. Then sponge all over the outside of the basket, replenishing your paint supply when necessary.

From a double layer of one colour of tissue, cut a 10cm (4in) square. Pinking shears give an attractive serrated edge. From another colour of tissue, also double, cut a smaller square, measuring about 6cm (2½in).

Arrange the fruit in the basket as shown, adding a few leaves for contrast. Clementines are shown here, but apples, bananas and other fruit could be added for variety.

Lay the smaller square on top of the larger one. Place the marzipan fruit in the centre and gather the tissue around it. Hold it in place for a few seconds and then let go; the crumpled tissue will retain its rosette shape. Place several of the parcels on a doily-lined glass or china cake stand.

For a bright party centrepiece — ideal for Christmas or New Year's Eve — fill a glass bowl with a mixture of shiny glass baubles, foil crackers, feathers and streamers. To make clusters of small baubles, first remove the hanging string. Put a dab of glue inside the neck of each bauble and push in a short length of florist's wire. Leave them to dry.

Hold the wired baubles in a cluster and wind fine fuse wire around the stems to hold them together.

Wrap a piece of shiny giftwrap ribbon around the stems and tie it into a bow. Arrange the baubles and other ornaments in the bowl as shown.

Believe it or not, this arrangement is quite simple once you get the hang of folding the cones. You need two colours of foil paper. Cut out lots of boat shapes 16.5cm (6½in) along the top and 12.5 (5in) along the bottom and about 6cm (2½in) deep. Glue one colour to another, back-to-back.

Form each boat into a cone and glue it in place. The first few you make may not look too professional, but it doesn't matter; these can go on the outside of the stand and will be partially covered. You will soon get the hang of folding the cones. Bend the bottoms under; it helps to hold the shape and looks tidier.

When you have several cones made, start gluing them around the edge of a 20cm- (8in-) diameter silver cake board. Place another two layers inside the first, leaving room for a chunky candle in the middle.

G old and silver look stunning by candlelight and this festive arrangement will flatter any table setting. To begin, spray a vine garland with gold paint, sprinkle with gold glitter, and leave to dry.

Take three flat-based candle holders and stick florists' fixative putty under each one. Position them evenly around the garland, using florists' wire to secure each holder firmly in place.

To make the silver roses cut strips of silver crepe paper 53cm (21in) by 9cm (3½in). Fold in half lengthways and tuck the short ends in. Run double-sided tape along the lower edge of a folded strip and place a wired group of gold balls at one end. Roll the crepe paper around the balls, pinching the paper tightly together at the base. Finally, crimp the petal edges to curve outwards.

Stick a double-sided adhesive pad to the base of each rose and position four flowers around each candle holder. Cut 23cm (9in) lengths of gold ribbon and fold into double loops. Secure the ends with florists' wire and stick between the roses using adhesive pads. Tease the rose petals and gold loops to shape to hide the holders and put candles in place.

Adorn the New Year dinner table with this attractive centrepiece. Cut a length of crepe paper 120cm x 20cm (48in x 8in). Stick the ends together on the wrong side with clear sticky tape. Place a 25cm (10in) diameter polystyrene ring in the middle and sew the long edges of crepe paper together with a running stitch enclosing the polystyrene ring. Gather up the seam and fasten off.

Spray five candle holders white and push into the ring evenly spaced apart. Then drape strings of white pearls and narrow green coiled giftwrapping ribbon around the ring, gluing the ends to the underside.

Stick two rectangles of metallic blue cardboard back to back with spray adhesive and cut out five masks using the template on page 47. Score gently along the fold line of the tabs with a craft knife and bend the tabs backwards. Stick each mask by the tabs, in front of a candle.

Glue tiny blue and green star-shaped sequins to the ring, then cut out ten small stars from silver cardboard and glue between the candles and to each mask. Finally, place silver candles in the holders.

It is easy and economical to make crackers. Cut crepe paper 32cm x 16cm (12¾in x 6¼in), keeping the grain of the paper parallel with the long sides. Lay a piece of thin writing paper 24cm x 15cm (9½in x 6in) centrally on top. Next cut thin cardboard 15cm x 8cm (6in x 3in) and lay it across the centre. Slip a cracker snap underneath.

Take two cardboard tubes, the sort found inside rolls of kitchen towel, and cut one in half. Lay the long tube on the lower edge of the crepe paper, with the end level with the cardboard edge. Butt a short tube against the long one and roll up tightly. Glue the overlapped edges of paper together with a low-tack adhesive.

Pull the short tube out for 5cm (2in) and tie thread tightly around the cracker between the tubes. Push the tubes together again then remove the short tube. Drop a gift, motto and paper hat inside and pull out the long tube a further 12.5cm (5in) . Tie thread tightly between the tube and cardboard inside the cracker. Untie the threads.

Cut two 25cm (10in) lengths of gold filigree lace – the kind that has a drawstring thread along one edge. Gather up the drawstring and tie the lace around the necks of the cracker. Gently stretch the ends of the cracker to flute the edges. Remove the drawstring from a length of lace and glue around the middle of the cracker. Glue a dried flower to the cracker to complete.

- Crepe paper
- Tissue paper
- Cardboard cylinder
- Stiff paper

Gather the paper together at one end and tie it with ribbon. Leave the other end open to drop in the gift, hat and joke of your choice. Tie this end and trim the ribbons neatly.

Cut a zigzag edge in the paper at both ends; or leave the ends plain, if you prefer.

Crackers are always a must at the dinner table at Christmas. The diagram above shows the materials required for a cracker: crepe paper for the outside, tissue paper for the lining, and stiff paper and a cardboard cylinder to hold the cracker in shape.

Cut the paper layers as indicated above. Roll them around the tube, and stick them in place securely with either glue or tape. A friction strip can be placed between the stiff paper and cylinder to provide a 'bang' when the cracker is pulled.

Add the final decorative touches — in this case, contrasting layers of crepe paper and a paper motif.

Fill this sleigh with foil wrapped candies for a charming table centrepiece. Apply gold embossed paper to both sides of thick cardboard with spray glue and cut a pair of sleighs using the template on page 163. For the base, glue gold paper to both sides of a rectangle of thin cardboard 36cm x 16cm (14⅛in x 6¼in).

Mark the broken lines on the sleighs. Score along the base 1.5cm (⅝in) from each long edge. Snip away tiny triangles up to the scored lines so that the base will bend easily. Bend the snipped edge backwards at right angles.

Glue the snipped edges between the sleighs along the broken lines and lower, straight edges. Use the template to cut out two flowers in red foil paper and two leaves in green. Glue two leaves under each flower and glue three sequins in the middle. Glue a flower to each side of the sleigh and line it with scrunched up iridescent film.

C hristmas colours are woven together to make a matching table mat and napkin set. From cartridge paper cut out a rectangle

37cm x 27cm (14½in x 10½in) and mark a 2.5cm (1in) border all round. Draw lines 12mm (½in) apart across the paper. Cut a piece of sticky-backed velour fabric a little larger all round and peel off the backing paper. Lay the the rectangle centrally on top and, using a craft knife, cut through the drawn lines as shown. Fold overlapping fabric over and stick down.

Weave lengths of green and white paper ribbon through the cut strips, arranging the ribbon so both ends pass under the border. Fold gold and silver crepe paper into narrow strips and weave over the green and white ribbon. Hold the strips in place with a little double-sided tape at both ends. Trim away the excess paper, then cover the back of the mat with sticky-backed fabric.

Cut a coaster mat from cartridge paper 17cm (6½in) square. Make a border as for the table mat, and mark, cover and cut in the same way. Weave with two lengths of each colour and cover the back with sticky-backed fabric as before.

To make the napkin ring cut a strip from cartridge paper 17cm x 6.5cm (6½in x 2½in). Mark out a 12mm (½in) border and divide into strips 12mm (½in) apart. Cover with sticky-backed fabric, and cut strips as before. Weave green ribbon and silver or gold crepe through the slits and secure with double-sided tape. Cut a length of fabric for the backing and stick in place.

Join the two ends of the ring with double-sided tape. Make a bow shape from white paper ribbon, binding the centre with fine florists' wire. Make a small bow shape from folded gold crepe paper and stick across the white bow with double-sided tape. Stick the completed bow over the join in the napkin ring using double-sided tape.

This sparkling placemat is an obvious winner for Christmas. First draw a Christmas tree on the reverse (matt) side of a piece of shiny green cardboard. The length should be about 10cm (4in) longer than the diameter of your dinner plate and the width about 20cm (8in) wider. Cut out the mat using a craft knife and a steel ruler.

Add 'ornaments' by sticking tiny baubles to the tips of the tree using strong glue.

Add a touch of luxury to a dinner party by decorating your own tablecloth in gold. First choose a simple image, such as the fleur-de-lys motif shown here. You can either decorate an existing cloth or buy a length of wide inexpensive cotton fabric. Draw the shape in pencil first, and then go over it in gold paint.

Cut out or buy a star shape to put at the top of the tree. Finally, stick small silver stars over the mat. Or, if you prefer, just scatter the stars freely over the mat, first positioning each mat on the table.

To echo the shape of the fleur-de-lys symbol you can dress up your table napkins as shown. A napkin with a lacy edge will look best. Fold the napkin into a square. Keeping the lacy edge nearest to you, fold the left- and right-hand corners in to overlap one another. Fold the remaining point in to meet them.

Slide the napkin, lacy edge towards you, into a shining foil gift bag. Because both napkin and china are white, a lacy gold coaster was inserted into the bag, underneath the lace detail on the napkin to give it more definition.

FLEUR-DE-LYS FOLD

DOUBLE CORNET

This design looks best in a conical glass but can be adapted for a wider-based container. Although it takes a little more practice than most, it is worth the effort. First lay the napkin flat and fold it in three lengthwise. Position it as shown, with the free edge on top.

Take hold of the top left-hand and right-hand corners of the napkin with the index finger and thumb of each hand. Roll the corners diagonally towards you as shown.

To make this graceful fold, lay the napkin flat and fold it in half diagonally to form a triangle. Position it with the folded edge towards you. Bring the top corner towards you, so that the point overlaps the folded edge slightly. Carefully turn the napkin over and repeat with the other corner.

Pleat the napkin evenly across from left to right, in accordion- or concertina-style, folds. Holding the straight edge of the 'concertina' firmly in position, arrange the napkin in a glass. Pull the front layer of the top point towards you, creating a pointed flap over the front of the glass.

Without releasing your hold on the napkin, continue to roll the corners inwards in one sweeping movement by swivelling both hands and napkin down, up and over until your hands are together palms uppermost. By now the napkin should be rolled into two adjacent flutes. Release your hands and place the napkin in a glass, arranging it neatly.

KITE PLACE CARDS

TARTAN PLACE CARD

These colourful place cards are perfect for a children's Christmas party. For each kite you will need stiff paper in two colours. From each colour cut two rectangles, each 10 by 15cm (4 by 6in). Draw a line down the centre, then another line at right angles across it, 5cm (2in) from one end. Join up the points, then cut off the four corners; set them aside.

Add a truly Scottish flavour this Christmas by making these tartan place cards for your guests. Use plaid ribbon and either white or coloured lightweight cardboard, and add a kilt pin for the finishing touch.

Use two of the corners of the red card to decorate the yellow kite, glueing them in place as shown. Similarly, use two of the leftover pieces of the yellow card to decorate the red kite. Write the name on each kite.

Cut a rectangle of cardboard about 10 by 12cm (4 by 5in), or a size to fit the plate. Fold it in half, and write the name on the left-hand side. Cut a piece of ribbon to edge the card front and back, allowing a little extra to turn under the edges.

Cut out squares of coloured tissue, allowing three for each kite. On the back of each kite, glue a 40cm (16in) strip of thin ribbon. Pinch the squares of tissue together in the centre and tie the ribbon around them. Cut a small strip of cardboard, fold it in two and glue it to the back of the kite; use this hook to attach the kite to a glass.

Stick ribbon onto the card with fabric glue, folding the excess underneath as shown. Pin the kilt pin through the ribbon and card to complete the authentically Scottish look.

Here's a novel way to show guests where to sit — a pastry place marker shaped like a Christmas tree. Make the dough by mixing three parts of white flour to one of salt, a spoonful of glycerine and enough cold water to give a good consistency. Knead the pastry for about 10 minutes, then roll it flat on a floured surface.

Cut out the shapes with a sharp knife or a pastry cutter. Remember to make a hole for the ribbon. Bake the pastry in the normal way.

For a children's party at Christmas this ingenious place marker is sure to be a winner. First, cut two boot shapes from bright-coloured felt, making sure that they are large enough to enclose a chocolate teddy or other favour. Stick the shapes together with fabric glue, leaving the top open.

From contrasting felt, cut a zigzag strip for the upper edge and some letters to make the name.

Either leave the shapes plain or colour them with water-based paint. You can pipe your guests' names on using tube paint. Varnish the shapes (optional) and attach a ribbon. Note that these pastry shapes are not edible and should be used only for decorative purposes; however, they will keep for years. They can also be used as Christmas tree ornaments.

Glue the strip and the letters to the boot as shown. Finally, insert the chocolate teddy into the boot.

Miniature holly sprigs give a festive touch to a place card. From thin cardboard cut a rectangle 7.5cm x 10cm (3in x 4in). Gently score across the centre, using a craft knife against a ruler, and fold the card in half. Punch a hole in the lower left side. Make a holly leaf template from thick paper and draw around the edge on to thick green paper (artist's Canson paper is ideal). Cut out.

Score lightly down the centre of each leaf and bend to shape. Bind a bunch of red flower stamens (available from craft shops) together with fine florists' wire and cut in half across the stems to create two bunches. Bind the stamens to the front of the leaves with red florists' tape.

Fold a short length of narrow curling ribbon in half, at a slight angle, and secure fold with a small piece of double-sided tape. Curl the ribbon against a scissor blade and stick to front of the holly sprig. Write the name on the card and push the holly sprig through the punched hole, securing the stems to the back of the card with a small piece of sticky tape.

Choose a simple motif, such as holly, mistletoe, or bells, and create your own unique festive tea service. For this attractive holly design, you will need plain white china, red and green ceramic paint and a fine paint brush. Paint the outlines of the holly leaves with green paint, grouping the leaves together in threes. Now fill in the leaf outlines with more green paint.

Join up the leaves with garlands of red berries made by applying dots of red ceramic paint with a very fine brush. Also add clusters of berries at the base of the leaves. When the paint is completely dry, finish off with a coat of ceramic varnish. To complete the picture, you can even paint the motif on to the corner of your paper napkins.

For an unusual centrepiece, fill a basket with festive fabric balls. Cut a holly leaf shape from medium weight interfacing. Cut a strip of fabric twice the length of the leaf and stitch the interfacing to the wrong side. Fold the fabric over the leaf and stitch over the previous stitches. Cut out with pinking shears. Make three more leaves, add beads for berries and sew to the basket.

Make up a 3cm (1¼in) wide frill by cutting a fabric strip twice the length of the basket top by 8cm (3¼in). With wrong sides together, fold in half lengthways so raw edges overlap in the centre; sew running stitches along the length and gather. Pull up to fit the top of the basket and handsew in position, neatening the ends together. Wrap glittery cord around the basket handle.

For each ball, cut a 20cm (8in) fabric circle with pinking shears. Wrap around a 5cm (2in) compressed paper ball, pleating up the fabric evenly. Cut a 25cm (10in) length of ribbon; gather along one edge with running stitch, pull into a rosette and fasten off. Pin to the top of the ball, through all layers of fabric, with a glass-headed pin threaded through a star-shaped sequin.

Lay a festive table with a cheery napkin ring for each guest. Cut out one pattern piece (see page 162) from white fur fabric, a piece of flesh-coloured felt 5.5cm x 4.5cm (2¼in x 1¾in), and a 15cm x 1cm (6in x ⅜in) strip of red felt. Stick the flesh-coloured felt centrally across the back of the opening on the fur fabric to form the face.

Now glue the red felt strip across the top of the fur fabric piece. Stick on two small eyes and a square of red felt for the nose. Fold the side panels back to form a ring, overlapping them by 1cm (⅜in), and glue. Finally fasten a bell to one side of the red band with a length of 'worked' thread, sewing a few strands between the band and the bell and working over them with buttonhole stitch.

Little boxes, decorated with tissue paper pom-poms and filled with candies, make lovely gifts at the Christmas table. To make the pom-pom, fold some tissue paper to get at least 12 layers, measuring 7cm (3in) square. Using a cup or glass, mark a circle on the paper, and cut it out. Staple the layers together at the centre.

Cut strips into the centre, making them about 5mm (¼in) wide at the edge and stopping short of the staple. Fluff up the tissue paper to form a pom-pom, and glue it to the box. To make the box, copy the template below and then refer to the instructions adjacent (i.e. those for the square gift box).

This elegant little box is ideal for wrapping a special gift for each of your dinner guests this Christmas. First draw the diagram to the specified measurements, then trace it. Tape the tracing to the wrong side of medium-weight cardboard with masking tape and draw over the outline to make a light indentation in the cardboard. Cut around the outline.

Score the fold lines carefully with scissor points and fold the box accordingly. Apply glue to the flaps and join the box together as shown. Allow it to dry thoroughly before using it.

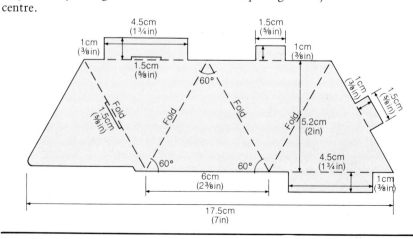

GIFT-WRAPPED SOAPS

GLAMOROUS GIFT BAG

Give each of your guests a little table gift this Christmas, wrapped up in some pretty fabric. Fine scented soap makes a perfect gift for the ladies. Cut a 15cm (6in) square of fabric, using pinking shears for a decorative edge and to prevent fraying.

A stunning, yet simple, idea for a festive dinner party, these net bags contain sweets for your guests. Cut a large gold doily in half. Fold the edges around to meet one another, creating a cone shape, and then secure them with tape.

For a gift bag, place the soap in the centre of the square of fabric. Gather the corners together in the centre. Tie a contrasting ribbon around the fabric and into a bow. For an envelope, fold the four corners of the square over the soap to overlap in the centre.

Cut out a square of black dress-maker's or milliner's net. Use it double for a fuller effect. Holding the net square in one hand, place the gold doily cone into it. Place three or four black and gold dragées in the cone.

Hold the flaps of the envelope in place and tie them up with a contrasting ribbon. Finish off with a large bow.

Gather the net and doily cone into a 'waist', leaving some extra at the top. Secure it with sewing thread, wrapped tightly around it several times, or with an elastic band. Cut equal lengths of thin gold and black ribbon, and tie them around the waist and into a bow at the front.

Be the belle of the ball with a lavishly jewelled mask. Spray glue two pieces of gold cardboard together for extra strength, then use the template on page 163 to cut out the mask. Stick double-sided tape to the top edge on the back of the mask. Cut a strip of iridescent film 50cm x 6cm (20in x 2¼in). Scrunch up one long edge and press onto the tape.

Glue an iridescent plastic flower to the left-hand corner. Glue small glass stones at random to the mask and stick one in the centre of the flower. A pair of tweezers is useful for holding tiny stones. Glue gold plastic leaves around the flower.

Spray a 30cm (12in) length of thin wood dowel gold and bind with narrow giftwrap ribbon. Glue the ends in place. Pull two lengths of giftwrap ribbon between your thumb and finger to coil them. Stick the ribbons to one end of the dowel with sticky tape and use a strong glue to stick the wooden handle behind the mask.

Here's a jaunty majorette's cap that is ideal for a fancy dress party. Cut a strip of coloured cardboard 60cm x 13cm (24in x 5in). Use the template on page 163 to cut out a peak in silver cardboard. On the wrong side, score the peak along the broken lines and make snips in the cardboard to the scored line. Bend the snipped edge upwards.

Stick an 18cm (7 in) long strip of double-sided tape in the middle of one long edge of the hat on the wrong side. Overlap the ends of the strip and lightly hold together with masking tape. Press the snipped edge of the peak onto the sticky tape. Remove the masking tape.

These conical hats are so easy to make that you will want to make one for each of your party guests. Cut a 30cm (12in) diameter circle of shiny cardboard for each hat and cut to the centre. Cut a slice out of the circle so that the hat is not too bulky. Overlap the cut edges and glue together.

Wrap the hat around your head, overlapping the ends, and stick together with double-sided tape. Pleat a rectangle of foil giftwrap and bind the lower edge closed with clear sticky tape, forming a fan. Glue to the front of the hat. Finally, cut out a diamond shape from silver cardboard and glue it over the fan.

There are many ways to decorate the hats – stick on gold stars or use glitter pens to draw a pattern. Another idea is to spread glue in moon shapes on the hat and then sprinkle on glitter, shaking off the excess.

Make a hole with the points of a pair of scissors each side of the hat and thread with hat elastic. Adjust the elastic to fit under the chin and make a knot behind the holes.

For those who prefer more natural Christmas decorations flowers are a must, providing all the colour and festive splendour anyone could want. Fresh flowers are glorious but dried flowers are so much more durable — surviving the whole festive season and on to the next! And, as this chapter shows, dried flowers are so versatile, ideal for decorating anything from wreaths and centrepieces to coasters and candlestick holders. To help you identify the plants used, a list of both common and Latin names has been provided on page 167.

Most arrangements are supported by either florists' foam or wire mesh. The foam comes in two forms — one for fresh flowers (designed to absorb water), the other for dried flowers. The latter comes in several shapes and sizes — spheres, blocks and cones — and can be cut down to any size required. Dry moss is also used as a support — packed inside a wire mesh frame to form a solid 'cushion' or bound on to a wreath frame with reel wire. Other than these supports, you will also need a sharp knife, a strong pair of scissors or secateurs and, for the dried flowers, some wire — stub wires (which come in various lengths and thicknesses), black reel wire and silver rose wire.

WIRING TECHNIQUES

Some dried flowers — yarrow and larkspur for example — have strong, firm stems that need no support. Others, such as helichrysums, have weak stems that cannot withstand the weight of the flowerheads. In the latter case, wire can be used to support the flower. Cut a stem down to about 4cm (1½in) and place it against the end of a stub wire. Then bind the length of the stem to the wire using silver reel wire.

To increase the impact of colours in a display, flowers are frequently tied into small bunches before they are arranged. To do this, cut down the stems of two or three flowers — weak stems should be cut down to about 4cm (1½in); strong ones can be left longer. Take a length of stub wire and bend back the top 3-4cm (1-1½in) to form a hair-pin shape. Place the pin against the end of the stems, bent end towards the flowerheads. Then, starting about half way down the pin, begin to wind the long end of the wire around both the stems and the short end of the wire. Bind it about three times as shown below, then straighten it so that it forms a 'stem'. Trim the wire to the required length and insert it into the display.

To give flowers more impact in a display, wire them into small bunches before arranging them. First bend the end of a stub wire to form a hair-pin shape.

Cut the flower stems short and place them against the pin. Wind the long end of wire round about three times then straighten it to make a 'stem'.

Transfuse the atmosphere this Christmas with the sweet scent of lavender and pot-pourri by making this charming basket. Begin by wiring small bunches of lavender — about three to four stems each. Attach a bunch to the rim of the basket, wrapping the wire through the wicker work. Position the next bunch over the stems of the first to cover the wires. Continue round the rim.

A collection of brilliantly coloured flowers makes a striking display for the sideboard. Begin by moulding some wire mesh into a three-dimensional shape, keeping the base flat and the top end open. Pack the mesh with dry moss, then close up the open end. Now insert wired bunches of stirlingia — tall, upright stems at the top, shorter, horizontal ones lower down.

When the rim is fully covered, cover the handle in the same way. Add a splash of colour to the display with wired bunches of small red helichrysum (everlasting or strawflower). Attach them at intervals to the rim of the basket, using the same method as before. Put two more bunches on the handle.

Next, arrange a few stems of blue larkspur around the top, and shorter bunches of blue statice lower down, following the general pattern set by the stirlingia. Follow with wired bunches of pink-dyed quaking grass, breaking out of the outline, and a few clumps of blue-dyed *Leucodendron brunia.*

Make a single bow out of deep red ribbon and wire it on to the middle of the handle. Cover the wire with a strand of lavender, fixing it in place using fine silver rose wire. To finish, fill the basket with pot-pourri, choosing a type that complements the colours of the arrangement.

Once you are happy with the general shape of the arrangement, start to fill in with bunches of large pink helichrysum (strawflower or everlasting). Pack them deep into the display. Add bright yellow highlights next with bunches of cluster-flowered helichrysum.

Finally, wire together a few bunches of rich red roses and scatter them throughout the display. It is important to position the roses last, because this ensures that the heads remain well exposed.

An attractive winter's wreath in muted creams and golds makes a pleasant change from the usual seasonal reds and greens, and gives a different and stylish Christmas decoration. Begin by covering a wreath ring in moss, packing the dry moss around the frame and binding it firmly in place with black reel wire.

Wire together some clumps of cream sea lavender and virtually cover the entire ring with it. Next, take some purple statice and wire together several bunches.

Intersperse the purple statice evenly amongst the cream coloured flowers which form the base of the garland. Then, place at regular intervals some wired clumps of yarrow and rhodanthe (sunray).

Finally, gather about 10 to 12 cones and wire them together in a large bunch. With more wire fix the cones to the wreath at the front. Pull a few strands of the flowers between the cones to add contrast. Intersperse a few more cones throughout the wreath as shown to complete the picture. This combination of flowers and cones is remarkably inexpensive, yet the result is quite stunning.

Hang this brilliant golden wreath on your front door this Yuletide to provide a colourful welcome for all your guests. It is possible to make your own base for the wreath as described opposite, but a florist should be able to provide you with a sturdy woven cane base, such as this one, for a small cost.

Wire up plenty of colourful flowers, either singly or in bunches, depending on their size. Allow plenty of wire for attaching them securely to the base. The flowers used here include helichrysum (strawflowers or everlasting), yarrow and sea lavender.

Pine cones can easily be wired around the base. Choose small closed ones for the best effect. If you cannot collect the cones yourself, your florist or a shop selling dried flowers will probably have some, and they should cost very little.

Some dried flowers come ready-wired, which makes the work easier, but a little more expensive. When everything is ready, begin wiring the various items onto the base, laying them all in the same direction.

Some flower heads will be very delicate and break off. If so, simply dab a little glue on the back and stick them on. If you start to run out of dried flowers, or you want to save some money, heather from the garden can be included; it will dry naturally once it is in place.

This unusual and imaginative wreath makes a striking decoration to hang on the door during the festive season. To create it, you will first need to buy a twig wreath from your local florist. Begin the arrangement by wiring small bunches of oak leaves together. Also take a few pieces of sponge mushroom and push wires through one side.

Attach the leaves and fungus to the wreath, forming three groups evenly spaced around the ring. Now wire up some lotus seedheads - wiring the large ones singly and the small ones in groups of two or three. Insert these in amongst the other plants.

Push short lengths of wire as far as they will go through one end of some walnuts. Form small groups of about three to four nuts each by twisting the wires together. Slot the walnuts into the three groups of plants. Next add a few witch hazel twigs, allowing them to break out of the arrangement and cover some bare patches between the groups.

To finish, wire together several bunches of yarrow and slot them into the arrangement, using them to close up the gaps slightly between the three main groups. The yarrow adds necessary colour to the wreath and brings it to life.

This sophisticated garland makes a stunning decoration to hang on a wall or sit on a side table. Insert four pairs of large dried flowers (we have used Carlisle thistles) evenly spaced apart in a florists' dry foam ring. Arrange white sea lavender between the flowers, virtually covering the ring.

Next, insert some cream-coloured teasels, followed by gold sprayed seed pods, artificial leaves and large wired fir cones, evenly spread throughout the garland.

Any gaps can be filled with cream helichrysum (strawflowers or everlasting) and small seed pods and fir cones. To wire the flowers, place a stub wire against the stem and bind them together close to the top with reel wire. Break off the extending end of the stem.

This stunning wreath, with its wealth of contrasting colours and materials, makes a beautiful decoration to hang on the door during the festive season. Begin by making a base using a wire wreath frame and some dry moss, binding the moss firmly on to the frame with black reel wire. Cover the base with green wreath wrap.

Take some colourful fabric and cut it up into rectangles. Now wrap about 8 to 10 small foam spheres in the fabric, gathering the material at the top and securing with wire. Leave long wire 'tails' for attaching the balls to the frame. Position the spheres in groups of two or three at regular intervals around the wreath.

Wire clumps of green amaranthus (love-lies-bleeding) and insert them into the wreath, keeping them generally quite close to the fabric spheres.

Next, wire clumps of white larkspur and intersperse these amongst the amaranthus. These reflect the white in the fabric and add highlights to the arrangement. Wire together several groups of cones and place them standing upright in the arrangement so that they do not get lost among the other plants.

Soften the display by scattering bunches of soft pink rabbit's or hare's tail grass throughout. The seeds tend to moult very easily so be careful when wiring and inserting the grass not to overhandle it.

Pick out the colours in the fabric by dotting clumps of rust coloured nipplewort (or broom bloom) throughout. The dark tones will also add depth to the display.

Finish off with a few colourful satin bows, binding each bow together with wire rather than actually tying it. Insert the bows in amongst the fabric spheres, trailing the tails prettily over the arrangement.

This striking tartan wreath makes a charming centrepiece for the table at Christmas and New Year. First you will need to buy a twig ring from a florist. Begin by individually wiring several heads of red rose. Arrange these in three small groups, evenly spaced around the ring.

Next, wire together nine small bunches of anaphalis (pearl everlasting) and push them into the ring so that they surround the roses. Take three lengths of tartan ribbon and make three single bows, wiring them together rather than actually tying them.

Take a fourth piece of ribbon, fold it in half and push a piece of wire through the folded end: this will form the long 'tails' of the arrangement. Cut a 'V' shape in the ends of the ribbons to finish them neatly, then wire a bow into each of the three gaps between the flowers. To complete the picture, wire the tartan tails beneath one of the bows.

Add several sprigs of holly, again securing them with wire. If the holly is a bit short of berries, you can add some fake berries at this point.

To hang the wreath you will need two lengths of satin ribbon. Each piece should be twice the length of the drop from the ceiling to your hanging height, plus an extra 20cm (8in) for tying around the wreath. Tie each of the four ends opposite one another around the wreath so that the two lengths cross in the centre.

Make four bows from the same colour ribbon and pin them to the wreath over the four tying-on points.

Gently push a length of florist's wire through each of four red wax candles, approximately 1.5cm (½in) above the bases, as shown.

Tʜis festive wreath makes an ideal centrepiece if you're short of space on the table — it can be suspended from a hook screwed into the ceiling. Use wire cutters to snip the hook off a coat hanger. Bend the hanger into a circular shape. Bunch damp sphagnum moss around the wire, binding black reel wire or gardener's wire around it to hold it in place.

Take several bushy branches of evergreen, such as cypress, and arrange them to cover the circlet of moss, overlapping the pieces to cover any stalks. Tie the branches to the ring with wire.

Position each candle halfway between two bows, and twist the wire around the wreath to hold it in place. To hang the wreath, tie another length of ribbon around the two main ribbons where they cross, make a loop to go over the hook, and tie the ends in a bow.

A traditional wreath on the front door gives a warm welcome to Christmastime callers. To begin, take a wire coat hanger and pull it into a circle. Bend the hook down to form a loop.

Now wire together small bunches of holly, spruce and other foliage. Then attach each bunch to the circle. Be careful when handling the holly; you can get a bit scratched, and some people can come out in a rash from it. Keep going in one direction until the whole circle is covered.

On top of this add some wired pine cones and, for extra colour, some curly red ribbon. (Use curling gift wrap ribbon for this, running the blunt edge of a pair of scissors along it to make it curl.) Red holly berries look great if you can get hold of them, but they tend to drop very quickly, so they would need replacing often. Finish off with a big red satin bow.

This sort of arrangement always looks very hard to achieve, but in fact it is very simple, provided you assemble everything you need before starting. What you need is a ring of florists' foam with a plastic base, which you can get from a florist. Also buy three plastic candle holders; stick these into the foam.

You will need holly, ivy and fern, all of them either real or fake, plus a selection of dried flowers. Used here are daisy-like sunrays, yellow helichrysum (strawflowers or everlasting), yarrow, safflowers and sea lavender. Simply break pieces off these and stick them into the foam. Try to space the flowers evenly in between the foliage.

When you have finished, stick three candles into the holders already placed. If any of the foliage is real, make sure to keep the foam damp.

IVY CANDLE-RING

FOREST FOLIAGE

This elegant candle-ring is the ideal centrepiece for a festive dinner party but it will only remain fresh for the one occasion. A circular cake base serves as the foundation for the arrangement. Begin by attaching strands of ivy to the edge of the base, securing them with drawing pins.

Build up the ring by adding more strands and bunches of leaves until only a small space remains in the centre. Push stems of freesia among the ivy leaves to provide colour contrast.

Use a mixture of white and green candles of varying heights to form the centre of the arrangement. Secure each candle to the base with a blob of glue or Plasticine (modelling clay).

The sideboard, as well as the table, needs a little dressing up at Christmas. This is bright and cheery, and the materials are quite easy to get hold of. If you don't have woodland nearby your florist should have small sections of bark for sale. Also buy a plastic candle holder. Onto the bark first put a large lump of green Plasticine (modelling clay), and on the top stick your candle holder.

Now take some plastic or silk fern and spray it gold. Break off pieces when it is dry, and stick them into the Plasticine. Also wire up strands of red paper ribbon, pine cones and red baubles and stick these in.

When the Plasticine is artistically concealed, pop a red candle in the holder, and set the arrangement on the sideboard. Put a mat under it, though, or it will scratch the surface.

CHRISTMAS CANDLES

RUSTIC CENTREPIECE

Add style to the dinner table with this traditional red and green centrepiece. Take a flat circular base — a cork mat or cake base will do — and glue single ruscus leaves around the edge. Stick three blocks of florists' foam on top, keeping one taller than the others. Now insert the red candles into the foam, cutting them down as necessary to vary their heights.

Build up the arrangement using gold-sprayed poppy heads, white helichrysum (strawflower or everlasting) and more ruscus leaves. The white adds essential highlights to the arrangement. Finish off by scattering single red roses throughout the display.

This attractive 'woodland' design makes the perfect centrepiece for those wishing to create a more rustic effect this Christmas. Begin by making a base out of three large dried leaves, such as these cobra leaves. Glue the leaves together, then glue a block of florists' foam on top. Wire up several cones and walnuts, forcing the wire through the base of the nuts as far as it will go.

Wire together clumps of oak leaves and build up the outline of the display. Now insert the nuts and cones, placing the former in small groups. Keep the shape irregular to make it more interesting. Brighten the display by scattering small clumps of ammobium (sandflower) throughout. To finish, trim a candle to the required length and push it firmly into the foam.

H ere is an exotic arrangement to grace the supper table. Cut a slice of florists' foam and glue to the centre of a plastic plate, then trim away the upper edges diagonally. Dampen the foam. Push three candle holders into the top, forming a ring, and insert three white candles of varying heights. Arrange short lengths of trailing ivy to hide the holders.

Push large ivy leaves into the foam to cover the plate as shown above then arrange apples on cocktail sticks around the foam. Next, place small bunches of grapes between the apples, securing them to the foam with stub wires bent in half. Fill any gaps with chincherinchee flowers and individual grapes on cocktail sticks as shown below. Be sure to wash the fruit afterwards if you intend to eat it.

This festive table centrepiece is inexpensive to produce as the foliage used can be found in abundance during the Christmas period. Take a florists' foam ring and insert four candle holders evenly spaced around it.

Dampen the ring and insert four red candles in the holders. We have used hand-made candles for added interest. Now push sprigs of yew into the ring, positioning all the foliage in the same direction.

Next, take four large fir cones and bind wire around the base between the lower scales leaving a long length of wire to insert into the ring. Push the cone wires into the ring between the candles.

Finally, add sprigs of holly and berries to the ring. Berries can be added separately to add colour evenly throughout the decoration. Artificial berries can be used if real ones are not available.

To make this splendid Christmas centrepiece, take a flat circular base such as a cake board and glue a cone of florists' foam to the centre. Then glue or staple a length of gold netting round the edge of the base, gathering it into bunches as you go. Crumple lengths of red fabric or ribbon into double loops and wire the ends. Arrange them in a ring on top of the gold.

Spray a number of Chinese lanterns and lotus seedheads with gold paint. When they are dry, wire the ends and insert them evenly spaced into the cone. Intersperse several long-eared pods throughout, pushing · them deep into the arrangement. Add highlights with a few honesty seedheads (silver dollar plant). Then wire together bunches of small red helichrysum (strawflower or everlasting) and dot them among the other plants, adding colour throughout. Finish off by inserting a few groups of white leaf skeletons — about two to three leaves per group.

A pair of candlestick holders is transformed by a tightly-packed arrangement of dried flowers. For each stick, cut a sphere of florist's foam in half and hollow out the centre of each piece so that the foam sits snugly round the stem. Wrap a piece of florists' tape around the two halves to hold them together.

Push short stems of orange South African daisy (a form of helichrysum) into the foam, keeping the arrangement spherical. Then fill in with small wired clumps of red helichrysum (strawflower or everlasting) and pink miniature sunray, being sure not to leave any gaps.

Create some pretty coasters using a few flowers and some mother-of-pearl discs. The latter can be bought from any shop specializing in shells. They should measure at least 4cm (1½in) more than the diameter of your glass base. Choose any combination of flowers or seedheads — shown above are helichrysum, honesty and hydrangea. Cut the heads off the plants.

Now create a ring around the edge of a shell by gluing the heads in position. The honesty can be stuck down first — the heads slightly overlapping — and the red helichrysum can be glued down on top at regular intervals. If you are only using helichrysum, alternate the colours for a more interesting effect.

TOP HAT

PRIMARIES

An old topper, bursting with colour, makes a delightfully unconventional design for the festive season. Begin by putting a large brick of soaked florists' foam into a container which will fit comfortably into the hat. Fan out sprays of *Mallalika* foliage and fill in with September flowers (a form of aster).

Rich red holly berries add a brilliant splash of colour to this attractive festive arrangement. Choose a long shallow glass bowl and pack it with wire mesh. Crushed wire mesh is the best medium for this type of shallow bowl as it keeps the flowers from sagging.

Recess white spray chrysanthemums into the foliage and use longer stems to establish the height towards the back. Have a couple trailing over the brim of the hat alongside a few of the September flowers.

Fill mesh with variegated *Pittosporum*, a bushy foliage which maintains its fullness even when cut short. Stems of gypsophilia (also known as baby's breath in the United States) are added next, spread across the arrangement.

The focal point of the arrangement is poinsettia flowers which should be conditioned first by searing the stem ends with a lighted candle. fill in the outline and balance the display with deep red spray carnations.

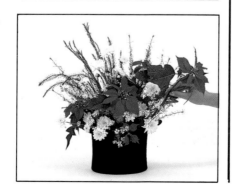

The three main stems of yellow lily, straddling the length of the vase, form the focal point. Intersperse the whole display with holly (known more specifically as English holly in the United States) berries, retaining the longer twigs for contrast and balance.

Keep the champagne in the refrigerator this Christmas and use the ice bucket for red roses instead! First, put soaked florists' foam at the base of the bucket. Then insert some variegated foliage — shown here is a spineless form of holly. Intersperse this with eight or nine red roses, still in bud. Have two or three longer stems rising from the foliage to one side at the back.

Fill in all the available space with jonquil, following the outline. The gold is highlighted by the yellow-edged foliage. (A handy tip: the roses will last longer if the stems are placed in boiling water for a minute before being given a long drink.)

Here, a wicker waste-paper basket forms the basis of an attractive festive arrangement of ferns and carnations. If you don't have a suitable red basket, you can spray a natural coloured one with red paint. Begin by taping soaked florists' foam into a container and positioning it inside the basket. Then fan out the fern fronds to form the setting for the flowers.

Take white spray carnations and intersperse them among the shorter fern fronds at the front, placing a few longer stems towards the back. Do the same with the bright red carnations.

Finish off by adding a sprinkling of September flowers (a form of aster) to soften the whole effect. (This display can also be acheived by pushing tiny phials of flowers into the soil of a real fern, such an arrangement being known as a pot-et-fleurs.

A silver bowl bursting with roses and freesias makes the perfect centrepiece for the festive season. Fill the bowl with water. Then cut short the stems of the cream spider chrysanthemums (to around 5cm, 2in) and pack into the bowl's wire mesh centre – these will give depth to the final arrangement.

Place yellow roses in between the chrysanthemums, keeping the stems slightly longer. Next, intersperse the arrangement with a few freesias.

Finally, place *Leucodendron* and freesia buds among the display, ensuring the stems are slightly longer than those of the other flowers; these will provide a stark contrast to the gold and silver. For a short period of time, such as during a dinner party, a full blown rose at the foot of the bowl will complete the picture, though, out of the water, the bloom's lifespan will be limited.

B ring your table to life with this attractive floral candle ring. Stick double-sided tape around the outside edge of a sponge ring mould. Adhere pleated green cellophane to this and secure with a little more sticky tape. This creates an attractive trim and is an alternative to foliage.

Insert chunks of soaked florists' foam into the ring, placing slightly thicker pieces at the back. Working around the ring insert short stems of daisy chrysanthemums to complete the circle.

Throughout the chrysanthemums dot blue-dyed yarrow and some little gold-sprayed cones on wires. Three white candles complete the garland. (The non-drip variety are best for a floral arrangement.)

T his sumptuous arrangement of plump flowers on a green glass cake stand looks almost edible! Place a round piece of soaked florists' foam in the centre of the stand. Then use yellow roses and alstroemeria alternately, cutting the stems on a slant and keeping them short so that once inserted into the foam the flower heads rest on the edge of the dish.

Finally, top the arrangement with a few sprays of mimosa which will retain its pretty fluffy heads longer if conditioned first. This is done by submerging flower heads under cold water then dipping stems into 2.5cm (1in) of boiling water for a few seconds. Stand in a jug of warm water until the flowers have dried off.

The next layer comprises the bobbly 'flowers' of *Leucodendron brunia* followed by a ring of Persian buttercups. The latter will last longer if their stems are put into boiling water for a few seconds, before being given a long drink.

A shallow ovenware dish forms the base for this arrangement of fiery chrysanthemums, carnations and capsicums (appropriately known as Christmas pepper in the United States). Place soaked florists' foam into the dish and cover with *Viburnum tinus* allowing the stems to escape over the sides of the dish.

To create the focal point of the arrangement, take six full blooming orange carnations and arrange them uniformly across the outline.

Fill in the outline with greenish white spray chrysanthemums. Their colour provides a dramatic contrast to the orange carnations, and their flame-shaped petals aptly fit the theme of the arrangement. Complete the display with capsicums, taking them through and along the length of the arrangement.

Add richness and colour to the home during the festive season with this vibrant design. First, roll some wire mesh into a tube, pack it with dry moss and close the ends. Squash the base into the basket and wire it in place as shown. Begin to form the outline of the arrangement with bleached white helichrysum (strawflower or everlasting), creating a dome shape.

Continue to build up the shape with white proteus. Add some clubrush next, followed by a number of cones, such as these meridianum. The colour of these two plants cleverly picks up the brown in the basket.

Wood always provides a perfect setting for dried flowers, and an old wooden plane makes an unusual festive design. Cut a block of florists' foam and wedge it tightly into the hole. Arrange wired clumps of cluster-flowered sunray first, keeping the outline low. Follow with pink *Leucodendron brunia,* allowing it to break out of the shape and dangle low over the sides.

Now add interest and a dash of colour with a few stems of bottlebrush. Put them in singly and keep them short so that their rich colour lies deep within the arrangement.

Complete the display with bright yellow clumps of cressia and cluster-flowered helichrysum. Place them low down in the arrangement, filling in the gaps between the other plants.

Soften the effect with a few clumps of grass interspersed throughout. To finish, add contrasting texture with three or four heads of *Leucodendron plumosum* set deep into the display.

To make a change from the more traditional holly, decorate your picture frames with this stunning tartan design. Cut a slice of florists' foam to fit one corner of the frame and tape it in place. Begin to loosely build up the shape using single stems of clubrush.

Add a splash of colour throughout the display with bright yellow cressia, allowing some to trail across the frame and picture. Then insert a number of single stems of bottlebrush to add interest and colour.

Fill out the display with plenty of bottlebrush foliage. Then add highlights with a few white leaf skeletons such as these peepal leaves.

Finally, make a double bow out of tartan ribbon, wiring it together rather than tying it. Attach this to the lower portion of the arrangement so that the long tails of the bow trail across the frame. Repeat the whole procedure on the opposite corner, being sure to keep the design well balanced.

The framework of this seasonal garland is made of cones and walnuts. Wire the cones by wrapping stub wire around the base. For the walnuts, push stub wire through one end as far as it will go. Take a group of cones and nuts and twist the wires together. Add to the base of the group and twist the wires again to secure. Continue in this way until the garland is long enough.

Wire together a double bow made from gold gift wrap ribbon and wire two extra tails on to it. (Just fold a length of ribbon in half for the tails and wire in the middle.) Attach the bow to one end of the garland, then wire a long length of ribbon to the same end. Wrap this through the garland, twisting it round the cones. Leave a long tail at the far end.

To finish, wire together small groups of bright Chinese lanterns and bunches of quaking grass. Intersperse them amongst the cones, entangling the wires to secure them.

These miniature arrangements make pretty novelties to hang on the Christmas tree. One of them is made with cinnamon sticks. Take about three sticks and bind them together with wire. Wire on a double bow made out of gold gift wrap ribbon and then add a posy of cones and small red helichrysum (strawflower or everlasting).

To make the other arrangement, first spray a small basket and some walnuts with gold paint. When these are dry, fill the basket with a block of florists' foam. Pack the foam with gold coloured South African daisies (a type of helichrysum) to form a spherical shape.

Push a length of wire through one end of each of the walnuts. Insert three or four nuts into the display, pushing them deep down amongst the flowers. Wire a small bow and attach it to the handle. Finally, hang each arrangement by means of a loop of gold cord.

Here are two more colourful decorations to hang on the Christmas tree. For the red ball, take a length of cord and wire the ends together, forming a loop. Push the wire right the way through a sphere of florists' foam and double it back on itself — into the foam — to secure. Now cover the foam with flowers.

Pack the flowers tightly into the foam to maintain the spherical shape. Those used here are deep red helichrysum (strawflower or everlasting). Fill in with little clumps of red nipplewort (or broom bloom). To finish, gather up and wire small pieces of silver netting, then insert them amongst the flowers.

This pretty display, arranged in a tiny gift box, makes an attractive miniature decoration. It would also make a delightful present. And with all that lavender, it smells as lovely as it looks. First cut a small block of florists' foam and pop it inside the box. Then wire a couple of red ribbons into bows.

For this design wire together a few flowers, such as these small white helichrysum and blue-dyed *Leucodendron brunia,* and attach three decorative bells. Gather up a piece of red netting and bind it on to the flowers. Make a double red bow, tie a long piece of ribbon round the middle (by which to hang the decoration) and attach the bow to the netting with wire.

Wire together bunches of lavender and pack them into the foam, keeping the arrangement tallest in the middle and splaying it out at the sides. Now scatter tiny, daisy-like glixia or grass daisies throughout; push some deep into the display. Finish off by attaching the two red bows, one to the box, the other higher up on a stem of lavender.

GIFT WRAPPING AND GREETINGS CARDS

A beautifully wrapped gift is a pleasure to give and a pleasure to receive. So here are over 40 imaginative ways to make your Christmas presents look that extra bit special. Having been shown how to wrap a variety of shapes, you will find some simple ways to make your own wrapping paper — a great cost saver — and lots of pretty decorations such as ribbon ties, rosettes and pom-poms to add those all-important finishing touches. There are also some ingenious ideas for greetings cards that are both simple to make and effective, and, finally, lots of inexpensive ways to make your own gift tags using last year's cards or motifs cut from wrapping paper.

Sometimes the gift wrap seems almost as expensive as the gift itself. But there are plenty of ways to get stylish results without the expense. Reels of gift ribbon can be turned into a vast array of different decorations, from stunning rosettes you couldn't tell apart from shop-bought versions to pretty pom-poms and posies. Braid, cord and even candies can also be used to make gifts that extra bit special.

When wrapping a cylinder, avoid using very thick or textured paper as it will be difficult to fold neatly. Cut the paper longer than the cylinder, allowing for extra paper at each end to cover half the cylinder's diameter, and just wider than the gift's circumference. Roll the paper around the parcel and secure with a little tape.

Begin folding the ends of the paper in a series of small triangles as shown here. Continue around the whole circumference, making sure that the 'triangles' are neatly folded into the centre.

Wrapping square or rectangular presents isn't difficult — but perhaps your technique needs brushing up. Wrap the gift wrap tightly around the box. You can simply stick down the free edge with tape or, for a smarter effect, fold over the top edge of the paper and stick double-sided tape underneath it, leaving a neat fold visible at the join.

Use a single piece of tape at the centre to fix all the folds in place. If the finished folds are not even, you could cheat a little by sticking a circle of matching gift wrap over each end of the cylinder.

If your paper has a linear design, try to align the design so that the join is not too obvious. Fold the joined section of paper down over the end of the box to make a flap; crease the fold neatly. Trim off any excess paper so there is no unnecessary bulk.

Crease the side flaps firmly, and fold them over the ends of the gift. Smoothing your hand along the side of the box and round on to the end ensures that each flap fits tightly. Fold up the remaining triangular flap, pulling it firmly along the edge of the box, and stick down; use invisible tape (its matt surface is scarcely discernible) or double-sided for the best results.

WRAPPING A SPHERE

AWKWARD ANGLES

The usual method of wrapping a sphere is to gather the paper around the gift and bunch it all together at the top. Here is a more stylish method. Put your circular gift in the centre of a square of paper, checking that the two sides of paper just meet at the top when wrapped around the gift. Cut off the corners of the square to form a circle of paper.

Bring one section of the paper to the top of the gift and begin to pleat it to fit the object as shown. The paper pleats at the top of the gift will end up at more or less the same point; hold them in place every three or four pleats with a tiny piece of sticky tape.

Continue pleating neatly and tightly all the way round the circle. It isn't as complicated or as time-consuming as it sounds once you've got the knack! When you have finished, the pile of pleats on top of the gift should look small and neat. Then you can either cover them with a small circle of paper stuck in place or, more attractively, add a bunch of colourful ribbons.

Wrapping awkwardly-shaped presents is just that — awkward. The gift wrap always looks creased and untidy around the angles of the gift. The solution is not to use paper — instead, use brightly-coloured cellophane which doesn't crumple. Cut a square of cellophane a great deal larger than your gift.

Gather the cellophane up and tie it into a bunch above the present. Fan out the excess and add some curled ribbon as a finishing touch. Alternatively, if your gift is cylindrical, roll it in cellophane somewhat longer than the parcel and gather the ends with ribbon.

Glittering wrapping paper is always glamorous, and with glitter available in such a variety of colours your creativity need know no bounds! Spread out a sheet of plain coloured paper and, using a bottle of glue with a fine nozzle, draw a series of simple patterns across it.

Sprinkle a line of glitter across the paper. Tip up the sheet and gently shake all the glitter from one side of the paper to the other, across the glued designs, making sure that all the patterns have been well covered. Tip the excess glitter off the page on to a sheet of newspaper; the glitter can then be used again.

Now use the glue to make more designs and coat these in glitter of a different colour. Localize the sprinkling of the glitter over the new patterns to be covered and leave to dry. Tip off the excess glitter and return it to its container.

Wallpaper is often useful as a gift covering — particularly if your present is very large. Here we have used thick wallpaper with an embossed pattern and given it a touch of style and individuality. Wrap your gift, and choose some wax crayons in contrasting shades. Rub a colour over the raised surface of the wallpaper to highlight one of the motifs in the design.

Choose another colour, and use it to pick out another section in the pattern. (Instead of wax crayons, you could use coloured pencils or chalk; the latter would need to be rubbed with a tissue afterwards to remove loose dust. The medium you choose must slide over the embossing without colouring in the whole design — paint is therefore not suitable.)

Repeat the process using a third colour and continue with as many shades as you like. A tip while wrapping your gift — you'll probably find that ordinary tape will not stick to the surface of wallpaper; double-sided tape used between two folds will be more effective.

All kinds of effects can be achieved with a sponge and some paint. You'll need a piece of natural sponge as man-made sponge doesn't produce the right effect. Choose some plain paper and mix up some poster paint to a fairly runny consistency. Test the paint on a spare piece of paper until you're happy with the colour.

Stencilling is great fun to do — and so easy. Design a simple motif then make a trace of it. With a soft pencil, scribble over the back of the trace and put the tracing paper face up on stencil cardboard. Draw round the design again, pressing hard so that the lines are transferred on to the cardboard beneath. Repeat the motif several times and cut out the shapes with a craft knife.

Dab the sponge into the paint and pat it evenly over the paper. The sponge should hold sufficient paint for about four 'dabs' before you need to dip it into the paint again. You'll need to mix up a lot of paint as the sponge absorbs a considerable amount.

Rinse the sponge out well and squeeze dry. When the paper has dried, repeat the process with another colour — you can use as many colours as you wish. Match the ribbon to one of the colours; see page 49 for instructions on how to create the ribbon trim shown here.

Position the cut-out stencil on plain paper, and either hold it or use masking tape to keep it in place. Mix up some poster paint, keeping the consistency quite thick. Apply the paint through the stencil, using a stiff brush. When you have finished a row of motifs, lift the stencil carefully and blot it on newspaper so that it is ready to use again. Leave the design to dry.

Keep repeating the process until you have covered enough paper to wrap your gift. To help you keep the spacing even between each run of motifs, add some 'markers' to the stencil. Cut half a motif at the end of the run and another one above the run to mark the position of the next row. Paint the markers along with the other motifs, then use this image for re-positioning the next row.

Employ a humble potato to create simple yet beautiful designs. Begin by cutting a large potato in half and draw a simple design on it. Use a sharp knife or craft knife to sculp the potato, leaving the design raised from the surface.

To ensure a regular print, draw a grid lightly in pencil on a sheet of plain paper. Then mix up fairly thick poster paint and apply it to the potato-cut with a paintbrush. Print the design in the middle of each square of the grid. You should be able to do two or three prints before the colour fades and needs replenishing.

Stylish, expensive-looking wrapping paper can be achieved very quickly with this method of spray stencilling. Choose some plain coloured paper for a base, and make your stencils from plain cardboard or paper. Cut the stencils into squares of two different sizes; alternatively you could use any kind of basic shape — stars, circles or whatever.

Cover the whole sheet with one design. Cut another design on another potato half; repeat the whole process, this time printing on the cross of the grid. When the paint is thoroughly dry, rub out the grid lines still visible and wrap up your present.

Lay some of the shapes in a random pattern across the plain paper, holding them in place with a spot of Plasticine or modelling clay. Cover the whole paper with paint spray. Use car paint or craft spray paint, but do carry it out in a well-ventilated room.

Once the paint is dry take off the sprayed squares and put a new random pattern of fresh squares across the paper. Overlap some of the original squares with the new ones to create interesting effects, then spray the entire sheet with a second colour of paint. Remove the squares and leave the wrapping paper to dry before using it.

The delicate silhouette of a doily against a contrasting background colour looks attractive on a gift. Wrap your present up in plain paper and glue the doilies wherever you like. To decorate the corners of a large gift, fold a doily in half, then in half again.

Unfold the doily carefully and spread it out. Cut off one of the quarters of the doily; the folds along which you should cut will be clearly visible.

Paste the doily over one corner of the gift as shown. Repeat with alternate corners, unless your gift has enough space to take a doily over each corner without overlap. The doilies don't have to be white: silver or gold is also effective. Nor do they have to be circular — square ones would be smart on a square-sided present.

Brightly-coloured adhesive tape can give any plain wrapping paper a touch of style. A geometric design is easiest to create with tape, and the most effective; curves are rather difficult! Work out your design first and measure it out accurately on the parcel in pencil.

Stick the tapes in place along the pencil marks. Take care that the tapes don't stretch at all during application or they will cause the paper to pucker slightly. Sticky tapes are available in an enormous variety of colours, textures and patterns; choose a strong contrast with your paper.

Y̲ou couldn't distinguish this pointed pom-pom from a shop-bought version — yet it's a fraction of the price! Use ribbon which sticks to itself when moistened. Make a small loop by wrapping the ribbon round your thumb; moisten the ribbon and fix it in place. Now twist the ribbon back on itself to form a pointed loop, as shown; stick it in position.

Go on looping the ribbon in twists, spacing them evenly as you go. It is fairly fiddly but keep trying — you'll soon master the technique. You'll probably need to wait a minute between each fixing for the ribbon's glue to dry before turning the next loop.

I̲t's hard to believe that these pretty flowers and the butterfly are made from tights (pantyhose) and fuse wire. Cut up a pair of discarded tights or stockings. Cut some 15 amp fuse wire into lengths, some shorter than others, suitable for making petals. Make a circular shape out of each length and twist the ends together.

Continue winding outwards in a circle until the bow is as big as you want; cut off the ribbon, leaving a small tail just visible. Attach the pom-pom to the present with double-sided tape.

Put a piece of stocking material over a wire circle and pull it tight, making sure that the whole circle is covered. Fix it in position by firmly winding matching cotton around the twisted stem of the wire. Cut off the excess fabric.

Take seven petals, smaller ones in the centre, and bind them all tightly with thread. Bend the petals around until you're happy with the look of the flower. Tie up your parcel with ribbon and attach the flower with double-sided tape. The butterfly is made in just the same way: two pairs of 'petals' are bound together with thread, then bent into the shape of wings.

CHRISTMAS LEAVES

DING DONG MERRILY

Holly leaves are an attractive shape and perfect for decorating a festive gift. Measure the length of the diagonal across the top of your parcel. On a sheet of plain paper, draw a large holly leaf, the 'vein' of which measures slightly more than half the length of the diagonal.

Trace four holly leaves on to some green cardboard, using the template you have just created. Cut the leaves out and bend them in the middle; creasing them slightly where the central vein would be.

Make the berries from a ball of cotton wool (known as absorbent cotton in the United States) wrapped in two squares of red tissue paper. Put a dab of glue inside and twist up the tissue tightly at the base. When the glue is dry, cut off as much excess of the twist as possible. Group the leaves and berries on the parcel; attach with glue or double-sided tape.

These Christmas bells ring out gaily from your present. Make two paper templates, both bell-shaped, with one showing the outline of the clapper from the bottom edge. From thin cardboard, cut out two of each shape.

Cover all the cardboard shapes with gold paper (or any colour which would co-ordinate with your wrapping paper). Cover both sides, and trim away all the excess paper. On the bell shapes with the clapper, cut a slit from the curved top of the bell to the centre of the bell. On the others (the plain ones) cut a slit from the middle of the bottom edge, also to the centre.

Pierce a hole in the top of the plain bell shapes and thread them with a length of ribbon. Then slot the pairs of bell shapes together (i.e. the plain one, and the one with the clapper) so that they form three-dimensional shapes, as shown here. Tie a group of as many bells as you like on to your gift.

The scrolled shapes of this decoration are reminiscent of the curlicues embellishing Queen Elizabeth I's signature. Wrap up your present, and choose some gift wrapping ribbon to match or contrast with the colours of the gift wrap. Hold the end of the ribbon in one hand, and form a loop as shown, leaving a small tail.

Make a corresponding loop below, forming a figure-of-eight shape. This will be the size of the finished product; adjust the proportion of the loops at this stage if you want a bigger or smaller bow. Continue folding loops of the same size until you have as many as you want — seven at each end is usually enough.

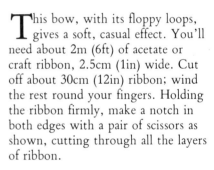

Check that all the loops are the same size, and pinch them all together by wrapping a piece of sticky tape around the middle. You can then hide this by wrapping a small piece of matching ribbon over it. Attach it to the present with double-sided tape.

This bow, with its floppy loops, gives a soft, casual effect. You'll need about 2m (6ft) of acetate or craft ribbon, 2.5cm (1in) wide. Cut off about 30cm (12in) ribbon; wind the rest round your fingers. Holding the ribbon firmly, make a notch in both edges with a pair of scissors as shown, cutting through all the layers of ribbon.

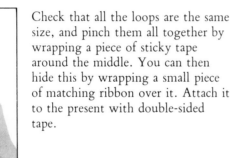

Take the ribbon off your hand and notch the edges of the opposite side of the loops. Flatten the loops so that the notches match in the centre and loops are formed either side. Take the 30cm (12in) length of ribbon and tie it tightly around the notches as shown.

Starting with the innermost loop on one side of the folded bow, gently pull each loop away from the other loops and into the centre of the bow. You'll end up with each loop being visible, thus forming the shape of the finished rosette.

RIBBON RINGLETS

RIBBON POM-POMS

A pom-pom bow adds a cheerful touch to a present of any shape or size. Use the kind of ribbon which will stick to itself when moistened. Cut seven strips; four measuring about 30cm (12in), the other three about 23cm (9in). You'll also need a small piece of ribbon about 5cm (2in), for the central loop.

Overlap the ends of each of the long strips and moisten them; stick them together to form a loop. Moisten the centre of each loop and stick it together as shown. Cross two of the looped strips, joining them at the central point. Repeat with the other two loops. Join both crosses together so the loops are evenly spaced apart.

H ere is an easy way to achieve a very pretty effect. Choose three colours of narrow ribbon which co-ordinate with your gift wrap. Using one ribbon, tie it around your parcel in the usual way, crossing it underneath the parcel and knotting it tightly on top; leave long ends. Tie a length of different coloured ribbon to the centre point, then do the same with a third colour.

Loop the three shorter lengths, and cross them over each other, fixing them together at the centre. Stick the resulting star in the middle of the large rosette. Fill in the centre with the tiny loop. Obviously, the length and width of ribbon can be varied, according to the size you want the finished pom-pom to be.

Continue tying on lengths of ribbon so that you end up with two lengths, (that is, four ends) of each colour. Tie the central knots tightly to keep them as small as possible. Pull a ribbon length gently along the open blade of a pair of scissors; this will cause it to curl into ringlets. Repeat with each length until they are as curly as you want.

An alternative is to use wide gift ribbon. Tie it round the parcel once, making sure that the knot is as neat as possible and leaving long ends. Cut two small nicks in the ribbon, dividing it evenly into three; pull it to split the ribbon up to the knot. Run each of these lengths along the blade of a pair of scissors until they form ringlets.

A sweet treat for children of all ages! Boiled sweets (hard candies) with plain cellophane wrappers look best because of their clear colours, but you can use alternatives such as toffees or peppermints. Select five or six of the chosen sweets, and hold them in a bunch by one end of their wrappers.

Take a narrow piece of ribbon and tie all the sweets together tightly; if the wrappers are a little short it may help to bind them first with sewing thread. Leave a reasonably long piece of ribbon on each side of the bunch of sweets so that you can attach it easily to the parcel.

Tie the same ribbon around the parcel, leaving the ends long, then tie the sweets to the centre point as shown. Curl up each ribbon end by pulling it gently along the open blade of a pair of scissors. Try to co-ordinate your gift wrap with the chosen confectionery — black and white paper with humbugs, for example, would look very attractive.

Brightly-coloured drinking straws lend themselves to decorating presents. Look for colours to co-ordinate with your gift wrap. The straws can be made of paper or plastic; both work well. Select the colours you want and cut four straws in half; discard one of each half. Cut another four straws in two, leaving one section slightly longer than the other; retain both pieces.

Place four halves, one of each colour, together over a central point in a star shape and staple them together. Do the same with the other slightly longer straws and their shorter counterparts so that you end up with three stars of slightly different sizes. With the smallest on top and largest on the bottom, staple all three together. Attach the triple star to the parcel with double-sided tape.

Craft foil is the perfect material for creating this decoration. Use a compass to draw four circles; the ones shown here measure 8cm (3in), 6.5cm (2½in) 5cm (2in) and 4cm (1½in) in diameter. Draw an inner ring of 2cm (¾in) in the centre of each circle. Rule lines to divide the circles evenly into eighths; cut along the lines to the inner circle to make eight segments.

Roll each segment of the circle into a cone; use a dab of glue to secure it. Make sure that each cone shape has a good sharp point by rolling it fairly tightly. The process is a bit fiddly; you may find it easier to roll each cone around the point of a stencil to give it shape. Repeat with the other circles.

Starting with the largest star shape, glue all the stars inside each other, positioning the points of each star between those of the preceding ones. When the glue is dry, gently bend each cone of the middle two stars towards the centre, to fill in the central space, so forming a semi-circular three-dimensional star.

A pretty arrangement of dried flowers make a lovely decoration for a gift. You can pick grasses and seedheads in the country or you can dry flowers from your own garden; it's fun and quite easy. Or you can buy them, though of course it's more expensive that way! First cut the dried plants all the same length.

Bunch the flowers together; when you're happy with them, wrap sticky tape around the stalks. Hide the tape by winding ribbon over it. Tie ribbon round the parcel, finish off with a knot, and attach the little bouquet by tying its trailing ribbons over the knot; trim the ends of the bouquet ribbon away. Using the ends of the other ribbon, finish off by making a pretty bow over the bouquet.

A small posy of pretty rosebuds makes a very special decoration for an extra-special gift. Cut a small length of ribbon — about 6-9cm (2-3½in), depending on the width of ribbon you've chosen. Fold the ribbon in half, right sides together, and join the two ends with a small seam. Run a gathering thread around one edge.

Pull the gathering thread tight to form the rosebud; sew it firmly across the base. Make another two or three buds and sew them all together at the base; you may need to add the occasional supporting stitch at the top edges to hold the buds close together.

The leaves add an attractive contrast. They are made from a strip of green ribbon, two corners of which have been folded over to form a point. Fix with double-sided tape since glue can leave a mark on ribbon. The illustration below shows the rosebuds grouped on a length of ribbon twice the width of the flowers, set off with narrow green ribbon.

A winning idea for any gift! Cut a length of fairly wide ribbon; you'll need about 30cm (12in) for each rosette. Fold it in half with the right sides of the ribbon together; sew up the two ends to form a seam.

Using tiny stitches, gather up one edge of the ribbon. Pull the gathering thread tight, arranging the rosette into a neat circle as you do so. Finish it off by sewing across the base. Make as many rosettes as you need and attach them to your parcel with double-sided tape.

A fan adds panache to a plain giftbox. Cut one long edge from a large rectangular paper doily, making it about 7cm (2 ¾in) deep. Cut cartridge paper a little deeper and wider than this and cover with foil gift wrap using spray adhesive. Glue the doily strip to one side. Cut the top edge following the curves of the doily, then pleat up concertina style.

Paint-sprayed plastic holly adds a flourish to a plain box. Spray two sprigs of holly with silver then, when dry, spray lightly with bronze to highlight the leaves and berries. Wire the holly together, then wire on three small glass balls, chosen to colour match the gift wrap. Wrap a piece of double-sided tape around the stems and wrap with silver crepe paper, gluing the end down.

Open out the concertina into a fan shape and run a length of double-sided tape along the base to hold it in place. Do not remove the backing paper. From narrow curling ribbon cut five 15cm (6in) lengths, and from foil, five 6cm (2½in) squares. Stick a square to the end of each ribbon with double-sided tape and curl the foil around it. Secure the end with more tape.

To make the bow, cut a strip of silver crepe paper along the length of the roll, 74cm (29in) long and 12.5 (5in) wide. Fold in the two long edges to overlap and crimp the folded edges between your fingers, gently stretching the paper. Pinch into a bow shape and wrap a short length of crepe paper, raw edges tucked in, around the centre. Secure with double-sided tape.

Remove the backing paper from the base of the fan and stick the ribbon ends to the centre. Make a gift tag from a rectangle of paper and cover with foil using spray adhesive. Punch a hole in it, attach a length of gold thread and join to the fan. Curl the ends of three lengths of ribbon and stick them to the front of the fan with PVA glue or tape. Stick the fan diagonally across the giftbox.

Cut a 6.5cm (2½in) wide strip of crepe paper along the length of the roll as before, cutting enough to wrap around the giftbox in both directions. Crimp the edges and attach to the box with double-sided tape, placing the joins under the box. Press a double-sided adhesive pad to the centre cross of the ties and press the holly bouquet in place. Finally, stick the bow in place over the holly.

GIFT BOX ROSETTE

TISSUE TWISTS

You will need the type of gift wrap ribbon which sticks to itself when moistened for this decoration. First cut two strips of ribbon at least 40cm (16in) long. Twist each piece into a figure-of-eight, moistening the ends to hold in place. Stick one piece at right angles over the other. Repeat with two more strips 5cm (2in) shorter.

Stick the second rosette on top of the first. To finish, make a loop out of a short strip of ribbon and stick it in the centre. For a more traditional rosette, simply make the loops shorter and tighter.

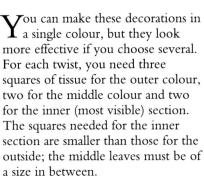

You can make these decorations in a single colour, but they look more effective if you choose several. For each twist, you need three squares of tissue for the outer colour, two for the middle colour and two for the inner (most visible) section. The squares needed for the inner section are smaller than those for the outside; the middle leaves must be of a size in between.

Pick up the squares in order, putting one on top of the other; outer colour first, then the middle, then the inner squares. Position them so that the corners of each square are at a different angle, as shown. Put a couple of stitches through the centre point to secure all the squares together and leave some thread hanging.

Fold the whole thing in half and half again, twisting the folded point at the base to form the shape of the 'flower'. Pull the thread out at the point, and wind it tightly around the twisted base to secure it; 'fluff' out the finished decoration. Make several 'flowers' and group them together on your present.

A delicate posy of dried flowers provides a perfect decoration for any gift. Choose a selection of brightly coloured, small-headed flowers and tie them together with fine wire. The flowers used here are blue larkspur, yellow South African daisy, (a type of helichrysum), small red roses and a touch of golden rod. Wrap a strip of white ribbon around the stems and finish off with a bow.

The posy on this gift box is made up in a similar way, using flowers in a range of colours that match those of the box. The posy contains green amaranthus (love-lies-bleeding), mauve xeranthemums, pink gypsophila (baby's breath), blue larkspur, cream 'cauliflower' and yellow dudinea.

Attach the posies to the gifts with glue. Alternatively you can wire them on. To do this you will need to pierce two small holes in the side of the box. Wrap wire round the stems of the posy and thread it through the holes; secure on the inside.

This is a simple but elegant way to use empty gift boxes as containers for pot-pourri. We have selected a green and a black box. Take the lid off one of the boxes and lightly secure three whole flower heads of cow parsley diagonally across it. With aerosol spray paint, give the top of the box two light coats of gold paint.

When the paint is dry, remove the parsley to reveal the unsprayed part of the box. This shows up as a pretty pattern through the paint. Now fix the gold sprayed cow parsley to the other box lid. These boxes are filled with 'Noel' pot-pourri, which is a festive mixture of small cones, tree bark and citrus peel. Cover the pot-pourri with cling film (plastic wrap) before replacing the lids.

How to give a tall thin present even more presence! Take a spool of gift ribbon — the sort that sticks to itself when moistened. Roll a length round your thumb to form a small circle; moisten and stick in position.

Make another ring, larger than the first; stick that down too. Make another circle, and another, ensuring that their increase in size is in the same proportion each time. Four circles is about the maximum the ribbon can take before flopping slightly and thus losing the crispness of the decoration.

It is quite easy to paint wide ribbon to co-ordinate with your wrapping paper. And the results are stunning! Choose a gift wrap with a simple design. Decide whether you want the ribbon to be a positive version of the paper's design, like the blue example shown here, or a negative one, like the black and white suggestions. Experiment with poster paint on your chosen ribbon.

Keep the design very simple and stylized. When you're happy with your pattern, paint enough ribbon to wrap up the gift, allowing sufficient for a fairly large bow. Leave the ribbon to dry thoroughly before tying it around the parcel. If the paint does crack a little when tying up the ribbon, simply touch it up and leave it to dry again.

SEQUIN SHEEN

The metallic sheen of sequins, and the strip of metallic plastic from which they are pressed, looks rather chic. Sequin waste — that is, the strip of metallic plastic — can be bought by the metre or yard from good craft shops. This idea looks best on rectangular flat parcels. Wrap a piece of sequin waste around the length of the present; fix it with tape.

Take another strip of sequin waste and join the two ends to make a large loop. Use sticky tape to fix them, making sure the holes overlap so that the join is almost invisible.

Put a strip of threaded sequin trim of the same colour across the middle of the loop. Remove a few loose sequins so that you can tie the trim in position. Repeat with another length of trim; space the two evenly apart in the centre of the loop to form a bow. Attach the bow to the parcel with double-sided tape. Sequin trim as a gift tie in its own right gives a glamorous finish to any gift.

LOOPING THE LOOP

This decoration looks best on a rectangular gift. Take 66cm (26in) of woven ribbon; lay it flat. Measure 13cm (5in) from one end of the ribbon and mark both edges. Then mark along the ribbon's length a further 10cm (4in), 7.5cm (3in), 5cm (2in), 7.5cm (3in), 10cm (4in). Using one piece of thread, pick up tiny stitches at each mark along one edge.

Run a similar gathering thread up the other edge of ribbon, making sure that the stitches are exactly level on both sides. Gather up the loops as shown; it's easiest to knot the two threads together at one end of the gathers and ease the loops along.

Pull the thread tight to make properly-formed loops; sew the joins in place and cut off the excess thread. Tie the ribbon around the gift and use double-sided tape to attach the loops in the centre of the long side of the gift. Snip a diagonal cut at the ends of the ribbon tails.

Disguise the unmistakable shape of a record by making it look like a cushion. First create paper tassels. Cut a piece of coloured paper into narrow strips leaving about 2.5cm (1in) at the bottom uncut so that you create a fringe. Roll up the fringe, catching in a short length of narrow ribbon. Secure the tassel with coloured tape.

Take some wrapping paper that is more than twice the size of the gift, fold it in half around the record and cut it so that it is just a little larger. Join two of the sides together with coloured tape along their full length, attaching the ends of the tassels at the corners as you do so. Put a strip of tape over the folded edge of the 'bag'.

Stuff the inside of the 'bag' on both sides of the record with shredded tissue, being careful to put some in the corners. Don't use too much or the wrapping paper will wrinkle. Seal along the remaining open edge with tape.

For an extra special gift at Christmas, wrap your present to look like a prayer book. Wrap the gift in gold paper so that it will look like the closed pages of the book. The last flap should not be folded in the usual way, but should be cut precisely to fit the side of the gift as shown; glue it in place.

Take two pieces of thick cardboard slightly larger than the size of the gift. You will also need a long strip of thin cardboard measuring the width and length of the gift. Use tape to stick the thick cardboard on to either side of the thin cardboard to make a book cover for the gift. Cover the outside with plain paper as shown; glue all the edges down firmly.

Spread glue over the inside of the book cover, and place the gift firmly on one side of it. Wrap the cover over the other side of the gift, making sure it's stuck properly. Cut out gold crosses (or other appropriate symbols relevant for your recipient's religion) and stick them in place.

These sachets are ideal for ties, soaps, scarves, jewellery, hankies, socks and so forth. On to thin cardboard, trace the template on page 166. It's probably more interesting to cover the shape with gift wrap as shown here, but you can use plain cardboard if you wish. If using gift wrap, cut out the shape and paste it on to your chosen wrapping paper.

Cut out the covered shape. Then score well along the curved lines of the ellipses which will form the overlapping ends of the packet. Use the back of a craft knife or the blunt side of a pair of scissors to make the score marks.

Stick the side flaps together with either double-sided tape or glue. Fold in the ends; if you've scored the lines sufficiently they should pop in easily with just a little guidance. They can be re-opened with no difficulty, but make sure the covering gift wrap doesn't begin to lift off the cardboard.

A handy gift container, ideal for home-made sweets, can be made from a well-washed juice carton. Draw V-shapes in each side of the carton. These should be inverted on two opposite sides, and pointing towards the top of the carton on the other two sides. Cut cleanly along the drawn lines with a craft knife as shown.

Cover the carton with gift wrap; adhesive in spray form achieves the best results. Make sure the join lies neatly down one corner of the box. Trim the overlap at the top of the carton so that it is even and fold the paper over the edges, taking care that the corners are neat. Punch a hole at the apex of both the pointed sides and thread ribbon through.

This method is best suited to a small box as the end result is not particularly strong. From thin cardboard, cut out a cross-shaped piece as shown, made up of four sides and a base, all the same size and all absolutely square. The lid will also be a square measuring 5mm (¼in) larger than the base, with sides about 2cm (¾in) deep.

This small narrow box would be ideal for giving someone a watch or a piece of jewellery this Christmas. Trace off the template on page 95 on to thin cardboard. Cut it out, and either cover it in gift wrap or, if you like the colour of the cardboard, just leave it plain.

Cut around the template with small sharp scissors to trim away the excess gift wrap; take extra care with the slots and handles. Then score along all the fold lines, using the back of the craft knife or the blunt edge of the scissors.

Paste both shapes on to gift wrap and when dry cut off the gift wrap around the box and lid, leaving a small turning or flap around each edge. Fold in the flap on the left of each side of the box and glue it down as shown. Score along the edges of what will be the base, to form fold lines for the sides of the box.

Bend the sides upwards. Put glue on the patterned side of the flaps of gift wrap left unfolded on each side; stick these flaps inside the box to the adjacent sides as illustrated. Crease down the sides firmly and leave to dry. Finally, fold in and glue the top lip. Treat the lid in exactly the same way.

Crease all the folds properly. Fold the box into shape and stick the side flap to the inside of the opposite side. Close the top section, being sure to fold the lid sections upright as shown, halfway across at the point where the two handles meet. Fold over the end flaps and slot them in position to close the box. Finally close the base.

Aplant is a notoriously difficult item to wrap; here's a smart solution. Measure an equilateral triangle on some coloured cardboard. The length of each side should be twice the height of the plant; use a protractor to ensure all the angles measure 60°

Divide each of the three sides of the triangle in half. Join all the half marks together to form an inner equilateral triangle; this will form the base. Bend the card along a ruler at each inner line as shown and bring up the sides to form a three-dimensional triangle. Punch a hole in each apex and thread ribbon through to close the parcel; double length ribbon gives a pretty finishing touch.

These rigid little boxes are ideal for presenting jewellery but you can make them to fit anything you like. Choose thin cardboard, either in the colour you want the finished box to be, or white so that you can cover it later with gift wrap. Measure out the template on page 166. The size of the triangular sides doesn't matter, as long as they are all the same, and the base is square.

Cut out along the exterior lines with a craft knife. If you're covering the cardboard shape with gift wrap, do it at this stage, cutting the paper to fit. Score along all the fold lines carefully, using the back of the craft knife, then bend the box along the score marks, creasing firmly.

Punch holes in each apex and fold the box into its pyramidal shape. Thread the ribbon in and out of the four holes and, making sure all the side-folds are tucked inside the box, tie the loose ends together with a bow.

Smart handles give this box style; they are also the mechanism for closing it. Use coloured cardboard for the box; if you try to cover the box pattern with gift wrap it will lift off. Copy the template on page 166, scaling it up or down if you wish. Use a compass to draw the handles. Cut out the shape with a craft knife, taking great care with the handles and their slots.

Score along all the fold lines using the back of a craft knife; crease them well. Fold the carton into shape, and stick down the side flap with double-sided tape or glue. Fold the base down, pushing the flap inside the box to secure it.

Close the first two flaps of the lid, folding the handles up to fit. Pinch the handles together and fold the two top flaps of the lid over them, fitting the handles through the slots.

Gift bags are very useful as containers for awkwardly-shaped presents and they can be made to any size. Find something with the required dimensions of the finished bag to serve as a mould — a pile of books should suffice. Choose a good quality, strong gift wrap for making the bag. Cut a strip of gift wrap long enough to wrap round the 'mould' and fold over the top edge.

Wrap the paper round the mould; glue or use double-sided tape to join the seam at the back. Fold over the end flaps in the usual way of wrapping any parcel to make the base of the bag; be sure to attach sufficient tape to make the base strong.

Slip the mould out. Fold in the sides of the bag, creasing them in half at the top; fold the base up over the back of the bag. Punch two holes, spaced apart, at the top of the front and back of the bag as shown. Thread through a length of cord to form a handle; knot each end inside the bag. Repeat on the other side. Alternatively, you could thread the bag with ribbon.

Making a box from scratch can be a little complicated, so why not start with an empty cereal packet? Take your cereal packet and carefully open it out flat. Separating the joins needs care - if necessary slide a knife between the seams to part the glue, rather than tear the packet.

Draw the box you want, using the template on page 165 as a reference. Make sure the lid measures the same as the width of the side panels. Cut out the new shape with a pair of scissors, and cover it with your chosen gift wrap. Spray adhesive is best, since this gives a very smooth finish, however glue in a stick form will do. When the glue has dried, cut neatly around the cardboard shape.

Score along the new fold lines of the box using the back of a craft knife or the blunt edge of a pair of scissors. Fold the box into shape. Stick the side flap in place as shown; you can use double-sided tape or glue. Fix the two flaps on the bottom (either glue them or tape them). Put in some shredded tissue as padding, slot in your gift and tuck the lid neatly in place.

This cube-shaped box is ideal for containing any kind of gift and it can be made to any size. Measure out the shape of the box on to thin cardboard, following the template on page 165. It's very important that all the squares are exactly the same size and that all the angles are right angles. Cut out the shape, and score along the fold lines—the back of a craft knife is useful for doing this.

Bend the card carefully along the score lines, making a neat crease along each fold. Crease the flaps on the lid and base and fold the four sides into the shape of the box.

Stick the side flap to its opposite side as shown. You can glue this, or alternatively, use double-sided tape. Fold in the base flap - it should fit precisely and thus give the box rigidity. Finally, close the lid flap.

A cylindrical box looks much more difficult to make than it is. Wrap a piece of thin cardboard around the gift to determine the measurement of the box. Cut out the cardboard, roll it up and stick down the edge with a length of tape. Draw and cut out a circular base, and a slightly larger circle for the lid. Attach the base with small bits of tape.

When re-covered in plastic, a shoe box makes a great container for a present. Put the box in the centre of a piece of self-adhesive plastic and draw around it. Then draw around the shape of the sides and ends of the box so you end up with a diagram of the 'exploded' box. Allow extra plastic all round for overlaps. Cut out the pattern you have just created.

Cut a strip of cardboard slightly longer than the circumference of the cylinder. To make the lid, stick the edge of the strip to the edge of the circle with tape. Next, spread glue on some gift wrap and roll the cylinder in it. Cut the paper to fit, allowing an overlap each end. Tuck the overlap into the open end; secure. Fold the base overlap in a series of small triangles and stick to the base.

Peel the backing off the plastic and position the box carefully in the middle of the covering. Smooth the rest of the plastic up over the box, starting with the ends. Wrap the small overlap around the corners as shown.

Draw a circle of gift wrap slightly smaller than the base. Cut it out and glue in position, hiding all the folds and bits of tape. Cover the lid in the same way. If you like, you can punch two holes in each side of the container and thread through short lengths of decorative braid.

Smooth the plastic up over the sides, trimming off the edges to make the pieces the exact size of the sides. Fold over the overlaps around the rim. Cover the lid in the same way. For complete co-ordination, you could cover the inside of the box to match. Alternatively, you could line the box with co-ordinating tissue paper or net.

Cube-shaped presents will look more interesting disguised as dice — and it's fun if a small, flat gift becomes a domino. For the dice, make sure the gift is a perfect cube by measuring it; the idea won't work well unless it is. Cover the gift with black paper. Then draw several circles on white paper; an easy way of doing this is by tracing the outline of a suitably sized coin.

Cut out the circles carefully and lay them on the box; glue them in place. Look at a real dice to get the juxtaposition of the sides correct. The domino can be treated in the same way.

Brighten up a dull-looking, flat gift by turning it into a playing card. Wrap the present in plain white paper. Make a template for the spade by folding a piece of paper in half and drawing half the outline against the fold; this way the design will be symmetrical. Trace around the template on to black paper and cut the shape out. Stick the spade in the centre of the 'card'.

Cut two small spades for the corner designs. Then, using a ruler, draw an 'A' in two of the corners, being careful to make them both the same. Glue the small spades underneath. Cut a piece of patterned paper — smaller than the card — and stick it on the back.

Here's a clever idea for disguising a record. Get two large squares of cardboard; the side of a box will do. Position the record in one corner as shown and draw a line from the bottom right corner of the record to the top right corner of the cardboard. Draw a second rule from the top left corner of the record to complete the kite shape. Repeat for the other square.

Cut out the shapes and sandwich the record between them. Cover one side in coloured paper, folding over the edges and fixing them with sticky tape on the reverse. Cut another piece of paper slightly smaller than the cardboard shape; glue it in position on the back of the kite.

Draw two lines joining the four corners of the kite, and put contrasting tape along them; take care not to stretch the tape as it will pucker the paper. Cut out as many paper bow shapes as you want for the kite's tail. Attach the bows with double-sided tape or glue to a length of ribbon and stick the tail in position behind the longest point of the kite.

Just the disguise for a cylinder-shaped gift this Xmas — the famous British red pillar-box (mailbox). Cut a strip of thin red cardboard to fit around your gift; secure it around the gift with sticky tape. Draw a circle for the lid, larger than the diameter of the cylinder; cut a line to its centre as shown.

Overlap the cut edges slightly to form a shallow cone, then fix with sticky tape on the wrong side. Wrap one end of the post-box with black paper, folding it over to prevent the present from falling out. Put double-sided tape around the inside of the lid and stick in position. Add a narrow black rectangle for the posting slit and a white rectangle for the notice of collection times.

Disguise a bottle as a pencil and keep the recipient guessing! Make a cylinder, about 5cm (2in) shorter than the bottle, from light cardboard, join the sides with tape. Draw a third section of a circle— about 7.5cm (3in) radius—on pale cardboard and cut it out. Roll it in to a cone shape, running the flat edge of a pair of scissors along it to help it curl. Tape in place.

Make a small cone for the lead of the pencil and glue it on to the larger cone. Attach several lengths of sticky tape to the inside edge of the cone and, putting your arm inside the cylinder, stick the tape down to hold the cone in position. Fit the pencil over the bottle and secure with two strips of tape across the bottom.

Bottles of seasonal spirits make an ideal present — but hide such an obvious-looking gift under the decorative guise of a Christmas tree. Find a flower-pot just big enough to take the base of the bottle. From thin cardboard cut out a third section of a large circle and make a deep cone about 8cm (3in) shorter than the bottle. Cover the cone with suitable wrapping paper.

Put the bottle in the flower-pot and place the cone on top. You may need to trim the cone if it seems to cover too much of the flower-pot; do this with care, since you could easily make the cone too short! Double over a piece of tinsel, tie it in a knot and stick it on top of the 'tree'.

Make a small present look that extra bit special — and that extra bit bigger! Wrap the gift into a ball shape, then cut a strip of paper about three times the width of the gift and long enough to form loops on each side of it. Fold the edges over. Gather small pleats at each end, securing them with sticky tape. Pinch-pleat four gathers in the middle of the strip and secure.

For the trailing sections of the bow, cut a five-sided piece of paper as shown. Fold over the edges in to the centre at the back and secure with tape. Gather pinch pleats at one end and secure. At the other end cut out a V-shaped section to form a nicely-shaped tail. Repeat the procedure a second time.

Turn the pleated ends of the long strip to the middle to form the loops, and secure with double-sided tape. Stick the tails under the bow with more tape. Finally, put double-sided tape over the join on top of the bow and stick the gift in position. Puff out the loops so they look nice and full.

What fun for a child to see Frosty and know that the snowman's hiding a gift! Wrap up a cylindrical gift in paper to form the body of the snowman. Crush newspaper into a shape for the head and stick it on top of the gift. Cover the body with cotton wool (absorbent cotton), sticking it on with dabs of glue. Create a face from bits of paper and stick in place.

For the hat, you need a strip of cardboard, plus a circle big enough to make the brim. Draw an inner circle in the brim, the diameter of Frosty's head; cut it out to form the 'lid' of the hat. Roll the strip of cardboard up to form the crown of the hat; stick it in place with tape.

Stick on the top of the hat, then attach the brim, putting strips of tape inside the crown. Paint the hat with black poster paint; it'll need two or three coats. Wrap around the red ribbon to form a cheery hat-band and put it on Frosty's head. Fray the ends of some patterned ribbon to form a scarf and tie it firmly in place.

With so many presents being exchanged at this time of the year, tags are very important. And they are so easy to make. Draw any festive shape you like on to thin cardboard; this one is a Christmas stocking. Cut out the shape and cover it with bright paper; try to co-ordinate the colours with those in the gift wrap you use for your present.

If your wrapping paper has a particular theme in its design make a tag to echo it. To ensure that your design is symmetrical, fold a piece of paper in half and draw on half the design against the fold. Cut around the outline through both layers of paper; open out and use this as a template for the design. Cover a piece of light cardboard with gift wrap and trace around the template.

Cut around the outline and punch a hole at the top of the tag. Write your message and tie the tag on to the parcel. You could cheat a little when designing the shape of your tag by tracing an illustration from a magazine or by using the outline of a pastry cutter.

A three-dimensional Santa Claus tag, complete with fluffy beard, provides a jolly festive decoration on a gift. Draw a fairly large rectangle on thin red cardboard; make sure that all the corners are right angles. Score down the middle and fold the cardboard, creasing it well. Draw an inverted 'V' for Santa's hat, and a curve for his chin; cut them out with a craft knife.

Curve the hat and chin outward to give them a three-dimensional look, then draw in the eyes and mouth. Form a beard from a small piece of cotton wool (absorbent cotton), and stick it in position with a dab of glue. Do the same with the fur trim on the edge of the hat and the pom-pom on its tip. Punch a hole in the back of the label, write your message and tie the tag on the parcel.

A heavenly messenger bears the greetings on this Christmas present. Cut a quarter section of a circle from light cardboard to form a narrow cone for the body. On a folded piece of paper draw one arm and one wing against the edge of the fold as shown, so that when they are cut out you will have a pair of each.

Used greeting cards can often be turned into very acceptable gift tags. Sometimes, as here, the design lends itself to forming a tag. Cut very carefully around the lines of the motif you want to use. Make a hole with a punch, thread a ribbon through the hole and no one would guess the tag had a previous life!

Make the cone and cover it with silver paper (aluminium foil would do). Trace the arm and wings on to silver paper; cut them out and glue them in their relevant positions on the body.

Sometimes a little imagination is needed to give the tag a new and ready-made look. Here, the shape of the tag is outlined on the cardboard in red with a felt-tipped pen. Draw the outline lightly in pencil first to be absolutely sure it is the right size and shape to create the finished label.

Make the head by rolling up some white tissue paper into a firm ball, twisting the ends of the tissue tightly to form a 'neck'. Glue the head into the top of the cone. Tie a scrap of tinsel into a loose knot and stick it on the head as a halo. Make a scroll from white paper, write on your message and stick it between the angel's hands. Attach the angel to the gift with double-side tape.

If you have a long message for the recipient of your gift, this fold-out tag allows lots of room. Select a gift wrap design that has a fairly large repeat. One motif must have sufficient space around it so that it can be cut out without including any others. Draw a rectangle around the motif, ensuring that all the corners are right angles.

Cut the rectangle out with a craft knife. Next, cut out a piece of thin cardboard the same height as the chosen motif and exactly three times its width. Fold the cardboard in three widthways, creasing the folds well, then fold the top two sections back on themselves, as shown. Mark the folds in pencil first to be sure they are straight.

Cut the motif from the gift wrap precisely in half. Glue each half on to the top two sections of the folded card. They should fit exactly, but if necessary trim the top and bottom to form a straight edge. Try matching the colours of the lining cardboard with the gift wrap; in the example shown here, red or even black could have been used, instead of white, for a different effect.

These effective tags are a useful way of using up scraps of cardboard left over from larger projects. Cut a card 10cm x 5cm (4in x 2in), score and fold in half. Measure 6mm ($\frac{1}{4}$in) down from the fold and mark 2mm ($\frac{1}{8}$in) in from the sides before cutting through both thicknesses with a craft knife to give a 'lid' shape. Run the blade along the steel ruler twice for a clean edge.

Punch a hole through both thicknesses at the centre top. Glue on ribbons in a cross shape, folding the raw edges over to the inside of the tag. Finish off with a bow or curled gift wrap ribbon tied through the hole at the top. The tags can be made up in any size or colour with contrasting ribbons to match your gift.

Match the label to the paper by creating a larger version of a shape which appears in the gift wrap. Begin by drawing a scaled-up shape of the motif from the paper and use it as a template from which to trace the design onto coloured cardboard.

For this idea to be really effective, the colour of the tag should be as close as possible to that in the gift wrap. A layer of tissue laid over cardboard of a near-match, as shown, might make all the difference to duplicating the final colour. Cut out the shape, and punch a hole to enable you to tie it to the gift.

There is such a variety of stickers on the market that you're sure to find one which will make an ideal label for your gift. Take a piece of thin coloured cardboard; this will form the background for the sticker. Draw a rectangle on to the cardboard, twice the width you wish the finished tag to be.

Cut out the rectangle with a craft knife and score down the centre to form the fold; crease well. Remove the sticker from its backing and place it in position on the front of the tag. Punch a hole in the back 'page' of the tag near the fold. Write your message inside and hang the tag on the gift.

Press some flowers and foliage to make these pretty gift tags. Cut a piece each of red metallic and glossy white cardboard 7.5cm x 10cm (3in x 4in) and fold widthways. Secure a tip of fern to the front of the red card. Spray with gold paint and when dry, lift off the fern, leaving a red silhouette. Fix the gold fern to the front of the white card. Punch a hole and thread with ribbon.

Cut a piece of single-sided glossy green cardboard 7.5cm x 10cm (3in x 4in). Crease and fold 4cm (1½in) from the left edge to give a folded card size of 7.5cm x 6cm (3in x 2½in). With a green marker pen, draw a border inside the larger page. Fix a spray of miniature rose leaves in one corner then form a loose line of guelder rose flowers up the page.

Having looked at the construction of an envelope make a miniature version from a 14cm (5½in) square of paper. Glue the envelope together and line the side flaps with a silver marker. Take wispy foliage, gypsophila and mauve lobelia and secure them inside the envelope so that they appear to be bursting out. Attach some curled mauve ribbon to the top of the tag.

Take some red and green single-sided cardboard and cut out some sock shapes. Using gold or silver aerosol paint, spray heads of fools' parsley; when dry, secure the best shaped florets to the heels and toes of the socks. Draw a ribbed border at the top of each sock, punch a small hole in the corner, and add coloured ties.

Crease and fold a small piece of yellow cardboard in half and, with your compass pencil just overlapping the fold, draw a 6.5cm (2½in) circle. Cut this out, leaving the card hinged together by about 3cm (1¼in) at the top. Draw a 5cm (2in) circle in green marker pen on the front cover and fix three daisies in the middle. Refold the card and fix a length of thin green ribbon about the fold.

Cut out tags in coloured cardboard or speckled paper. Either cut a single tag and write the message on the back or fold the card in half and cut out a double tag where the message will be inside. Cut a section from a gold paper doily and stick it to the front with spray glue. Trim away any excess level with the edges of the tag.

To make this dotty Christmas tag, make a cracker-shaped template and trace around it onto brightly coloured cardboard. Reverse the template along one long edge and trace around it again. Cut out the tag and fold it in half. Use pinking shears to trim the ends. Cut three strips of florists' ribbon to fit across the cracker. Pink the edges and spray glue them to the cracker.

Pierce a hole on a corner of the tag with the points of a pair of scissors. Cut a length of fine gold cord and bend it in half. Insert the ends through the hole and pull through the loop. Knot the cord ends together or sew them to small gold tassels for extra style.

Tie two pieces of giftwrap ribbon around 'ends' of the cracker as shown. Split the ribbon down the centre and curl each length against a scissor blade.

To decorate the tags further you can write the recipient's name in gold pen and glue on a bow.

Cut a card 15cm x 7.5cm (6in x 3in), score and fold in half. Cut a piece of sequin waste to fit and attach to the front of the card with spray glue. Colour in circles with felt-tipped pens, many different patterns can be made. Punch a hole in back and thread with ribbon.

Cut a gold card 30cm x 15cm (12in x 6in) and score 7.5cm (3in) in from each side. Trace off the template on page 165 and carefully work out where the points will fall. Mark the design on the back of the gold card and cut out using a sharp craft knife and ruler for straight edges.

Burnish the edges of the gold card with the back of your thumb nail if they have lifted. Cut king's clothes from three pieces of brocade, slightly larger than the apertures. Place small pieces of double-sided tape around the kings on the inside of the card and stick brocade in place.

Cut the kings' gifts from gold card and glue in place. Attach sequins to the points of their crowns. Stick on a piece of white card to cover the back of the centre panel. To protect the points, slip a further piece of card into the envelope. The three kings which have been cut out could be used for a further card or gift tag.

New Year celebrations are particularly associated with Scotland. So here, in traditional Scottish style, we have tartan and golden bells for our New Year greeting. A ready-cut window card was used. Remove the left-hand section off a 3-fold card with a sharp craft knife and ruler. Use this spare card to make two bells.

Cut a piece of tartan fabric or paper to fit inside the back of the card, attach with spray glue and trim the edges. Draw two bell shapes onto the spare gold card. Cut out and back with tartan using spray glue. Trim with small scissors and punch holes in the top.

Make a bow from narrow satin ribbon and cut a length of ribbon for the bells to hang from. Thread the first bell and hold in place with a dab of glue, then thread the second bell. Sew the bow onto the card, above the aperture, and through the ribbon suspending the bells.

Cut a card 15cm x 22cm (6in x 8½in), score and fold in half widthways. Mark the centre top of the card with a pencil dot. Cut a triangle from sequin waste and stick centrally on the card applying a little glue around the edges only. Hold in place on the card until the glue dries. Any residue glue can be rubbed away afterwards.

Cut a base for the tree from a piece of cardboard or paper. Curl over scissors a number of pieces of narrow gift wrap ribbon, cut about 9.5cm (3¾in) long.

Glue on the base and add a sequin star to the top of the tree. Slip the curled ribbons through every other hole in the sequin waste and every other row, starting at the top of the tree. You shouldn't have to glue them as they will stay in place. But you will need to deliver this card by hand if it is not to get squashed.

Cut a green card 15cm x 20cm (6in x 8in) and score down the centre. Draw one half of a Christmas tree and cut out a paper template. Draw around this onto the green card, reversing the template along the scored line; cut out. Set your sewing machine to a wide satin stitch and, moving the card from side to side, sew the garlands. Pull loose threads through to the back and knot.

Decorate the tree with self-adhesive spots to resemble Christmas tree baubles. Then cut narrow satin ribbon into fourteen 1cm (½in) strips.

Glue strips in place at the end of the branches on the back of the card: tweezers will help you to hold them steady. Leave until the glue dries, then cut the tops diagonally to look like candles. Add the finishing touch with a red star on top of the tree.

On red fabric, draw four 9cm (3½in) squares and cut them out. Fold in a 6mm (¼in) seam allowances and press. Find the centre of each square by folding it diagonally twice and press with the tip of an iron. Open out the squares, then fold the corners into the centre. Catch the centre points with a small stitch. Fold in again and sew along the seams!

Cut four 2cm (¾in) squares from fir-tree fabric. Place two red squares right sides together and sew down one side to make a double square. Pin a fir-tree patch diagonally over the seam on the right side, and curl back the red folds surrounding the patch to cover the raw edges. Slip stitch to hold in place. Repeat to make another double square.

Sew the double squares together and place a third and fourth fir-tree patch over the seams. Sew tiny beads in the corners. Cut a card 25cm x 18cm (10in x 7in), score and fold in half. Mark the top centre and 6cm (2½in) down either side. Cut out to form a point. Glue the finished square onto the card and draw a border with a gold felt-tip pen.

A simple, easily-made card in unusual colours for Christmas. Cut a card 11cm x 20cm (4¼in x 8in), score and fold in half. Keep the fold at the top of the card. Cut a strip of green plastic from an old shopping bag. Tear four strips of tissue in shades of orange and yellow. The fir-tree is taken from a strip of self-adhesive stickers.

Arrange the strips so that the colours overlap and produce new colours and tones. Stick the tree in place, then spray glue onto the backs of the strips and stick down also.

Trim any excess paper from the edges of the card with a sharp craft knife and steel ruler.

A friendly snowman invites you to come outside to play. Cut off the left-hand side of a 3-fold card so that light will shine through the window. Cut a piece of film slightly smaller than the folded card. Draw a snowman and trees on to paper to fit between the window bars. Place the paper under the film and trace the outline of the snowman and trees with a silver pen.

Turn the film over and colour in the trees and the snowman using a white chinagraph pencil.

Turn the film the right way up and draw a scarf and nose with a red chinagraph pencil. Add face details in silver. Attach the film to the inside of the card with double-sided tape and place a silver star where it can be seen shining through the window.

There is a surprise for the person who opens this card. Cut a rectangle of blue cardboard 20cm x 16cm (8in x 6¼in). Score widthwise across the centre and fold in half. Tear white paper into strips and glue across the lower edge on the front and inside. Cut out two green trees from thin cardboard and glue to the front.

Paint snowflakes with a white typing correction pen. Use the template on page 164 to cut out the snowman in white cardboard, the hat and scarf in yellow and the eyes, nose and buttons in black. Draw a pattern on the scarf and hat with a red pen. Glue all the pieces to the snowman and draw a smile with a black felt-tipped pen.

Score along the centre of the snowman and the broken lines on the tabs. Bend the snowman in half along the scored centre and place him inside the card matching the fold to the opening edges of the card and keeping the lower edges level. Glue the tabs inside the card.

Cut a card 18cm x 23cm (7in x 9in). Score and fold in half. Draw a border in silver pen around the card. Make a sock-shaped template out of thin cardboard and draw around it onto red felt using a water-soluble pen. Now hold the template in place over some sequin waste and cut around it.

Sew the sequin waste to the felt by hand or machine, then trim both layers neatly.

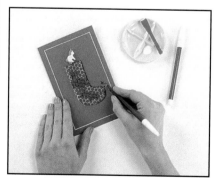

Glue the stocking to the card, then add the little pony eraser or another small gift that can be glued on. Draw holly and berries using felt-tipped pens. You could also add beads and sequins if you wish.

Colourful puffins, cut from a sheet of wrapping paper, keep a lookout from their perch. Cut a card 28cm x 13cm (18in x 5¼in). The card should be blue on the inside and white on the outside. On the outside, score lines 9cm (3½in) and 19cm (7½in) in from the left and fold. Turn the card over and on the inside score and fold 20cm (8in) in from the left.

Cut out three puffins and spray glue the first one on to the outside of the far right-hand panel of card, facing right. Cut around him with a craft knife leaving him attached to the card by his tail. The score line on the outside will allow him to stand forward.

Glue the other two puffins in place on the inside. Any wrapping paper with a distinct animal motif can be used in this way to make a striking card.

Cut a card 23cm x 18cm (9in x 7in), score and fold in half. Trace the pattern from page 165 and transfer it onto thin cardboard to make a template. Place on some polystyrene wallpaper and draw around it with a soft pencil. Cut out with a craft knife. Also cut out some ice caps and ground from iridescent plastic or silver paper.

Glue down the mountains, ground and polar bear, placing the latter in front of the peaks. Then decorate with silver sequin stars.

With a silver pen draw in the polar bear's features: the legs, paws and ears. As an alternative, the polar bear could also be made from white felt.

In this section, we demonstrate that a hand-made gift can look both stylish and professional, and be a delight to the recipient. Floral gifts are ideal for female friends and relatives; we have selected a range of ideas to choose from, from pot-pourri bags and picture frames to attractive floral arrangements. For the men in your life, there are desk sets, stationery, photograph frames and modern decorative ornaments, such as the ducks on page 152. We've also included soft toys for the children – or your big sister! – and a number of items which you can enhance by painting: plates, pots and china as well as tea cosies and potato print cushions.

These tiny pot-pourri bags are so easy to create, and they make delightful gifts. Take a length of cotton fabric and, using a plate as a pattern, cut out a circle about 25-30cm (10-12in) in diameter. Hem the edge with running stitch, leaving long tails of thread at either end. Cup the fabric circle in your hand as shown and fill it with pot-pourri.

Gather the fabric into a tight ball by pulling the threads. Secure with a knot. Wire together a small tight bunch of helichrysum (strawflower or everlasting) using fine silver rose wire and attach the posy to the bag, threading the wire through the fabric on both sides to secure. (Use a needle to make holes in the fabric first if necessary.)

Make a double bow out of satin ribbon and wire this on to the bag. finally, cut a length of gold cord about 35cm (15in) long and tie it round the posy, finishing with a double knot. Tie the ends of the cords at the desired length and hang the bag by this loop.

A couple of old wooden spoons form the basis of a pretty arrangement that would brighten up any kitchen. First, wire the spoons together at an angle as shown, winding the wire round the handles several times to secure firmly.

Wire together several small groups of plants, choosing an attractive range of colours. Shown here is yellow quaking grass, white helichrysum (strawflower or everlasting) and dudinea seedheads. Wire the small groups together to form one large bunch and attach this to the spoons so that the blooms sit prettily over the bowls.

Make a large bright double bow out of satin ribbon and tie it with a second length of ribbon around the spoons and the posy.

A pair of butter pats makes an unusual setting for this kitchen design. Take a length of ribbon and wire up one end. Thread the ribbon through both holes from the front, leaving a long tail between the pats. Loop the ribbon over the top and thread through from the front again, pulling it tight. Make a second loop in the same way, leaving it long for hanging the display.

Secure the wired end of ribbon at the back with a knot; cut off any excess. Wire a small bow on to the front of the pats. Then attach half a sphere of florists' foam to the ribbon 'tail' using tape. Wire small bunches of blue jasilda and tiny red helichrysum and push them into the ball, packing them tightly together.

Add longer stems of blue larkspur, leaving some pieces trailing down the pats to break up the outline of the ball. Finally, wire up short double loops of ribbon and intersperse them among the flowers, finishing off with a couple of longer strands at the bottom.

Pressed flower specimens hung on a ruby satin bow make the perfect gift. Take 2½m (2¾yd) of 7.5cm (3in) wide ribbon, and cut it into three lengths: 50cm (20in), 58cm (23in), and 1.42m (56in). Fold the shortest length, ends to centre, to form a bow and gather the centre using needle and thread. Do the same with the next longest length.

Place the smaller bow on top of the larger one, gather them tightly at the centre, and stitch together. Fold the longest length approximately in half around the centre of the double bow, and sew together at the back to form the knot of the finished bow. Also sew in a small curtain ring at the back by which to hang the design. Trim the ends of the ribbon as shown.

Cut three ovals from beige cartridge paper to fit some miniature plaques. Using a fine pen, write the botanical names of your specimens neatly at the bottom of the ovals. For the first oval, arrange stems, foliage and flowers of forget-me-not to simulate a growing plant. When satisfied with their positioning, fix down with latex adhesive and re-assemble the plaque.

For the second oval, take a large heart's ease and fix it one third of the way up from the base, then add further flowers finishing with the smallest at the top. Now introduce heart's ease leaves to give the appearance of a vigorous young plant. When satisfied, fix in position and then carefully assemble within the plaque.

Place a curved stem in the centre of the third oval and fix borage flowers and buds along the stem in a natural way so that it resembles the top of a growing stem. As before, when you have completed the picture, assemble the plaque. Take the three plaques, and arrange them down the ribbon at regular intervals. Now sew them in place, parting the ribbons slightly.

Drop two or three colours onto the water and swirl together with the end of a paint brush. Cut plain paper to fit the tray. Wearing rubber gloves, start at one end of the tray and lower the paper onto the surface of the water so it can pick up the pattern. Carefully lift up the paper.

Leave the paper to dry overnight on newspaper. You can remove the paint from the tray by drawing strips of newspaper across the surface of the water.

Now you are ready to cover your gift. Cut a rectangle of marbled paper large enough to wrap around the book with a 2.5cm (1in) margin on all sides. Wrap the paper around the book, open the cover and glue the paper inside the opening edges.

Prop up the book so the cover is open at a right angle. Snip the paper each side of the spine and stick the top and bottom margin inside the covers, folding under the corners.

Push the paper at the ends of the spine between the spine and the pages with the points of a pair of scissors. Arrange jewellery stones on the cover and use a strong glue to stick them in place. Cut two pieces of paper to fit inside the covers and glue inside.

For that extra special gift, cover a plain diary or note book in hand-marbled paper. Fill a shallow tray with water. Put spots of enamel paint on the water with a paint brush. If they sink the paint is too thick and needs thinning with a little white spirit. If they disperse into a faint film it is too thin and should be mixed with more paint.

Use the traditional art of quilling to make this attractive gift box a gift in itself. Cut coloured paper strips 4mm (³/₁₆in) wide and about 20cm (8in) long. Scratch the end of a strip to soften the paper. Now coil the strip tightly between your thumb and finger. Release the coil so it springs open and glue the end against one side.

The coils can be gently squeezed into various shapes to fit your chosen design. Experiment with forming different shapes such as triangles and teardrops. To make smaller coils, cut shorter paper strips.

Draw a design on the lid of a wooden box and spread paper glue on a section of the lid. Arrange the coils on the glue and then move onto the next section. Fill in the whole design – any gaps around the motif can be filled with coils that match the colour of the box.

Transform ordinary pencils into these smart covered ones with scraps of wrapping paper. Choose round rather than hexagonal-shaped pencils. Cut a strip of wrapping paper wide enough to wrap around the pencil and as long as the pencil. Spray the back heavily with spray glue and wrap around the pencil.

To finish, simply trim away the excess at the end of the pencil with a pair of small scissors.

There is no excuse for mislaying letters with this smart letter rack. From thick mounting board cut a rectangle 24cm x 8cm (9½in x 3¼in) for the front and 24cm x 10cm (9½in x 4in) for the back. Diagonally trim away the top corners and cover one side of each piece with giftwrap.

Cut giftwrap slightly smaller than the front and back sections and glue in position on the wrong side. Take a piece of wood 24cm (9½in) long by 3cm (1¼in) wide and 1cm (⅜in) thick. Cover the wood with coloured paper.

Cut a rectangle of mounting board 27cm x 7cm (10½in x 2¾in) for the base and cover with coloured paper. Use a strong glue to stick the front to one narrow edge of the wood keeping the lower edges level. Glue the back to the other side in the same way. Finish the letter rack by gluing this upper section centrally to the base.

Make this carrier bag and you have a gift bag for your presents or go a step further and make the bag itself the present. Cut a piece of thick yellow cardboard 57.5cm x 29cm (22⅝in x 11½in). Refer to the diagram on page 167 and score along the solid and broken lines. Cut away the lower right-hand corner and cut into the base along the solid lines.

Fold the bag forwards along the solid lines and backwards along the broken lines. Turn the bag over and, with a pencil, lightly divide the front into quarters. Cut out a small hole at the centre for the clockwork. Cut out four pieces of red paper 1.5cm x 1cm (⅝in x ⅜in) and glue on the divisions 7cm (2¾in) from the hole.

Rub out the pencil lines. Join the side seam by gluing the narrow tab under the opposite end. Fold under the small base sections then glue the long sections underneath. Cut two strips of green cardboard for handles 30cm x 1cm (12in x ⅜in). Glue the ends inside the top of the bag. Insert the clockwork rod through the hole and attach the hands.

Paint a plain ceramic honey pot and transform it it into something striking for a unique gift. Using a fine paint brush and black ceramic paint, paint some bees on to the lid of the pot. If you are worried about painting free-hand, first draw the bees on with a chinagraph pencil. And if you are not even sure how to draw a bee, get a picture of one to copy.

Now paint the stripes with black ceramic paint. If, like this one, your pot is ridged, use the raised surface as a guide for your lines of paint. Otherwise you can use strips of masking tape to mask off those areas which are to be yellow. In order not to smudge the work, you may find it easier to paint the lower half first and then leave it to dry before painting the top half.

When all the black has dried, apply the yellow ceramic paint, carefully filling in the bee's striped body with a fine brush. Fill the pot with honey and have a nice breakfast!

Clowns are a very bright and jolly popular image and, painted on to wall plates like these, they make a colourful gift to decorate a child's room. Look at birthday cards, wrapping paper, toys and in children's books for inspiration.

Once you have drawn your design on paper, copy it on to a plate using a chinagraph pencil. When drawing your design, consider the shape of the plate; make the feet curl round the edge, as we have done here, and try to make the image fill as much of the plate as possible. Next, follow the chinagraph line with a line of black ceramic paint.

With a combination of ragging and flicking you can transform a plain china vase or jug into a work of art. You will need a piece of cloth for the ragging, a couple of fine artists' brushes and some ceramic paints. Dip the rag into one of the paints and then blot it onto some waste paper to remove any excess paint. Now begin to dab paint on to the vase.

Leave gaps between the dabs of paint to allow the background colour to show through. When you have evenly covered the surface, leave it to dry. Now spatter the vase with white ceramic paint, flicking the paint on with a fine brush. Once again, leave to dry.

Colour the main features such as clothes and hair using very bright ceramic paints: cherry red, lavender, blue, orange, yellow and green. Make the clothes colourful and busy, with plenty of spots, checks and patches.

Finally, fill in the background with circles, triangles or wavy lines, painted in brightly contrasting colours. When the paint has dried, finish off with a protective coat of ceramic varnish.

Finally, apply some gold ceramic paint with a fine paint brush, forming clusters of little gold dots across the surface of the vase. Be sure to clean your brush thoroughly in turpentine when you have finished.

M ade in the Phillipines from balsa wood, these lovely ornamental ducks are exported all over the world and are widely available in department stores. They are ideal for painting and make beautiful gifts. Draw your design on to the duck in pencil, either following one of the designs shown here or using a bird book as reference. Now start to paint.

Acrylic paints are ideal on this surface but you can also use glass or ceramic paints, or even a mixture of all three. Paint the main areas of colour first and then change to a finer brush and fill in details such as the eyes, the white ring round the neck and the markings on the wings and tail.

Finish off with a coat of polyurethane gloss varnish. If you have used a variety of paints remember that they will dry at different rates so make sure they are all dry before varnishing.

These jazzy potato printed cushions make inexpensive yet stylish gifts – you may even want to make some for your own home! Cut a potato in half and draw the design on to one half with a felt tip pen. Now cut around the motif so that the design stands proud of the background.

Paint some fabric paint on to the potato motif with a brush. Stamp off any excess paint on to some waste paper then print the motif on to your chosen fabric, leaving plenty of space for a second and even a third motif.

Cut another simple motif from the other half of the potato. Apply the colour as before and print on to the fabric. When the fabric has dried, iron on the back to fix the paints. Your fabric is now ready to be made up into cushions, curtains, blinds and so forth.

This pretty hand-painted frame is an ideal gift. Firstly, sand the frame until it is smooth and then give it a coat of white acrylic paint. Apply a second coat of paint if necessary and, when dry, draw the design with a soft pencil. Paint the design using acrylic paint in soft blues and greys with the flower centres in bright yellow.

Remove the backing and the glass and give the frame a protective coat of polyurethane varnish.

Decorate kitchen ware with a simple but effective design of cherries for a unique gift. You will need some fabric felt tip pens and/or some opaque fabric paint plus an apron, tea cosy, pot holder and tea towel to decorate.

Practise the design on some paper first, then, when you are confident, use a fine fabric felt tip pen to draw the outline of your design on to the fabric. Here, the leaves and cherries have been spaced out so that they appear to be tumbling down from the tree. On the apron pocket the leaves are grouped to act as a nest for the falling cherries.

Now fill in the outlines with red and green paint. On dark backgrounds you will need to use opaque paints; these are harder to apply than the felt tip pens, so be patient and keep going over the design to achieve the intensity of colour desired.

When the paint is dry, use the black felt tip pen to add veins to the leaves and shading to the cherries. To complete the design, add white highlights to the cherries. this can be done either with a pin or with the opaque fabric paint. Finally, iron the back of the fabric to fix the paints.

One square represents 2.5cm (1in)

Hat brim
Cut two
Black felt

Hat top
Cut one
Black felt

Hat
Cut one
Black felt

Nose
Cut one
Orange felt

Button
Cut three
Black felt

G

A A

Front body
Cut one
White fur

Arm
Cut four
White fur

Head
Cut two
White fur

Eye

Dart

Nose

Eye

B B

Holly
Cut two
Green felt

E

F

C

Boot
Cut two
Black felt

D

F

Boot sole
Cut two
Black felt

E

D

Side body
Cut two (one reversed)
White fur

A

B

B

G

A

Inside leg
Cut two (one reversed)
White fur

E D

E

C

Gap

159

Join the head gusset piece to the side of the head on the side body piece by sewing seam J-K. Repeat on other side. Then sew up seam J-D at the front of the head.

Sew the inside body to the side body, starting at seam D-E. Then sew seam F-G and finally seam H-B. Repeat on other side.

MATERIALS

30cm (12in) white fur fabric
1 pair 13.5mm black safety
　eyes with metal washers
1 small plastic nose
Black embroidery thread
Filling

Fold the tail in half lengthwise. Sew along the curved edge, leaving the top open. Turn the tail, poking out the tip carefully. Sew seam K-B on the back of the bear, sewing in the tail at the same time where the two darts meet. Open out and stretch the bottoms of the feet and sew in the foot pads.

This charming toy will delight any child. Size up the pattern opposite and cut out all the pieces. Pierce a tiny hole at the eye position and cut a slit for the ears on each side body piece. Join both pieces of the inside body by sewing seam A-B, leaving a gap for turning and filling. Open out the inside body. Sew the under chin piece to the inside body along seam C-A-C.

Turn the bear the right way out. Insert the safety eyes through the holes made earlier and secure on the reverse with metal washers. Poke a tiny hole at the very end of the snout and secure the plastic nose in the same way.

Sew up the darts at the rear of the side body pieces. Sew both halves of ears together, leaving the straight edge open. Turn the right way out and make a small tuck at the raw edge of the ear on both sides to curve the ear slightly inwards and oversew into place. Push the straight edge through the slit in the side body and sew the ears into position through all layers of fabric.

Fill the bear with stuffing, starting at the feet. Flatten the feet slightly as the filling is added. Mould the head shape by pushing more filling into the cheeks. When satisfied with the general shape of the bear, close the gap in the tummy using a ladder stitch.

With black embroidery thread, stitch through the feet four times on each paw to form claws. Using the same thread, embroider a smile on the bear's face. Finish off the mouth on either side with a small stitch at right angles to the main stitch.

Finally, taking a long needle and white thread, pull the eyes slightly together by passing the threaded needle from corner to corner of the opposite eyes, through the head. Fasten off securely.

Side body
Cut two (one reversed)
White fur

G

F

Dart

Tail

B

K

Ear

Eye

D

J

A

C C

Under chin
Cut one
White fur

D

One square represents 2.5cm (1in)

B

Inside body
Cut two (one reversed)
White fur

H

Gap

G

F

A
C

E

Foot pad
Cut four
White fur

K

Head gusset
Cut one
White fur

J

Tail
Cut one
White fur

Ear
Cut four
White fur

Size up the templates on the following pages as follows: draw up a grid of 2.5cm (1in) squares, then copy the design onto your grid, square by square, using the grid lines as a guide.

Stars and Bows
(page 8)

Felt Hearts
(page 19)

Patchwork Stars
(page 20)

Christmas Bells
(page 20)

Side panel

Base

Clapper

Santa Napkin Rings
(page 61)

Chinese Lantern
(page 162)

Star Garland
(page 29)

Christmas Tree Frieze
(page 29)

Incognito
(page 64)

Strike Up the Band
(page 65)

Place on fold

Dancing Santas
(page 27)

Masquerade
(page 47)

Place on fold

Candy Sleigh
(page 51)

Blue Angel
(page 17)

Place on fold

Place on fold

Place on fold

Star pockets
(cut 23)

Large star
pocket
(cut one)

Pop-Out Snowman
(page 134)

What a Cracker!
(page 23)

Cracker Ends
(page 23)

Three Kings
(page 126)

Birds of a Feather
(page 131)

New Year Dove
(page 131)

Paper Holly
(page 129)

Polar Bear
(page 135)

Squared Up
(page 114)

324mm
(13in)

412mm
(16½in)

100mm
(4in)

100mm
(4in)

12mm (½in)

Box Clever
(page 114)

12mm
(½in)

New flap

New
box
top

Match to side
measurement

25mm
(1in)

New flap

New flap

Existing flap

Measure
side of
ceral
packet

100mm
(4in)

Existing flap

Existing flap

Existing flap

Existing flap

TEMPLATES

Smart Sachets (page 110)

12mm (½in)
36mm (1½in)
Compass point
48mm (2in)
60mm (2½in)
Fold
Compass point
Compass point
Fold
Compass point
60mm (2½in)
72mm (3in)
Compass point
Compass point
Compass point
36mm (1½in)
Fold
Can lengthen parcel between compass points
Fold
138mm (5½in)

The Pyramids (page 112)

250mm (10in)
12mm (½in)
12mm (½in)
100mm (4in)
Construction line
100mm (4in)
Construction line
75mm (3in)
50mm (2in)
50mm (2in)

Boxed In (page 85)

10mm (⅜in)
44mm (1¾in)
10mm (⅜in)
10mm (⅜in)
7mm (¼in)
22mm (⅞in)
15mm (⅝in)
15mm (⅝in)
2mm (⅛in)
30mm (1¼in)
84mm (3¼in)
30mm (1¼in)
84mm (3¼in)
84mm (3¼in)
12mm (½in)
30mm (1¼in)
35mm (1⅜in)
15mm (1⅜in)

Handle With Care! (page 113)

50mm (2in)
18mm (⅜in)
25mm (1in)
Radii of handles
50mm (2in)
100mm (4in)
100mm (4in)
2mm (⅛in)
50mm (2in)
100mm (4in)
100mm (4in)
200mm (8in)
100mm (4in)
200mm (8in)
100mm (4in)
12mm (½in)

SCIENTIFIC CLASSIFICATION

The following is an alphabetical list of the common names of plants
used in this book and their Latin equivalents

Common name	Latin name	Common name	Latin name
Baby's breath	*Gypsophila paniculata*	Oak	*Quercus*
Bottlebrush	*Callistemon*	Pearl everlasting	*Anaphalis*
Carnation	*Dianthus*	Poppy	*Papaver*
Chinese lantern	*Physalis*	Rhodanthe (sunray)	*Rhodanthe manglesii =*
Clubrush	*Scirpus*		*Helipterum manglesii*
Cypress	*Cupressus*	Rabbit's or hare's	*Lagarus ovatus*
Glixia (grass daisy)	*Aphyllanthes*	tail grass	
	monspeliensis	Rose	*Rosa*
Holly	*Ilex aquifolium*	Safflower	*Carthamus tinctorius*
Honesty	*Lunaria annua*	Sandflower	*Ammobium alatum*
(silver dollar plant)		Sea lavender	*Limonium tataricum*
Ivy	*Hedera*	September flower	*Aster ericoides*
Larkspur	*Delphinium consolida*	Spruce	*Picea*
Lavender	*Lavandula angustifolia*	Statice	*Limonium sinuatum*
Lily	*Lilium*	Strawflower	*Helichrysum*
Love-lies-bleeding	*Amaranthus caudatus*	(or everlasting)	
Nipplewort (Dutch	*Laspana communis*	Sunray	*Helipterum*
exporters call it broom bloom)		Yarrow	*Achillea*

Clockwise Carrier Bag
(page 149)

INDEX